THE
STEP BY STEP
GUIDE TO
PHOTOGRAPHY

THE
STEP BY STEP
GUIDE TO
PHOTOGRAPHY

MICHAEL LANGFORD

BOOK CLUB ASSOCIATES
LONDON

Editor **John Smallwood**
Art editor **Patrick Nugent**
Designer **Denise Brown**
Assistant editors **David Lamb, Lucy Lidell**
Staff photographer **Andrew de Lory**
Picture research **Elly Beintema**
Managing editor **Joss Pearson**
Editorial director **Christopher Davis**

The Step by Step Guide to Photography was conceived, edited
and designed by Dorling Kindersley Limited, 9 Henrietta Street,
London WC2

First published in Great Britain in 1978 by Ebury Press.
This edition published 1980 by
Book Club Associates
By arrangement with Ebury Press

Printed in Italy by Amilcare Pizzi

Contents

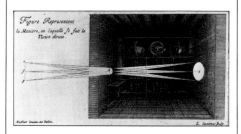

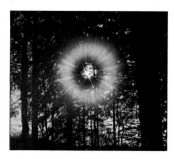

CONTENTS

How to use this book

This book is a teach-yourself, structured course in photography. It takes you from absolute basics to a fairly advanced level in a logical progression of stages, which you can work through at a pace which suits you. As you can see from the contents list, black and white and color photography – camera and darkroom work – are both featured in depth, presented in sections which make maximum use of drawings and photographic examples.

Photography is a combination of applied science and art, and both aspects are explained in technical and picture building sections respectively. These are organized in such a way that you can concentrate on the practical aspects of technique at one level and follow this with an appropriate stage of picture building before progressing further.

At regular intervals you will find assignments, reminders and summaries. Tackling the sort of practical photography suggested in the assignments will make it very much easier to learn and understand points made in the main text. The summaries and reminders are particularly useful if you are using this book as part of a photography course.

There are ten main sections. The first section looks at some of the ways photography is used today, the second at the basic principles of light and light-sensitive materials which make photography possible.

The third section – Camera Technique – covers the basic methods of using a camera. It is the foundation of all the other work in the book because it explains the camera controls, from a cheap simple camera to a more sophisticated single lens reflex. It is divided into four sub-sections or "Steps" which are intended to be read in sequence. We look, for example, at choosing film – at this stage for black and white photography only. The reason why black and white photography is covered before color is that all the basic controls can be learned in the simplest way. Color photography (and particularly color processing) is easier to understand once you are familiar with black and white work.

The fourth section – Picture Building – begins with the fundamental aspects of composition in black and white. The photographs and practical assignments suggested here can be carried out with the equipment discussed in the preceding section. The third and fourth sections form a mini-course in themselves and provide the foundation for the rest of the book.

The fifth section is Black and White Processing and Printing. The first Step shows how to process the film, for which a darkroom is not essential. Later Steps explain contact printing and enlarging, and show the darkroom facilities, equipment and materials needed for this work.

Advanced sections

By this point in the book you should be able to use a camera with a standard lens in natural lighting, and successfully process and print your results. But further equipment such as extra lenses, close-up accessories, and artificial lighting can extend the scope of your photography considerably. The sixth section – Further Equipment and Techniques – is an advanced course in various aspects of camera work and more sophisticated equipment which, although still based on black and white photography, will also have direct relevance to the later color sections. The last Step of this section introduces some additional facets of picture building, made possible by this extra equipment.

The following section – Advanced Darkroom Techniques – takes your work in the darkroom further by discussing ways in which you can control and manipulate the quality of the negative and the final image. The section ends with finishing, mounting, and presenting your black and white prints.

The next two sections deal with color photography. The first – Color Photography – deals with most of the aspects of color work outside the darkroom. It concentrates first on the technical differences between black and white and color films, such as the need to relate film type to lighting. Step 2 looks at the additional scope that working in color provides for your picture building.

The second section – Color Processing and Printing – is another self-contained "mini-course", this time dealing with the film processing and darkroom aspects of color photography. It explains how slide and print processes work and, in particular, the procedures for processing both types of color film, and making your own color prints at home.

The last main section is called Evolving Your Own Approach. Up to this point all the illustrations have showed you how and what to do. These pages contain a selection of work by fourteen photographers who differ greatly in their approach to photography. The work included shows just what an individualistic medium photography can be. The photographs demonstrate how the technical principles and visual ideas discussed in the earlier parts of the book can be applied in a highly personal way. The aim of this section is to show how, given confidence and control of the medium, and a point of view to communicate, you can develop a strong style of your own.

The Appendix contains information on a variety of cameras and techniques, which are not covered in the main part of the book, and a glossary of common photographic terms.

Working through the book

The book is designed to be read through in sequence – terms are explained as they are introduced and information becomes progressively more concentrated in the later sections. But you could use each section or group of sections as self-contained units, to cover particular aspects of photography that interest you. For example, perhaps you are a beginner with no processing facilities and you just want to take black and white and color pictures. Then the sections on Camera Technique, Picture Building, and Color Photography together with the final section of different photographer's work would be most helpful.

If you already know the principles of camera and darkroom work but want to extend your basic equipment and begin color photography, you can start at page 89. If you are considering buying a camera, the Camera Technique and Further Equipment sections will show you what features to look for.

This step-by-step course introduces the range of photography that is open to the amateur. It will show you not only how to take technically correct pictures, understanding and making the best use of your photographic equipment, but also how you can make your pictures visually interesting.

Introduction—the scope of photography

On August 19th, 1839, in Paris, it was announced that Louis Daguerre had discovered a way "to capture the image in the camera obscura by the action of light itself". He had developed a suitable light-sensitive material which could record an image direct. Although this first process was primitive, and it involved exposing the "film" to light for up to half an hour, its impact was tremendous. Here was a way of reproducing landscapes, portraits and other subjects without using drawing skills.

It was forty years before photographs began to appear on the printed page, in books, newspapers and journals – more before first films, and then television, brought motion pictures into our everyday lives. Today we are so accustomed to the existence of photography, we are hardly aware of how it has widened and changed our view of the world. Without photography, our experience of the world around us would be limited only to what we could see with our own eyes.

Photography is an important scientific and documentary tool as well as a creative medium in its own right. The following pages show some of the ways photography has altered and widened our experience. It has, for example, enabled us to get an almost first-hand knowledge of other countries and cultures, and provided detailed images of subjects that the eye could not normally see. At the end of this book, we show you the interpretative and creative potential of photography. These two sections together are designed to introduce you to the scope and power of modern photography, and to set your technical abilities and practical work in perspective.

Photography and science

The camera is one of the scientist's most valuable tools. It can record the briefest event with micro-second exposures, or show changes that occur over a long period of time through time lapse techniques where the camera is set up to take a picture perhaps twice a day for a month. Cameras enable us to see a process too quick for our senses to record or too slow for us to remember with accuracy. We can see the detail of an insect's wing during flight or trace the growth of a flower, "stop" the motion of a bullet as it emerges from a gun barrel or record a subject's movements during sleep night after night.

Cameras can be attached to many advanced optical instruments. Astronomers and space technicians can study pictures of galaxies thousands of light years away. The photographs can reveal new information about the universe, and enable astronomers to map out the surfaces of unknown planets. Geographers and meteorologists can also use photographs taken from satellites orbiting the earth to improve existing maps and make weather forecasting more accurate than before. Experts can use special aerial photographs to assess crops or reveal geological features of the landscape which are hidden at ground level. The photographs they use also provide them with a permanent, detailed record of their subject.

Fixed to microscopes and electronic close-up devices the camera can record a world too small for the resolution of the unaided eye. Small objects just inside our visual range take on dramatic proportions when photographed, say, fifty times

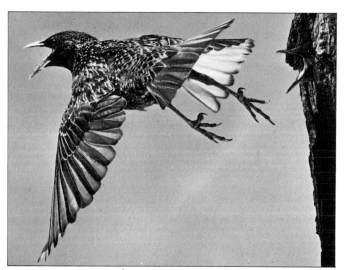

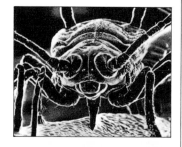

Photography and natural history
Photography can reveal and record on film unseen aspects of the natural world. The starling, left, was caught in mid-flight using an electronic flash, triggered by the bird itself. The picture of a greenfly, right; and a potato leaf, far right; show the ability of photography to reproduce in detail minute subjects.

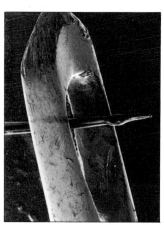

Photography and space research
Photography has played an important role in space research. Although the picture, right, was taken from about 98,000 miles out in space, weather conditions and certain physical features are still discernable on the Earth.

Photography explores structures
Photographing through a micro-scope allows striking comparisons to be made between man-made and natural forms. The picture left shows a bee sting passed through the eye of a needle.

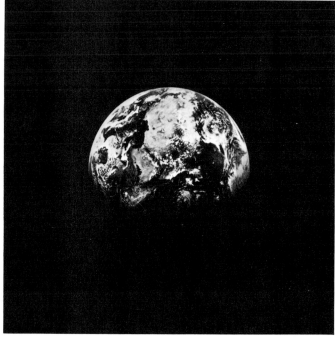

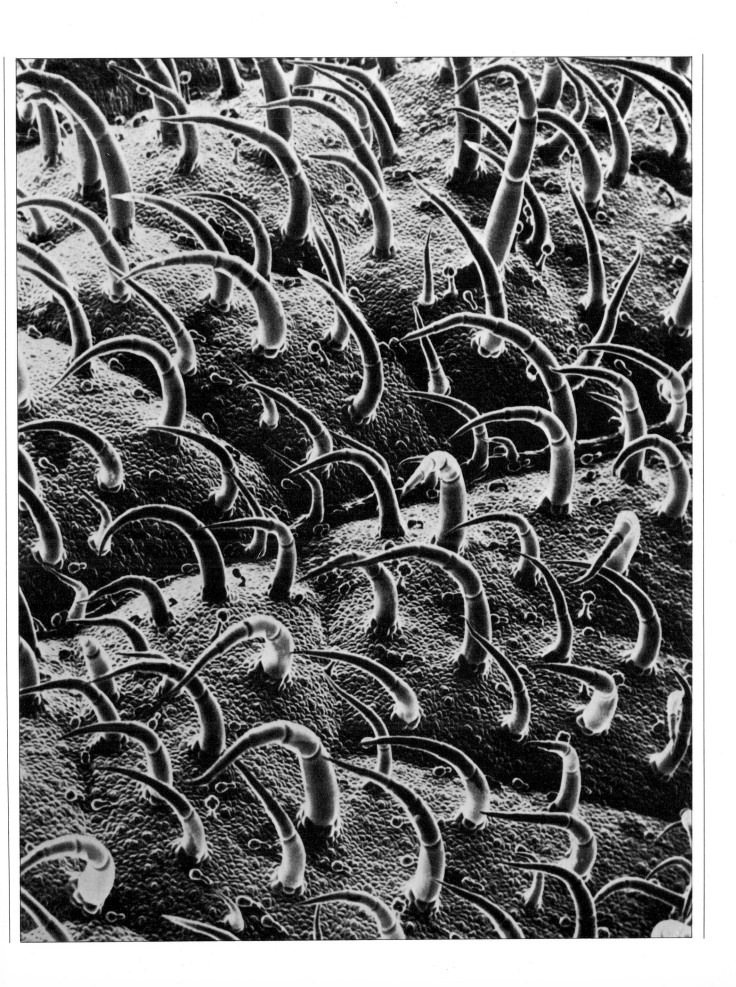

normal size. Further down the size scale, film can accumulate the three dimensional scan of an electron microscope to show details of structures enlarged five hundred or one thousand times. Some microscopes can go in so close that at magnification of several thousand times, scientists can study on photographs the surface of a single crystal of metal or blood corpuscles.

Such specialized photography is becoming essential for scientific research. Because they can be reproduced in magazines and books with great fidelity, non-specialists can keep in touch with scientific progress and obtain useful information and ideas for their own areas of interest. Engineers can form new ideas about construction from the structures they see in photographs of minute, natural cells. Artists can take inspiration from the designs they see in micro-organisms or views of distant galaxies.

Extending our view of the world

Recording an event or place on film has become an accepted way of authenticating our experience and sharing it with others. Cameras can take us to places and give us the opportunity to share visual sensations beyond our own likely experience. We can share the climb to the summit of Mount Everest. Underground explorers can use camera equipment with powerful flash illumination to show us remote crevices and caves thousands of feet below the earth's surface.

We cannot all get to spectacular viewpoints, but in the hands of an expert the camera can record for us a spectacular aerial

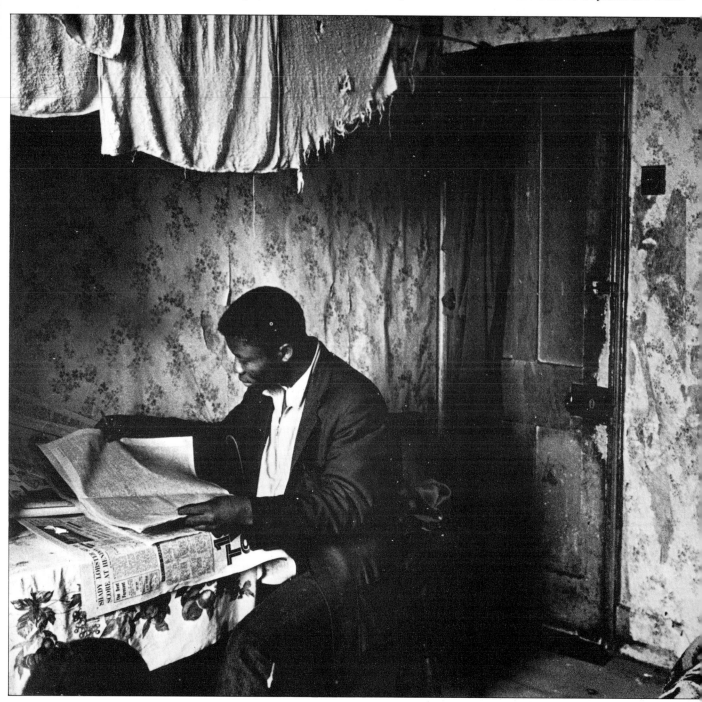

view of an oil-rig or a hydro-electric dam. High quality cameras were essential equipment on each of the moon trips for scientific and documentary purposes. They can show us what it was like for the men who actually set foot on the moon. The accurate film record of the voyages and landings, enables us to share the experiences of the astronauts and is an important historical and scientific document. On a lesser scale, travel photography can give us all a taste of remote places and events.

Remote control cameras can take pictures from positions that are too dangerous or too small for man to go. The early tests of the Atom Bomb, for example, were recorded on film by cameras positioned close to the explosion. In industry, remote controlled trolleys are used to carry cameras along narrow drains to record

details of corrosion. The camera unit contains integrated flash lighting as good color results have to be achieved. In hospitals, cameras with a special lens at the end of a flexible, light-bending tube are used. The lens can be pushed deep into a patient's throat or stomach to give the surgeons detailed information on film from which diagnoses can be made. Similar attachments enable cameras to take pictures in furnaces or vacuum chambers, or check the equipment inside an aircraft's wing.

The camera is infinitely more sensitive than the eye, particularly when extended by electron techniques. Things that you cannot normally see can be photographed because light can now be amplified like sound. A camera fitted with a battery-operated image convertor lens will operate at night as if in

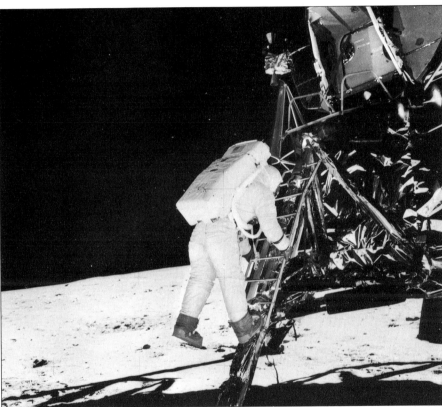

Photography and exploration
Cameras and film are now an essential part of all exploration. The pictures taken on the Moon, such as shown above, are of great scientific and historical importance.

Documentary photography
Documentary photography has had a long and important history. It began with some of the earliest travel photographs and soon developed into social and political areas, using pictures, such as the slum shown left, to press for reforms.

Photography and technology
The aerial picture, right, is one of the more dramatic examples of the use of photography in industry and technology. It shows one of the largest oil-rigs in the world begining a 250 mile journey across the North Sea to its permanent site.

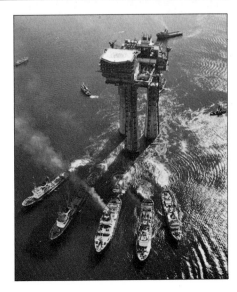

daylight. Even when there is no moonlight, ambient light from the stars, or reflected off clouds from street lights is sufficient to allow pictures to be taken using this camera. Detail is poorer than normal photography but most of the scene is clearly recorded.

Documentary and news

Photography is generally regarded as truthful and accurate. Cameras document stolen property, damage and injury, and forensic detail as well as criminal acts. In a Court of Law such photographs are objective evidence. We talk of infallible, "photographic" memories, and we readily believe what we see in pictures. This is partly because the interpretation that goes into a photograph is not always as obvious as in a drawing or painting. We are most satisfied with "real" visual confirmation of events and situations. But as the camera is essentially only a tool in human hands, the pictures it produces can be as subjective and sometimes as biased as any other recording medium.

The first consideration of documentary pictures is that all the elements of good picture building should be concentrated into expressing the particular event. But also documentary and news pictures have a strong purpose or message to communicate. Documentary photographs taken during the exploration of the American West helped to persuade the American authorities to delimit Yellowstone National Park. Social reformers Jacob Riis and Louis Hine took photographs as evidence of child labor abuse and wretched housing conditions in New York in the late nineteenth and early twentieth century. Farm Security Administration photographers produced thousands of pictures to show the plight of Midwest farmers during the Depression in the 1930s. The success of these pictures is that they captured the facts and conveyed their message so well that public opinion was stirred and reforms were introduced.

The "frozen" quality of a still photograph can be more powerful than a newsreel. The Vietnam war is the most highly documented conflict in history, but of all the thousands of feet of motion picture film shot, often the most poignant records are still photographs. It is this power that has made the camera a vital piece of equipment not only for those who want to document events for historical or simply news purposes but also for those who want to stimulate changes or reforms.

Although visual evidence is hard to disbelieve, documentary and news pictures are rarely objective. The photographer usually expresses his opinion of an event through his photographs. If he is photographing bad housing conditions he can choose to dramatize them to make a more powerful image – he can choose to ignore or play down certain aspects. This bias in documentary and news photography can often be introduced in unexpected ways. The very presence of a photographer can sometimes encourage an event to happen, just for the camera. A political demonstration, for example, can become more violent when those involved realize that it will be recorded on film. Photographers are seldom responsible for the final way their work is presented and used. How a picture is cropped, its position in relation to other photographs, and the wording of captions can change, transforming or even distorting the original content.

The Camera and History

The camera is a device for recording moments in time. The realism and detail of photographs can take you back to an earlier age, providing accurate historical documents of important events and everyday life. Until 1839 all visual records were drawings, engravings or paintings. We have photographs of the Civil War but not the War of Independence; we can see how Lincoln really looked, but not George Washington. Queen Victoria was the first monarch to be recorded by the new process.

The Crimean War (1853-6) was the first conflict to be recorded by camera. The limitations of the process and the sentiment of the time influenced the way things were actually shown. The photographer – Roger Fenton – used a 20 x 16 ins camera and glass plates which had to be coated with light-sensitive collodion in a mobile darkroom immediately before exposure. He could not possibly show cavalry charging or the cannons firing because he had to use long exposure times. So Fenton's pictures are limited to scenes of the damage and carnage after battle, and groups of soldiers posed outside their tents. Similarly, most nineteenth century portraits and scenes are "set pieces" in the formal artistic style of the day.

The situation changed during the 1870s and 80s when hand cameras and faster, more sensitive photographic materials made it possible to take "instantaneous" pictures almost anywhere. Some museums were quick to see the importance of gathering photographs showing contemporary life, rather than the contrived, posed camera work which was then considered good enough for photographic exhibitions. Today these collections are valuable references, but often for reasons unforeseen at the time of taking the picture. They show the everyday clothes, the forms of transport, buildings and streets, the advertisements, even the attitudes and manners of the time.

Uses of photography in research and industry

No center for medical, industrial or scientific research would be properly equipped without photographic facilities. Medical research cameras are attached to various sorts of microscopes to record bacteria and viruses within our bodies. Because photographic materials are sensitive to X-ray wavelengths as well as visible light, X-ray radiographs can be made of the internal parts of our bones. X-ray sources linked to computers can record on film selected cross-sections of any part of the living, human body, enabling doctors and specialists to diagnose accurately physical complaints.

X-rays are also used in industry for detecting cracks, faulty casting and welding, and fatigue in metals. No aircraft would be test-flown without special photographic cameras first monitoring its fuselage. In map making, aircraft (and satellites) carry cameras able to record the layout of ground detail with great precision. Pictures from pairs of cameras are analyzed by lasers and fed through computers to read out as contour maps.

Minute printed circuits of very great complexity can be produced by photography. A large scale drawing of the circuit is photographed and then reduced down to micro size and printed on to a metal surface which is etched to form an electrical circuit. Circuits like these are now built into cameras, and practically every form of compact electronic device.

The words you are reading now have been exposed from a master negative of alphabet characters on to a large sheet of photographic film. The machine which does this works like a very sophisticated typewriter, using light instead of ink. The film is then exposed on to a light-sensitized metal surface, and from this the book is finally printed. Illustrations are shot on high-contrast film that reduces everything to either black or white. The film is developed, producing a line negative from which the plate for printing is made.

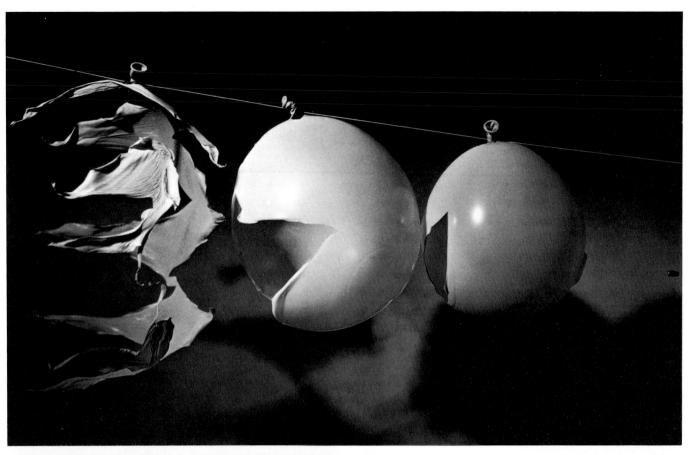

Photography and scientific research
The ability of the camera to "freeze" movement is invaluable to the scientific study of motion and change. It can provide information on anything from the formation of a wave of water to the strength of a material. The picture above shows the progressive disintegration of three balloons which have been burst by a single bullet.

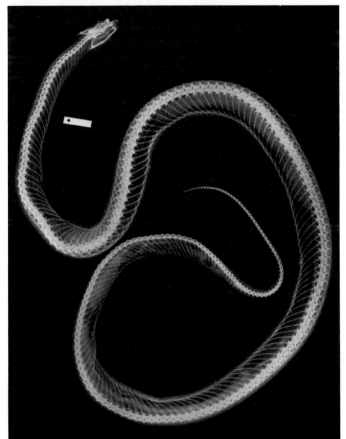

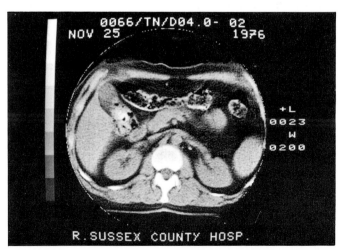

Photography and X-rays
Photographic materials can record X-rays enabling the camera to take "pictures" of the internal structure of visually opaque objects. These images can be of aesthetic and scientific interest, such as that of the snake, shown left. The cross-section of the human body, above, was produced for medical diagnosis, using a computer. It shows the human abdomen, with the kidneys and spine clearly visible.

Taking your own photographs

As a method of making pictures photography can be used by everyone – it does not require either drawing or scientific skills. Thousands of "snapshots" are taken every day by non-experts, without any artistic knowledge or commercial aim. Mostly these are simple personal records of people, places, and events.

Most people are dissatisfied with their photographs and conscious they could do better. Usually things could be improved by a little more experience of picture making, and more understanding of how the camera itself controls results. Of course there is a danger of going too far in both these areas. You might end up taking only "picturesque" images and ignore the camera techniques which could improve your results. At the other extreme, you may become so deeply absorbed in the way the camera actually works, so that your pictures are technically good but visually uninteresting.

Somewhere between these extremes there is room to learn more about photography, taking it to whatever level your time and interest allows. The pages which follow offer that choice. The information and advice they contain will give you ideas for improvements, suggest where you may be going wrong, show how you might develop your photographic ability. As a whole it aims to strike a balance between the processes and techniques, and the more subjective aspects of picture building. It does not intend to tell you which way you should choose to go. But it will show some of the options, then leave you to move forward using your own imagination and ideas.

Photography and History
The pictures, right and bottom, are examples of the important part that photography plays in providing us with social and historical documents. The photographs of the Generals in the US Civil War and London in the 1890s, below, are permanent historical records.

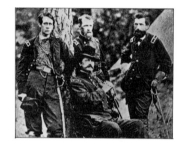

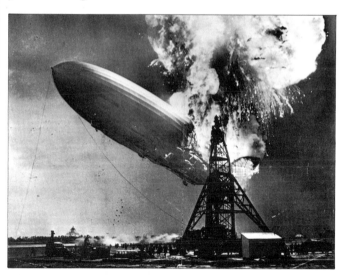

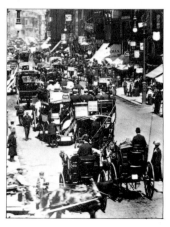

Photography and news
Since its earliest days the ability of the camera to record the instantaneous, newsworthy event was widely exploited. The pictures, above and right, show two such moments – the dramatic Hindenburg disaster in 1937 and the murder of President Kennedy's assassin in 1963.

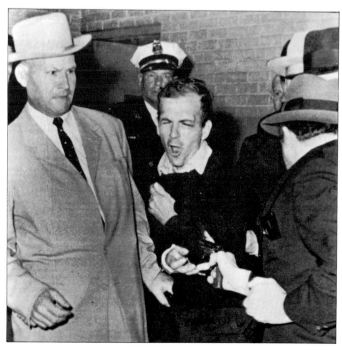

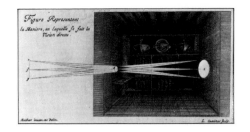

PRINCIPLES OF PHOTOGRAPHY

Light – photography's raw material

Light is fundamental to photography – the very word means "writing with light" or "drawing with light". Without light you can neither see nor take a photograph because it is light reflected from the world around you that makes the world visible both to the human eye and to the camera.

Light, like sound, is a form of energy. It is radiated out in waves at colossal speed from a source such as the sun, an electric lamp or a flashbulb. As a form of energy, it affects the nature of materials it falls on, causing certain chemical changes to take place – skin becomes tanned by the sun, and fruit ripened. The most important feature of light for the purposes of photography, however, is that it travels in straight lines. You can see this for yourself if you observe the straight shadows formed behind objects that block light from the sun or watch rays of sunlight passing through smoke.

The behavior of light varies according to the material or surface it strikes. Opaque materials such as wood or metal block the passage of light by absorbing most of its rays. Transparent materials such as glass or water transmit light, allowing it to pass through. Textured surfaces scatter light in all directions as they reflect it, so that the light is softened and "diffused". Clear smooth surfaces, like polished metal or glass, return the light waves without much scattering, so that you can see reflected mirror images. Most surfaces reflect some light rays back – the paler the surface, the more light it reflects. Black surfaces reflect no light, while white surfaces reflect almost all the light rays.

Light is also the source of all colors. It is composed of waves of different lengths (called wavelengths), some of which are visible to the human eye and are perceived as different colors – long wavelengths as red, short wavelengths as blue-violet. The sun, as well as most other light sources, radiates a continuous spectrum of all these wavelengths, which we see as "white" light. But objects around us absorb some wavelengths and reflect others. A ripe tomato, for example, absorbs most of the green and blue wavelengths but reflects red light, so you see it as red.

Transparent materials transmit all wavelengths equally unless they are colored. For instance, a blue stained glass window or color filter transmits blue light and absorbs all other wavelengths. Similarly, a red filter allows only red light to pass through, absorbing other wavelengths. This selective transmission is very important in photography. In black and white photography it affects the way tones reproduce, suppressing some, intensifying others (see p. 100). In color photography it is essential to the way that negative and slide film reproduce colors and to color processing and printing (see pp. 141-3, 162-3).

Light determines the way you perceive the shape and form of objects. For example, a tomato side-lit by the sun reflects red light strongly on the lit side. Light strikes its curved surface at different angles and is therefore reflected back to your eye at different intensities. Your eyes and brain recognize that these gradations of brightness signify "roundness" without your having to touch the tomato to find out.

However, you can only see the objects around you clearly because your eyes admit only a restricted amount of light (through a minute hole – the pupil, see page 20) which is then focused by the lens of the eye.

Light, lenses, and forming images
The principle of admitting light through a minute hole in order to produce a reflected image has been known since ancient times – it is the principle of the pinhole camera or "camera obscura". The

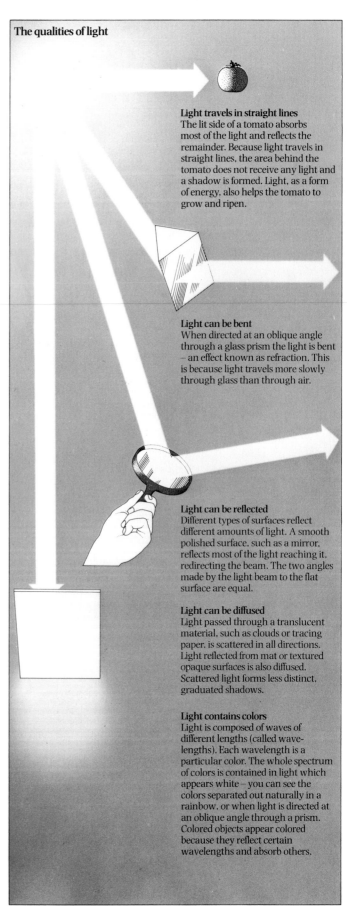

The qualities of light

Light travels in straight lines
The lit side of a tomato absorbs most of the light and reflects the remainder. Because light travels in straight lines, the area behind the tomato does not receive any light and a shadow is formed. Light, as a form of energy, also helps the tomato to grow and ripen.

Light can be bent
When directed at an oblique angle through a glass prism the light is bent – an effect known as refraction. This is because light travels more slowly through glass than through air.

Light can be reflected
Different types of surfaces reflect different amounts of light. A smooth polished surface, such as a mirror, reflects most of the light reaching it, redirecting the beam. The two angles made by the light beam to the flat surface are equal.

Light can be diffused
Light passed through a translucent material, such as clouds or tracing paper, is scattered in all directions. Light reflected from mat or textured opaque surfaces is also diffused. Scattered light forms less distinct, graduated shadows.

Light contains colors
Light is composed of waves of different lengths (called wavelengths). Each wavelength is a particular color. The whole spectrum of colors is contained in light which appears white – you can see the colors separated out naturally in a rainbow, or when light is directed at an oblique angle through a prism. Colored objects appear colored because they reflect certain wavelengths and absorb others.

explanation of this phenomenon is quite simple. As light travels in straight lines, light rays from the top part of the scene outdoors can only reach the bottom part of the receiving area through the pinhole, and vice versa, creating an inverted image of brighter and dimmer reflections. An image produced in this way is rather dim and ill-defined, because the hole is very small and light rays travelling from each point of the subject are slightly dispersed as they pass through the hole.

To produce a brighter and sharper image it is necessary to gather more light, and converge the light rays, that is, focus the image. This requires a lens.

When a light ray enters a transmitting material, such as glass, at an oblique angle, it is bent or "refracted". You can see this if you put a spoon in a glass of water – from certain angles the spoon appears bent. If you make a disk of glass with curved surfaces ground thinner at the edges that at the center, you can use the principles of refraction to converge the light rays so that they meet together at one point. This is the principle on which the converging lens is based.

A converging lens transmits light rays from each part of the subject and brings them to focus on a flat surface (such as paper or film). Light rays from the top and bottom, left and right parts of the subject are brought to focus on diametrically opposite parts of the receiving surface. This produces a sharp and detailed image of the subject, upside-down.

The converging lens was added to the "camera obscura" as early as the sixteenth century. It took another three hundred years to find a way of recording the image, as explained overleaf.

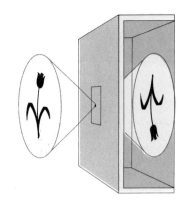

Pinhole image
You can form a crude image by admitting light from a brightly lit scene through a tiny hole into a dark box or room. On the surface furthest from the hole an inverted image of the scene will be visible. This is because light from the top part of the scene can only reach the bottom part of the receiving surface through the small hole, and vice versa. Details in the image are never quite sharp because the light is not bent to a point of focus but simply restricted to a narrow beam the size of the hole.

Making a pinhole image
You can produce a pinhole image by using a short tube with a piece of tracing paper at one end and an opaque material with a tiny hole in the center at the other. If you hold this in a dark corner of a room with the pinhole pointing toward a brightly lit object, an inverted image will be formed on the tracing paper.

How lenses work

Refraction
When passed through a block of glass, such as shown left, light rays are refracted and bent.

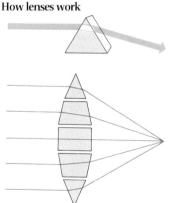

Converging light
If two prisms are placed base to base light rays are refracted so that they bend toward each other and converge. This is the principle of the converging lens, above left, a lens used in all cameras. It is a disk of glass ground thinnest around the edges so that light rays from different directions are bent to focus on one point. A magnifying glass is a converging lens. It will bend the light from the sun on to a piece of paper. To form an image it must be held at a certain distance from the paper – known as the focal length of the lens.

Replacing a pinhole with a lens
A light converging lens solves the problems of using a pinhole to form an image. It bends incoming light to points of focus, so that each part of the subject is rendered with great clarity. The lens must be accurately distanced from the receiving surface (focused) so that the surface coincides with the sharp image. A lens can also be much wider in diameter than the pinhole so that the image formed is much brighter and easier to see. Try making this change yourself, using a simple magnifying glass. In fact a magnifier still has many aberrations (optical errors) which distort image shape and detail.

Lens shapes
Lenses which are made thicker in the center than at their edges converge light. If the center is ground thinner than the edges the lens has the opposite effect on light rays – it causes them to diverge. Weak diverging lenses are combined with strong converging types in cameras to help correct aberrations in the image. The amount by which a lens converges or diverges light depends upon its thickness, and the type of glass from which it is made.

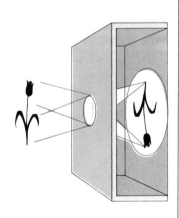

Converging lens

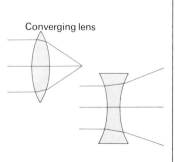

Diverging lens

Light-sensitive materials

There are two essential stages to taking a photograph. The first is forming an image of a subject, the second is recording the image permanently. You have seen how the camera forms an image using a lens and a small aperture to focus the reflected light. This image is simply a pattern of brighter and dimmer light, corresponding to light and dark areas of the subject. On pages 16-17 you saw that light is a form of energy. Energy can cause changes in materials, and it is the changes caused by light which record the image. If a material which is changed by light is exposed to a light image, it will change more where the image is bright, less where it is dim. In this way it may slowly take on an imprint of the light and dark area of the subject.

It is easy to test this out quite simply without using photographic materials at all. Leaves use the energy of sunlight to make chemicals essential to their growth. One of these chemicals is the green pigment, chlorophyll. If you tape a black shape on to a living green leaf, and leave it there for several weeks, it will block out the effects of the sunlight. As a result, the covered area will turn a paler green than the rest of the leaf. This is because the transfer of energy from light to chlorophyll – the green pigment – has been halted.

Many other familiar materials will change when exposed to light. A newspaper in the sun with an opaque object on top will turn yellow except where it was covered. A lawn will leave the pale shape of a water hose imprinted on the darker grass. Tanned skin will show the outline of your wristwatch.

By the early eighteenth century, it was known that some chemicals – particularly silver salts – darkened rapidly when exposed to light. A hundred years later, in the 1820s, attempts were made to use these silver chemicals to record the image formed in the "camera obscura". A layer of these light-sensitive silver salts (halides) was coated on to a flat surface, and placed where light from an image fell.

How silver salts record an image

You can see yourself what the result was. Take a piece of modern photographic film or printing paper (which is also coated with silver salts), and leave it out in sunlight with a small opaque object, such as a bunch of keys, placed on top. After about twenty minutes, the parts unprotected by the keys will have turned a dark purplish gray – the creamy silver salts will be changing into black, finely divided metallic silver. If you leave the film or paper out in overcast daylight, it will take longer to darken. This shows that light energy affects the silver salts cumulatively – either by short exposure to bright intensity, or long exposure to dim light.

When you lift the keys off the light-sensitive surface, their shape is visible as a pale silhouette against a dark surround. In terms of light and dark, this image is the opposite of the original, dark keys on a white surround. The image formed is therefore said to be a negative image.

Later in the book you will see how you can use this simple technique, in the controlled conditions of a darkroom, to make photograms (see p. 132). By arranging objects directly on a sheet of photographic printing paper or film, and then exposing it to light for a specific time, you will create a negative image of the objects in black, white and gray. But you cannot just walk out of the darkroom with your carefully exposed image and expect it to remain unaffected by any more exposure to light. Light-sensitive materials have to be processed to make images permanent – not sensitive to any further exposure to light. The development of these processes is an important part of the history of photography.

Sensitivity to light

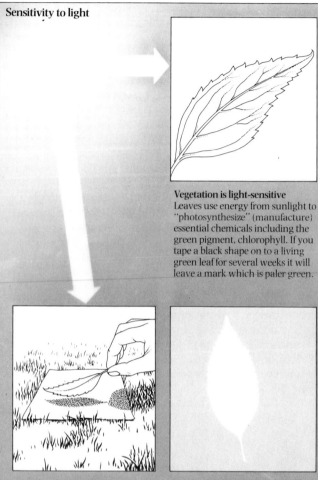

Vegetation is light-sensitive
Leaves use energy from sunlight to "photosynthesize" (manufacture) essential chemicals including the green pigment, chlorophyll. If you tape a black shape on to a living green leaf for several weeks it will leave a mark which is paler green.

Printing with sunlight
When exposed to bright sunlight, some dyes and pigments begin to bleach, and cheap papers often discolor. You can see this by placing an object, such as a leaf, on a piece of newspaper in the sun. The cheap paper will become yellow except where protected from the action of the light by the object.

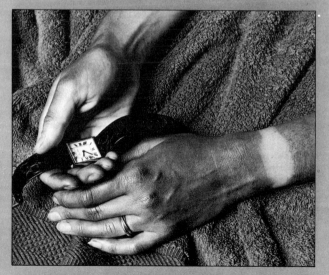

Sunburn
Skin is sensitive to the sun's rays. Both visible and ultra-violet radiation stimulate it to produce a dark pigment, visible as tanning. Shapes on the skin protected from the sun, such as a wristwatch, are clearly visible as lighter areas.

In the early days of photography, there were three main problems to be solved in recording the camera image: how to make silver salts react to very short exposures – even fractions of seconds – when presented with the rather dim image formed by the lens; how to prevent the picture from continuing to darken each time it was brought out into the light to be examined; and how to turn the incorrect, negative toned image formed by the action of the light on the salts into a correct, positive toned one.

The modern photographic process

The light-sensitive silver-based materials used in modern films and photographic papers solve all these problems. You expose the film to light only long enough to start the darkening process. At this stage, the change in the material is not visible to the eye; but wherever light has reached the pale silver salts they have begun to turn to black silver. The film is kept in the dark, and treated with a chemical solution which develops and accelerates this change until a strong visible black silver image appears. Still in darkness, it is then treated with another kind of chemical – a fixer. This desensitizes the remaining white silver salts unaffected by light, allowing them to dissolve away by washing. You are left with a stable negative image, which can then be safely exposed to light without any further change occurring.

Turning the negative into a recognizable positive picture is quite simple. If you shine a beam of light through the negative, you can project the image on to another light-sensitive material – a sheet of photographic paper. This time, the dark areas of the negative will produce little response in the silver salts, while the light areas will produce a strong dark image. So after the paper has been developed and fixed you have a positive image – a picture with light and dark parts of the original subject correctly reproduced. Mid-tones in the subject appear as a range of grays, because the light has only partially darkened the silver salts. This negative/positive process is very useful – you can enlarge the image, alter its tones, and take as many copies from a single negative as you like.

One further problem remained. Silver salts are sensitive only to blue light. So they respond to blue and white light (which contains blue light), but "see" red and green, the other two primaries, as "no light" – that is, indistinguishable from black. Not until the end of the nineteenth century was it discovered that adding traces of dyes which absorb red and green could create a more normal, gray tone response to these colors. The result was "panchromatic" film for black and white photography. The same discovery later led to color photography.

Pigments that absorb certain color wavelengths are also present in the human eye – in the cells sensitive to color which line the retina. In fact there are many features in common between how your eyes see, and how cameras and film work. But this does not mean your photographs will record the world just as your eyes see it and your brain interprets it. There are several basic differences – and these form the third basic element of photography, looked at on the next two pages.

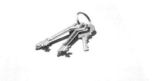
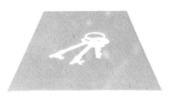
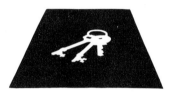

Exposing photographic paper to light
Most salts of silver darken under the action of light. They break down into finely divided dark metallic silver, even without any processing. You can see this by taking a sheet of photographic printing paper from its packet in the dark, and positioning an opaque object such as a bunch of keys on its sensitive surface. Take this out into sunlight and let it stand.

Gradually the light-sensitive salts turn gray or purple (a rich black is never reached). When you remove the keys, their shape remains visible on the paper as a white, negative image. But the white shape is not permanent and begins to darken once it is no longer hidden from light. Instead of using a long exposure to imprint the image direct, you can give a brief exposure under weaker light and then amplify the image to a rich black using developer chemicals. The result is a bold, permanent negative image.

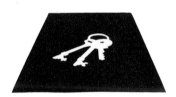
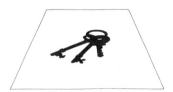

Obtaining a positive from a negative image
A simple shape like a bunch of keys may be acceptable as a negative image, but pictures taken in the camera would look very odd if left with all their light and dark areas tonally reversed. To convert the negative into a positive, you simply print in on to another sheet of light sensitive material. Take the paper negative of the keys, top left, and press it face down on to photographic printing paper. Then direct a lamp through it for about a minute. After processing, the new sheet of paper will carry a "negative of a negative" – a positive image, left.

Taking photographs and seeing

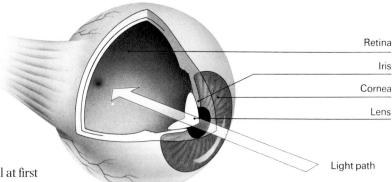

If you compare the camera with the human eye, you will at first find many similarities. Your eye admits light through the cornea and the pupil, with a variable iris to adjust brightness; it uses a tissue lens to give a sharp image, and a light-sensitive area – the retina – to receive it. The camera admits light through the lens aperture, which is adjusted by a variable diaphragm (or iris); it uses a glass lens, and a light-sensitive film. Both lenses can be focused for different distances, and both form miniature upside-down images of the scene.

But here the likeness ends. You cannot assume the camera sees as you do. There are basic differences between seeing and photography which you should understand – otherwise your pictures may look very different from the scene you remember. With practice you can learn to anticipate what the camera will see, and adjust your photography accordingly.

Selective vision
Human vision is controlled partly by the eye, partly by the brain. This arrangement gives you selective vision – you can "notice" important images on the retina and disregard others. For example the words you are now reading appear sharp and clear, whereas the words surrounding them are less distinct. Selective vision eliminates distracting elements. The camera cannot do this – it records what is there, with objects at the same distance all appearing equally clear. So photography often records too much – the unimportant along with the important. You must get used to scanning your viewfinder frame thoroughly for unwanted elements, particularly around the edges. You can usually exclude them by changing your viewpoint or framing.

The eye seldom presents you with an out-of-focus image. If you glance up from this book to look at a door or window across the room, the detail will look equally sharp. Your eyes have refocused for the new distance automatically. Only if you hold your book up in line with the door or window, and try to see both at once, will you discover that focusing on one causes the other to appear unsharp. You can alter the focus of a camera lens in the same way. But if you take a picture with, say, the book sharp and the room out-of-focus, this situation is fixed within the photograph. You cannot then move your eye from one to the other to see both clearly. So you must show a particular part of the scene in focus when you shoot the picture. This selective focus is useful for directing attention in your pictures.

The photographed scene
Looking through the camera viewfinder you see a picture framed by hard edges and corners. But the scene your eyes see is limited only by your attention, as your eyes regularly scan and move across it. A photograph is taken from a fixed viewpoint, which determines what is included. The proportions of the frame affect how the elements in your picture relate to each other. Try

How the human eye works
The human eye is a sphere about one inch (2.5 cm) across, with a precision optical system at the front which projects a sharp image upside-down on to the curved back wall, or retina. Here light-sensitive cells receive the image and convey it directly to the brain. Light reaching the eye first passes through the cornea which bends and focuses the light to pass through a small hole, the pupil. The size of the pupil can be altered by the tiny muscles of the iris, to adjust the brightness of light entering the eye. Within the eye, the light passes through a flexible lens. The lens is fixed in position, but can expand or contract to focus objects at different distances on the retina.

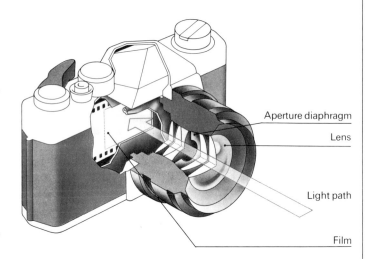

How the camera works
The camera includes similar elements, but is much cruder than the human eye. It has an optical system at the front, to project a sharp, upside-down image on to the film held flat at the back. Here light-sensitive chemicals record the image. Light first enters the camera through the compound lens, a series of glass elements that bend and focus the light. The amount of light entering is controlled by an aperture, usually formed by a ring or diaphragm of adjustable metal leaves within the lens body. Unlike the eye, the camera uses a shutter between lens and film to determine when and for how long light acts on the film. The camera lens focuses objects at different distances by moving backward or forward, not, as in the human eye, by changing its shape.

looking around you in terms of rectangles – horizontal or upright. How would the scene appear?

The camera reduces the three-dimensional world to a two-dimensional image. The picture formed at the back of your eye is also two-dimensional, but you see in three dimensions. This is partly because you have two eyes and so see everything from two slightly different viewpoints. Look through your left eye only, and line up a close subject with one much further away. Without moving your head, now look through your right eye only – the relationship of the two objects will change. Your brain interprets these differences to judge space, distance, and depth. You can also estimate distance by changing your viewpoint – notice how near objects appear to shift more than those further away. In a two-dimensional photograph you have to communicate depth by creating perspective, by overlapping near and far objects and by choosing lighting that shows three-dimensional form.

A photograph isolates and records a moment of time. The skill lies in choosing the moment that expresses the essence of the changing scene or event you are looking at. You must learn to anticipate, to see only what the camera will see at the moment of exposure. Your eyes see motion as change: in a still photograph, you can only imply motion, perhaps by blurring the image.

Eye and film sensitivity

Your eyes alter their response to light in different conditions, but film is less flexible. You see colors most strongly in bright light. When very little light is present – under moonlight, for example – you see almost entirely in black, white and grays. When it is very dark, you gradually "get used to the dark" as the retina increases its sensitivity by hundreds of times. Film sensitivity is more fixed. But, unlike the eye, film will accumulate light, so you can give a long exposure and overcome dim conditions this way. Film will exaggerate the contrast between the light and dark parts of a scene. If you are inside on a sunny day, you can usually see details of a bright scene outside the window just as clearly as details of the darker scene indoors. But film cannot cope with such a range. You must choose between exposing the interior detail correctly, and allowing the outside to appear too pale; or exposing the outside correctly, and leaving the interior almost black. You can estimate how film will respond by half closing your eyes and looking through your eyelashes.

Film possesses neither the same light-sensitivity as the retina, nor the power of the brain to interpret what it sees. The eye functions equally well in semi-darkness or bright sunlight. But there is no one film that can cope with such a range of light intensity. Films therefore come in a variety of speeds – the speed denotes the sensitivity of the film to light. Fast film requires less light to record an image and can therefore be used in dimmer conditions; slow film has a relatively low sensitivity to light and so requires bright lighting. In color photography, you will also have to consider the color of your light source. If, for instance, you take a color picture by artificial lighting with a film intended for outdoor use, your result will be tinged with red. The film has recorded the fact that the light source had a higher proportion of red than natural daylight, while your eyes registered the scene according to the brain's preconception of how a scene lit by white light should look.

These differences between seeing and photography are the "ground rules" of a photographer. When you work through the section on Picture Building (pp. 45-64) you will find that many of these differences can be turned to your advantage.

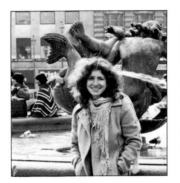

The camera cannot discriminate
Pictures often turn out cluttered, because your eyes showed you only the element you were concentrating on in a scene, whereas the camera recorded everything equally clearly. Always look carefully at the subject in your viewfinder, and try to simplify it. The photograph, left, for example, includes important and unimportant elements without discriminating between them. The subject could have been isolated by changing the viewpoint or using selective focus.

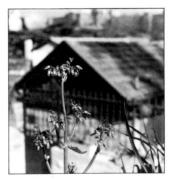

The camera must be focused
Wherever you look, you see a sharply rendered scene. You are not aware of your eyes adjusting to focus at different distances. So it is easy to forget that the camera will only render the focused distance sharply, as shown in the picture, left. You must set your chosen subject distance on the camera lens, so that the subject you wish to emphasize is rendered sharply. As you can see from this photograph, selective focus is a powerful tool for isolating a subject.

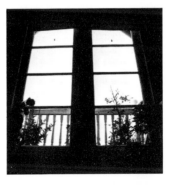

Film exaggerates contrast
When viewing the scene shown in the picture, left, the photographer saw detail in both the bright daylit balcony and the dark interior. But film exaggerates extremely light and dark tones if they are present in the same picture. So for a scene like this, you may have to decide whether to expose dark parts correctly so that detail elsewhere is bleached white by overexposure, or expose light areas correctly and accept that dark areas will be solid black.

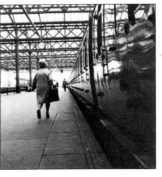

A photograph is two-dimensional
A photograph is a flat image with height and width but no depth. So you have to learn to suggest the third dimension, depth, experienced in human vision. The picture shown left does so by using strong perspective lines, and lighting that exaggerates the three-dimensional form of the train. The part of the train on the right-hand side of the picture appears much closer to you than the woman in the center, though both lie in a two-dimensional picture.

Drawing and photography

Using a camera to take a photograph, like using a pencil to draw, is a way of communicating. Basically both are putting marks on paper, making a visual statement – factual information perhaps, or ideas, or some expression of emotion. There is much in common between the two mediums, even though the method of working looks so different.

In the early days of photography it was the camera's ability to record factual detail accurately that captured everyone's interest. For centuries the artist had longed for some means which would help him show objectively the way elements in a scene relate in line and scale. Devices like the one shown below helped to determine the scale and proportions of objects and showed the artist the subject within a frame. But he still had to draw out all the detail that was projected on to the final surface.

The invention of a practical method of photography in the late 1830s, by combining the camera obscura with light-sensitive silver chemicals, was therefore revolutionary. The camera lens recorded all the detail in a subject by the direct action of light. People were fascinated that the camera took the same time to record a complicated street scene as a single object. It was difficult to imagine a more "truthful", objective means of representation, and some artists believed that because of this painting had been superseded by the camera.

Their dismay was understandable because at the time painting was mostly judged by its accuracy. However, artists soon discovered that the camera is only a machine – in the hands of someone unable or unwilling to develop their picture building ability the results it produced could often be dull and boring.

Artists themselves have gained a lot from the camera. It captures instant moments no matter how brief, showing how things move, or change. It has introduced unusual viewpoints and angles, and blur effects, which have influenced painting.

In recent years photographic equipment and materials have become more refined less complicated. Systems are more standardized and compact, processing easier. This allows you the freedom to concentrate on good composition and capturing unusual lighting conditions. You still have to learn how your equipment works, why it produces the results it does and what it can, and cannot do. But you can progress quickly to the important picture building aspects of photography.

Since the advance in photographic technology, most people now expect a good photograph to contain more than just clear details. Your choice of subject and the way it is photographed become increasingly important as your technical ability improves. So it is worth understanding the basic "seeing" aspects of drawing – the use of tone, line, color, and so on – not to ape the artist, but to find the strongest methods of presenting the subjects in your photographs visually.

Exploring picture building is an interesting and continuous process because you have to decide your own values – these may change as you widen your knowledge and gain in confidence. Above all it allows you to express yourself – to make your own visual statements in your own way, often using similar visual ideas to an artist but employing different technical skills.

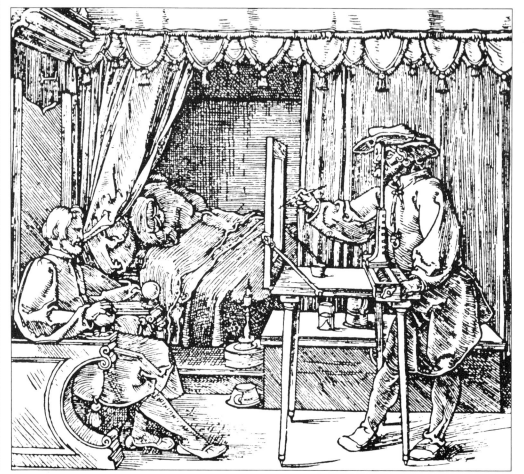

Drawing machine
This 16th century engraving by Durer shows an artist's drawing machine. By keeping his eye at the sighting stick, the size and relationship of one part of the subject to another remains constant (provided the subject does not move). The whole arrangement works like a direct viewfinder on a camera, but in this case the artist had to painstakingly trace the information by hand on to glass, before transferring it on to another medium.

CAMERA TECHNIQUE

STEP 1: The simple camera

STEP 2: Camera controls

STEP 3: Controlling picture sharpness

STEP 4: Film and measuring exposure

This first main section introduces you to the basic tools and materials of photography, and establishes fundamental camera-handling skills. It draws directly on the principles of image-forming and light-sensitivity discussed on pages 16-22. Starting with the simplest kind of modern camera, it progresses to the popular single lens reflex type. Each camera control is looked at in turn, to see what it contributes to practical picture making. Combining the various controls leads on to choosing film and the measurement and control of exposure.

You need not have a darkroom, or do your own processing, or even have any knowledge of how cameras work, before starting this section. If you are an absolute beginner, it is the most important technical part of the book. It explains and establishes all the terms – such as f number, depth of field, and exposure – that you will meet regularly in later sections. If you already have some experience with a camera, use the section as a refresher course to check your knowledge.

Work through the material page by page, because terms are explained as introduced, and lead on one from another. Don't limit your learning to reading. Test out the statements made and tackle some of the assignments. You will find it much more interesting and instructional if you take pictures as you go along. All you need is a camera with a normal lens, some form of exposure meter, and a reasonable supply of black and white film. (You will not be dealing with taking pictures in color until later, on pages 141-58.)

You must expect to use a fair amount of film to begin with as it will take practice to be able to predict your results accurately. You will be making comparison pictures, experimenting – and inevitably making mistakes. It is important to practice as much as you can, so that you have some practical results for comparison. You will see and remember the points this book is making much better if they appear in your own pictures.

Think carefully before composing and making the settings for every shot. What effect are you trying to achieve? Perhaps you are comparing the results of different settings; or applying a technique to a particular subject; or (and this is equally important) breaking the rules to see what visual effect will occur. Get into the habit of taking several versions, perhaps making notes so you can remember the settings. Have the film processed and printed promptly, and learn to assess your results critically along with the notes you have made.

Don't expect perfect results at this stage. Your early efforts will be in the nature of exercises. Concentrate on learning from your mistakes as well as your successes. Keep to simple subjects at first, and avoid difficult lighting conditions – such as extreme contrasts between highlights and shadows or dim indoor conditions. Your main aim should be to get comfortable with your camera, and familiar with its controls. Only then can you begin to "work through the camera" and respond freely to your subject matter and lighting conditions.

Arrangement of steps
The section begins by looking at a cheap simple camera, because this has all the essential controls – lens, shutter and viewfinder – in their most basic form. You must still learn to load the film in the same way, and with the same accuracy and speed, as with other more expensive cameras. But simple camera settings for lens and shutter are either fixed, or have a very narrow range. This makes the camera uncomplicated and quick to use.

This very lack of control soon becomes frustrating, however. You will want to be able to work closer to your subject, to take pictures under all sorts of lighting conditions, or to emphasize one part of a picture by making everything else unsharp. For this you need a wider choice of lens and shutter settings. So the next step moves on to a more elaborate camera which offers much

more flexibility – with fully variable lens, aperture and shutter. Here the single lens reflex type of 35 mm camera is mainly featured because of its popularity and comparative simplicity.

With a single lens reflex camera, such as a Pentax, Nikon, Minolta or Canon, you can predict the appearance of your photographs with great accuracy, because you view the actual image formed by the taking lens. These cameras each form the basis of a system – a whole range of lenses and accessories which you can build up as your experience of photography grows.

The 35 mm single lens reflex camera is therefore the principal camera used throughout the book. But although most diagrams show this sort of camera, the information is valid for other cameras too. If for example you own a larger camera, perhaps a twin lens reflex, or a good non-reflex 35 mm camera, you can work through the book just as well. Most of the principles discussed apply equally to all camera types. Where their mechanical or optical arrangements differ, these will be shown. (You will find details of other camera types, such as a twin lens reflex, in the Appendix, on pages 204-10.)

Reading over this section should enable you to identify all the controls on whatever camera you possess, and see how they each alter your results. The first control is the focusing ring on the lens. As you have already seen on pages 20-1, focusing a lens has a similar effect to focusing the eye. Cameras use various devices to show you which parts of the scene are being sharply focused. On some you just set the subject to camera distance on a scale. Others show you a double picture in the viewfinder, until the focus is set properly. Best of all are cameras with focusing screens that show you how the image actually looks – which different parts are sharp or unsharp, and what the overall effect will be. The single lens reflex is one such camera.

This section and the next deal only with the "normal" lens – the one usually sold with the camera and accepted as giving a view most similar to the eye. (Other lenses are introduced on pages 92-9.) On a 35 mm camera a normal lens has a focal length of about 50 or 55 mm. If your camera is larger or smaller than this, the "normal" focal length is scaled up or down. For example, 80 mm for a $2\frac{1}{4}$ ins square rollfilm camera, and 25 mm for a 110 pocket camera.

The second camera control you are introduced to is the lens aperture. This follows on from focusing, partly because it is often placed right next to the focusing ring on a camera, but mostly because it also affects sharpness in your pictures. The aperture setting controls the amount of light entering the camera. To control aperture, you must get used to a scale of "f numbers", and understand how different settings will affect the amount of the scene rendered sharp at one focusing distance. It helps if you can actually see the effect of altering aperture on your viewing screen. Here again a single lens reflex camera is the best.

The third control introduced in the shutter. You are probably quite familiar with this control, because no camera is without it. Shutter determines when, and for how long, film is exposed to light. The speed you select has some interesting effects on the way moving subjects (or movements of the camera) are recorded in your photographs.

Aperture and shutter together control exposure – the total quantity of light given to your film. One alters the amount, or "intensity", of light admitted, the other the time that light is allowed to act. Many beginners in photography are worried by having to judge correct exposure. But it is surprisingly straightforward, as a rule. Modern light-reading meters can be very accurate, and variations from correct settings may still give acceptable results on today's black and white film. (Color film requires greater accuracy.) The important thing is to know how to make readings as quickly and accurately as possible, and what sort of visual effects you can achieve by giving deliberate over- or underexposure to particular subjects.

The development of camera technology

This section is also worth studying if you are thinking of buying a camera. It will highlight features that may affect your photography, so you can assess the various models and prices more critically. The general trend is for cameras and the pictures they take to be made steadily smaller. The first popular camera, invented by George Eastman ninety years ago, took 100 pictures $2\frac{3}{4}$ ins wide. It even had to be returned to the manufacturer when each film was used up, to be opened and have the film developed

MAY 31, 1889.] THE PHOTOGRAPHIC JOURNAL. v

THE KODAK

Is the smallest, lightest, and simplest of all Detective Cameras—for the ten operations necessary with most Cameras of this class to make one exposure, we have only 3 simple movements.

NO FOCUSSING. NO FINDER REQUIRED.

Size 3¼ by 3¾ by 6½ inches. **MAKES 100 EXPOSURES.** Weight 35 ounces.

Setting the Shutter. Exposing. Winding more Film. Cutting off Exposure.

Removing the Roller Slide.

Drawing off Exposed Films.

Cutting off Exposures.

Developing 12 at once. Placing New Roll of 100 in position.

Placing Film in Roller Slide. Examining Negatives (three on one strip).

Complete Kodak. Carrying Case.

FULL INFORMATION FURNISHED BY

THE EASTMAN DRY PLATE & FILM Co., 115, Oxford St., London, W.

Early cameras
By the end of the nineteenth century mass-produced hand-held cameras, then called "detective cameras", from their early use in police work, were becoming popular. The "Kodak", invented in 1888, was probably the most famous of these. Until the model shown above was introduced – in 1889 – all film had to be sent to the manufacturer's for processing. For the first time this model used film which enabled amateurs to process their own pictures.

and printed. Some years later, Thomas Edison, working on an instrument for making movies, used Eastman Kodak rollfilm slit down the middle – so it became $1\frac{3}{8}$ ins (35 mm) wide. He cut perforations down each side for transporting it through the camera and projector. Much later, in 1924, an employee of E. Leitz, the German microscope manufacturers, designed a little camera for taking still pictures on lengths of this 35 mm motion picture film: it was called the Leica, the first precision 35 mm camera – the most popular modern format.

Up until World War II however, most family cameras used rollfilm – from box cameras to precision types such as the Rolleiflex. Serious photographers used even larger cameras, taking plates (and later, sheet film). 35 mm cameras were not very popular, because prints made by contact from the tiny negatives were too small. Lens quality was poor unless you bought the most expensive 35 mm models. So the "miniature" film was unable to resolve really fine detail, and gave disappointing enlargements. To measure exposure you had to use tables, or a meter the size of a modern cassette tape recorder.

During the 1950s and 60s, improvements in lens optics and the production (mostly in Japan) of precision single lens reflex cameras made the 35 mm camera the world's most versatile and popular design. Improvements in precision optics still continue – today's even smaller, 110-size camera (using 16 mm wide film) will eventually offer all the facilities of 35 mm. Provided that final prints are of equally good quality, a smaller, handier camera will always have great appeal.

In 1948 the first instant picture camera system was invented (see p.210). This camera and special film offer the tremendous advantage of allowing you to check results on the spot, and if necessary take the picture again. There are disadvantages: camera size is directly linked to picture size; materials are expensive; and for serious photography, image manipulation is very restricted, particularly since on the majority of systems you do not retain a negative but get a print direct.

Deciding on a camera

Choosing a camera today can be as easy or difficult as choosing a car. What sort of work do you want to do with it? How much can you afford – for both the equipment and the materials? Which type and shape of camera design suits you best? If you intend to do a lot of photography you are likely to spend more on film than you spent on the camera. Film 35 mm wide in 36 exposure lengths is still cheaper per picture than either rollfilm or 16 mm wide 110 film, in its convenient but costly drop-in cartridge.

In the 35 mm camera range, designs using a separate (non-reflex) viewfinder system are cheaper than the mechanically more complex single lens reflex. But look ahead – will you soon want to buy extra lenses (discussed on pages 92-9), or other special attachments? If so, a reflex camera backed up by a whole system of lenses and accessories would be a better choice.

Having decided the size and type of camera you need, think hard about what you can afford. Cameras are now so competitive that you generally get what you pay for. Current catalogs will show three or four different brands at each of several price levels. How will you spend your money – on a really good camera body and normal lens, for additions later? Or on a cheaper model together with several lenses?

Narrow down the two or three camera models you can afford, and then actually handle each one of them. If you can, borrow a camera of the model you are considering buying, to make sure it

suits you. You must consider features such as size and weight; how easy you find the viewing and focusing; the speed and convenience of changing aperture and shutter settings; even the way the camera "sits" in your hands.

Most cameras have excellent built-in light meters and these are worth comparing (see pp.40-1). You can even buy a camera with a "fully automatic" meter, which takes over all exposure decisions on a programed basis. This is efficient and convenient; but long term it will prove restrictive. You don't know what settings are being made, and cannot give a selective exposure for a part of a subject, or intentionally over- or underexpose for particular effects. Perhaps a camera offering the choice of automatic or manual metering is best. You can learn to use the manual settings, creatively exploiting the various side-effects they produce. But you can still switch to automatic for quick shots when a generally correct exposure is all you need.

Don't overlook reliability. It is very depressing to find that a whole film has turned out blank, because the shutter stuck, or the film failed to wind on. Often reliability is reflected in price, so it really is worth buying the best camera you can afford. A well known make is a reasonable guarantee of quality.

A thorough understanding of your camera will give you confidence and control when you start work on the important picture making aspects of photography, in the next section. So use this section to make yourself completely familiar with the basic tools of photography, and particularly with your own camera's range and limitations. The four Steps in this section are: the basic camera; the camera controls (focusing, aperture, shutter); controlling picture sharpness; and measuring exposure. Information on more advanced equipment and accessories is given in the section beginning on page 89, and further details of camera types in the Appendix.

STEP 1: THE SIMPLE CAMERA

You can take good photographs with the simplest of cameras – it need only be a light-tight box with a lens (to select and focus reflected light rays from the subject), a shutter (to admit light briefly to the film), and a compartment for film. A simple viewing system is helpful, to show you which area of a scene will be recorded. Many people start their photography with a simple camera like this – a basic, non-adjustable 35 mm or 110 pocket camera, such as those shown below. However sophisticated your own camera may be, understanding the components and workings of a simple camera is important since it applies the basic optical principles of photography (discussed on pp. 16–19) in an elementary manner.

Most simple cameras have a fixed focus lens built in to the front of the body; focus is not variable, the lens being set to give maximum overall sharpness, as explained below. Behind the lens, a metal shutter consisting of movable blades or a rotating disk protects the film from light. When you press the shutter release button on the top of the camera, the blades open, or the disk rotates, and light falls briefly on the sensitive film surface. The viewing system is usually a tube on top of the camera with a lens at each end. Through it, you look directly at the subject, which will appear reduced in size. This view is not exactly that "seen" by the taking lens and this creates a problem at close distances as explained on the opposite page. Cameras with this type of viewing are called direct vision viewfinder cameras.

Limitations of a simple camera

It is quite possible to take successful pictures with a simple camera, but you must know its limitations. Work out of doors, in bright light; watch for viewfinder errors; and avoid subjects closer than about $6\frac{1}{2}$ ft (2 m) because the fixed lens cannot render them in focus. Also, because the lens on a simple camera is cheap, the image is not as sharp or bright as it might be and enlargements are generally of poor quality.

Simple camera formats

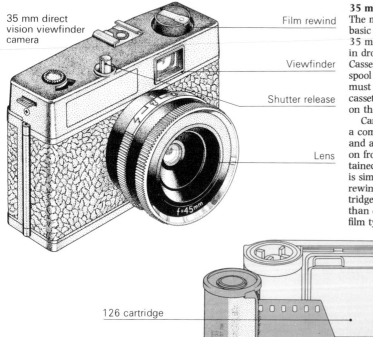

35 mm direct vision viewfinder camera

Film rewind

Viewfinder

Shutter release

Lens

110 camera and cartridge

126 cartridge

35 mm cassette

35 mm film cameras
The majority of cameras, like the basic model shown left, take film 35 mm wide, either in cassettes or in drop-in cartridges, but not both. Cassette cameras have a take-up spool for exposed film; the film must be re-wound back into the cassette before removal (as shown on the opposite page).

Cartridge cameras merely have a compartment for the cartridge and a mechanism to draw the film on from one end of the self-contained pack to the other. Loading is simple and you don't have to rewind the film at the end, but cartridges cost you more per exposure than cassettes, and the range of film types is more limited.

Pocket size simple cameras
Simple direct vision viewfinder cameras are made in various sizes besides 35 mm, ranging from 120 rollfilm cameras down to the very popular pocket 110 type, above, which takes pictures only 13×17 mm. Because of the considerable enlargement necessary to make prints of an acceptable size, the lens on a 110 camera must be of good quality, and this often increases the cost. In other respects, the simple pocket model works like any basic camera. Film can be bought in cartridges only, a convenience when loading such a small camera.

Simple camera mechanism

In all cameras, light rays reflected from a subject, right, are bent through a converging lens and pass a shutter to reach the film, forming an image on it reversed left-to-right and upside down. The fixed lens in a simple camera is situated at or about its "focal length" from the film plane (see p. 17). Positioned here, it brings most rays to sharp focus on the film, so rendering any scene sharply from the horizon to about $6\frac{1}{2}$ ft (2 m). When the shutter is fired, a shaped cut-out allows light to reach the film. The length of this exposure depends on the shutter speed.

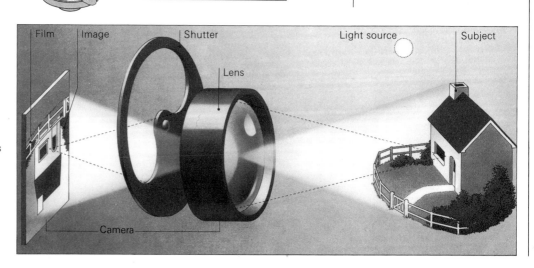

Film | Image | Shutter | Light source | Subject

Lens

Camera

Using a simple camera

The photograph below was taken with a simple 35 mm camera like the one shown opposite. It shows the sort of results you can expect under the right conditions and with a straightforward subject.

Be sure to hold the camera still. On a simple camera the shutter is set to work at about 1/60 sec, which is slow enough to give a blurred picture if you or your subject are moving.

There are advantages to using a simple camera. The viewfinder is bright and clear and everything will always appear sharp. As there are almost no controls to set you can concentrate on the composition of your picture. Within general limitations, very little can go wrong when you use such a camera — as long as you don't expect outstanding results every time.

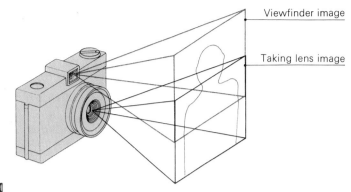

Viewfinder image

Taking lens image

Viewfinder systems

The viewfinder on a direct vision camera often shows slightly more of the subject than will be recorded. This is intended to help you when framing. Lines, or corners marked in the viewfinder frame, below right, show the true picture area.

Direct vision viewfinders are also subject to a framing error created by "parallax". This is caused by the position of the viewfinder — above and to one side of the lens. For distant subjects, this slight misalignment does not affect the picture, but close-up the viewfinder may show more of the top and one side of the subject than will appear in the picture, see above. When working at the nearest limit of the simple camera's sharpness—often around $6\frac{1}{2}$ ft (2m)—try to aim the camera a little high, so that the subject appears low in the frame, to avoid cutting off parts of the subject.

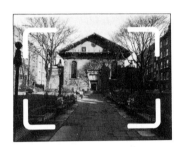

Loading and unloading cassette film

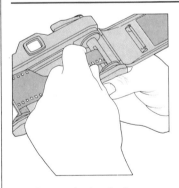

1. Indoors or in the shade, open the camera back, pull up the rewind knob and place the cassette in the left-hand compartment. Push down the knob and attach the film to the take-up spool.

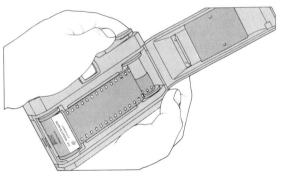

2. Use the film advance lever to wind on until the perforations in the full width film engage with the sprockets on the take-up spool. Close the camera back and wind on two frames.

3. At the end of the film you will not be able to wind further and you must rewind the exposed film back into the cassette. Press the button in the base of the camera to release the wind-on mechanism, then unfold the handle in the rewind knob and turn this until you feel the film leave the take-up spool. Now open the camera (in the shade) and remove the cassette.

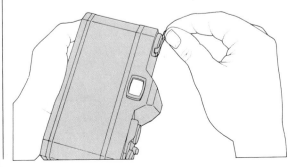

STEP 2: CAMERA CONTROLS/Focusing

As we have seen, a fixed position lens on a simple camera is placed so as to give an equally sharp image from about $6\frac{1}{2}$ ft (2 m) to infinity. At closer distances, the nearer you are to your subject the more the image will be out of focus. This can be avoided if you have a lens on your camera which can be focused: that is, moved away from the film plane. As shown in the diagram, right, the nearer the subject is to a lens, the farther behind the lens its image is formed. Thus for close subjects the lens must move away from the film plane to focus the image.

Being able to focus the lens gives you two important advantages: you can get sharp pictures when you are quite close to your subject, and you can give emphasis to one part of the subject by focusing on it and allowing everything nearer or further away to appear progressively unsharp. In both cases it is vital to know which part of the scene is being sharply rendered. An adjustable focusing lens body therefore has a scale (or at least a series of symbols) showing the correct lens positions for focusing on various distances. To set this you have to estimate the subject distance, unless you have a camera with a focusing aid coupled with the viewfinder or through-the-lens focusing, as shown opposite.

Subject distance and focus

When a convex lens is focused for very distant subjects it is positioned at its own focal length from the film, for example, when the film is 50 mm away from a 50 mm lens. If the subject is closer, its rays are much less parallel when they reach the lens, and the "bending power" of the glass will only bring them into focus, to form a larger image, at a greater distance from the lens, as shown in the diagram, right. On many cameras, the lens moves forward to compensate for this, so that the image still focuses on the film plane. The nearer the subject, the greater the distance required between lens and film.

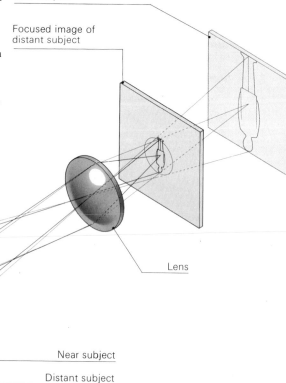

Focused image of near subject

Focused image of distant subject

Lens

Near subject

Distant subject

Using the focus control

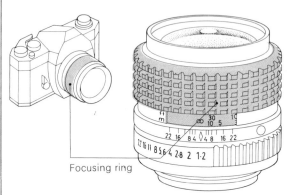

Focusing ring

Most lenses are focused by turning the largest control ring on the lens barrel. This will slowly extend or retract the lens. At the same time a scale of subject distances moves past a fixed mark. One end of this scale is marked "inf." or ∞, which denotes infinity. On this setting the lens is at its closest position to the film, and will give sharp images of distant subjects – in practice about 50 ft (15·2 m) or beyond. At the other end of the focusing scale, which may read 3 ft (0·9 m), the lens will have moved out to its furthest distance from the film. Some lenses have a greater focusing movement (and therefore allow closer photography) than others. The limiting factor is usually image

quality, since a lens designed for general distance photography may not perform so well when used extremely close up. Attachments for close-up work are discussed on pages 102–3.

Focusing symbols

Some simple cameras use symbols on the focusing scale, like those above, which focus the lens for close-up, middle distance, and distant shots.

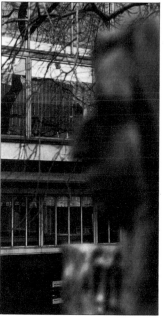

The effect of focusing
The two pictures above differ only in the camera focus setting and show how this control can be used to pick out parts of the subject. In the picture, left, the lens setting was about the same as for a fixed focus lens – 30 ft (9 m). Almost all the picture, except for the foreground, is sharp.

In the picture, right, the lens was focused for about 3 ft (0·9 m) so that the foreground appears sharp while detail in the background is unsharp. In this way you can use the focus to concentrate interest on areas of your subject, in the same way as subconsciously you focus your eyes on selected parts of your field of vision.

Focusing systems

If your camera allows lens focusing you will need to measure or estimate the subject distance; this takes time and may not be too accurate. Some camera designs include a simple built-in focusing aid such as a large tinted head outline which appears in the viewfinder when the lens is set for portraits. You then move the camera to the distance where the subject's head just fills the outline. More advanced direct vision viewfinder cameras sometimes have a coupled rangefinder for focusing. This is an optical device linked to the focusing ring that produces a double image in the viewfinder until the subject is correctly focused.

The single lens reflex camera, right, offers a viewing system with the important advantage of showing you the image formed by the taking lens itself. You can adjust the lens until the image you see appears sharp. The system completely eliminates parallax error, and the image is always seen the right way up and corrected left to right. As shown below, right, an angled mirror just behind the lens reflects the image up to the horizontal and a pentaprism – a five sided block of glass – corrects the left-to-right reversal. When the shutter release is pressed the mirror hinges upward out of the way, briefly blocking the image from the focusing screen, and the shutter in front of the film opens to expose the film.

35 mm single lens reflex camera

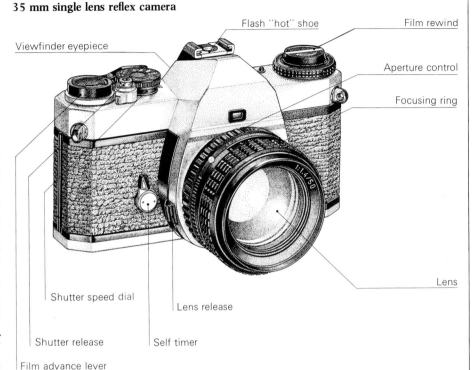

Viewfinder eyepiece
Flash "hot" shoe
Film rewind
Aperture control
Focusing ring
Lens
Shutter speed dial
Lens release
Self timer
Shutter release
Film advance lever

Direct vision rangefinder camera

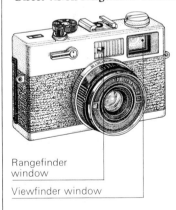

Rangefinder window
Viewfinder window

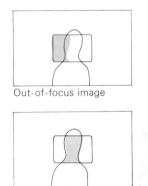

Out-of-focus image

Focused image

A more advanced direct vision viewfinder camera, above, includes a rangefinder for accurate focusing. The viewing system is still separate from the taking lens, but instead of estimating the distance, you align two separate images of the subject for the correct focus, above right. When you look through the camera viewfinder you see a pale tinted area in the center of the picture. This area, top right, shows a double image. To set the correct distance you point the camera so that the most important part of the subject appears in the tinted area, then turn the lens focusing ring until the image in this area shifts left or right to coincide with the main image. The central area of the image will now photograph in focus.

A rangefinder system is very quick and clear, but, unlike a focusing screen, does not show you how the image will actually record on the film, since out-of-focus parts of the background and foreground always appear sharp.

The SLR viewing system
Single lens reflex cameras are so designed that the distance between the lens and the focusing screen (via the mirror) is exactly the same as between the lens and film. Consequently whatever parts of the image appear in focus on the screen will also record in focus on the film. The same applies if you change lenses or fit various lens accessories – there is no parallax or focus error. To make it easy to use at eye-level, the focusing screen on most SLRs is viewed through a "folded up" reflecting system formed by a five-sided, partially silvered, glass prism. A small magnifying lens in the eyepiece helps to make the screen look large and clear.

Sometimes two small prisms are incorporated in the central zone of the screen – when out of focus, the image appears split and offset in this area, below. Other screens have a central grid of minute prisms which give a shimmering effect when the image is not sharp. Devices like this are helpful if you have difficulty checking sharp focus, particularly in poor lighting. But beginners sometimes find such marks on the screen distracting when composing pictures.

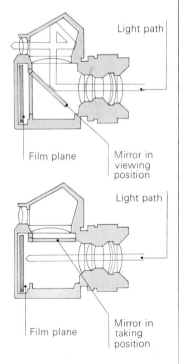

Light path
Film plane
Mirror in viewing position

Light path
Film plane
Mirror in taking position

Out-of-focus image

Focused image

Aperture

An adjustable camera controls the amount of light reaching the film in two ways. It can make the image darker or lighter by a variable aperture, positioned behind the lens, and it can control the length of time that the light reaches the film, by a timed shutter.

The lens aperture consists of overlapping movable leaves which form a diaphragm. This can be set to a range of diameters, so that the quantity of light admitted is controlled in the same way that the width of a funnel controls the quantity of water flowing into a container. When photographing a dimly lit subject you use a wide lens aperture to admit as much light as possible; for a bright subject you can change to a small aperture to reduce the amount of light. In this way the film still receives the same amount of light.

Since doubling the diameter of a circle increases its area by four times, as you double the diameter of the aperture the light admitted becomes four times brighter. The aperture control ring on a camera includes intermediate settings, creating a series which progressively doubles (or halves) the light that is admitted. Each setting is given an "f number" (f stop), see above right.

Apart from controlling light the aperture also increases or reduces the "depth of field" — the zone of sharp focus in front of and behind the focused subject (see pp. 32–3).

Aperture settings and focal length

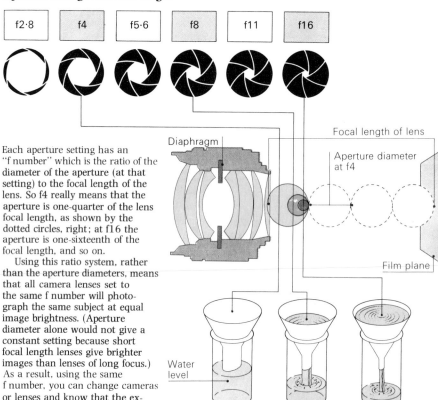

Each aperture setting has an "f number" which is the ratio of the diameter of the aperture (at that setting) to the focal length of the lens. So f4 really means that the aperture is one-quarter of the lens focal length, as shown by the dotted circles, right; at f16 the aperture is one-sixteenth of the focal length, and so on.

Using this ratio system, rather than the aperture diameters, means that all camera lenses set to the same f number will photograph the same subject at equal image brightness. (Aperture diameter alone would not give a constant setting because short focal length lenses give brighter images than lenses of long focus.) As a result, using the same f number, you can change cameras or lenses and know that the exposure effect will remain the same.

Using the aperture control

Aperture control ring

The aperture is usually adjusted by turning a narrow ring near the focusing control. The ring is marked with the internationally agreed series of f numbers shown at the top of this page. The widest aperture (lowest f number) varies according to lens design and price. Lenses of good quality with wide apertures are expensive to make. Many good standard lenses have a maximum aperture of f2, others may only open to f2·8 or f4.

Most single lens reflex cameras focus at maximum aperture — whatever the f number chosen, the aperture only changes to its true setting at the moment of exposure. With some cameras, however, altering the setting

directly changes the aperture, and so affects the brightness and depth of field of the image seen through the viewfinder. With these it is best to focus at maximum aperture first, so that the image is brightest, then set your f number.

Aperture symbols

Simple cameras use weather symbols instead of f numbers — smallest aperture for brightest conditions. To reduce costs a sliding metal strip with holes of different sizes may replace the adjustable diaphragm.

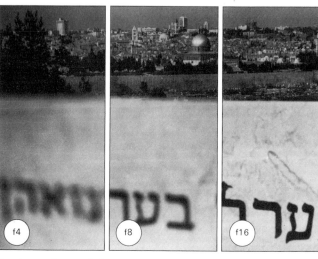

Aperture and zone of sharpness
The effect of the aperture setting on the sharpness of your image can be clearly seen in the three pictures above. They were taken, from left to right, at f4, f8, and f16 with the lens focused for infinity.

At the largest aperture (f4), left, only a small part of the image is sharp, and objects in the foreground of the picture are rendered unclear. This sharp zone, known as the "depth of field", is greater in the center picture, which was taken with a smaller aperture — f8. Finally, in the right hand picture,

which was taken at f16, almost everything from the foreground to the background has recorded sharply. From this you can see that as the aperture is reduced the depth of field increases, (see pp. 32–3).

Most simple cameras, such as the 35 mm model on page 26, have a fixed lens aperture (about f11) which enables the fixed focus lens to record detail from infinity down to about $6\frac{1}{2}$ ft (2 m).

Shutter

The shutter not only controls the exact moment when the film is exposed to light but also the duration of the exposure i.e. the amount of light that is admitted. We can use the same analogy as we did for the aperture. The length of time the shutter remains open controls the quantity of light that reaches the film in the same way that the quantity of water admitted to a container is controlled by the length of time it flows. Doubling the time the water flows will double the quantity in the container and, equally, doubling the time that the shutter remains open doubles the amount of light admitted to the film.

Some shutters, generally those on direct vision viewfinder cameras, fit within or just behind the lens body and use a set of blades which rapidly open or shut. These are called diaphragm, or leaf shutters. The other principal type of shutter — the focal plane shutter — is found on most single lens reflex cameras and consists of two separate blinds positioned just in front of the film.

Shutter speeds vary little between cameras — usually the longest time the shutter will automatically remain open for is 1 sec, the briefest exposure may be 1/250 sec, although many single lens reflex cameras have shutters with 1/500 or 1/1000 sec settings. As well as exposure, shutter speed controls how subject movement records (see below and pp. 34–5).

Shutter speed settings

| B | 1 | 1/2 | 1/4 | 1/8 | 1/15 | 1/30 | 1/60 | 1/125 | 1/250 | 1/500 |

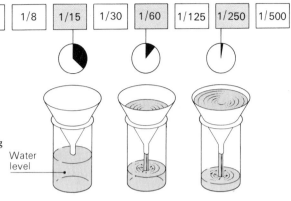

Shutter speeds, like f numbers, decrease in a regular sequence — each shutter speed setting is half the previous exposure time. This shared doubling and halving sequence is particularly important when combining aperture and shutter settings (see pp. 36–7).

Set the shutter to B ("Bulb"), and it will remain open for as long as you hold down the shutter release button.

Water level

Bladed and focal plane shutters

Bladed shutters are fitted to direct vision viewfinder cameras and those cameras where the viewing system is such that light need not pass through the lens until exposure. The mechanism is inside the lens body.

On a single lens reflex camera, with through the lens viewing, the shutter is positioned in the camera body, just in front of the film (at the focal plane). This means that you can change lenses at any time without exposing the film.

Focal plane shutters have two blinds, which pass in succession in front of the film to give the exposure. The shutter speed dial alters the gap between them — the narrowest gap giving the shortest exposure time.

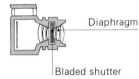
Diaphragm
Bladed shutter

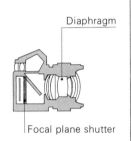
Diaphragm
Focal plane shutter

Using the shutter speed control

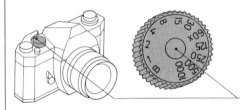
Shutter speed dial

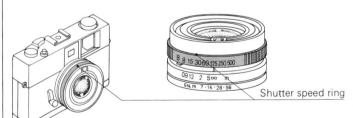
Shutter speed ring

The positioning and appearance of the shutter speed dial vary according to the two types of shutter. Most focal plane shutters have a setting dial on the top of the camera body. The numbers represent fractions of a second — "250" is 1/250 sec. Most bladed shutter (direct vision viewfinder) cameras have a similarly numbered ring around the lens body, near the aperture control.

In both cases the shutter mechanism is tensioned when you wind on the film ready for the next exposure, and fired by pressing the shutter release on the top or front of the camera body. (Simple cameras either have a one-speed shutter, or offer two or three speeds, marked not in times, but, say, in weather symbols.)

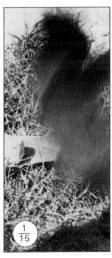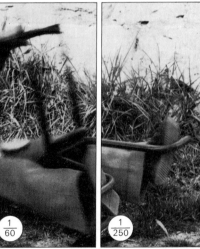

Shutter speed and movement
Shutter speed makes a considerable difference to the way moving subjects record in your pictures. The three pictures above show the same scene taken at, from left to right, 1/15 sec, 1/60 sec, and 1/250 sec. At the lowest shutter speed — 1/15 sec — subject movement has recorded blurred, implying action, but with a loss of detail. The faster times — 1/60 sec, center, and 1/250 sec, right — progressively eliminate the blur, revealing detail, but reducing the sense of movement.

At speeds less than 1/60 sec it is easy to blur the entire image accidentally because you are holding the camera unsteadily. If you want to avoid camera shake and most subject movement blur, keep to speeds of 1/125 sec and shorter. You can prevent shake at lower speeds by supporting the camera securely, preferably on a tripod (see p. 34).

STEP 3 : CONTROLLING PICTURE SHARPNESS/ Depth of field

Usually you will want to produce sharp, clear pictures, but even when you want an image to be blurred for a particular effect it is still important to know how to produce the right amount of sharp detail. The two main ways of controlling how much of the subject appears sharp are: use of depth of field (the zone that is sharply in focus) controlled by the aperture setting, and the shutter speed (discussed on pp. 34–5).

Aperture and depth of field
The two photographs of the chess pieces on this page illustrate how dramatically a picture can change by altering the depth of field. If your subject is a distant landscape, or has little depth, such as a face-on view of a building, changing depth of field has little effect. Because the elements of these subjects are all about the same distance from the camera, they will appear equally sharp at any aperture setting. However, a subject with close foreground elements and distant background elements will appear differently when the aperture setting (and therefore the depth of field) is altered. Both the foreground and background will grow much sharper as the lens aperture is reduced, that is, as the f number is increased.

Single lens reflex cameras usually have a pre-selective aperture control — whatever f number you set, the lens stays at its widest aperture for focusing, so that the subject

is bright and clear (when the shutter fires it closes down to the chosen aperture). Most of these cameras have a "preview" button which closes the diaphragm to the working aperture so that you are able to check depth of field before exposure. If you have such a camera, you can test this for yourself — when you press the preview button the picture will darken, but ignore this, and notice how those parts previously out. of focus now appear sharper. It is important to remember this change in depth of field when using a camera at small apertures — your photographs may include

How aperture affects depth of field

In the two diagrams, right, the lens remains focused for the figure, but at different apertures the amount of the subject that is sharp on the film plane (depth of field) changes. At a wide aperture, top, the tree comes to focus in front of the film plane and so would record unsharply. (Equally, foreground elements would come to focus behind the film and so would also be unsharp.) By reducing the aperture, bottom, the cones of light are narrowed. As a result, the tree (and any foreground elements) now form smaller circular patches of light and so give a more acceptably sharp image on the film plane.

more sharp detail in the foreground and background than you expect, or want.

Although rangefinder focusing cameras clearly show the point of focus, they do not show the depth of field. This is where a depth of field scale on the lens is helpful. This shows the extent of the depth of field either side of the focused subject at each aperture.

The aperture is the main way of controlling depth of field, but subject distance is also a contributing factor. It is always easier to produce sharpness throughout a picture where everything is a long way from the camera than in close-up shots.

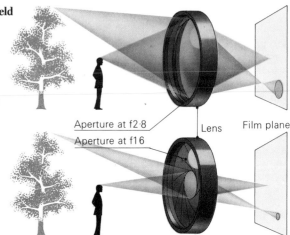

Aperture at f2·8
Aperture at f16 Lens Film plane

Depth of field and sharpness

As the diagram, below, and the two pictures, right, show, depth of field extends equally in front of and behind the focused subject when it is close-up. In both photographs the focus — set on the center chess piece — remained unchanged; only the aperture was altered. In the top photograph, taken at f16, the depth of field is wide so that the chess pieces in the foreground and background are also sharp and clear. Simply by widening the aperture to f2·8 (i.e. reducing the depth of field), below right, the foreground and

background chess pieces become unsharp. So, with the same subject. you can produce quite different results by altering the aperture setting (and depth of field) creatively.

Depth of field is also altered by the camera-subject distance. As this increases the proportion of the sharp zone in front of, and behind, the subject changes. On a standard 50 mm lens at distances of about 3 ft (0·9 m) and over, the depth of field extends about one third in front and two thirds behind the subject.

f16

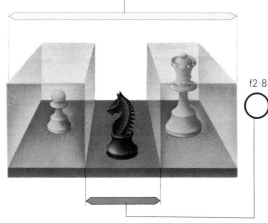

f2·8

Using depth of field

Often lens bodies have a depth of field scale next to the focusing ring so that you can more easily predict the depth of field at each aperture setting. This scale is marked in f numbers to show how far the depth of field extends in front of and behind the focused subject. For example, when the lens shown below is focused for 20 ft (6·6 m) the depth of field extends from 10 ft (3·3 m) to infinity at f16. At f2·8 it only extends from about 18 ft (5·4 m) to 24 ft (7·3 m). The scale acts as a guide to the f numbers you should select to get a particular depth of field in your picture.

Depth of field scale

Getting maximum depth of field

If you are photographing a subject which extends over a considerable distance, such as a deep landscape, it is not always best to focus the lens for infinity. The top picture, right, was taken with the lens set for infinity and the aperture at f16. Everything is sharp from the horizon (infinity in your picture) down to a near limit of sharpness (the hyperfocal point) at about 18 ft (5·4 m) and foreground elements are blurred. However, the depth of field can be maximized by refocusing for the near limit. This increases the depth of field so that the horizon is the furthest point that is sharp and elements in front of the near limit also become sharp. In the bottom right picture, focused for the near limit, the depth of field extends down to about 10 ft (3 m) away from the camera.

Depth of field and subject distance

The closer you get to your subject the shallower the depth of field becomes. The picture below was taken with the lens focused for its nearest subject distance and set to its widest aperture. The depth of field is only about 3 ins (76 mm) — everything nearer or further away is completely out of focus. At the same aperture the same lens would give a much greater depth of field if it was focused for a more distant subject. Focused for a subject 15 ft (4·5 m) away, for example, the depth of field would be 14—17 ft (4·2—5·1 m).

Even at a small aperture setting it is difficult to get a great depth of field when working close-up. This means that you must be particularly careful to focus accurately since there is little latitude, either side of your subject, for error. Therefore if you want the subject to be sharp throughout, try to choose a viewpoint from which most of its elements are equidistant from the lens.

Assignment: exploring depth of field

Select an interesting subject, preferably outside, and position yourself so that the foreground and background (up to about 20 ft, 6·6 m) includes detail. In good lighting take the following pictures:

A. With the lens focused for the main subject and set to its widest aperture.

B. With the lens at the same aperture, using the depth of field scale to focus on the hyperfocal point.

C. With the lens focused for the main subject again, using the smallest aperture on your camera. (Increase the shutter speed proportionally.)

D. With the focus and aperture settings just making the foreground and main subject sharp, leave the background unsharp. Use the depth of field scale.

E. Using focus and aperture settings to render the subject and background sharp, and the foreground unsharp. Again use the depth of field scale.

F. Selecting a detailed part of the main subject, move in very close-up and repeat A and C again.

Compare your results and decide which picture(s) of your subject works best.

Shutter speed and blur

A camera with a range of shutter speeds helps you to give correct exposure under all kinds of lighting conditions and, just as important, it allows you to choose whether movement will record "frozen" or blurred. A stationary subject photographed with the camera supported on a tripod will appear the same at any shutter speed. But if your subject is moving (or if you are holding the camera unsteadily), different shutter speeds will produce quite different results.

As we have seen the shutter speed determines the length of time that the film is exposed to the image. So the slower the shutter speed, the greater the blur created by subject movement. The exact effect depends on how fast the subject is moving in relation to you, how near you are to the subject, and whether the movement is side-on or directly toward the camera. A fast shutter speed is most likely to record all movement as if stationary.

Some photographers use the fastest shutter speeds to avoid recording accidental camera movement, but this can destroy any sense of action. With slower shutter speeds you can achieve many kinds of atmospheric effects, through diffusion and blur.

Shutter speed and subject movement

The cyclists were moving at the same speed in each of these three pictures, but the exposures were 1/30 sec, right, 1/125 sec, below left, and 1/500 sec, below right. You can see how the fastest shutter setting freezes the action — the image remains on the film so briefly that no movement has time to record. The slowest, at 1/30 sec, has blurred the group of cyclists, separating them from their background and creating a strong impression of speed. At 1/125 sec there is more detail and only the fastest moving elements — the outer spokes of the wheels — show blur although the sense of action is still present.

Supporting the camera

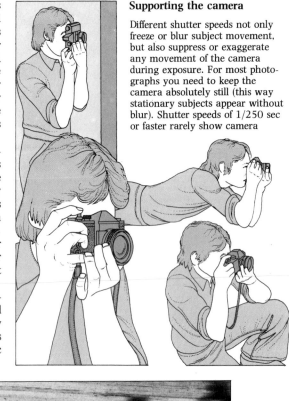

Different shutter speeds not only freeze or blur subject movement, but also suppress or exaggerate any movement of the camera during exposure. For most photographs you need to keep the camera absolutely still (this way stationary subjects appear without blur). Shutter speeds of 1/250 sec or faster rarely show camera shake, provided you are standing still. 1/125 sec is also safe, but remember to depress the shutter release gently — don't just jab it. For slower speeds you really need to provide extra support for your camera. Press your elbows into your waist, use your knee or, better still, the ground or a table as a base. Sometimes you can press the camera hard against a wall, or something similar, which will give sufficient support for longer exposure of 1 sec or so. But for the best results use an adjustable tripod, below, and a screw-in cable release for the shutter. Provided the ground is firm you can then safely make long exposures.

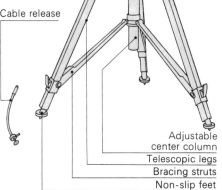

Pan and tilt head

Cable release

Adjustable center column
Telescopic legs
Bracing struts
Non-slip feet

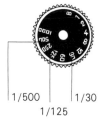

1/500 1/30
1/125

Blur and direction of movement

Unlike the pictures of the cyclists opposite, all three pictures here were taken with the same shutter setting – 1/60 sec. The differences in blur are completely due to the differences in the direction of movement. Movement toward, far right, or directly away from the camera always produces less blur than movement across the picture plane, near right. The center picture, with the figure moving diagonally, shows an intermediate effect. So if lighting conditions or other factors force you to use a slower than normal shutter speed, use a head-on rather than side view of the action if you want to reduce blur.

 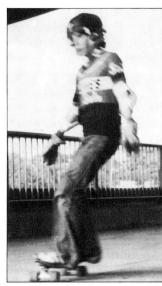 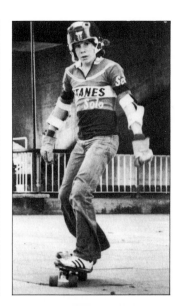

Creating blur

Sometimes an impression or interpretation of the subject is more interesting than a straight record.

Camera movement

Most shutters have a B-setting, so by using a tripod, you can give long exposures necessary for night scenes such as the bridge, above (5 secs at f11). For the interpretative version, right, an additional two seconds were given during which the camera was slowly tilted downward. As a result, every light, following the camera movement, described its own vertical line against the black sky.

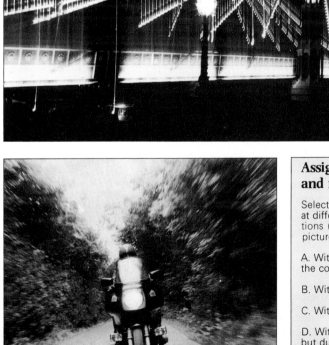

Creating a blurred surround

It is not essential for the camera to be stationary when taking a photograph. The motorcyclist, right, was taken from the back of a moving vehicle. The shutter speed was only 1/60 sec, but because the motorcycle was travelling at the same speed as the vehicle it has recorded on the film as if it were stationary. The surroundings rushing by, particularly at the edges of the picture, create a blurred impression of speed. Like all the pictures shown here, this result is possible with quite a simple camera. Later we will be trying similar effects by using a zoom lens (see p. 99) or by "panning" the camera (see p. 116).

(see p. 99) ... (see p. 116).

Assignment: exploring blur and movement

Select a scene containing subjects moving at different speeds and in various directions (a sports event is ideal). Take four pictures:

A. With the shutter set for the fastest time the conditions will allow.

B. With the shutter set at 1/8 sec.

C. With the shutter set at 1 sec.

D. With the shutter set at 1/8 sec again, but during exposure shifting the camera smoothly in the same direction as the general flow of subject movement.

Select the picture you think is most interesting.

Combining aperture and shutter speed

We have been looking at the three most important camera controls: focus, aperture, and shutter. Focus has the most straightforward function. It is used to give a sharp image of the key part of the picture – perhaps a building in a landscape, faces in a group, or the eyes in a close-up portrait. Lens aperture and shutter speed each affect the image in two distinct ways. First, they modify the amount of light which reaches the film – the aperture by altering its brightness, the shutter speed by controlling the time it is allowed to act. Second, they both have their own effect on the image. The aperture alters the depth of field, which is important when the subject includes elements at different distances from the camera. The shutter speed affects the image when either the camera or subject is moving.

Shutter speed and aperture combinations

For the film to record the image clearly it must receive the right amount of light, that is, it must not be overexposed or underexposed. Under normal lighting conditions it matters little whether you use a fast shutter speed with a wide lens aperture or a slow shutter speed with a small lens aperture; both give the film the same amount of light. (A container can be filled with the same amount of water over a short period of time through a wide funnel, or over a long period through a narrow funnel.)

The diagram below shows the doubling and halving relationship of the aperture and shutter settings on the camera. This allows you to combine different settings, altering the effect on the image, but admitting exactly the same quantity of light. For example, your exposure meter or film instruction leaflet may indicate that your subject needs an exposure of 1/60 sec at f8. Instead of using this exposure, you could set 1/500 sec at f2·8, or 1/15 sec at f16. Each combination will expose the film to the same quantity of light, but, as the pictures at the top of the opposite page show, they give very different images. The choice of settings on both controls can be used to suit the subject and the effect you want to create.

Selecting the exposure

Sometimes the light level alone determines the exposure setting. It may be so low that you have to use a slow shutter speed and a wide aperture to get any image at all, letting as much light as possible through to the film. Or it may be so high that the fastest speed and smallest aperture are needed. But for a great deal of your photography you will find from your exposure meter or guide that you have a reasonably wide choice of different aperture and shutter speed combinations. In the pages which follow we shall be looking at the way the correct exposure for various lighting conditions and subjects is measured.

Once you have determined the exposure, you can then decide how you will interpret your subject. Consider the ways depth of field can be used either to emphasize one chosen zone or to get everything in focus. When setting the shutter speed, remember to consider the effects of camera shake and the blur created by moving subjects.

How aperture and shutter speeds combine

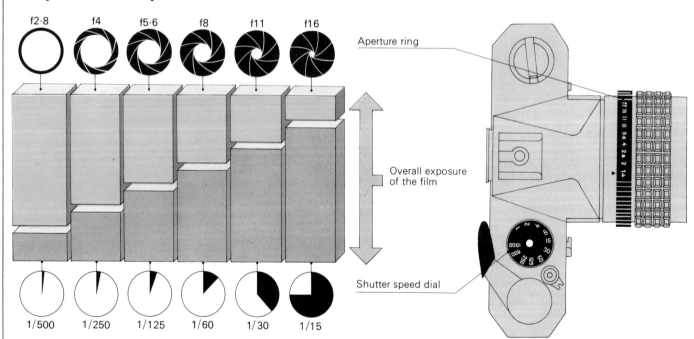

Aperture ring

Overall exposure of the film

Shutter speed dial

The combinations of aperture and shutter settings above show how exactly the same exposure can be given in various ways. Provided that each change of f number is matched by a corresponding change of shutter speed, the film will receive the same amount of light. So if your light meter (or film instructions) suggests one of these combinations, you can change to any one of the others to alter the depth of field or the amount of blur. If you change one control without compensating with the other the overall exposure is altered. For example 1/30 sec at f8 gives the film twice as much light as 1/60 sec at f8.

Not shown in this diagram is the range of very slow speeds, down to 1 sec, offered by many cameras, which combine with aperture settings in the same way.

The controls on the camera
The location of the aperture and shutter controls shown on the camera above is typical.

Some cameras have the controls on adjacent rings. If you first set any combination to give the required exposure, the two rings, turned together, will keep the exposure constant by altering both the aperture and shutter speed in inverse proportion.

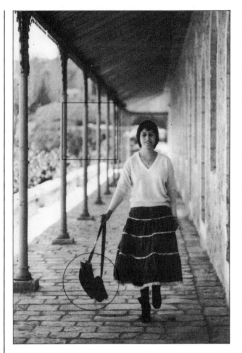

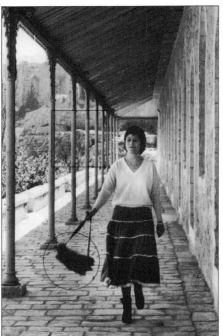

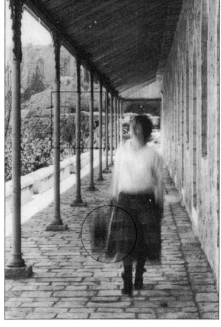

Exposure at 1/500 sec at f2·8
The picture above was taken using a very fast shutter speed and a wide lens aperture. Even the fastest movement (ringed area) has been "frozen" and the wide aperture has left much of the background (boxed area) unsharp.

Exposure at 1/60 sec at f8
The picture above had the same overall exposure as the one on the left, but used a slower shutter speed and a smaller aperture. The fastest movement (ringed) has blurred and the middle distance has become sharp.

Exposure at 1/15 sec at f16
Here the same overall exposure combined a very slow shutter speed and a small lens aperture. Nearly all movement has blurred, and the small aperture has made almost the whole scene sharp (boxed area).

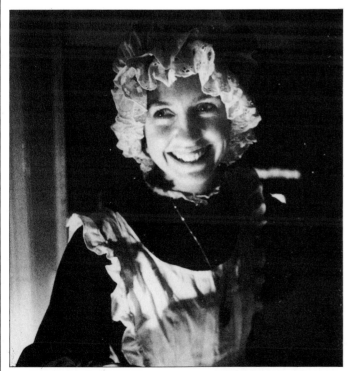

Exposure at 1/15 sec at f2·8
When your subject is very dimly lit, as shown above, you may have to combine a slow shutter speed with a wide lens aperture to give the film enough light. In this ex-ample you could give the same exposure by choosing ½ sec at f8, or 2 secs at f16, provided you support the camera steadily, prefer-ably on a tripod, and the subject remains absolutely still.

Reminders: camera controls

Focusing controls which part of the subject records sharply

Moving the lens brings parts of the subject at different distances from the camera in or out of focus. You can measure and set your subject distance or you can check the sharpness visually, by a focusing screen or rangefinder.

The extent of sharp detail is controlled by the aperture

The aperture controls image brightness (through the amount of light it admits) and the depth of field. The aperture ring is scaled in f numbers. The higher the f number the smaller the aperture and the greater the depth of field. Depth of field also increases if you use a shorter focal length lens (see pp. 94–5) or increase subject distance.

Shutter speed affects the way movement records

The shutter controls the time the image is exposed to the film, and consequently, the amount of blur on the image. Blur varies accord-ing to camera movement, and the relative speed, direction, and distance of the subject.

The exposure is determined by the aperture and shutter speed

When taking a photograph you usually have a choice of combinations of aperture and shutter speeds. Provided they still give sufficient light to the film you can choose to have either wide or narrow depth of field, frozen or blurred movement.

STEP 4: FILM AND MEASURING EXPOSURE/Film

Exposure — the amount of light that is allowed to act on the film — is controlled by the aperture and shutter settings. In order to set the correct exposure on your camera, you need to know the light-sensitivity of your film, and the brightness of your subject (lighting and tone). On this page, we look at factors involved in choosing film; the following pages deal with ways of measuring light and calculating the exposure.

Film size and speed

First you must select the right size film to fit your camera: some cameras take drop-in cartridges, 110 or 126 size (see p. 26), others take larger rollfilm (see p. 204), but the most popular size for direct vision and single lens reflex cameras is 35 mm wide and is packaged in a metal cassette. Cassettes contain enough film for either 20 or 36 exposures, with each frame 36 × 24 mm.

The next important factor when choosing a film is its sensitivity, or "speed", which is given by its ASA (American Standards Association) or DIN number. DIN numbers are used mainly in Europe, but most film packs give both ratings.

A film marked 400 ASA is twice as sensitive, or fast, as a 200 ASA film; doubling the ASA number doubles the speed. The faster the film the less exposure you need to give, but the coarser and more "grainy" your picture will appear. This is because a

fast film gains its sensitivity by using larger grains of silver, so the resulting negatives have a coarse granular pattern that can be clearly seen in enlargements.

To decide on a speed of film you have to consider the lighting conditions and subject matter of your pictures. Films of 64, 32 or lower ASA numbers are slow and have a very fine grain. They are a good choice if you want high quality, grain-free enlargements with lots of detail, but because of their slowness the lighting generally must be quite bright. A slow film is also useful if you need to give long exposures for blur effects without overexposing.

Films of around 125 ASA still have a fine grain and are more generally applicable. They are ideal for average subjects outdoors and well-lit indoor subjects. Faster films of 400–800 ASA begin to show grain but are sensitive enough for a wide range of subjects, inside and outside. Ultra-fast films of 1000 ASA and above are intended for quite dim lighting, or if you deliberately want to produce a grainy picture, or whenever you want to freeze fast action while using fast shutter speeds.

The best general advice is to keep to one brand and one speed — such as 125 ASA or 400 ASA film — for all your regular photography, and really get used to it. Then change only for unusual subjects or to achieve particular effects.

Negatives and positives

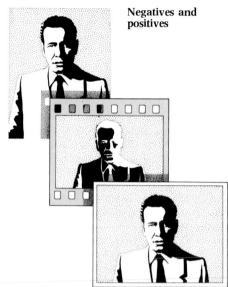

Nearly all black and white films give a negative record of the image so that light areas of the subject are dark, while dark parts of the subject appear as clear film. Printing from this on to photographic paper (see pp. 74–7) again reverses the tones to create a positive picture. As many prints as you want can be taken (and enlarged) from each negative.

Film speed and grain

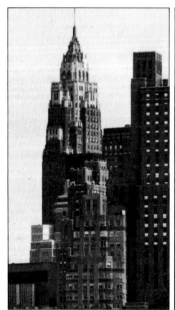

The picture above, left, was photographed on 32 ASA film. Even though the negative is shown here enlarged six times, the grain pattern is almost unnoticeable. The other picture, right, was exposed on 1250 ASA film. At the same enlargement this much faster film shows a distinct granular pattern. Notice how the grain shows up clearly in mid-gray areas. It tends to break up fine detail, but can give a textured effect which suits some subjects.

Decoding the pack

The most important pieces of information on the film pack are the film speed (shown in both ASA and DIN numbers), film size (this pack contains 35 mm film), number of exposures (20 or 36, on 35 mm film), and whether the film is color or black and white. You should decide these before you buy film. Other information includes the brand name and type and the expiry date for the film. To obtain maximum life from unexposed film you should store it in a cool, dry place.

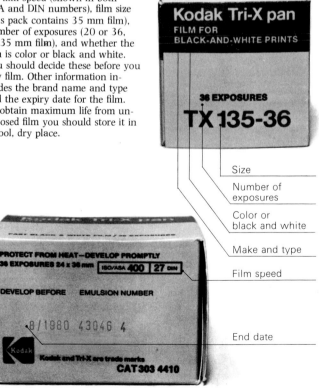

Size
Number of exposures
Color or black and white
Make and type
Film speed
End date

Exposure tables and hand-held meters

Once you have selected a film you must find out what exposure is necessary for the particular subject and lighting conditions. After determining this, you can alter the aperture and shutter speed settings (preserving the combined exposure) to obtain the depth of field and blur you want.

If you have a simple camera, the easiest way of deciding the exposure to give is to use the symbols marked on the camera or follow the instructions packed with the film. The advice shown, right, will give you reasonable results for typical outdoor subjects, under five different daylight conditions. But as soon as you tackle a different sort of subject, work inside or under artificial lighting, or use a different film speed, the guide fails. This is where an exposure meter, either a hand-held model or one built into the camera, is essential (see pp. 40–1).

Meters have a light-sensitive surface or "cell" to measure accurately the actual illumination reflected from the subject under all sorts of conditions. A separate hand-held meter has the advantage of serving all cameras and, unlike meters that are built into the camera, enables you to check exposure quickly without having to use your camera. This is particularly useful when you have the camera on a tripod with a carefully set viewpoint, because you are free to take close-up readings without disturbing the camera position.

Exposure tables and symbols

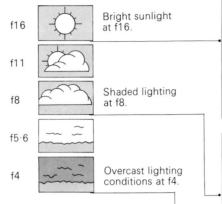

f16	Bright sunlight at f16.
f11	
f8	Shaded lighting at f8.
f5·6	
f4	Overcast lighting conditions at f4.

The table above shows exposure information that is included with film. It lists the apertures needed for a 125 ASA film, when using a 1/125 sec shutter speed, under various conditions.

From top to bottom, the symbols describe direct, bright sunlight; partly obscured sun; shaded light and a bright sky; hazy overall cloud; and overcast conditions. If you wanted to use a different shutter speed, the aperture settings would have to be correspondingly increased or reduced for each lighting condition.

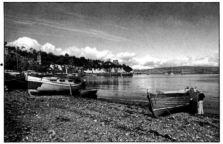

The hand-held light meter

Most hand-held meters have a light-sensitive cell, a needle and light-reading scale, and a calculator to convert the reading into f numbers and shutter speeds.

The meter shown below has a selenium cell, which generates its own electricity from light and so does not need a battery. Some hand (and all through-the-lens) meters use a smaller, photo-resistant cell, which is more sensitive but needs a battery. With selenium cell meters under poor lighting, the hinged baffle at the back of the meter should be down to allow the needle to read over one scale. Under bright light the baffle should be up, covering the light-sensitive cell — the needle then reads over a different, higher scale. When using a hand-held meter be careful not to obstruct the light-sensitive cell.

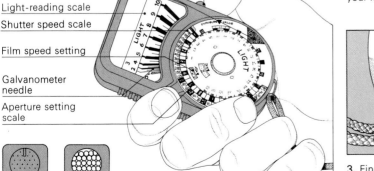

Needle release switch
Calculator
Light-reading scale
Shutter speed scale
Film speed setting
Galvanometer needle
Aperture setting scale

Baffle up Baffle down

Using a hand-held meter

1. Set the ASA (or DIN) rating of your film in the appropriate window on the calculator dial of your meter.

2. Point the light-sensitive cell on the rear of the meter toward the subject, and press the needle release switch to get a reading on the scale.

3. Find this reading on the calculator dial and move the pointer on the aperture setting scale to meet it.

4. The correct exposure is now given by any of the aperture and shutter speeds shown adjacent to each other, such as 1/150 sec at f16, above.

Meters on cameras

Nowadays most cameras have their own built-in light meter, which can be either coupled or uncoupled. On an uncoupled meter you must first read the meter, then choose and set the shutter and aperture values. On coupled systems the read-out, usually in the camera viewfinder, responds directly to adjustments of the aperture and shutter controls and indicates when they are correctly combined.

The light-sensitive cell in a built-in metering system is either on the exterior or inside the main body of the camera. If it is on the exterior, the cell does not measure the light entering the lens (that is, the light that acts on the film) so it can be misleading. It only measures light coming from the general direction of the subject, and does not compensate when a filter or a different lens is attached.

These problems are overcome by a "through-the-lens" meter (TTL), which appears almost exclusively on single lens reflex cameras. Its light-sensitive cell, positioned inside the camera, measures the light that passes through the lens, thereby taking into account the effect of lens aperture and any filters or close-up attachments you may fit to the camera. Through-the-lens meters are always coupled directly to the shutter and aperture controls, and some can set the controls automatically.

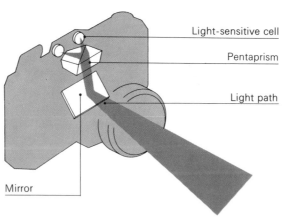

Light-sensitive cell

Pentaprism

Light path

Mirror

Meters on single lens reflex cameras

Most built-in meters on single lens reflex cameras are through-the-lens types. They have the advantage of only measuring the light that forms the image. The light-sensitive cell can be in various positions. Often several cells are used on or around the pentaprism, where they receive a general view of the image on the focusing screen. The meter is powered by a small replaceable battery housed in the camera body. Exposure information is shown on a display on the focusing screen, either by a moving needle or colored indicator lights.

Viewfinder displays
Three typical viewfinder displays for through-the-lens meters are shown left. The simplest, top, is a needle which is centered for the correct exposure by adjusting the aperture or shutter (according to the model of camera). The center display includes the shutter setting and is centered by changing the lens aperture. A similar arrangement to this, but using light signals, is shown in the bottom viewfinder display.

Meter reading areas

Through-the-lens meters measure light from the subject in various ways. Some view the whole picture area, averaging out the light and dark areas, top right. This is fine if your picture has roughly equal amounts of light and dark areas.

A few through-the-lens meters give "spot" readings, center right — they read a small area of the picture, usually a central zone marked on the focusing screen. This enables you to read exposure for just one key area, such as a face, or to take more than one measurement — from the light and dark areas — which can then be averaged to get an overall reading. A spot reading allows you greatest control and accuracy but it is also easy to make a mistake, for instance measuring only the sky when your subject is mostly landscape.

Some meters use a "center-weighted" system, which measures most of the picture but gives prominence to the central area, bottom right. This works well provided the central area is representative of the whole scene.

Using a through-the-lens meter

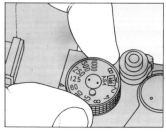

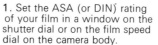

1. Set the ASA (or DIN) rating of your film in a window on the shutter dial or on the film speed dial on the camera body.

2. Set the control (i.e. shutter or aperture) most important for the picture, considering subject movement and depth of field.

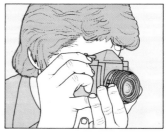

3. Focus the image. Then, if you have a spot or center-weighted meter, point the camera so the meter reads the appropriate area of the subject.

4. Turn the aperture ring (or alter the shutter speed) until the indicator (or lights) in the viewfinder display shows that the correct exposure is set.

Priority metering

Some single lens reflex cameras have priority automatic metering — you select either aperture or shutter speed and the meter automatically sets the other control.

Aperture priority

If your camera has an "aperture priority" system you always set the f number yourself and the camera sets the shutter speed automatically. This is particularly suitable for subjects such as landscape, still life, or close-up work, see right and below, where careful control of the depth of field is important.

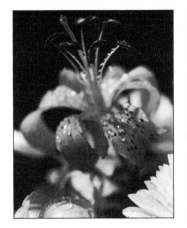

Shutter speed priority

Some automatic meters have shutter speed priority — you choose the shutter speed and the meter sets the aperture. In bright conditions you will be likely to get a greater depth of field than when the lighting is poor. Shutter priority systems are particularly suited to action photography, below, or where you want to create blur deliberately, such as shown right.

Usually priority automatic systems are options on cameras that also allow manual operation. On some cameras now you can choose either aperture priority or shutter priority automatic metering.

Meters on direct vision cameras

Light meters on direct vision viewfinder cameras are either coupled to the exposure controls, or uncoupled. The uncoupled meter camera, right, is the simplest: first set the film speed on the calculator on top of the camera, shown right; a needle moves along a scale on the calculator to give the reading. When your selected aperture or shutter speed is set against the reading, the calculator will show you the other setting to make for the correct exposure.

The cameras, below right, have coupled meters, which may be manually set. Manual cameras may have a "follow pointer" read-out, as shown far right. Automatic cameras may have priority metering, or may set the controls independently, without you having to do anything.

The two cameras shown near right have selenium cell meters which do not need batteries; the third has a battery-operated CdS cell meter.

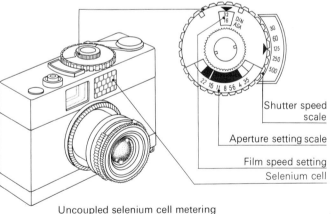

Shutter speed scale

Aperture setting scale

Film speed setting

Selenium cell

Uncoupled selenium cell metering

Follow pointer viewfinders

Some manual coupled-meter cameras have a needle-and-pointer exposure guide in the viewfinder. The needle is fixed by setting either aperture or shutter (depending on the camera); the pointer is then moved by altering the second control — when they coincide, the correct exposure is set.

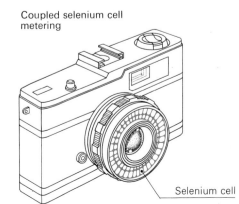

Coupled selenium cell metering

Selenium cell

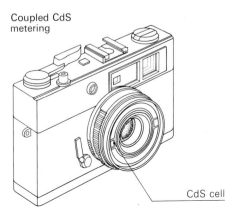

Coupled CdS metering

CdS cell

Taking exposure readings

Correct exposure is a relative term. Under normal lighting conditions, film will record an image over a wide range of exposures; which exposure you choose depends to a great extent on how you want your subject to look. Generally you will want the subject to record with detail throughout, but sometimes you may want to emphasize one part by selectively measuring the exposure.

An image formed through the lens will cover a range of brightness, depending on the tones of the subject and the lighting. If a subject is harshly lit, it will have a wider range — from deep shadow to bright highlight — than if it is flatly lit, as in overcast daylight. Ideally you will want important detail from both light and dark areas to record. However, film cannot record a vast range of brightness all in the same picture. If you try to expose long enough for the deep shadows, the lightest parts of the picture may be overexposed and vice versa.

Exposure tables are useful guides for "average" subjects in specified lighting conditions, but an exposure meter is much more versatile and accurate because it reads your particular subject and lighting conditions. For a subject like the picture right, a general overall meter measurement will give good results. But sometimes the meter can give a misleading reading of the exposure. Some of the ways to avoid this are explained below and on the opposite page.

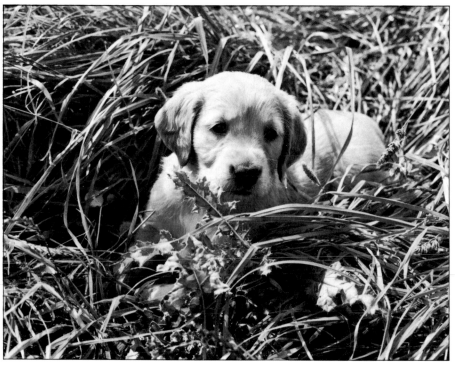

Using one overall reading
The exposure for the sort of scene above can be accurately judged by taking one general meter reading from the camera position. Shadows and highlights in the subject are about equal in area and the meter will average them both. The meter must point at the same area of the scene as you have in your viewfinder.

Where general readings are deceptive

A general reading is misleading if the important element is quite small. When the background is bright, below left, the reading underexposes the face so that on the print it is too dark.

A dark background, bottom left, produces the opposite effect — the face is now too pale (overexposed). In the two larger prints, below, the light readings were taken for the figure alone, so that the background lighting does not dominate the result.

Taking a selective reading

To overcome the type of exposure reading difficulties described left, you must make sure that the meter only reads from the most important area of the subject — in this case the subject's face.

Moving closer
For built-in meters that give a general reading, move in until the main subject fills the viewfinder. You can then take your exposure reading without the background affecting the reading. Move back again to take the photograph.

Taking a spot reading
If your camera has a through-the-lens meter which makes a "spot" reading (see p. 40), align this marked area of the focusing screen with the main subject. Since the meter ignores other parts of the picture, it will give the correct exposure for the main subject.

Local hand meter reading
If you use a hand-held meter you can bring it up close to the main subject to take your reading. In doing so, be careful not to cast a shadow on the area being measured.

Exposing to suit the subject

The exact exposure you give depends upon which parts of the picture you have selected as being important. In the near right picture the exposure (1/60 sec at f11) was read mostly from the shadow area, so that the highlights are very overexposed, with a consequent loss of detail. The center picture was given an average overall reading (1/250 sec at f11). For the third version, far right, the exposure (1/500 sec at f16) was read from the highlights. The picture is underexposed, but is perhaps the most satisfying result.

Brightness range reading

Sometimes you want to record as much detail as possible in a subject that has a wide brightness range (high contrast) like the photograph, right. If you have time, use your built-in meter to take two readings. For example, taking a reading from the darkest part of the subject may suggest an aperture of f2·8; then reading from the lightest part may give you f11 (at the same shutter speed). By halving the difference between these two settings you will arrive at f5·6 as the best compromise setting.

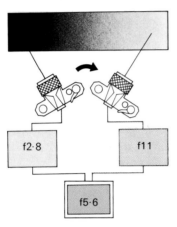

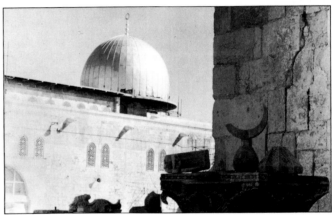

Substitute readings

Often action pictures allow you no time to make several elaborate readings. Also, on some occasions, you may not want to make it obvious that you are taking pictures. One method of solving this is to take a reading from a substitute that is about midway in tone between the darkest and lightest parts of your subject. This could be a mid-gray card, or your hand (as a substitute for someone's face, for example). The action picture below is typical of the sort of subject that can only be taken if the exposure is pre-set from a substitute reading.

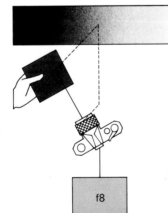

Reminders: Film and exposure

Film sensitivity is given by its speed	Film sensitivity is given in ASA numbers, where double the number means double the speed. Fastest film gives coarsest grain.
Exposure is related to subject brightness and film speed	To measure exposure, subject brightness (surface tones and lighting) must be related to the speed of the film.
Light meters are sometimes coupled to camera controls and differ in the area they read	Exposure meters are more versatile than exposure tables. Most meters are built into the camera, often coupled to its controls — "automatic" metering is based on either shutter or aperture priority. Built-in meters differ in the subject area they read. Those that take general readings suit evenly distributed tones; spot systems are best for measuring one key area or checking brightness range; a center-weighted meter is good for most general subjects.
Take the readings from the most important subject area	Try to take your reading from the most important subject area. If you want to record extremes of brightness, work out an average exposure.

SUMMARY Camera technique

Focusing

A camera with an adjustable lens extends the range of distances you can be from your subject and allows you to choose which parts of the subject you want sharp. By moving the lens away from the film plane you can focus on closer subjects, and by racking it closer, more distant subjects become sharp.

Aperture and shutter speed

Adjusting the size of the aperture alters the quantity of light that is admitted; the shutter speed controls the time for which light is admitted.

Aperture size is given in "f numbers". The higher the number the smaller the aperture, and therefore the less light is admitted.

The shutter can be opened and closed for precise, preset periods. If the time that the shutter is open is relatively long, and the subject or the camera move, then this movement will be recorded as blur in the image.

Depth of field

The size of the aperture changes the depth of field recorded by a camera. The higher the f number, the greater the zone of acceptably sharp detail in front of and behind the focused subject. The lower the f number, the more isolated the subject in focus will become. With subjects further than about 3 feet (0·9 m) away depth of field extends further behind the focused subject than in front of it.

Exposure

Exposing the film correctly means combining the right aperture with the right shutter speed. For each exposure you can choose between letting light pass through a smaller aperture for a longer time, or through a larger aperture for a shorter time.

Film

Once you have chosen the right size film for your camera, and the number of exposures you require, your main consideration will be to choose the right speed of film, as shown by the ASA or DIN number. The higher the number the quicker the emulsion reacts to light because of its large grain size. The lower the number the slower the emulsion reacts to light because of its small grain size. Detail is recorded more sharply on fine-grained emulsion.

Light meters

Make sure that your meter "sees" a representative area of the subject. Take your readings from those areas of the subject that are most important, and if necessary, average out the light and dark areas.

The subject

Try not to let the choice of controls come between you and your subject. It is sometimes advisable to set your camera controls in advance to a probable shutter speed and aperture so that you can take a quick picture without making further adjustments.

The diagram below shows a typical sequence of decisions necessary when taking a photograph. It is not meant to be comprehensive or invariable. Your camera may have slightly different controls or you may prefer to set the aperture or shutter before you focus. A similar procedure applies if you are using a hand-held meter or if you have an aperture priority camera.

1. Film loading
Always load and unload film in the shade. Set the film ASA rating on the exposure meter.

2. Focus
Select your viewpoint and focus on the main part of your subject.

3. Shutter
Set a shutter speed, remembering the effect of movement and camera shake.

Simple camera Automatic Shutter priority

4. Aperture
Set the exposure according to the weather symbols.

4. Aperture
Using the meter, take a reading from an appropriate area of the subject. Alter the aperture until the meter read-out shows the correct exposure.

5. Expose
Check the composition and, with the camera steady, choose the right moment to gently press the shutter release. Wind on the film.

PICTURE BUILDING

STEP 1: Viewpoint and lighting

STEP 2: Using subject qualities

STEP 3: Responding to the action

This section is concerned with the pictures themselves, rather than the technical means of recording them.

By this stage you should have worked through your basic techniques and gained some confidence with your camera. You should know enough to focus and expose correctly any of the photographs shown here – using only black and white film and the equipment introduced in the previous section. The challenge is to put together the right visual elements in your pictures – shapes, lines, patterns, and tones for example – to produce an effective and satisfying composition. Picture building involves selecting and controlling these elements – or seeing the precise moment or viewpoint that brings them together – to make the strongest possible visual statement. But first you must have something to say – a subject or situation you wish to show, a point of view to convey. Like control of language in writing, control of visual elements in photography is merely a means of expressing your ideas effectively.

Use this section as a visual vocabulary, to stimulate your seeing and develop your awareness of potential subjects for your photographs. Don't treat the statements and suggestions made here as rules to be followed slavishly – try them out, and see if you agree with them. Although the material is presented in separate steps, you can read them in any order. In fact the best way to approach this section is to regard each topic as a theme for development in your own work. Even when you are without a camera, look around you for the visual elements discussed here, and imagine how you would turn a particular scene into an effective photograph.

At first sight, the number of picture building aspects introduced in this section may seem overwhelming. How can you juggle with so many when you are actually taking a photograph? Don't be put off – just look the section over at first, and absorb some of the ideas. You will soon find yourself noticing some of these elements in scenes around you – they will seldom be all present at once. For clarity, each basic element is presented here separately, so you can concentrate on one at a time. In real situations you will find that they overlap and change, so that you have to respond quickly, taking advantage of opportunities as they present themselves. This is where your knowledge and experience of visual devices really counts. In time, you will begin to draw automatically on visual elements in a scene to strengthen your main subject, developing a natural visual language which is part of your photography.

The differences between how your eyes and the camera see the world were discussed on pages 20-1. You may find it helpful to look back over this information. Certain basic visual limitations are imposed by black and white photography – it translates the three-dimensional colored scene you see in motion around you into a still, two-dimensional picture consisting of gray tones, isolated and bounded by a hard edge. This change is severe; but it is also your primary picture building tool. The secret is to use this change to help simplify and clarify your pictures. For example, reducing color to blacks, whites, and grays can make shapes stronger, and suppress distracting color details. To take advantage of such effects you must learn to see your subject in terms of light and dark tones.

Normally, when you look at an object you are constantly moving your eyes or sometimes moving around it, but a photograph can only be taken from one fixed viewpoint. By "pinning down" subject and surroundings to one relationship, your photograph is directing the viewer to one set of conditions. Providing you recognize this, and compose your picture with care, you have great power over what the viewer sees. Even the simple fact that you have selected a subject at one particular moment in time, to present in a photograph, gives it special significance relative to the comparatively confused world seen by the eye.

Arrangement of topics

The section begins by discussing choice of viewpoint and the effects of picture shape – upright, horizontal or square. You are still dealing primarily with a camera fitted with a normal lens at this stage. Later, in the section beginning on page 92, you will see the further possibilities offered by lenses of other focal lengths. Your choice of viewpoint is the one element over which you have most control. You should always try to consider using different camera angles – if all your pictures are taken from eye-level they can become very predictable.

The next topic is light. The height and direction of lighting is fundamental to the appearance of things. So is lighting quality – whether it is strong and direct, producing harsh, sharp-edged shadows, or soft and diffused. The quality of light often determines the "feel" of texture and form in objects. The overall strength of light also affects how a scene appears, but the result depends on the exposure you choose. You must train your eye to observe the changes in natural light and the effects they have on things around you. They will be very apparent in your picture, and the quality of the light cannot really be altered by any technical adjustments later. This section deals only with the effects of daylight, both outdoors and indoors. The same principles apply to all lighting, but you will find more on the controlled use of artificial light later (see pp. 108-13).

Tone control follows naturally from lighting. It is an important picture building element, particularly in black and white work. You will learn how you can consciously use mostly dark or light tones in a photograph to determine its mood. You will see too how tonal contrast can emphasize your main subject, and give strength to a picture. You can alter the tonal range in a subject by control of exposure and lighting. Later you will be shown how to control tone during the developing and printing of your film as well (see pp. 86, 128-9).

Lines and shapes can also support and emphasize your main subject. By carefully selecting your viewpoint and lighting you can organize line and shape in your pictures to direct the viewer's eye, or form strong, interesting patterns. A small camera is easily moved to almost any viewpoint, to reveal different juxtapositions of shapes and directions of lines. Take advantage of this to exploit the bold imagery of shape and line to the full.

The final Step considers selecting the "moment in time" recorded on your film. For some types of subject – still-life, for example – there is no problem, because you are in control of all the elements in your picture. But even for stationary subjects like landscapes, you may have to respond quickly to capture the perfect moment – when the lighting is exactly right, for example. With moving subjects, your experience and ease with visual elements are really important. Often you must simply do the best you can in a hurried situation. But most subjects require some careful planning as well as a quick and spontaneous response. With practice you will be able to make decisions intuitively, watching the way things come together in your viewfinder, and responding by changing viewpoint or focus, until the right moment arrives. This is why you must work by looking through your camera, and learn to see as the camera sees, previsualizing what will record in the instant the shutter fires.

Learning to develop a style

Look at the way the famous French photographer Henri Cartier-Bresson has handled the picture opposite. By his choice of viewpoint he has placed the bold shape of his subject strongly against the lighter-toned parts of the background. The lines formed by the tops and bottoms of the trees lead in to the man's head, giving emphasis. Distracting background details have been softened out by differential focus and the diffused lighting conditions. The shutter was released at the right moment to capture the subject in a characteristic attitude, isolated against the distant perspective. Cartier-Bresson's picture is essentially simple and direct. Yet it manages to show both an individual personality and his environment.

You can learn much by looking at the published work of other photographers. You will find a range of diverse styles in the final section, pages 178-202, and many excellent individual collections in books at your local library. Visit exhibitions, and try assessing photographs in terms of their picture structure, as well as their content and underlying statement.

Early photographers had to use large cameras on tripods, working in a static way like a painter. Mostly they fell into the trap of trying to ape the romantic paintings and uplifting themes of their time. Photographs were conceived and staged like paintings, and contrived to look as little like photographs as possible. Fortunately modern cameras and the many uses of photography have led to a much broader idea of the nature and potential of photography.

Picture building is not a matter of obeying rules or following artistic trends. You must learn to look afresh at the world around you, to become aware of shapes, forms, surprising visual juxtapositions, the effects of light, which many people take for granted. Once you learn to see, you can select or reject, emphasize or suppress, to express your main subject in a visual language which is all your own.

Chair and shadow
The picture, left, relies for its effect on simplicity – close framing of a bold image. The photographer, Frank Hermann, used an unusual view-point to make lighting, tonal contrast, shape, and line work together.

Allée du Prado, 1932
The picture, right, uses many compositional elements. But the photographer, Henri Cartier-Bresson, has combined them so skilfully that the subject appears to be captured effortlessly.

STEP 1 : VIEWPOINT AND LIGHTING/Viewpoint

Re-positioning your subject in the viewfinder frame and changing the camera viewpoint are two simple ways of controlling the composition and altering the image.

In a photograph a subject is restricted to the rectangular (or sometimes square) format imposed by the camera. This frame is an important compositional element. It can, for example, sharply cut off parts of the subject and create completely new shapes, as shown in the picture of the building below. With rectangular formats, whether you hold the camera horizontally or vertically is an important consideration.

Most cameras are designed for eye-level use — the height from which we see the world — and the majority of pictures are taken from this level. Photography from a different viewpoint can often add drama and excitement, or sometimes bring out an unusual aspect of a subject.

Picture format
The proportions of most photographs are rectangular — the normal 35 mm full frame format having a ratio of 2 to 3 (24 × 36 mm). The choice of whether to hold the camera horizontally or vertically can have a great effect on your final composition as shown left by the two marked areas.

For example, in the horizontal version of the landscape your eye is led along the valley from the nearby tree to the dip on the horizon. When the same subject is taken with the camera held vertically, notice how the horizontal flow of the composition is reduced. The house becomes more strongly placed, and the white clouds seem to repeat the shapes of the foreground bushes. The scene now appears much less enclosed.

Symmetry
The subjects above and below have been positioned symmetrically within the picture format by careful use of the picture frame. A symmetrical composition gives a balanced result but used alone is often monotonous. Irregular elements, such as the vertical bar on the door and the worn step, below, relieve the formal pattern and add interest to the picture.

Balance and variety
The photograph above uses the window bars and edges of the picture to create four separate areas. The composition is asymmetrical but has balance, provided by the flowers and window catch. Each of the four frames has simple differences in size and shape which give interest and variety.

High viewpoint

The viewpoint used for the picture below eliminates the sky from the picture and fills the whole frame with the textured surface of the grass. Because from this position the man is not immediately recognizable, his abstract shape becomes part of the two-dimensional design.

Against a simple, flat background the positioning of the main subject is critical. Here the man is placed off-center, but moving parallel to the edges of the picture frame, giving the composition balance and interest.

Working close-up

The portrait, right, shows the powerful effect that can be achieved by filling the whole picture frame with your subject. Even though much of the child's head is lost by this extreme close-up, the essential features of the face are still captured.

There is no correct position from which to take portraits — it should be selected according to the subject. Sometimes you may want to include the surroundings or an object that is associated with the subject. This helps to convey information and create a mood.

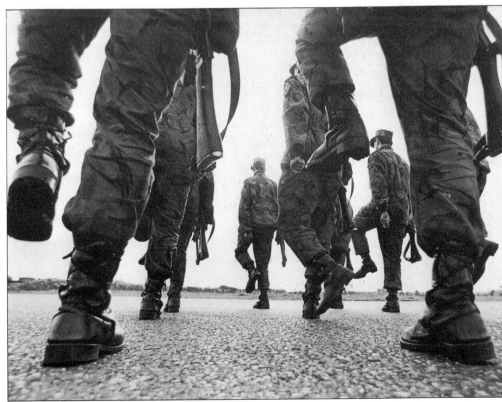

Low viewpoint

The distorted scale created by the low viewpoint in the picture, left, greatly adds to the menace of the armed soldiers.

An eye-level viewpoint would have made each of the soldiers recognizable characters, all on a normal scale. This choice of framing and viewpoint has depersonalized the soldiers and emphasized boots and rifle butts.

Lighting quality

Light is the basic material of the photographer. The amount of light determines whether a subject can be recorded at all, and the quality and direction of the light controls the appearance of the subject. For good picture building therefore, you must develop an awareness of how changes in lighting affect things around you. Lighting can be used to create mood, draw attention to an area, to modify or even distort shape, or bring out form and texture in a subject.

Sometimes you will be able to choose the kind of lighting that you want to suit a particular subject by waiting for the appropriate weather conditions or time of day. At other times you will have to make the best use of the available lighting quality.

Sunlight on a clear day has a very hard (or harsh) quality. Shadows have sharply defined edges and are frequently very dark; sometimes they can even appear stronger than the main subject, and attach themselves to its shape.

Hard lighting is excellent for dramatizing texture, shapes etc., and for creating interesting patterns (see p. 58), but it can also obliterate detail and reduce surfaces to flat areas of highlight or shadow. The complete photographic process from exposure to printing always tends to increase the contrast between light and dark, so you have to be careful with very harsh lighting to avoid creating a stark or "contrasty" final image.

At the opposite extreme, outdoor light diffused by mist or an overcast sky has a very soft quality. Shadows are ill-defined and no longer a potentially dominant feature, while the low contrast helps to give roundness and form to objects. This lighting is often more suited to subjects with complicated, delicate elements that would otherwise become obscured or confused by small patches of shadow.

The level of contrast can subsequently be modified during processing and printing. Over- or underdevelopment (see p. 73) and the paper grade or type (see pp. 84–5, 87) increase or reduce the contrast in the image.

Hard light
Hard lighting results when you have a relatively compact light source. Areas behind objects are blocked off from light, and form hard shadows, as shown above. Hard light sources include the sun (which is comparatively small in the sky), flash bulbs, and bare light bulbs.

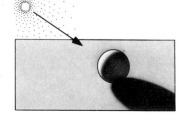

Soft light
Lighting is softened when the illumination is scattered, perhaps as a result of sunlight passing through cloud or the light being reflected from a light-toned surface. The result is a generalized lighting, which creates shadow areas that are diluted and soft-edged, above.

Hard evening sunlight

The scene above shows how hard light can emphasize simple shapes in a picture. The low, strong rays of the evening sun have brought out the rough texture on the cottage walls, reduced the figure almost to a silhouette, and created interesting lines and shapes in the elongated shadows. The exposure was measured from the white walls, in order to give maximum detail to the stonework and reduce shadow areas to solid blacks.

Soft, diffused daylight

The portrait, right, was photographed in overcast daylight, and shows how form and detail are brought out by diffused lighting. Dull, overcast days are often quite good for subjects in which you want to include maximum detail. Since the lighting was also rather dim, a wide lens aperture (f4) was used, giving strong differential focus. The exposure reading was taken close to the girl's face.

Lighting direction

The direction of lighting, together with its quality, affects the amount of contrast (difference between light and dark areas) in a subject. Contrast is closely related to the tonal range in a subject, and with shape it determines form. When the light quality is hard, contrast is generally high, and the direction of the lighting can be used to emphasize or suppress the form of your subject, as shown right.

If your subject is static you may have to alter your viewpoint to make the best use of available lighting. The strongest three-dimensional effects are usually produced by side-lighting; with the light behind the camera ("front lighting"), subject detail is brought out with minimal texture and depth; shooting against the light ("back lighting") creates high contrast, reduces detail, and simplifies form. (Never look directly into the midday sun through your camera. You may permanently damage your eyes and your camera.)

Sometimes you may be able to select the ideal viewpoint and then return when the lighting direction and quality give the sort of effect you want. The time of day (see p. 154), and prevailing weather conditions affect the direction and quality of natural lighting most. But in practice your viewpoint often has to be a compromise between the best view of the subject and the best use of existing light.

Lighting direction and form
The two pictures, right, were photographed from exactly the same viewpoint but at different times of day. Together they show how lighting direction alters the appearance of form.

The top picture was taken in the early morning with the sun casting hard light from directly behind the camera. All the surfaces of the building are illuminated equally and the detail is generally good. But the form of the building is weak and unclear — surfaces at right angles to each other are difficult to separate.

In the lower picture, hard quality sunlight was also present. However, this picture was taken in the late afternoon with the sun low and well to the left of the camera. The different direction of the light strongly separates the front and side surfaces of each tower, and the shapes of the windows are more distinct. Overall, the whole building has more depth and body, but detail is lost in the strong shadow areas.

Back lighting: high contrast
The picture of Whitby Abbey in Yorkshire, England, left, was taken looking directly into the setting sun, so that contrast is very high and the ruin appears as a two-dimensional silhouette. The delicate window shapes are emphasized by the lighting, but almost all other detail is lost. To increase the contrast, the exposure was measured from the bright sky to the right of the abbey. The viewpoint was chosen to include just enough sun to flare into the picture; this gives a point of emphasis, and adds to the dramatic atmosphere.

Using high contrast
The picture of the novelist William Burroughs, right, shows how a portrait can be deliberately simplified by controlling the contrast. It was taken indoors with a large window at the rear. Dark furnishings behind the photographer reflected very little window light into the shadows. By measuring the exposure for the forehead the photographer has recorded detail only in the lit edge of the profile.

Using low contrast
The schoolgirl below was lit similarly — by soft directional light from a window well to one side — but here bright surroundings (including the book on the desk) reflected diffused light into shadow areas. Consequently, fine detail, particularly on the girl's face, has been brought out. If you want to reduce lighting contrast when working with close-up subjects, such as portraits, hold a sheet of paper or white cloth near the camera to reflect light into shadow areas. Outdoors, a light toned sky, building or fence can have a similar effect on contrast.

Assignment: using viewpoint and lighting

1. Choose an interesting, static subject such as a tree or a building. Take the following pictures over a short period of time so that lighting direction and quality remain as similar as possible:

A. With the picture frame filled with the subject and from a viewpoint which emphasizes its most important features.

B. From two different viewpoints which significantly change the subject's relationship to its surroundings.

2. Take the following head and shoulders portraits of someone you know, keeping the camera at the same height and distance:

A. Take a full-face portrait, in direct sunlight, mostly from behind the camera.

B. Turn the subject and, using a viewpoint that sidelights the face, make the head look as three-dimensional as possible.

C. Move your subject into a shaded area so that the lighting is more diffused. Take two more shots using the same camera angles and subject distances chosen for A and B.

Compare your results and decide which are the most successful pictures of the two assignment subjects.

STEP 2: USING SUBJECT QUALITIES/Tone

Most subjects contain many gradations of tone between black and white. The tonal range is affected by the lighting, the reflective properties of the materials, and the colors in the subject. Subject tones may change sharply, as in the picture of the rocks and sea at the bottom of this page, or graduate gently, as in the lake scene next to it.

The most valuable function of tone is to convey volume and form, creating a feeling of three-dimensions in your pictures. The roundness of the man's head in the picture on the opposite page, for example, is conveyed by graduated tone; and in the lake scene, gently changing tone values help to convey a sense of distance — by "aerial perspective" (see p. 115).

A subject may contain a full range of tones from black through to white, or it may have mostly pale (high key) or mostly dark (low key) tones, or it may be very contrasty with its tones virtually restricted to black and white alone. Low key and high key pictures both tend to convey mood and atmosphere, the first often suggesting delicacy, the second seriousness and mystery. Contrasty pictures usually create a feeling of strength and drama, so positioning subject elements to create contrast gives them added emphasis.

Tone can be modified by the exposure you give, and through controls during processing and printing (see pp. 84–7).

Emphasis through contrast
Shadowy doorways, windows and archways sometimes create deep shadows even in soft lighting conditions. These may form excellent contrasting backgrounds or frames to emphasize a subject particularly when, as above, most other areas of the picture are limited to neutral tones of gray.

Tonal range

You can create a complete tonal range as shown above by cutting out and piecing together small areas of photographs. At the low end of the scale are black and dark grays. These graduate through to pale grays and white. A picture may use the whole range or just a few values at one end of the scale or the other. For example, the picture of the rocks and sea, right, uses mainly dark tones in sharp contrast to the few pale tones, and the landscape, far right, uses mainly light tones.

Exposure and printing greatly affect the tonal range in your final print. The effects on tone of using different printing papers are described on pages 84–7. Exposure has the most direct effect on tone. As shown on page 43, if you measure the exposure only from the light areas of the subject then dark tones tend to merge together and obscure detail and vice versa. If you want the fullest range in your pictures you should take readings from the lightest and darkest important areas and average the two readings.

Low key
The low key picture, above, has a mysterious, forbidding air created by the predominant dark tones and the few highlights.

High key
The high key landscape, above, uses pale tones from the high end of the tonal range to create a sense of space and softness.

Low key portrait
The somber, slightly mysterious atmosphere in the portrait, right, is largely conveyed by the predominant dark tones of the image. The choice and arrangement of clothing, the underlit background, and the exposure — which was measured only for the flesh tones — all help to limit detail to the face and hands. In these flesh areas form is strongly conveyed, giving the portrait character and individuality. Although the main body is reduced to a dark area, it is still just discernible from the background. Without this separation the head and hands would appear disconnected and lost in a sea of black.

If you are taking a low key portrait, you should always try to exclude any unimportant light-toned objects which could compete with the main subject.

Tone and form
The three-dimensional form of the rocks, left, is mostly conveyed by variations in tone alone. The lighting was hard and from the side, but because the exposure was averaged from the lightest and darkest areas, detail is not lost and a wide range of tones is recorded.

High key portrait
The lightness and delicacy of the high key portrait, above, comes from its use of values at the pale end of the tone scale. This has been created by the light background and clothing, fair hair, and very diffused, mostly frontal lighting. Light-toned surroundings also helped to reflect light and eliminate dark shadows.

For high key pictures, expose normally but keep the final print light, without letting it become gray and flat (see pp. 84–5).

Texture

The surface qualities of a subject are conveyed by texture. Texture can be used to give realism and character, and may itself form the subject of a photograph. It can be brought out either by working very close-up, as in the picture, right, or by working at a distance where large areas of the subject merge to create texture. Used as a subsidiary element, it can add strength to the main subject, as in the portrait below.

Lighting quality and direction are of the first importance in revealing the texture of a subject — they must give a rich tonal range (which can be further enhanced by exposure and printing). If you are working very close-up you must have a good lens to obtain a sharp and clear picture. In some cases, you may need to use an extension tube (see pp. 102–3). If necessary, use a tripod to avoid camera shake.

Texture and lighting
Harsh angled sunlight emphasizes the aged weather-beaten texture of the door, above. Textured surfaces that are mostly on one plane are often accentuated by hard, oblique lighting. Close-up shots often need a point of reference like the latch in this picture.

Skin texture
The wrinkled texture of the man's face in the picture, left, gives the portrait a strong and interesting character. The man was positioned in the shade so that soft, reflected light illuminated his skin evenly without dense shadows.

Combining textures
In the picture below two quite different textures are combined. The textures of the pebbles and the smooth wet rock are enhanced by direct, hard sunlight from behind the subject.

Line

Line is important in picture building because it can be used to give structure to your photographs. It can unify your composition by leading on from one part of the picture to another; it can draw your attention to a point of interest, or lead your eye away to infinity; it can be used to divide up your picture; or, by repetition, it can create patterns. Line can also give a sense of depth, through linear perspective (p. 115).

The general arrangement of lines can exert a rhythmic influence on a picture. For example, the photograph of the road, right, with its flowing line, has a sense of movement which contrasts with the more static vertical and horizontal lines in the composition below. Generally, angular lines, curves, and spirals create a sense of movement and tension. Vertical and horizontal lines, echoing the edges of the picture, make for a more static composition. Also, upright pictures emphasize vertical lines, horizontal pictures emphasize horizontal lines.

Line is not only present in the shapes of objects, but can also be created by positioning several objects so that they form lines by their relationship one to another. You can often alter the apparent direction of lines, joining some and breaking others, simply by shifting viewpoint. Vertical or horizontal lines can be changed into diagonals by rotating or tilting the camera.

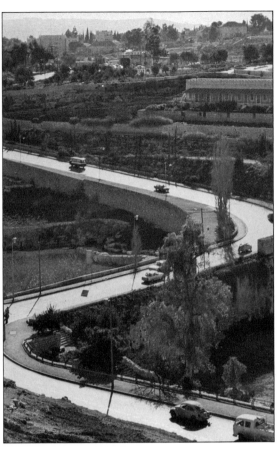

Curved line
A pleasant visual sense of movement is induced by the curves of the road in the picture, left. The shape of the line is strongly brought out by the light reflecting off the surface of the road against the dark underexposed surroundings.

Vertical and horizontal lines
The carefully composed lines at right angles to each other give the photograph below a static, ordered feeling.

Pattern

Pattern is formed by the repetition of line and shape. Like texture, pattern can be found almost everywhere, from urban environments to natural forms. It can occasionally form the main subject of a picture but more often it is used as a secondary element to structure a composition, or create rhythm, or simply to attract the eye. When employed as a subsidiary element, pattern must be used carefully — it can sometimes confuse or overwhelm the main subject.

When using pattern, it is important to include slight variations in the design to prevent the repeating elements from becoming monotonous. Sometimes you can introduce variety by combining several quite different patterns in one composition.

There are no rules for the best lighting conditions for pattern, but generally it is enhanced by contrasting tones and by suppressing other aspects of the subject, such as texture and form. Variations in lighting quality and direction will alter pattern dramatically.

Framing and viewpoint can be used to intensify the overall impression of pattern in a picture. Sometimes, taking a close-up picture of a small part of a pattern creates a more powerful impact, by eliminating the context and distracting detail. If the whole picture frame is filled with pattern it becomes much stronger in its overall effect.

Composite patterns
The picture on the left combines two patterns — the parallel slats of the chairs and the angled positions of the chairs themselves. A high viewpoint was chosen so that the chairs fill the picture frame against a flat, tonally contrasting background. The soft, even daylight is ideal — the shadows created by hard light would have confused the complicated lines. The exposure was measured from both the seats and the ground and then averaged.

Shadow patterns
On a clear day with hard sunlight, shadows are an endless source of interesting patterns. The late afternoon picture of the railings, below, was taken from above with the camera at an angle to avoid complete symmetry and uniform repetition. The steep perspective created by the railings is counteracted by the flattening effect of their shadows which run across the picture. The exposure was measured off the bright sidewalk so that the shadows record dark and featureless and attach themselves to the railings.

Combining patterns
Construction sites are often good places for finding patterns. The regular, formal pattern in the background buildings, below, contrasts with the irregular pattern in the concrete slabs in the foreground. To increase the effect, the lighting and square-on viewpoint compress both patterns on to simple, flat planes.

Human patterns
A wide variety of interesting patterns can be formed by a single person or a group of people. But when subjects are not posed it is often difficult to capture them on film. In the picture, right, the camera viewpoint was a critical factor in capturing the momentary pattern formed by the three heads. A position to the left or right would have missed the repeating lines of the three profiles.

Pattern in landscape
A simple rhythmic pattern is created by the white ridges of the snow in the landscape, right. On its own the pattern formed by the ridges would be uninteresting, but here it is only part of the composition. The delicate shapes of the trees and the large area of plain toned sky in the photograph contrast with and strengthen the lines of the pattern.

Shape

Shape is fundamental to picture building. It is generally the first means by which we identify objects, and with line it provides the main structure of most compositions.

Shape is a two-dimensional element; however, lighting, and the tonal range which lighting brings out, can give it a three-dimensional quality, or form. Lighting can also destroy form or, by creating dark shadows, merge several shapes into one.

Shapes can be strengthened by positioning them against a plain, tonally contrasting background, such as the sky. The most extreme example of this is silhouette, where shape is further emphasized by the elimination of other features of the subject, such as form and texture.

If your subject contains very strong shapes, try to position yourself so that they combine well with each other. This will prevent shapes from clashing against each other and creates a rhythm or flow which encourages the viewer to explore the picture, as explained on the opposite page.

Shape and tone
One way of strengthening interesting shapes is to show them against a simple background. The waist high viewpoint in the picture, above, brings the two shapes of the tent and the figure into prominence, making an interesting and balanced composition.

Shape and rhythm
The sinewy flow of the water terraces in the picture, left, creates a strong abstract structure. Shape was given to their strong lines by selecting a camera position that caught the white reflection of the overcast sky on the waters, introducing tonal contrast.

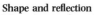

Shape and reflection
Mirror images formed on still water can be used to double the mass of shapes to create entirely new outlines. The shape and line of the mountains in the picture, right, were enhanced by deliberate underexposure. The exposure was measured from the bright areas on the lake, so that the dark land areas recorded without detail and merged with their reflection to form one dramatic tapering shape. The lighter toned sky and a few rocks breaking the water's surface relieve the symmetry of the picture.

Framing with shape and line

Both shape and line can be used to direct the viewer's eye across the picture to the main subject. Weak pictures often lack a center, or have the dominant lines or shapes leading away from the main subject.

Shapes can direct the eye simply by framing the main subject — photographing through a doorway or window creates a frame within the picture frame. Objects enclosed by the frame then become separated and emphasized. Ideally the frame should relate in some way to its contents — a churchyard shown through the church doorway is an example; but you can use almost anything to frame your subject — trees, man-made structures, even people.

The frame of your picture itself is a shape which will appear to repeat rectangular shapes placed in it. Circular shapes will stand out in contrast to this geometric frame.

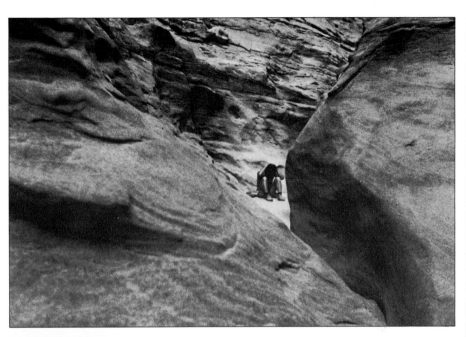

Framing and lead-in
The viewpoint in the picture, above, uses the rock shapes to provide a relevant frame and lead-in to the small figure of the climber in the background. The wide range of tones in the weathered rocks conveys form and texture.

The two readers in the picture, left, are isolated from unwanted detail by the view down the spiral staircase which frames and leads-in to them. Two exposure readings were taken — for the stairs and the table—and these were averaged.

For really accurate framing, a camera free of parallax error (see p. 27) is essential.

Assignment: using subject qualities

Choose an interesting landscape and take the following pictures:

A. Recording a full range of tones in the subject. Then take three more pictures: one using gray and white tones only for a high key effect; one using gray and black tones only for a low key effect; and one (waiting for stronger lighting if necessary) which uses dark and light tones only, with high contrast.

B. Using the lighting to bring out a pattern. Make this the full frame-subject of the photograph.

C. Of a textured surface close-up using the lighting quality and direction to enhance the surface quality.

D. Of subjects within the landscape, perhaps on a near horizon, that are strongly backlit. Take two pictures: one which emphasizes the shape of a single subject, the other which masses two or more shapes into one, perhaps reducing them to a single silhouette.

E. Using lines formed by roads, tracks, field boundaries or even the curve of a hill to draw the eye toward a point of interest.

STEP 3: RESPONDING TO THE ACTION

One of the major differences between photography and the older image-making arts like drawing and painting, is that a scene can be captured instantaneously. The camera shutter works so fast that you can record almost any event, no matter how brief. Ideally the exact moment you choose will not only capture the action successfully but will also make a well composed picture.

When using the camera very quickly to take a candid shot or capture a momentary picture, it is obviously advisable to try to set the focus and exposure, and consider viewpoint and composition, in advance. This is easiest with repeating events such as a motor race or track meeting, where you can choose a particular section of track to focus on and wait for the action to come into your viewfinder frame. But even when you are taking pictures of momentary events, you can often anticipate the action before it occurs, although you do need fast coordination for good results.

When several different aspects of the subject are changing at the same time, it may be necessary to take several pictures in succession in order to capture the precise moment you want. At other times you will need great patience to wait for the right expression or the best positioning of elements within the picture frame.

Momentary expression
For candid momentary pictures, such as the one shown above, you need patience and quick reflexes. In this case, the camera was preset out of sight of the subject so that the picture could be taken quickly. Notice how the subject has been isolated from the background by a shallow depth of field.

Changing relationships
Reacting quickly to passing encounters can produce very rewarding results. The lines in the composition, left, divide up the picture well, but its success results from the exact conjunction of the two women and the chicken, which would have been absent a moment earlier or later.

Action and viewpoint
One of the difficulties in photographing personalities at crowded events is separating them from the confused surroundings. One solution is to move in close, but this often loses too much of the environment — the picture could have been taken anywhere. In the picture, right, the photographer thought ahead and carefully chose his viewpoint. The high camera position turned the confusion of faces into an interesting pattern of hats. The photographer successfully gambled that his subject — Princess Anne (center) — would look up within camera range.

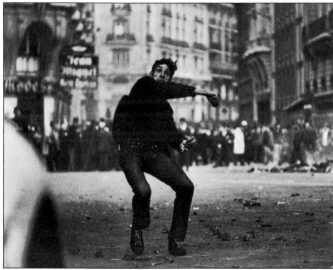

Action and context
The split-second timing of the exposure and the direct, frontal viewpoint captures the aggression of the rioter, above. Photojournalists frequently have to capture a very brief event and, for them, information takes precedence over composition. This picture conveys information with a good composition. In the background the disordered crowd suggests a context and mood, but is not clear enough to detract from the central interest of the figure.

Action and mood
In the picture, right, the photographer chose a position near the finishing line of a race in advance and successfully captured the elation of the winner. By using a low camera viewpoint and a shallow depth of field, distracting background elements were reduced to insignificance.

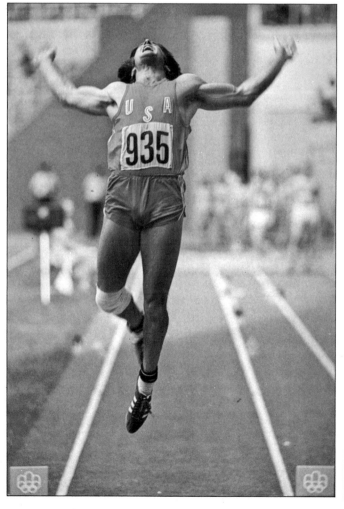

SUMMARY Picture building

In this section the elements of picture building have been separated for convenience and clarity. The photographs themselves illustrate how much these elements overlap and work in conjunction.

You will often find that strengthening one element of picture building can weaken another. For example, strong texture can detract from shape, while pattern can confuse form. Generally, it is better to keep your composition as straightforward as possible, and to use the elements of picture building simply and directly.

A good practical way to start picture building is to photograph architecture, landscape or still-life, because with these subjects you can more easily control the composition. Begin by deciding what visual aspects of the subject are important then set yourself the task of recording just one aspect at a time in a series of photographs.

You will often find it helpful to compare your results with other people's photographs and see if they have approached similar subjects in significantly different ways. This will help you to develop a critical approach to your photography.

Texture
Lighting conditions are fundamental to revealing texture as in the picture below top. Be careful that strong texture does not confuse your composition.

Line
Line, shown below center, forms a strong element in your pictures. It can be emphasized or subdued by viewpoint.

Lighting
Make sure that the lighting enhances your subject, as below. Sometimes it may be better to wait for different weather conditions or another time of day. Changing your viewpoint can alter the lighting direction and quality on your subject.

Shape
Lighting is all important when recording shape, as shown below. It can eliminate unnecessary detail and strengthen the main shapes in the composition.

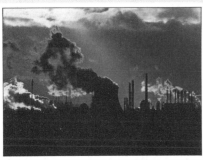

Tone
Tonal range affects the form and depth in your pictures, as shown above. Tone can also be used to create atmosphere, or render detail accurately.

Responding to the action
Interesting situations are often brief and unrepeatable. If possible, try to compose and focus the subject in advance.

Pattern
Pattern can bring order or rhythm to a composition, left. A break in the design provides relief and a focal point.

BLACK AND WHITE PROCESSING AND PRINTING

STEP 1:	Processing film
STEP 2:	Printing from negatives
STEP 3:	Enlarging
STEP 4:	Manipulated printing

You can take good photographs without doing your own processing and printing. Some of the photographers features in the Evolving Your Own Approach section (see pp. 177-202) send all their exposed film to a reliable laboratory. Others consider their composition as only half complete when taken from the camera, and often manipulate the result extensively during printing. Therefore, you may wish to pass over this section and move on to more advanced camera work or color photography. But even if you do not intend to start processing and printing your own films, reading this section will show you the effects of over- and underexposure and of faulty printing, and will help you to identify and eliminate them from your work.

The main advantage of processing and printing yourself is that you can control the final picture in various ways. You can be as creative in the darkroom as you were with the camera. By the end of this section you should be able to turn the picture originally seen in the camera viewfinder into a good, straightforward, black and white enlargement. All the basic items of equipment you will need are shown, and step-by-step sequences will guide you through each stage. The Steps in the section are intended to be worked through in order and you should complete each one before passing on. It may help to start by re-reading the basic points on light-sensitive materials discussed on pages 18-19.

Get into the habit of making careful notes of the processing time required for your particular combination of film type and developer before you start. Keep your notes of times and temperatures and printing exposure details along with your results. This is always useful when you are just beginning so that you can learn from your mistakes. Details of procedure may differ slightly according to the make of equipment you buy, but the general sequence of operations applies to almost all films and papers, and can be followed with the book open beside you.

Organization of the section

There are two quite different parts to the section; developing your film to form black and white negatives, and making contact prints and enlargements on to paper. Film processing is really quite simple. You don't need a darkroom, because the job is carried out in normal lighting with the film in a small light-proof tank. The tank takes a minute or so to load in a light-tight closet or a black fabric changing bag. Apart from the tank you need a few simple items, in particular a clock, a thermometer and some containers for the processing solutions. Processing takes about 40 minutes not including drying time. From the processed negatives you can judge if your images are sharp, correctly exposed, and well framed.

The next stage, printing, really does require access to a darkroom – either your own, or one run by a college or club. The best way to see if you will enjoy this side of photography is to watch someone more experienced actually making prints. Reading through the stages from page 75 will explain what is involved. Two darkrooms are shown on page 74, one is an ideal, permanent room; the other is a closet, temporarily converted for darkroom work. Most people begin with this second, smaller room. If you decide to do your own printing, you can control the size and quality of each print individually and, after the initial outlay on equipment, you will be able to get your prints faster and more cheaply than if you sent them to a commercial service.

There are a number of important factors to consider when you set up a temporary or permanent darkroom. Dust must be kept to a minimum so ideally you should choose an area for your darkroom with smooth, plastered walls, and not uncovered brickwork which collects dust. If possible, remove any obvious dust traps, like unnecessary shelves and other wall fixtures. Extreme care must be taken to make door frames, windows, and even ventilation grills light-tight. This usually means that you

must provide supplementary air conditioning that is light-proof, if you intend to spend long periods in your darkroom. You will need several electric power outlets and, ideally, a supply of running water. It is advisable to lay chemical-resistant flooring to guard against the spillage of corrosive liquids.

The effort involved in establishing a permanent darkroom demands good planning. You will see on page 74 that you should divide the room into "dry" and "wet" areas, separating liquid processing from the electrical equipment used for enlarging and drying. When you install lighting, ensure that the normal white light switch is within easy reach, so that there is no trouble in finding it in the dark. A wall-mounted safelight should be positioned over the developing tray so that you can watch the development. To prevent any chance of unintentionally exposing light-sensitive materials, you must put the safelight the recommended distance above the tray (see the manufacturer's instructions). A light or some other device outside the darkroom, to show when it is in use, is also important. This prevents people from accidentally opening the door while you are working, and spoiling your work.

Film processing

Most early photography was done using light-sensitive materials which had to be processed immediately. Photographers struggled out with darkroom tents and chests of chemicals, as well as a large plate camera. Often pictures were taken close to streams and lakes which provided water for mixing the solutions. Sheets of glass had to be coated with a sticky material called collodion which contained the light-sensitive silver halide crystals. Silver halides are compounds (salts) of silver and the various halogens – bromine, iodine, chlorine, and flourine. These salts produce tiny grains of metallic silver on exposure to light. The prepared plate was exposed in the camera and then processed while still wet.

Using glass as a support for the light-sensitive layer obviously has disadvantages. It is heavy and only practicable with large camera formats. Plastic (or cellulose) triacetate has proved to be the most versatile and useful of film bases. It is light and flexible enough to be wound on to spools for easier camera loading and wind-on, and it is cheaper to produce than glass. The back of modern film has a dark appearance before processing, as the base is coated on its non-emulsion side with an "anti-halation" dye. This prevents light reflecting off the base, back into the light-sensitive layer where it would form halos around highlights.

About one hundred years ago collodion was replaced by gelatin, as a better way of binding a layer of silver halides to a suitable base. Photographic gelatin has so many advantages as a binder that it has not been improved on since. A toughened version of the gelatin used for jello, it swells when placed in liquid, allowing processing chemicals to enter and react with the silver halides it contains. When dry the gelatin coating returns to normal thickness, without distorting the shape or position of the image. So it is ideal for the wet processing techniques used with modern photographic chemicals.

When untreated silver halide crystals are bound to the gelatin medium, the resulting emulsion is only sensitive to blue and ultra-violet light. The color sensitivity of the crystals can be extended by dyeing them. First advances with dye sensitizing produced "orthochromatic" emulsions. This meant that the emulsion was capable of recording naturally occurring colors in tone values of the same brightness as they appear to the eye. In practice, orthochromatic emulsions are sensitive to the blue and green regions of the spectrum, but are insensitive to reds and oranges. Dye sensitizing for the full range of colors is a more recent development – most modern photographic emulsions have this facility and are termed "panchromatic".

It takes a relatively long time for light to change enough silver halide grains into metallic silver to form a visible image. So in the camera, an invisible, latent image is formed. Only relatively few atoms of the emulsion are affected by the initial exposure in the camera. These can later be amplified millions of times, by development using developing chemicals which increase the

Portable wet-plate viewing tent
Early photographers had to carry around cumbersome equipment for the messy wet-plate process. The portable viewing tent, left, was used for inspecting the wet plates in the dark immediately after exposure – so that a further exposure could be made if results were unsatisfactory.

Travelling photographic van
Roger Fenton, the first English war photographer, used this converted van, left, as a travelling darkroom in the Crimean War in the 1850s. The cumbersome van was an easy target as he moved around the battlefields, taking photographs for the *Illustrated London News*.

amount of silver in those areas of the image affected by light.

The three processing chemicals you need – developer, stop bath, and fixer – are usually solutions which you simply have to dilute with water. They are cheaper if you buy them as ready-weighed packets of powders which you dissolve in water before use. You can also make up your own solutions from the basic chemicals, shown on page 213; this is cheapest of all. There are several types of developer available (see p. 125). To start off, it is probably best to buy or make up a fine grain general purpose developer such as Kodak D76, any stop bath (you can use a water rinse instead), and an acid fixer.

Film is extremely sensitive so you must be careful not to scratch or to handle the picture area of the film particularly when it is wet or only partly dry. At this time it is very easy to damage or contaminate the film surface with dust and grit.

Most photographic processing chemicals deteriorate when in contact with air so you must store them in a stoppered bottles of the right size to be completely filled by the solution. This means keeping a number of different size bottles, or using one of the concertina types which can be pushed down to expel air from the container. Use plastic graduates to measure out exact amounts of each chemical for the film you are processing.

Film developer is the most expensive of the chemicals. Some types are re-usable and these work out cheaper, but you have to slightly increase development time with each successive processing, as recommended by the manufacturers. Keep a record of how many films you have developed with your developer. After acting on the film, both stop bath and fixer can be returned to their storage bottles for re-use. About two pints of stop bath or fixer will serve about thirty 35mm films.

A minority of people are allergic to some chemicals used in developers, and these can cause a skin rash. Fixing solutions will make any cuts or scratches on your hands sting. For these reasons you will see that rubber gloves are shown along with the other processing equipment. When processing color material you must wear a pair of these gloves for protection, but they are not essential for black and white work and most photographers do not use them.

Processing exposed film forms negative images, in which the original subject tones are reversed. In the enlarger, the dark and light tones of the negative control the amount of light which reaches the light-sensitive photographic paper (bromide paper). Dark parts of the negative, which represent the brightest parts of the subject, stop the light, and vice versa. When processed, the print will be palest in those areas on the negative which received most light, and darkest in those areas which received least light, producing a positive image.

Printing
We look first at contact printing, which means making positive prints the same size as the negative, on photographic paper. At one time, when everyone used large format cameras, all prints were made this way because no enlargement was needed from the large negative. Today, you have to enlarge the much smaller negatives to obtain a print of a reasonable size. Sheets of contact prints taken from complete films are a very useful record of each picture you take. From these sheets you can decide which pictures you want to enlarge, and you can analyze any exposure, framing, or processing and printing errors. You don't need an enlarger for contact printing – the exposure can be made with any low wattage desk lamp which gives even lighting.

As with film, your exposed print also has to be processed. To process prints, you use three print-sized trays for the developer, stop-bath, and fixer. Buy a print developer, such as Kodak D163; or use a "universal" developer – which can be used for film or prints – and dilute it for prints. The stop bath and fixer can be the same types used for films, but you often have to alter the dilution, so check the manufacturer's instructions.

For contact printing, you require a "normal contrast" grade paper – perhaps with a white smooth glossy finish – 10 x 8 ins in size. Contrast refers to the number of grays given between black and white. Hard contrast papers give a few grays, soft contrast papers give many more tones of gray. As soon as you start making enlargements, from a range of negatives, you will want several contrast grades – soft and hard grades as well as normal contrast. Soft and hard grade papers give normal contrast prints from harsh and low contrast negatives respectively, as shown on pages 84-5. You can also buy variable contrast paper, with which, by using color filters over the enlarging lens, you can produce any contrast grade – locally or overall (see p.87). You may decide to do all your printing on "resin-coated" (plastic-based) paper. This processes, washes, and dries faster than the older, fiber-based papers. But it is more expensive and the final print is slightly more difficult to mount and retouch (see p.88).

After contact printing, we move on to making enlargements. The enlarger you buy for black and white printing can be quite simple, provided it evenly illuminates the negative and has a good quality lens. Even if you have a high quality camera lens, fine detail on the negative will be lost on the print if your enlarger lens is poor. When buying an enlarger look ahead to the possibility of using it for color printing, too. If it has a filter drawer or, better still, a dial-in color head then you can easily use it for color printing (see p.165).

Enlarging allows you several controls over the image. You can print the negative at almost any size, and also crop (omit) any parts of the image (at the edges) you wish to leave out. This is a common practice among photographers, and is a simple way of eliminating framing errors (see p.83) or strengthening an image. You can determine how light or dark the print will appear, by your choice of exposure time. You can make a local area of the print lighter by blocking out the light ("shading", or "dodging") during part of the exposure; or darker ("printing-in") by giving it an additional period of time. There is no limit to the number of identical prints you can make from one negative. You can go back to old negatives printed by the store and see if you can improve on their results. You can even make black and white prints from color negatives to create special effects (see p.172). None of these controls will make a good picture out of a technically inadequate or uninteresting negative, but you can make a good image much stronger and more effective by sympathetic printing. For example, image contrast can be increased to add drama, or reduced to give a softer effect.

Doing your own black and white processing and printing is a logical extension of taking your own exposure readings and controlling the camera image, because you will come to know what results you can, and cannot, produce. With experience, merely looking at a negative will give you a good idea of the sort of print quality to expect. What you learn in this section, for black and white photography, is essential information if you are considering doing your own color processing and printing. Color processes are longer, and more decisions are involved in judging color prints, but you follow similar basic procedures.

STEP 1: PROCESSING FILM/Preparation

Although starting to do your own film processing may seem a big step, the equipment needed is not very complicated or costly. All the basic items are shown at right. Both types of developing tank are shown, the rubber gloves are included as an optional protection from the processing chemicals, and the concertina storage bottle is a simple means of keeping the developer from oxidizing in the air.

You don't really need a proper darkroom, because once the film is unwrapped and loaded into the light-proof developing tank – a job which can be done in a loading bag or a light-tight room or closet – all the processing stages can be carried out in normal lighting. The most important part of doing your own processing is the need to take great care. Film is extremely sensitive and must not be fingermarked, bent or scratched. Always handle the film by its edges, and make sure that it is not in contact with itself at any point.

Although at present we are dealing with black and white work the same basic equipment can be used to process color transparencies and negatives. Only the chemical stages are different.

The developing tank

The daylight developing tank is your single most important item of equipment. There are two main types – plastic and stainless steel, each using a different type of reel to hold the film. Plastic tanks are cheaper, and easier for a beginner to load, but stainless steel tanks can be loaded much faster once you have learned how. In both cases it is important to practice loading in daylight first, using a length of scrap film and following the relevant sequence of instructions on the page opposite. Do this first with your eyes open, then shut. All the other items needed for processing – the chemicals (developer, fixer, and stop bath), clock, thermometer etc. are shown in use on page 70. All can be bought in most camera stores.

When you can insert a practice film properly into the processing reel without jamming or buckling, decide how you will work. You may prefer to use a black fabric loading bag into which you put all the bits of the tank (including the lid!) and the film; then by putting your arms down the elastic sleeves you can load in normal room light. Alternatively you can work in a blacked-out closet or a darkened room at night and load the film direct. Test your surroundings first: if after about five minutes in the dark you can begin to see around you then the room is not dark enough. Either way, once the film is reeled and inside the closed tank you are ready to begin the next and simpler stages of processing, washing, and drying.

Basic equipment

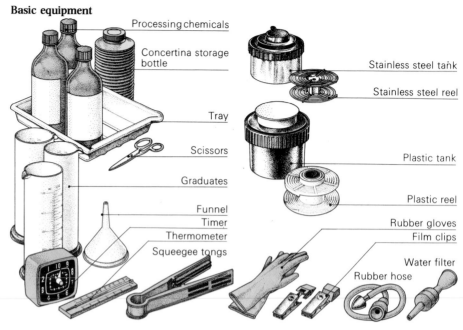

Processing chemicals
Concertina storage bottle
Tray
Scissors
Graduates
Funnel
Timer
Thermometer
Squeegee tongs
Stainless steel tank
Stainless steel reel
Plastic tank
Plastic reel
Rubber gloves
Film clips
Water filter
Rubber hose

Unwrapping the film

As taken from the camera, the exposed film has to be removed from its container in the dark immediately before you load it on to the developing tank reel. The methods of unwrapping the three main types of film packages are described below.

35 mm cassette film
Use a bottle opener to pull off one end of the cassette, then slide out the film spool. The shaped first few inches of the film must be trimmed square for loading. If you don't rewind the film completely into the cassette when it is in the camera, then the end can be trimmed and attached to the developing tank reel in daylight.

Rollfilm
This needs several inches of its backing paper unrolled until the free end of the film can be felt. Unroll and separate the film from the paper, and remove the tape at the far end that attaches them to each other.

Plastic film cartridge
This must be broken in half. Remove the full spool from one end and separate the film from its backing paper as with rollfilm.

Break open the cartridge

Remove the spool

Developing tanks

The plastic developing tank

A typical tank has five plastic parts, shown right. The tank body is threaded at the top to receive the light-proof lid. The reel, which loads from its outer edge, has a spiral groove designed to hold the film in a loose coil. Slots top and bottom allow solutions to reach the film freely. Some reels have an adjustable center core — you can pull top and bottom further apart to accept wider rollfilm.

A baffle system in the lid allows solutions to be poured in and out of the tank without admitting any light. The plastic rod drops into this hole for rotating the reel, or you can agitate the solutions by putting on the cap and turning the tank upside down.

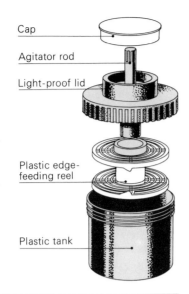

Cap
Agitator rod
Light-proof lid
Plastic edge-feeding reel
Plastic tank

The stainless steel tank

The various sections of this stainless steel tank have the same function as their plastic counterparts. Although it is more expensive than a plastic tank, it is smaller, simpler, easier to clean, and quicker to dry. The tank body has a push-on light-proof lid, and contains a non-adjustable metal reel. This has a spiral channel designed to be loaded with film from its center outwards.

The light-proof lid has a baffle system like the plastic tank, so that once the film is enclosed it is fully protected from light. You can pour solutions in and out through the lid center in normal room lighting conditions. To circulate solutions in a stainless steel tank put on the plastic cap, then turn the whole tank upside down.

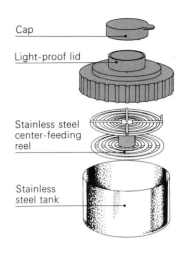

Cap
Light-proof lid
Stainless steel center-feeding reel
Stainless steel tank

Loading an edge-feeding plastic reel

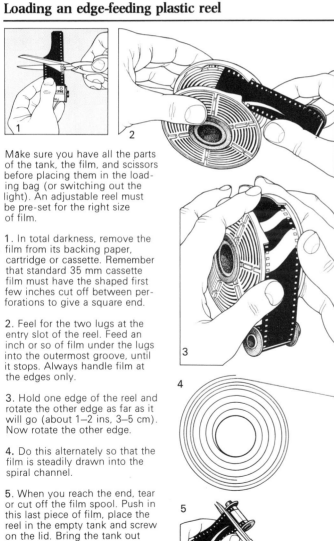

Make sure you have all the parts of the tank, the film, and scissors before placing them in the loading bag (or switching out the light). An adjustable reel must be pre-set for the right size of film.

1. In total darkness, remove the film from its backing paper, cartridge or cassette. Remember that standard 35 mm cassette film must have the shaped first few inches cut off between perforations to give a square end.

2. Feel for the two lugs at the entry slot of the reel. Feed an inch or so of film under the lugs into the outermost groove, until it stops. Always handle film at the edges only.

3. Hold one edge of the reel and rotate the other edge as far as it will go (about 1–2 ins, 3–5 cm). Now rotate the other edge.

4. Do this alternately so that the film is steadily drawn into the spiral channel.

5. When you reach the end, tear or cut off the film spool. Push in this last piece of film, place the reel in the empty tank and screw on the lid. Bring the tank out into the light.

Loading a center-feeding stainless steel reel

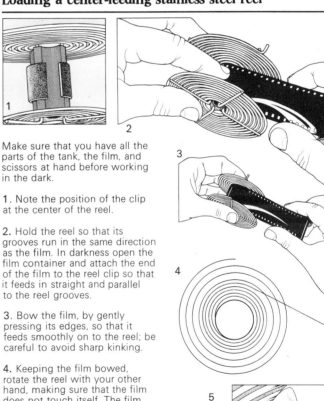
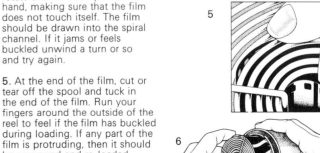
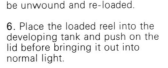
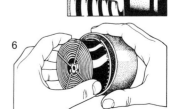

Make sure that you have all the parts of the tank, the film, and scissors at hand before working in the dark.

1. Note the position of the clip at the center of the reel.

2. Hold the reel so that its grooves run in the same direction as the film. In darkness open the film container and attach the end of the film to the reel clip so that it feeds in straight and parallel to the reel grooves.

3. Bow the film, by gently pressing its edges, so that it feeds smoothly on to the reel; be careful to avoid sharp kinking.

4. Keeping the film bowed, rotate the reel with your other hand, making sure that the film does not touch itself. The film should be drawn into the spiral channel. If it jams or feels buckled unwind a turn or so and try again.

5. At the end of the film, cut or tear off the spool and tuck in the end of the film. Run your fingers around the outside of the reel to feel if the film has buckled during loading. If any part of the film is protruding, then it should be unwound and re-loaded.

6. Place the loaded reel into the developing tank and push on the lid before bringing it out into normal light.

Developing and fixing

Once the film is in the tank, you can carry out the processing in normal lighting. Have all the necessary equipment, shown right, ready before you start; follow the manufacturer's instructions for diluting and mixing the developer and, if necessary, the fixer. If your developer, fixer, or stop bath are re-usable, keep a record of the number of films they have processed.

The solutions must be kept at about 68°F (20°C) during processing; this can be done by standing them and the loaded tank in a tray of water at this temperature. Before starting, set the timer to the developing time recommended for your film.

Equipment ready for processing

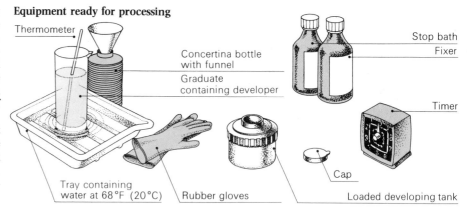

Thermometer

Concertina bottle with funnel

Graduate containing developer

Stop bath

Fixer

Timer

Cap

Tray containing water at 68°F (20°C)

Rubber gloves

Loaded developing tank

The processing sequence

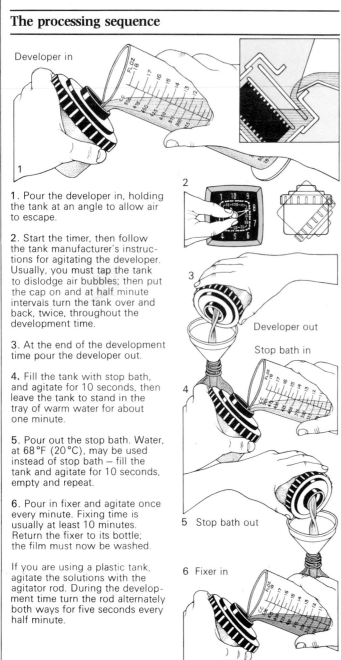

Developer in

1. Pour the developer in, holding the tank at an angle to allow air to escape.

2. Start the timer, then follow the tank manufacturer's instructions for agitating the developer. Usually, you must tap the tank to dislodge air bubbles; then put the cap on and at half minute intervals turn the tank over and back, twice, throughout the development time.

3. At the end of the development time pour the developer out.

4. Fill the tank with stop bath, and agitate for 10 seconds, then leave the tank to stand in the tray of warm water for about one minute.

5. Pour out the stop bath. Water, at 68°F (20°C), may be used instead of stop bath — fill the tank and agitate for 10 seconds, empty and repeat.

6. Pour in fixer and agitate once every minute. Fixing time is usually at least 10 minutes. Return the fixer to its bottle; the film must now be washed.

If you are using a plastic tank, agitate the solutions with the agitator rod. During the development time turn the rod alternately both ways for five seconds every half minute.

Developer out

Stop bath in

5 Stop bath out

6 Fixer in

What happens during processing

When the exposed film is first removed from the camera, no record of the image is visible. This is because the film only receives enough exposure in the camera to form minute atoms of black silver in the light-sensitive silver halides. Processing acts as a form of amplification. Chemicals in the developer encourage the formation of tiny filaments of black metallic silver so that the image appears.

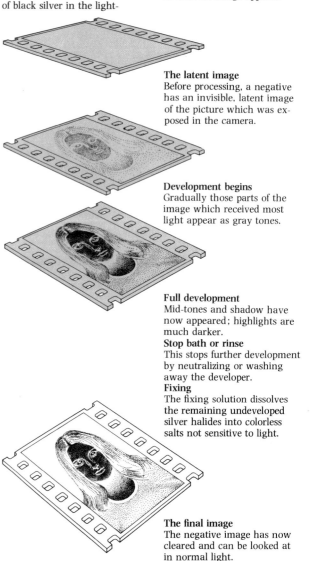

The latent image
Before processing, a negative has an invisible, latent image of the picture which was exposed in the camera.

Development begins
Gradually those parts of the image which received most light appear as gray tones.

Full development
Mid-tones and shadow have now appeared; highlights are much darker.
Stop bath or rinse
This stops further development by neutralizing or washing away the developer.
Fixing
The fixing solution dissolves the remaining undeveloped silver halides into colorless salts not sensitive to light.

The final image
The negative image has now cleared and can be looked at in normal light.

Washing and drying

The final stages of processing — washing and drying — need the same care and attention to detail as the earlier steps. Washing must remove the processing chemicals, which will otherwise stain the film. When wet, negatives are very sensitive: hairs, scratches, and even dust will damage the delicate surface of the emulsion. Even after drying, negatives must be handled carefully, always by the edges only.

Wash the film in normal light, but keep it in the developing tank — a rubber hose can be used to connect the faucet with the tank (use a water filter if your water supply sometimes contains grit). After the wash, which should thoroughly clean the film, use a wetting agent to assist drying. Then remove the film from the reel and hang it to dry by film clips; surplus liquid should be wiped off by running wetted, rubber-faced squeegee tongs down the face of the film.

Taking care of your negatives

Once the film is absolutely dry, protect it as soon as possible; do not just roll it up, as this is bound to cause scratches. Some sort of permanent protective file is essential once you have more than a couple of reels of developed film. For storing the film, cut it into strips about five or six negatives long and put them in transparent sleeves or, better still, a negative album. It is best to give the whole film a number and mark this on the film envelope or album page for future reference. Since each negative already has a number printed beneath it in the rebate (margin), you can quickly find a specific image on the film by a simple reference, e.g. 12/3 would mean film number 12, negative number 3.

Washing equipment

Water filter
Rubber hose
Graduate
Squeegee tongs
Wetting agent
Film clips

Negative filing

Loose-leaf albums with transparent sleeves are an efficient means of storing your negatives safely. The contact prints of each film can be inserted opposite the negative strips.

Washing and drying processed film

1. Remove the lid from the developing tank and wash the film for about 15–20 mins. Push the hose well down into the center of the reel, and have the faucet on so that the water overflows steadily from the tank.

2. For the final rinse use a photographic wetting agent to hasten drying. Pour a few drops of the agent into the tank and leave for one minute.

3. Attach a clip to the end of the wet film and remove the film from the reel. Wipe off the surplus liquid with wetted squeegee tongs, but beware of grit on the rubber pads of the tongs.

4. Fix a clip to the other end of the film and hang it up to dry. You can use a collapsible film dryer, shown right, this will dry the film in about 15 minutes.

Reminders: black and white processing

Load in complete darkness	Test your room or closet by staying inside for at least five minutes; if you can then start to see around you, it is unsafe!
Always handle the film by its edges	Before, during, and after processing, film is very sensitive to finger marks, scratches, dust etc.
Remember the four main processing controls	Temperature – this should be 68°F (20°C); stand solutions and containers in water to maintain this temperature. Time – follow the manufacturer's instructions for your film. Agitation – too much or too little may cause uneven development. Developer – check its dilution and, if it is re-usable, the number of times it has been used.
Wash and dry the film thoroughly and carefully	Chemicals, dust, and grit will permanently damage your negatives.
Wash and wipe out all processing equipment after use	The processing reel and tank must be clean and dry before loading them with another film.

Assessing negatives

Wait until the film is completely dry before assessing your results in detail. The film can be seen best if it is held a short distance away from an evenly lit sheet of white paper; use a magnifying glass if necessary. If you are not used to reading negatives, the images will seem almost unrecognizable at first, with subject highlights dark and shadows light. However, you can now check three important aspects of the negative: density, sharpness, and marks.

Density and sharpness

The density of the negative is affected by exposure and development and is measured by how light (or dark), contrasty (or flat) it appears. Check the density by looking to see if detail has recorded in important highlights and shadows in the picture (ignore plain white or black backgrounds). How strong is the difference (contrast) between the highlights and shadows? Negatives which look very bright or contrasty are often too harsh to print. Ideally, a black and white negative should have rather low contrast with plenty of detail to print well. Use a magnifier to check if the image is sharp overall or at least in those areas which you wanted to record clearly.

Marks

Look for scratches, uneven processing marks, bits of dust or finger marks on the film, as these will all show up on the print.

Assessing the final negative

Highlight
On the print, this will be the brightest area. It should be dark on the negative, but still show detail.

Sharpness
Assess sharpness by checking fine detail areas such as a necklace, eyes, or teeth.

Shadow
The man's hair will be the darkest main shadow area on the print. It should contain detail.

Tones
There should be a wide range of gray tones to give detail and "roundness" to the image.

Analyzing spoilt negatives

Serious marks on the negative, or even complete absence of image, could have been caused during either exposure or processing. The letters and figures in the rebates (margins) of the film will help you discover when the fault arose. If they are present then the fault occured during exposure, since a mistake during processing would affect all of the film.

Exposure errors

If your film is clear, with no negatives at all, but the characters in the rebates are present, then the film was unexposed. This happens if the film is not wound on properly in the camera. A black film (with normal rebates) results when the film is rewound in the camera with the shutter open.

Processing errors

If both rebates and film are clear, then the film was not developed. You may have used fixer and developer in the wrong order. A totally black film was probably "fogged" (accidentally exposed) in the darkroom. Other, typical processing faults are shown right.

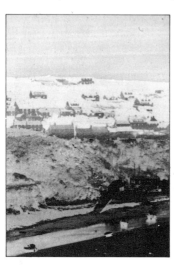

Insufficient developer
An uneven band throughout the film, shown above, is caused by having insufficient developer in the tank. You can avoid this by measuring the capacity of your tank beforehand using water and a graduate (measuring jug).

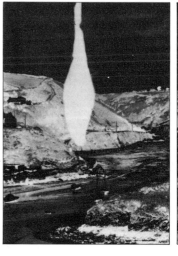

Film contact
The blemish above occurs when film touches itself in the developing tank. The resulting mark is creamy gray or (if the film has separated during fixing) completely transparent. You can detect where the film might be in contact with itself by running your fingers around the outside of the reel (as shown on p. 69).

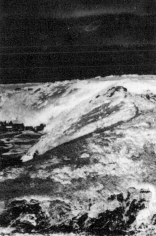

Water marks
The negative above shows water marks which are usually due to uneven drying or splashes of water on the film while it was drying. Always remember that film is extremely sensitive both before and after processing.

Underexposure

Both underexposure and under-development give thin negatives, but underexposure also creates empty shadows. Detail in the areas of highlight is usually excellent and of normal contrast. Underexposure could result from setting the wrong (too fast) ASA film speed on your camera or light meter, measuring the light from the highlight areas only, or simply setting too short a shutter speed or too small an aperture.

Little can be done to improve a seriously underexposed negative: keep to a dark (overexposed) print – the picture may be able to be read from mid-tones and high-

light areas alone. A typical print from an underexposed negative has solid black shadows or, if given a shorter exposure, it will have flat gray areas.

A print on normal grade paper from an underexposed negative.

Overexposure

A dark, dense negative, which has less contrast than that created by overdevelopment, is produced by overexposure. Shadow detail is reasonable but highlight areas are dense and flat with little detail. The usual causes of overexposure are: setting the wrong (too slow) ASA speed on your camera or light meter, taking a light reading only from the darkest areas of the subject, or having too slow a shutter speed or too wide an aperture.

Often you can improve the negative by using a reducing solution (see pp. 124–5), but this will make the grain pattern more visible. Detail in the highlight

areas on the print can be improved by giving a long printing exposure on a hard grade paper (see pp. 82–3).

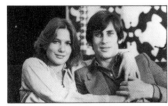

A print on normal grade paper from an overexposed negative.

Underdevelopment

Underdevelopment produces a negative which is weak, or "thin", with lower than normal contrast. Shadow detail is barely present and highlights are gray rather than black. This happens if the developer was partly exhausted, over-diluted, or too low in temperature; or when the development time was too short for the type of film.

It is possible to remedy mild underdevelopment by intensification during printing (see pp. 124–5). Otherwise a print on normal grade paper looks flat and gray. Better results can be achieved by printing on extra hard paper (see pp. 82–3).

If you want to take a picture of a subject which is harshly lit, slight overexposure followed by underdevelopment may give you a normal contrast negative.

A print on normal grade paper from an underdeveloped negative.

Overdevelopment

A negative which looks dense, or "thick", and contrasty is over-developed. You will find that shadow detail is bright and strong while tones merge in subject highlight areas. The causes and the effects are the exact opposites to underdevelopment. Over-development is caused by the developer being too warm, too concentrated, or when the development time is too long for the film.

Some reducers (see pp. 124–5) will remedy overdevelopment, by chemically lightening the negative. Otherwise a print on normal grade paper is bleached and contrasty. Printing on extra soft paper

will improve this (see pp. 82–3).

Slight overdevelopment can compensate when the subject and lighting are flat and gray.

A print on normal grade paper from an overdeveloped negative.

STEP 2: PRINTING FROM NEGATIVES/The darkroom

As we saw earlier, you do not need a darkroom to process film. But if you want the enjoyment of making your own prints and enlargements, some sort of temporary or, better still, permanent darkroom is essential. It is not difficult to convert a room for this, and there are several advantages to having your own darkroom. It means that pictures can be produced more quickly and cheaply than by using a commercial processor. With your own darkroom you can manipulate the image to achieve the result you want.

Fitting out a permanent darkroom
If you have the facilities, a permanent darkroom is ideal. A room about 9 × 7 ft (2·7 × 2·1 m), perhaps an unused bedroom, is large enough. It must be really light-tight, but with sufficient ventilation for long periods of work; you may find that some kind of additional ventilation is necessary once you have blocked out the light.

Ideally you should divide the room into "wet" and "dry" areas. This not only reduces mistakes, but, since water and electrical equipment are being used close to each other under dark or dim conditions, is also safer. Keep the enlarging and contact printing equipment and printing paper on the dry side of the room. A large bench which drains into the sink is useful on the wet side; place on this all the processing dishes, ranged from the sink in reverse order of use. The supply of water and the sink enable you to wash prints and equipment, mix solutions etc. Place the safelight at the height recommended by the manufacturer above the developing dish.

Adapting a closet
If you cannot take over a whole room permanently, you can use a large closet as a darkroom. It must have an electricity supply and, preferably, a white light so that you can see to clean and prepare the darkroom for printing. Just as with the permanent darkroom it is important not to keep out all the air with the light and some sort of electrical ventilator may be necessary.

In this confined space it is even more important that the "wet" and "dry" operations are strictly separated, and even greater precautions should be taken to avoid spillage of liquids. If you do not have a supply of water, use a pail to rinse your hands between operations and another water-filled pail to put the fixed prints in before taking them outside to be washed properly.

A large, permanent darkroom

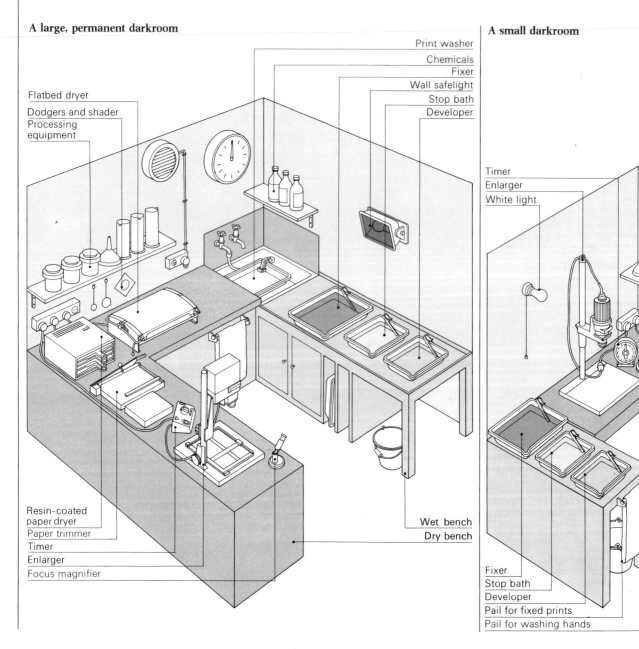

A small darkroom

Print washer
Chemicals
Fixer
Wall safelight
Stop bath
Developer

Flatbed dryer
Dodgers and shader
Processing equipment

Safelight
Processing equipment

Timer
Enlarger
White light

Resin-coated paper dryer
Paper trimmer
Timer
Enlarger
Focus magnifier

Wet bench
Dry bench

Fixer
Stop bath
Developer
Pail for fixed prints
Pail for washing hands

Contact printing

Your first job in the darkroom is likely to be contact printing the negatives you have just processed. Contact printing means placing the negatives with their emulsion side in contact with the emulsion side of a sheet of light-sensitive photographic bromide paper (further information on photographic papers is on p. 77). Bromide paper is sensitive to normal light but not to orange light, so only use an orange safelight, and always remember to replace the spare sheets in their light-proof container before turning on normal lighting. To print the negatives on to the bromide paper, expose them to light from a reading lamp or empty enlarger. You will be able to judge the required exposure time with experience. After exposure, remove the negatives and process the print as shown on page 76.

Preparing and printing the negatives
The basic equipment for making a contact print is shown right. It is helpful to cut the film into strips of six negatives— this way a complete 36-exposure film (i.e. six strips) will cover one sheet of 10 × 8 ins (25·4 × 20·3 cm) paper. If each film is printed on to a separate sheet, it can be filed and numbered with its negatives. Make sure that all your negatives are the right way around and that all the pictures are the right way up (by checking the position of the numbers on the film). The strips must be in complete contact with the paper: lay a sheet of heavy, clean glass on to the negatives and the paper to press them together. Equally you can use a contact printing frame — this saves time when several contact prints are wanted from one film.

Exposing equipment

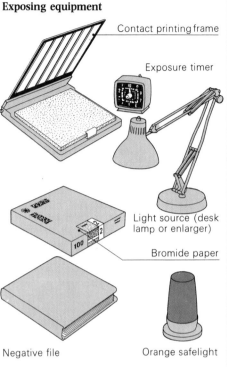

Contact printing frame

Exposure timer

Light source (desk lamp or enlarger)

Bromide paper

Negative file

Orange safelight

Identifying the emulsion surfaces of film and paper
Film and photographic bromide papers curve slightly, with their emulsion surfaces inwards. For film, check by the lettering — this should be the right way around when read from the back, i.e. the non-emulsion side of the film.

Making a contact print — exposure

1. Use a soft, dry cloth to clean dust and marks off the glass.

2. Change to safelighting, and lay a sheet of bromide paper, emulsion side upward, on the baseboard. Place your negatives on this, emulsion side downward.

3. Cover the paper and the negatives with the glass. If you are using a contact printing frame, close the lid on top of the paper and negatives.

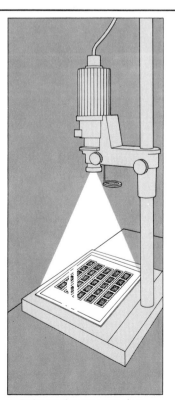

4. Estimate the exposure time from experience — try eight seconds (with the enlarger lens two f numbers below the widest aperture).

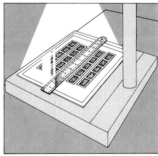

Masking If one strip will print too dark, because the images are very pale, then cover this particular strip for half of the total exposure time.

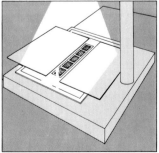

Burning in If one strip looks as if it will print too light, because the images are very dark, then give it double the exposure time.

Print processing

The exposed print is processed on the "wet" side of the darkroom by a developing and fixing procedure similar to that for the film. A latent image has been formed wherever light reached the paper during exposure. Since more light passed through the clear parts of the negative than the darker parts, the print will be a positive image — with dark shadows and light highlights.

Equipment and procedure
The basic equipment for print processing, shown below, differs from that used for film. You need three trays — one for each of the chemicals — instead of a developing tank, and the procedure takes place under orange safelighting rather than in darkness. You use the same type of stop bath and fixer as before, but you need a faster acting developer, which is more concentrated.

The usual development time for paper-based paper is about two minutes. Resin-coated ("plastic-based") papers, described on the opposite page, need shorter times in all the processing stages than paper-based papers — their development time is only about one and a quarter minutes.

Maintain the developer temperature at 68°F (20°C) throughout; this may mean housing the developer tray inside another, larger tray containing warm, or cool, water. Give the prints their full development time; even if they seem to be coming up too dark, give them the full two minutes and make any corrections by altering the exposure time, not the development.

Basic sequence
The print processing sequence is also develop, stop or rinse, fix, then wash. Carefully space the trays to avoid one solution contaminating another.

Print processing equipment

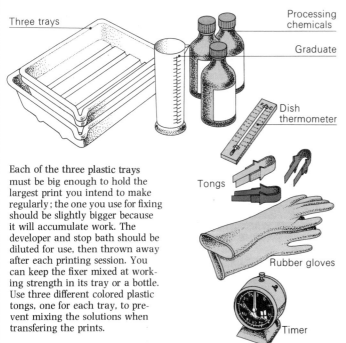

Three trays

Processing chemicals

Graduate

Dish thermometer

Tongs

Rubber gloves

Timer

Each of the three plastic trays must be big enough to hold the largest print you intend to make regularly; the one you use for fixing should be slightly bigger because it will accumulate work. The developer and stop bath should be diluted for use, then thrown away after each printing session. You can keep the fixer mixed at working strength in its tray or a bottle. Use three different colored plastic tongs, one for each tray, to prevent mixing the solutions when transfering the prints.

Print processing sequence

1. Check that the temperature of the developer is 68°F (20°C) and make a note of the development time before you start. Slide the paper, face down, into the developer.

2. Turn the paper over using the tongs so that the emulsion side of the paper is face up and evenly coated with developer.

3. Gently rock the tray to keep the paper constantly moving. After about 30–40 seconds an image should start to appear on the paper. Always give the full development time.

4. When development time is complete lift out the print and allow it to drain. Then lower the print into the stop bath (or water), releasing the tongs before they reach the solution.

5. Pull the print through the stop bath with the stop bath tongs and transfer it to the fixer with the fixer tongs. Paper-based prints should remain in normal type fixer for at least 10 minutes.

6. Once the print has been in the fixer for about one minute you can examine it in normal light to decide whether it should be darker (needing more exposure) or lighter (needing less exposure). Prints can remain in the fixer for up to 20 minutes without harm.

Print washing and drying

Once the print has been processed it must be thoroughly washed to remove the chemicals created during fixing as well as the fixer itself. An unwashed print will dry with a chemical scum and may bleach and discolor within a few days.

Washing and washing equipment
Normal washing time for paper-based papers is about 15 minutes; for resin-coated papers, in washers such as the sprinkler tray shown below, total washing time is only from one to two minutes. Resin-coated papers need less time for washing since the resin-coated base is nonabsorbent and only the paper surface needs to be washed.

If you do not have a supply of running water or a sink, wash the prints by letting them soak in a large tray and change the water every five minutes — about six changes of water will do. If you prefer, you can buy special equipment for washing; these gadgets generally need a supply of running water and a sink. The simplest and cheapest is a large perforated plastic tube which fits over the outlet of a sink, regulating the outflow of water. A siphon washer, that clips on to the side of the tray, provides a constant flow of water over the prints. In a grid washer prints are held separately, to prevent contact, in a continuous spray of water.

Drying and glazing
Glossy paper-based prints can be dried with or without a glaze — this is a matter of choice; other paper-based prints will dry unglazed. A flatbed dryer, shown below, is for paper-based prints only and gives you the option of a glazed or unglazed finish, whereas photographic blotter paper only produces unglazed prints.

Glossy resin-coated papers always dry with a glaze. They must be air dried, by pegging them on a line or putting them on racks, such as the air-drying rack shown below. There are also electric heater dryers available that will dry resin-coated papers in about 30 seconds.

Print washing equipment

Perforated tube

Siphon washer

Grid washer

Sprinkler tray

Print drying equipment

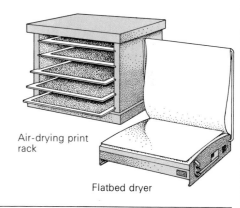
Air-drying print rack

Flatbed dryer

Drying prints with a flatbed dryer

1. Dry the wet print initially between two sheets of photographic blotting paper (not ordinary blotting paper).

2. For a glazed finish on glossy papers, squeegee the print face down on to the glazing plate; place the print face up on the plate for an unglazed result.

3. Place the metal plate, with the prints, on the machine and close the lid. Leave until the fabric surface of the lid feels dry — usually about 10 minutes.

4. Open the lid — glazed prints will curl over the plate surface; unglazed prints will curl upward, away from the plate.

Photographic papers
The appearance of your print is affected by the photographic paper you choose. The majority of photographic papers are "bromide" papers — that is, their light-sensitivity depends on silver bromide salts in the emulsion coating. These papers come in a wide range of types and sizes. With experience, you will be able to decide which paper you prefer for a particular subject or effect.

Surface texture
Paper surfaces range from glossy to mat and include "luster", "tweed", and "silk". Glossy prints have the richest blacks, and can be glazed; mat prints are easiest to retouch.

Base tint
White is the most popular paper color, but others include "warm-white" and the stronger "cream-white". For extreme effects there are fluorescent colored papers.

Paper thickness
Thicknesses range from light or medium to double weight. The card-like "double weight" is the most expensive, but more robust.

Base type
Photographic papers may either be the simple paper-based type (paper on one side and emulsion on the other) or resin-coated (RC) — with an additional plastic coating on both sides of the paper before the emulsion is added. Such resin-coated (or "plastic-based") papers have the advantage of faster processing and drying.

Contrast grade
You can buy up to six contrast grades ranging from very soft to extra hard. These are explained on pages 84–5. Variable contrast papers, which alter local contrast, are explained on page 87.

Not all papers are offered with every one of these variations. If you have not printed before it is best to start with glossy, white, paper-based, single weight, bromide paper of normal contrast grade. This long description contains terms defining surface texture, color, thickness, base type, and contrast.

STEP 3 : ENLARGING/The enlarger

So far we have only used the enlarger as a handy light source for making contact prints. Before making enlargements we really need to know more about what this equipment does and how it works.

An enlarger is a projection printer, similar to a slide projector but mounted vertically and with a much less brilliant lamp. Like a slide projector, it has a condenser (which consists simply of one or two converging lenses) that concentrates the light source into an even, focused beam (some enlargers use a plastic diffuser for this). Below the condenser, the film is held by its edges in a carrier that has its central area cut out in a rectangle the size of one negative. When an exposure is made, the lamp above the carrier projects the image down through the enlarging lens so that it appears enlarged on a sheet of light-sensitive paper laid on the baseboard below.

Components of the enlarger

Although the enlarger is basically a very simple device, it is as important for producing a quality print as a good camera. The lamp must illuminate the negative evenly; a central bright spot or dark corner, for example, will give greatly exaggerated dark or light areas on all your prints. In addition, the lamphouse must prevent light escaping through the ventilation holes as this might fog the paper on the baseboard. The carrier should hold the negative absolutely flat, otherwise parts of the picture will appear out of focus or distorted. For the same reason, the lamp must not over-heat and distort the film. The enlarging lens, which normally has a longer focal length than the lens on a camera, must be the best quality that you can afford. If you have a good quality lens on your camera, the detail it gives will be lost if you enlarge through a poor quality enlarging lens.

Controls on the enlarger

There are three main controls on the enlarger – the position of the enlarging head, the focus, and the aperture. Move the whole enlarging head toward or away from the baseboard along the column to alter the size of the enlargement; the column should be large enough to allow the biggest print you will normally want. For even larger images, some heads can be swung around the column to project on to a distant surface such as a wall or floor. The second main control on the enlarger is the focus; it should give a smooth, fine focus of the image on the baseboard. The lens must not slip out of focus when, for example, you are adjusting its aperture or when swinging over the red filter. The third control is the aperture, which with the timer determines the exposure of the print; its stops follow the same sequence as the f numbers on your camera.

The enlarger and accessories

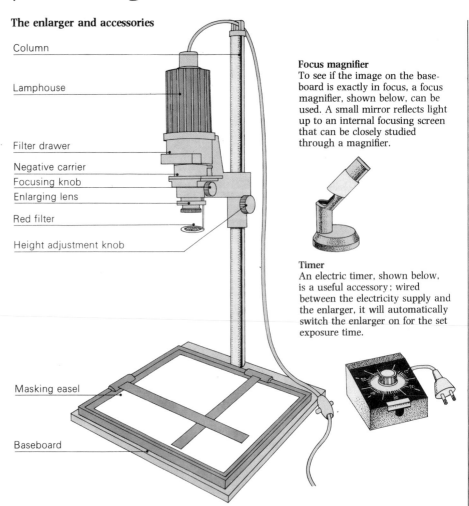

Column

Lamphouse

Filter drawer

Negative carrier

Focusing knob

Enlarging lens

Red filter

Height adjustment knob

Masking easel

Baseboard

Focus magnifier
To see if the image on the baseboard is exactly in focus, a focus magnifier, shown below, can be used. A small mirror reflects light up to an internal focusing screen that can be closely studied through a magnifier.

Timer
An electric timer, shown below, is a useful accessory; wired between the electricity supply and the enlarger, it will automatically switch the enlarger on for the set exposure time.

Types of enlarger

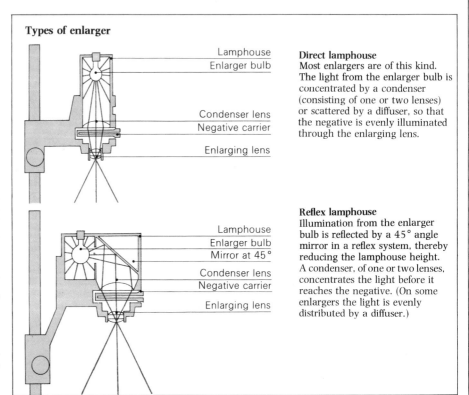

Lamphouse
Enlarger bulb

Condenser lens
Negative carrier

Enlarging lens

Lamphouse
Enlarger bulb
Mirror at 45°

Condenser lens
Negative carrier

Enlarging lens

Direct lamphouse
Most enlargers are of this kind. The light from the enlarger bulb is concentrated by a condenser (consisting of one or two lenses) or scattered by a diffuser, so that the negative is evenly illuminated through the enlarging lens.

Reflex lamphouse
Illumination from the enlarger bulb is reflected by a 45° angle mirror in a reflex system, thereby reducing the lamphouse height. A condenser, of one or two lenses, concentrates the light before it reaches the negative. (On some enlargers the light is evenly distributed by a diffuser.)

Preparing to make an enlargement

You save yourself a lot of time in the darkroom by using your set of contact prints to work out in advance which images you want to enlarge and how this can best be done. Use a print magnifier or large reading glass to select the pictures you want to enlarge; check carefully the composition and image sharpness. If you have taken a series of exposures of one subject, a contact print sheet enables you to select which, if any, are the most successful.

Cardboard transparency mounts or, better still, two shaped cards will help you isolate your chosen pictures from the adjacent images. You can even use the cards to work out improvements in framing, cutting out unwanted elements by cropping (see p. 83). Use a white grease pencil to mark up the chosen images on the contact sheet.

Remember that enlarging will not only bring out the detail in your pictures but will also show up any deficiencies, such as camera shake, bad focusing, and dust or scratches on the negatives. Check the negatives for cleanliness before setting them up in the enlarger. Even a tiny hair or a small scum mark on the back of the film will show up on the print.

Selecting and positioning the negative

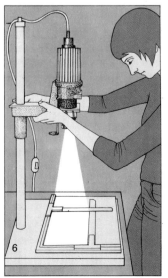

1. Use a magnifier to examine the contact print and a blower brush to clean the negatives. Mark the images you want to enlarge with a grease pencil.

2. Make sure that the negative you have selected is absolutely clean.

3. Check that the numbers in the rebates match those on the contact print to ensure that you have the right image.

4. Place the negative strip in the carrier shiny side upward with the image you want to enlarge positioned over the aperture.

5. Close the carrier and carefully insert it in the enlarger.

6. Switch out the white light and turn on the enlarger. Open the lens to the widest aperture and adjust the enlarger head until the image is approximately the size you want.

Selecting the exposure time

Before making an enlargement, you must choose an exposure time that will produce the best results from your negative. Do this by making different exposures in separate bands on a single strip of normal grade bromide paper; from this test strip you can quickly judge how the image will look at those exposure times.

Make the test strip a reasonable size, say half a sheet of paper, or a third — each exposure band need only occupy a small area. Ideally the strip should be positioned on the baseboard so that every band will be representative of the whole image: try to include a cross-section of the light and dark parts of the picture in each band, and avoid having all shadow in one, all highlights in another. Having taken a range of exposures around an estimated time, such as 3, 6, 12, and 24 secs (for an estimated correct exposure time of 10 secs); develop the print fully and, after fixing for a minute or so, switch on the white light and check your results. You can now decide which time will give the print you want. You may well decide that the best exposure time for the final print falls midway between two of the test bands, in which case choose a time half way between the two times. Finally, take a complete sheet of paper and expose it for the time you have selected; then process it to produce your enlarged print. When it is dry, you can assess the quality of the print, as shown opposite, and check for any errors in enlarging and processing.

Making a test strip

1. Adjust the focus until the image is absolutely sharp. As focusing also affects size, you may have to readjust the enlarger head.

2. Use a smaller aperture, say f8 or f11, for light negatives than for dark ones. This will prevent excessively long or short exposure times.

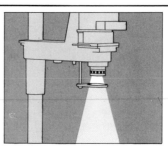

3. Swing over the red filter and tear or cut a strip of normal grade bromide paper large enough to get a representative range of exposure times.

4. Insert the paper strip under the masking easel, shiny side up, and position it so each exposure band will include both light and dark parts of the image.

5. Remove the red filter and expose the whole paper strip for 3 seconds.

6. Using a piece of card, cover one quarter of the paper strip and expose the remainder for another 3 seconds.

7. Cover half, and then three quarters of the strip, giving additional 6 and 12 second exposures respectively.

8. Process the test strip following the same procedure you used for a full sheet, as shown on page 76.

The test strip

Range the exposures on the test strip around the estimated exposure time for the negative (in this case 10 seconds). The most satisfactory result in this example appears in the band which received a total of 12 seconds exposure; other bands appear too dark or too light.

If your whole strip is too dark, or too light, make another test strip with increased, or decreased, exposure times. It may be helpful to close or open the lens aperture by one stop; this will give the exact equivalent of half or double the exposure time. Each time you change your negative or alter the size of the enlargement you should make another test strip.

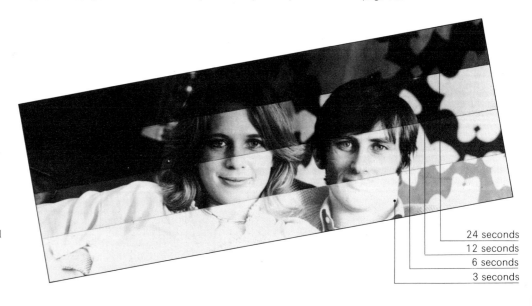

24 seconds
12 seconds
6 seconds
3 seconds

Making the enlargement

1. Under safelighting, place a sheet of bromide paper squarely under the masking strips of the easel.

2. Check that the red filter is out of the way. Now switch on the enlarger for the time given by your test strip (in this case 12 seconds).

3. When the time is complete, carefully remove the paper and follow the processing procedure for the print, described on page 76.

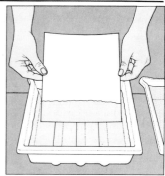

Assessing the final print

Lighting
Check for even illumination across the print. In this picture the lighting direction is from right to left, but because of the reflective surroundings there is no detectable fall-off in illumination. Sometimes less exposure (by "shading", see p. 86) is needed for one side of a print than the other, to compensate for uneven lighting.

Highlights
The lightest important detail areas on the print should not appear "washed out", or grayed over — the forehead here shows a graduated tone, giving roundness of form. There should just be a tone difference between the skin and the whiteness of eyes and teeth. These highlights should almost be as white as the picture borders.

Shadows
Print blacks should be a rich black, to give the image body and "depth". But try not to let darkest important detail turn into solid, featureless black paper — there is still just enough hair detail here to give shape to the top of the man's head.

Tone range
There should be a wide range of gray tones between lightest highlight and darkest shadow. This gives a natural, three dimensional appearance. Excessive grays give a very "flat" appearance, while too few have a harsh effect. You can adjust contrast by printing on a different paper grade, as explained on pages 84–5.

Printing errors

If you are not satisfied with your print, you may at first be unable to identify the nature of the fault. Begin your analysis by carefully comparing print and negative. Often faults such as poor tone, marks, and unsharpness can be due to these same errors in the negative. But if the negative seems fine there are other possible causes.

Wrong density or contrast

A print which appears too light or too dark has probably had the wrong printing exposure. If, for example, highlight details in the negative come up blank on the print, increase the exposure time, either overall or just for this part of the print ("printing-in"). Equally, areas of detail that are too dark and lost on the print can be improved by "dodging" during exposure. Printing-in and dodging are explained on page 86.

Excessive contrast (too few gray tones between black and white) is probably due to using too hard a paper grade. Low contrast (flat, gray appearance) results if the paper is too soft, or the print underdeveloped. Check development time, and the temperature, dilution, and age of your developer. If the print seems grayish, with little contrast, you may have dust, condensation, or marks on the enlarging lens.

An unsafe safelight or badly blacked-out darkroom will also reduce print contrast by "fogging" — minutely tinting the whites gray. You can check for this by comparing the white back of the paper with the brightest image highlights. Other causes of fog (often giving a yellowish stain too) are overdevelopment, or lifting the print from the developer too frequently to check the image.

Marks and stains

The usual cause of gray, yellow, or purplish patches is insufficient fixing. Sometimes refixing the print can remove these stains. Black lines on the print — often quite short and in groups — are created if the emulsion surface is grazed. A print with concentric white or gray rings (Newton's Rings) results when the two glass surfaces of the negative carrier are not in complete contact.

Unsharpness

Always check the sharpness of the grain (see p. 38) on the print first; if this is sharp any unsharpness of the final image must exist on the negative. If the print grain is unsharp, but the negative is sharp, then the fault must have arisen during enlargement. Perhaps the enlarger shifted position or was jarred during exposure, the negative may have buckled in the carrier, or the image was focused through the red safe filter. Images which lack strong shapes are quite difficult to focus in the enlarger, particularly if the negative is also dense. In such cases, switch out the safelight and use a focus magnifier to focus the grain pattern itself.

Checking against the test strip

Underexposing the print, giving the shortest exposure time on the test strip, below, results in a weak, pale image, right. Over-exposure, has the opposite effect, below right, giving a dark print with blackened shadows, even though highlights may show detail. If your results are still too light or too dark, even after quite long or short exposure times, you should adjust the lens aperture — each click stop doubles or halves image brightness.

Spread shadows

Dust, grease, or condensation on the enlarger lens will diffuse and scatter light during exposure. Since light causes printing paper to darken, the resulting print appears slightly smudgy with shadow areas "spread", right. Check the lens by looking up through it with the enlarger switched on. If the glass seems misty, clean the top and bottom surfaces with a soft brush or cleaning tissue. One of the biggest enemies in the darkroom is dust, and it is always advisable to cover equipment such as the enlarger when it is not in use.

Abrasion of paper

Although printing paper emulsion is generally tougher than film it is quite easily marked. It does not need to be handled by its edges, but scraping it over a rough surface or catching it with your finger nail creates black scratch marks, as shown right. Similarly, you can mark the print by rough handling with tongs in the developer. A really severe gouge may even scrape some of the emulsion off, leaving a white mark. Handle paper carefully and do not, for example, move it face down across a bench surface or box edge.

Contamination marks
Contamination marks are caused by handling dry paper with damp fingers, and by splashes of fixer solution. Keep the dry and wet darkroom areas separate, and always dry your hands before touching dry printing paper.

Fogged paper
Accidental fogging shows mostly in the highlights and white borders of the print, as a slight gray veiling. The usual cause is a safelight which is either too bright, too close, or not the right color.

Patchiness
Uneven illumination of the negative or debris on the top surface of the condenser causes patchiness on the print. Often this cannot be detected when focusing the image at a wide aperture.

Image shake
Blurring or double image is usually caused by jolting the enlarger or knocking the baseboard during exposure. However, sometimes a worn enlarger will slip or shift slightly on its column and blur the image.

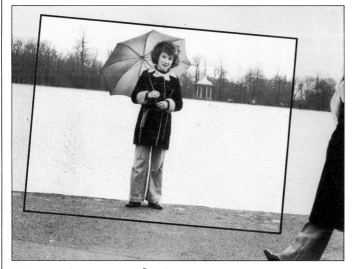

Using cropping to correct framing errors

One of the advantages of printing your own negatives is that you can enlarge selected parts of your pictures to cut out unwanted detail, alter the proportions and even change from a vertical to a horizontal format by cropping the image. By turning the masking easel on the baseboard of your enlarger you can correct sloping horizontal and vertical lines originally caused by not holding the camera straight.

For example, the print above could be greatly improved by restricting the enlarged print to the center area to cut out the distracting figure, right, and moving the easel to straighten the horizon. The limiting factors to enlarging only a part of the negative are the increase in size of the film grain and the decrease in image sharpness.

Reminders: printing and enlarging

Always take care of your negatives	Unlike prints they cannot be replaced; hold them by their edges and protect them from dirt, liquids etc.
Photographic printing paper is sensitive to white light	Always keep it in its light-proof container; make sure you replace it before changing to normal lighting.
Keep the developer at around 68°F (20°C) in temperature	If necessary, put the developer tray inside another, larger tray to maintain this temperature.
Always give the correct development time	Adjust your results through exposure not development.
When making a contact print, the emulsion sides of the film and the paper should be in contact	The emulsion side of film and paper is that toward which they curl; it is dull for film and shiny for paper.
Cleanliness in the darkroom is essential	Dust or grit, particularly in the enlarger, can ruin your work.
Always make a test strip of each print	Assess the strip and choose the exposure time before printing and changing to the next negative. Too much haste can waste time and expensive materials.
After enlarging, assess your print	Enlarging makes the most of your pictures but it will also show up faults which may be remedied.

STEP 4 : MANIPULATED PRINTING/Contrast control

You have already seen how to compensate for overall darkness or lightness of a negative by varying the printing — either giving longer or shorter exposure times, or adjusting the enlarging lens aperture. But you may also want to alter the contrast on the print, that is the range and gradation of gray tones, and you can do this by using papers of different contrast grades.

The negative shown enlarged on page 81 was printed on normal grade paper, but photographic paper can also be bought in soft and hard grades. Soft grade papers will produce far more gray tones between black and white than hard grades. (Although not shown here, extra soft and extra hard grades are also available in some popular printing papers, giving up to five grades in all.) You can see the effects on contrast of printing a normal contrast negative on soft, normal, and hard papers across the middle row.

This ability to control contrast becomes really useful when you are printing a low contrast negative like the statue of the lion, top, or a high contrast negative like that of the building, below. As you can see, the flatter, or lower in contrast, the negative, the harder the grade of paper needed to compensate and give a normal contrast print.

If you are a beginner at enlarging and unsure about judging negative contrast by sight, first make a test strip followed by the best possible complete print, on normal grade paper. Then you can decide whether an increase or decrease in overall contrast would help the picture. Later you will be able to decide this direct from the test strip, but when you are beginning it is difficult to assess the overall print contrast from the narrow exposure bands. When changing from one grade to another, remember that some brands of bromide paper require slight adjustment of exposure time, so that you may have to make a new test strip. Generally, the harder paper grades need longer exposures than normal or soft grades.

Variable contrast papers

Instead of having to buy a stock of papers in each grade, you can use a variable contrast paper, such as Kodak Polycontrast. This alters the contrast it gives according to the color of the printing light used (the process is explained on page 87). Without a filter the paper gives relatively normal contrast; a pale yellow filter converts it to soft contrast, and a bluish filter changes it to hard. A range of seven filters is available, allowing you to make gradual changes. They are made in two types: acetate, which fit in the enlarger filter drawer, or gelatin or glass, for use below the lens. Again, some adjustment of exposure time is needed when changing filters. Variable contrast papers are more sensitive to yellow light so you may need a darker, more amber safelight.

Assessing negative contrast

To assess the contrast on the negative, look at the range of grays between the darkest and lightest important parts of the image. (Compare this against the sort of tonal range you have discovered will print well on normal grade paper on your enlarger.) Don't be misled by overall density – very dense (dark) or very thin (pale) negatives are often rather flat in contrast. Contrasty negatives will appear "bright" and have bold tone differences; flat negatives look gray.

Low contrast negative
A flat, or low contrast negative, due to overcast lighting, hazy conditions, or underdevelopment (or a combination of these), will print best on hard grade paper, far right.

Normal contrast negative
A normal contrast negative prints well on normal grade paper, center. Notice the effects of printing on soft grade paper, near right, and hard grade, far right.

High contrast negative
The high contrast of a harsh, or "contrasty" negative could be caused by harsh side-lighting, or overdevelopment. Contrasty negatives print most successfully on soft grade paper, near right.

Paper grades

Soft grade paper
Soft contrast photographic paper is usually rated by the manufacturer as grade 1, or the even softer grade 0. It forms a large range of grays between black and white, which will counteract the harshness of a contrasty negative.

Normal grade paper
Normal grade paper is usually
described as grade 2. It is designed
to suit an average contrast nega-
tive and normal enlarging con-
ditions. Normal grade paper is
suitable for average subject light-
ing and development, but you
may decide to use a harder or
softer paper to suit the subject.

Hard grade paper
Photographic papers of grade 3,
or the more extreme grades 4 and
5, give a smaller number of grays
between black and white than
normal paper. They reduce and
simplify the excessive grays in a
low contrast negative, printing
them as fewer and more separate
tone differences.

A flat negative prints
best on hard grade
paper, near left.

A normal negative
prints best on normal
grade paper, center.

A contrasty negative
prints best on soft
grade paper, far left.

Local control of print density

You will often find that, although you have given your print the correct overall exposure, some areas of the picture are slightly too dark or too light so that information on the negative is lost. You can control the local print density by reducing exposure time for parts you want lighter ("shading" or "dodging"), or increasing it for areas you want to be darker ("printing-in"). To lighten an area, use your hand or a piece of black card to shade this part of the paper for several seconds during the main exposure. To make an area darker, first give the overall exposure then, with a hole in a card or cupped hands, give extra exposure to the selected area only.

Working out the exposures

With experience you will soon be able to guess the number of seconds needed to shade or print-in. But to begin with, refer to your test strip, or make one specifically for this purpose.

On the print with 5 seconds exposure, below left, the background figure has detail, but everything else is too light. At 20 seconds, below right, the detail is clear in the foreground figure and the rest of the picture, but the background figure has lost detail and is now much too dark.

From this you can see that the background figure should be shaded (given less exposure) and

the remainder of the picture printed-in (given more exposure). The bottom picture shows the final print, after shading and printing-in; it contains all the information that was present in the 5 and 20 seconds prints, without any loss of detail. During one 20 second exposure, the background figure was shaded for the first 5 seconds; then the whole image was exposed for a further 5 seconds, and finally the foreground figure and the highlight areas were printed-in for 10 seconds.

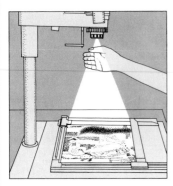

Shading. Cast a shadow with your hand over the relevant area of the picture during part of the exposure. Keep your hand well above the paper, and continually moving, to soften its outline.

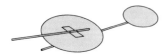

Dodging. A more localized form of shading can be done by making a small "dodger" with a piece of black card and wire.

Printing-in. After the main exposure use your hands to form a hole, or a piece of card with a hole in it, to give extra time to areas which printed too light. Blur the outline of the darkened area by moving your hands or the card.

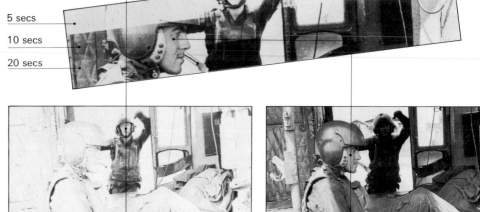

5 secs
10 secs
20 secs

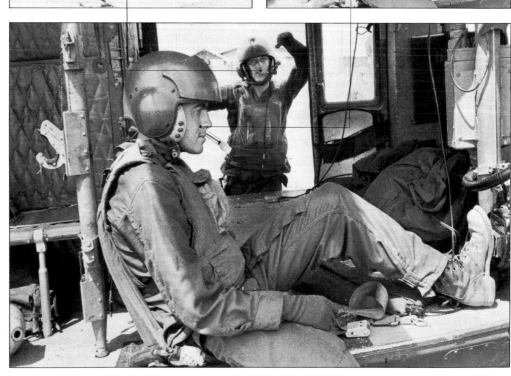

Local control of contrast

One advantage of variable contrast paper is that you can alter the contrast of different parts of the same print. This is useful when, for example, part of the picture is in deep cast shadow and the rest in harsh sunlight. The sunlit area needs soft grade paper, but if you shade to reveal some detail in the shadow this may record unnaturally gray and flat. The problem is solved, as shown below, by exposing the shadow area only through a high contrast filter (such as a number 3 filter), then changing to a low contrast filter (such as a number 1 filter) to print-in the harshly lit part. This technique is also useful for boosting the contrast of sky areas where overexposure on the negative has merged clouds and blue sky.

Another way of altering contrast over a small central part of the print is to shade-out this area with a dodger during the main exposure, then print it in again through a hole in a card with a different filter in place. You can even tape a gelatin filter over the actual hole. With experience you can use shaped filters attached to wire as dodgers, changing contrast and lightening the print at the same time.

The makers of variable contrast papers sell a simple calculator showing how much exposure is affected when changing from one filter to another. However, variable contrast papers are unlikely to replace graded papers, partly because of the bother of handling filters. In addition, a good print on a graded paper is of slightly better quality than the same negative printed on variable contrast paper.

Using variable contrast paper

1. Estimate the contrast grade needed for the shadowed zone. Using the appropriate filter on the enlarger, make a test strip of varying exposure times across the shadowed area.

2. Decide the grade for the bright area. Change to this filter and make another test strip, this time for the sunlit area. From the two processed test strips estimate the required exposure times for each area.

3. Using a full sheet of paper, give the correct exposure for the shadowed area through its filter. Shade the light area as much as possible, using a piece of card or a dodger.

4. Change to the other filter and print-in the sunlit part, giving the exposure time your second test strip showed to be correct.

Improving local contrast
Subjects like the scene below benefit from variable contrast printing. Exposed at low contrast, shadows were flat, below left; at high contrast, the window was harsh, bottom left. For the final print, below right, the interior was exposed at high contrast, the window printed-in at low contrast.

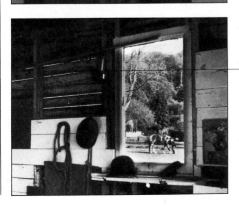

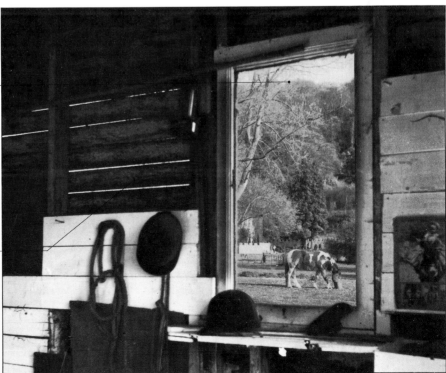

Simple print retouching

Although you may take the greatest care, occasionally an unwanted mark will turn up on your prints. Usually this will be grit or dirt on the film that has been magnified along with the image to form a noticeable mark. More seriously, you may find your negative has scratch lines (which print white) or pinholes (which form black specks). You can hide most of these defects by retouching the final print — by "spotting" or "knifing" each mark until it merges with its surroundings. This is a job for which you require the few tools shown right: a very fine brush, a scalpel blade and holder, either black retouching dye or water-color, and a small ceramic palette or saucer.

1. Tube of watercolor
2. Black retouching dye
3. Palette
4. Fine brush
5. Scalpel blade in holder

Spotting and knifing
It is much easier to retouch a print on mat, semi-mat or luster surface paper than on glazed, glossy paper — its finish readily shows up retouched areas.

Retouch black specks by gently brushing them with the scalpel blade so that they are gradually reduced to the desired tone.

For white marks, use diluted dye or watercolor on an almost dry brush. Build up and match the white areas to the adjacent grain pattern by stippling with the brush in gray. The retouched print below shows the results you can achieve with practice.

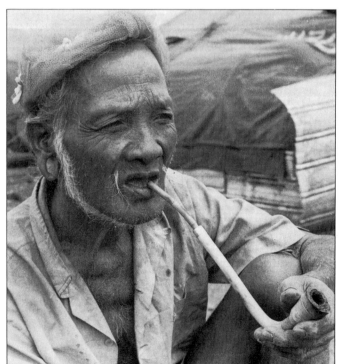

SUMMARY

Black and white processing and printing

Processing

Film processing is deceptively simple once you have mastered loading the developing tank spool, but take care over the factors that control results — time, temperature, agitation, and solution condition. Even at the washing or drying stage your processed film can be spoiled by careless handling. Cut up your strips of negatives and protect them as soon as possible.

Negatives

Negative quality determines final print quality. You cannot make a print with good detail and tone values if these do not first exist on the negative. Learn to assess your films for technical errors. It may be better to re-shoot the picture than struggle for hours to print a second-rate negative.

Try to contact print all your negatives. Then you can study and mark up those prints for enlarging without further handling the film.

Darkroom and Printing

For contact printing and enlarging you need a darkroom. Plan it with wet and dry areas clearly divided, and keep it clean.

Your enlarger must give even lighting and have a good lens.

Standardize your print processing. Control the results by altering exposure time or contrast grade of paper. The print needs thorough fixing and washing; this causes no visible change but greatly affects the permanence of your picture.

Organize your test strip intelligently to give maximum exposure information, and process it with the same care as a full print.

Decide the best contrast grade to suit your picture. Usually flat (low contrast) negatives need hard paper, contrasty (high contrast) negatives, soft grade paper.

Most print faults are caused by careless paper handling, fogging with light, and errors in focusing, exposure, or choice of paper grade. Make sure that the negative is not the real cause of the trouble.

Practice local control of print density by shading or printing-in. This is a really useful technique because often you cannot fully control lighting at the time of exposure. Enlarging skills improve with practice.

Don't be in too great a hurry — give yourself time to experiment and produce the best possible print from one negative before changing to the next.

Finish off prints by careful drying or glazing, and finally spot in or knife out blemishes. If most of your prints require this, it suggests mishandling of negatives.

FURTHER EQUIPMENT AND TECHNIQUES

This section presents more advanced camera equipment and techniques with which you can extend your range of photography. Up until now you have been working with a camera with a normal lens, using straightforward natural lighting. Here you will be exploring the visual possibilities of lenses with different focal lengths, specialist lenses, filters, and close-up attachments. Next you will be introduced to controlled exposure techniques. These enable you to cope with difficult existing light situations, or to determine the tonal range in a photograph. This leads on to the principles and equipment involved in lighting with studio lamps and flash. Lastly the section develops further picture building aspects which arise from your extra equipment and knowledge.

Before tackling anything in this section you must have worked through the Camera Technique section, (pp. 23-44) and preferably the first Picture Building section too, (pp. 45-64). These two sections provide you with the experience and knowledge of camera stills and composition necessary for this part of the book. You don't have to know how to process and print your film, however, because all advanced aspects of darkroom work have been collected into the section which follows this one.

Organisation of the section
Most topics in this section relate equally to black and white and color photography (except the filters shown on page 100, which apply to black and white photography only). However, before trying any of these techniques in color, you should first work through the Color Photography section (pp. 141-58). There are many factors particular to color photography you should know about, since they will affect your results. Before working on the lens aspects of this section, you may find it helpful to re-read the basic principles of image-forming, seeing, and photography on pages 16-17 and pages 20-1.

It is not necessary to work through the steps in this section sequentially. Each one is a separate topic, so you may want merely to dip in – to cover, say, wide-angle lenses, or filters. Which steps you choose to tackle will depend largely upon what equipment you possess or are intending to buy. Reading through this section will give you a good idea of whether certain items are worth acquiring or not.

Much depends on what type of photography you are interested in doing. Working with a moderate range of lenses can be useful in a variety of situations. But you are unlikely to use the very long and short focal length types so often, because the images they give are so extreme. Often you can hire these lenses for unusual jobs – or you may buy a particular lens to suit your special interests, for example a telephoto lens for wildlife photography. Close-up attachments are also much used for natural history photography – as well as for copying stamps, coins, and similar collectors' items.

Understanding how to use studio spot and flood lighting is essential for still-life pictures, commercial work, and formal portraiture. On the other hand, if you are more interested in action shots, documentary pictures, and location work where you must carry lighting around, then flash may be the more practical lighting technique.

The Steps concerning controlled exposure techniques and further picture building skills apply to whatever type of photography you undertake. Working through them will lead you on to developing your own personal style.

As always, the best way to learn and absorb the material here is to practice – even though, in this case, you may have to borrow items of equipment you don't yet possess. Incidentally, if you are making your own comparisons between different lenses, attachments, and light arrangements, it will be helpful to have a tripod to support your camera. With a tripod you can keep the

camera viewpoint identical or carefully control any changes through a series of shots so that differences created by the items you are trying out can be isolated.

Using lenses

The first Step looks at the advantages of having additional lenses for your camera. Lens interchangeability is one of the great features of the single lens reflex camera. Remember, it has a focal plane shutter in front of the film so you can remove and replace lenses at any time without fogging the film. This camera also always shows the image "seen" by the lens on the focusing screen. A few expensive direct viewfinder cameras with focal plane shutters also allow lens changing, and either have marks in the viewfinder to show how much of the scene you will record with each type of lens, or have coupled rangefinders that change according to the lens fitted. But the range of lenses is limited compared with the great number of lenses available for SLR cameras. This is because it would be impossible, for example, to indicate the angle of view of a fisheye wide-angle lens on a direct vision camera. Some twin lens reflex cameras accept different focal length lenses, but here too the range is limited, and expense is also restricting as you have to buy a pair of lenses for every new focal length (see p. 205).

Unfortunately most makes of interchangeable lens camera are designed with their own exclusive method of lens attachment. Some accept screw-in lenses; others half-turn (bayonet) lenses. Each is usually incompatible with other makes. This means that you are encouraged to buy from the camera manufacturer's range of lenses, and it is arguable that these lenses will give the best optical quality with the cameras they are built to complement. But the range and price of these lenses are factors you should consider when you are first deciding which camera to buy. However, there are manufacturers who only make lenses. These fit various makes of camera either by copying the thread size on the mount, or by adaptor rings. The advantage of these lenses is that you may not have to change them if you change your camera model.

If your camera has a fixed lens, it may be still possible to use different focal lengths, by adding a convertor lens attachment. In this case you may be able either to adapt the viewfinder, or fit an extra one into the camera accessory shoe.

You will see that lenses divide into two groups: a basic set of three – moderately wide-angle, normal, and moderately long focal lengths – and a variety of special types. Most photographers will agree that the basic set is well worth acquiring, because it can be used in so many ways. Which actual focal lengths you choose however is a much more personal decision. The wide-angle and long focus lenses shown here are 28 mm and 135 mm respectively. But you may prefer, say, a 35 mm wide-angle and a 200 mm long focus lens. These focal lengths apply only to a 35 mm camera (24 x 36 mm format). The equivalents to 28 mm and 135 mm for a $2\frac{1}{4}$ ins square camera would be about 50 mm and 250 mm, because everything is scaled up proportionally. In fact, all focal lengths given throughout this section relate to a 35 mm size camera. So if you are using a $2\frac{1}{4}$ ins format camera, multiply quoted focal lengths by just under two times. The more unusual lenses have specialist applications. Some, like the shift lens, are useful in architectural and still-life photography. Extreme telephoto (or the less bulky, mirror long focus) lenses give effects like photographing through telescopes. They can pick out detail at very long distances. Extreme wide-angles allow

you to include almost a whole room in your picture, while the fisheye version gives weirdly distorted shapes.

Modern lens optics

All these lenses are made to various standards of optics, which are generally indicated by their price. A cheaper lens may sound a bargain, but test it out first at various distances, photographing a finely detailed subject such as a newspaper. Then check image resolution on the negative with a magnifier. Good quality lenses may seem very expensive, but this is the result of solving extremely complex design problems and precision assembly of the various glass elements.

Before the 1960s, most of today's extreme lens types were impossible to make. Advanced digital computers are necessary to test proposed lens designs. They predict the paths of hundreds of light rays through the lens element to each part of the picture area. From the results, the computer builds up profiles of lens elements of the right shape and glass type, so that when combined in a compound lens they will counteract each other's aberrations (optical errors).

Extremely efficient optical glass materials have been developed in Germany and Japan. They have strong refractive index (light bending power) but do not appreciably disperse white light into its component colors (see pp. 16, 148). It is such types of glass which have made modern lenses so accurate for color work in particular. These glasses are ground and polished into highly accurate shapes, which are able to fit together, and strong enough to stand up to wear. Optical engineers have to devise lens barrels which will hold up to twenty separate elements per lens, accurately aligned and spaced, which will not be affected by the air temperature around them.

Each glass surface is coated with several thin films of transparent material to minimize internal light reflections. Without this "blooming", reflections from the dozens of air-to-glass surfaces would give a gray, flat image, like looking through a number of windows. Look into a good quality modern lens, and you will often see the slight yellow or purple "bloom" reflected from the outer coating of its top surface. Turn the lens around and look through it, and this color disappears. Coated lenses are not only essential for modern multi-element designs, they also greatly reduce light flare when you are photographing toward a bright light source. If you buy a secondhand lens made in the 1950s before they were all coated, you will see its notably poorer performance under these conditions.

This also explains why you must take such care when cleaning the camera lens, see page 211. If you wipe it with an ordinary cloth you may scratch the coating layer or the relatively soft optical glass beneath. A lens damaged in this way may scatter light, giving you a grayer, less brilliant image. Similarly, dropping your lens may not appear to create much damage but it can misalign some of the glass components, and so seriously upset image quality.

Using lens attachments and filters

Camera lenses have to be designed for a known set of working conditions – say for subject distances ranging from infinity down to two or three feet. So each lens has a near focusing limit. Attachments such as rings or bellows enable you to focus nearer subjects, but the lens is not then performing under its intended conditions and image definition may be slightly poorer. Perhaps the corners will look less sharp than the image center. Close-up

rings and bellows are difficult to use on a viewfinder camera because you cannot see what is in focus. Some solutions to these problems are discussed in the third Step, showing lens attachments. The previous Step covers color filters for black and white photography. Before working with these you should look forward to the details on complementary colors on pages 148 and 160-1. They explain unfamiliar color names, such as magenta and cyan, and shows how primary and complementary (opposite) colors relate to each other.

Unlike lenses, filters will fit on any camera, provided they match the lens diameter. But if you work much with filters, you will find it easiest to use a single lens reflex camera with 'through-the-lens' metering. A filter over the lens reduces light reaching the film as well as affecting the image. Through-the-lens meters will read the correct exposure, allowing for the filter; while the reflex viewing will show you how the filter alters the picture tones. With viewfinder cameras you must calculate filter exposures, and judge the filtration effects, from information supplied with the filter pack – and your own experience.

Using exposure and lighting

Step four shows you how to solve particular exposure problems – with metering techniques which give greater accuracy in extreme conditions. Before reading this part, turn back and recap basic exposure metering on pages 39-43. You are now dealing with more difficult indoor conditions, where lighting is weak and often contrasty too. Understanding the meter response can help you to judge exposure for particular effects, or aim for an ideal tone value for the most important part of your picture. Choice of exposure can be a creative decision. Later you will learn how to follow it through in the darkroom by further control at the development stage (see pp. 126-7).

The next Step, on artificial lighting, is concerned more with the appearance of the subject than the technicalities of camera and film. If you are considering buying equipment, some of the points made here are again worth noting. If you are working in color, it is essential that you have read through pages 141-7 of the Color Photography section before starting this Step, because unlike black and white materials color films respond differently to different types of lighting.

There is a very close relationship between the quality and direction of natural daylight and the type and positioning of studio lamps or flash units. Before starting on this Step it will help you to check back to the pages in the Picture Building section on lighting (pp. 50-3), and revise your knowledge and understanding of light direction and quality.

Lighting is not just a technique to give enough illumination for convenient exposures. It is also a highly creative tool and fundamental to picture making. This applies particularly to flash, which is often just mounted on top of the camera so that every picture is lit in exactly the same way.

In the early days of flash lighting, photographers poured magnesium powder into trays and lit a slow touch paper or ignited it with sparks from a flint. The whole process was very dangerous, and the photographer had to open the shutter with one hand and fire the flash with the other. Later, magnesium foil was fitted into lampsize flashbulbs and fired by electricity. Press photographers of the 1930s used large flashbulb holders clamped to the side of their cameras.

Electronic flash units appeared after World War II, at first of very low efficiency. Since then both bulb and electronic units have steadily shrunk in size. Today the small flash cube or flash bar or "flip-flash" give several flashes before having to be changed. The electronic flash unit is often very little larger and gives several hundred low cost flashes. You can use both on long extension leads, away from the camera. Bigger, more powerful (but more expensive) units can be used in twos and threes instead of studio lamps. You must decide which will suit your use of flash best. Remember that the principles of lighting – and the need for thought and care in picking and arranging lighting conditions – apply equally to daylight, tungsten lamps, and flash lighting.

Using equipment creatively

The final pages of this section are a continuation from basic picture building, (pp. 45-64). Now however you can exploit the extra equipment which has been discussed. For example, linear perspective and lens focal length are closely related. So are aerial perspective and control of exposure and lighting. Learning to use both forms of perspective enables you to increase or suppress apparent depth in your pictures.

Lighting such as flash, and techniques such as camera panning and using the shallow depth of field given by long focus lenses, allow you to give emphasis to particular elements in your picture. Try some of these effects yourself – your experiments may encourage you to buy some of the equipment seen earlier.

By the end of this section you will see how each worthwhile piece of equipment or technique widens the range of images that you can put on to your film. None of them however are substitutes for ideas and imagination. They are all tools, which different photographers will choose to use in quite diverse ways, as some of the individual styles presented at the end of this book show. One of the dangers of photography is that the tools are so ingeniously and beautifully made that you may start to collect equipment instead of producing pictures. But it is your own ideas, and your interest in a particular subject or effect, that should come first.

STEP 1: ADDITIONAL LENSES/Angle of view

On some direct vision viewfinder and most single lens reflex cameras the lens barrel can be detached from the camera body. This enables you to change to lenses of other focal lengths. Most lenses attach and detach with a half-turn action, others screw-on.

A single lens reflex camera is ideally suited for a range of lenses. Its through-the-lens focusing system shows you the altered amount of the subject the lens includes. Direct vision viewfinder cameras must have additional frame lines for each lens marked in the viewfinder.

A basic set of three lenses are shown below. On a 35 mm camera these are typically a standard 50 mm lens, a short focal length, or "wide-angle", lens of 28 or 35 mm and a long-focus, or "telephoto", lens of 100 or 135 mm. These three form a useful set for most work, but for more specialized needs there are many intermediate lenses to choose from, as well as the more extreme wide-angle and telephoto types, discussed on pages 96–9.

Having interchangeable lenses means that picture making can be extended in three important ways. First, you can change the amount of the subject included from the same camera position. Second, you can control the perspective in your pictures. Third, you can reduce or increase the depth of field, as explained on pages 94–5.

Angle of view and focal length

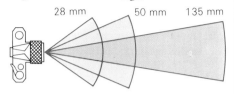

On a standard 35 mm camera the angles taken in by 28 mm, 50 mm, and 135 mm lenses are about 73°, 45°, and 20° respectively.

Lenses and picture areas

The angle of view is the amount of the subject that is included within the picture at any camera position. The three pictures, right, were all taken from the same camera position, shown in the diagram below, but with 28 mm, 50 mm, and 135 mm lenses. The sequence of pictures shows the dramatic effect that changing lenses has on the amount of the subject you can include in the picture.

With a 50 mm lens, center right, the angle of view is about the same as normal human vision. With a 28 mm short focal length lens, top right, more of the scene is included, but everything is reduced in size. A long focal length lens of 135 mm, bottom right, magnifies the main subject, so you fill your picture frame with a smaller area of the subject.

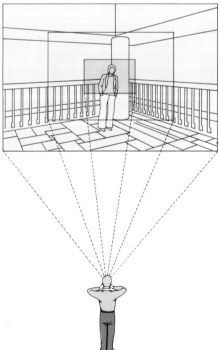

28 mm lens

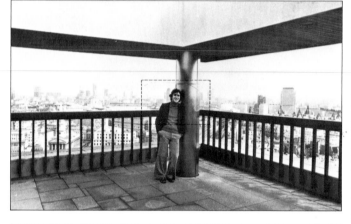

50 mm lens

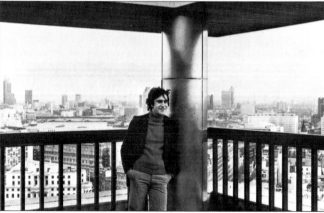

135 mm lens

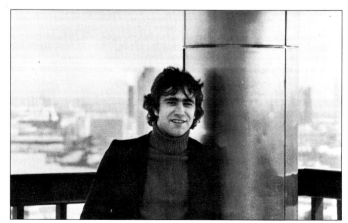

Perspective

Another important effect of using different lenses is the way they help you to alter the linear perspective in your pictures. The eye judges distance by the way objects diminish in size, and the angle at which lines and planes converge. This is what we mean by linear perspective. Using the right combination of camera distance and lens you can make the whole picture look deep or shallow, as shown in the three pictures, right. The feeling of increased or reduced depth is purely illusory, but is an important compositional technique, (see pp. 114–15). You can, for example, use steep convergence of lines or planes to lead the eye toward the center of interest.

A short focal length lens used from a close viewpoint gives your pictures a greater feeling of depth than a standard lens. Elements in the background recede and appear much smaller in size. Lines and planes converge strongly within the picture to add to the depth. Long focal length lenses used from a more distant camera viewpoint have the opposite effect.

28 mm

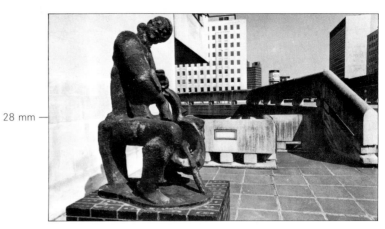

50 mm

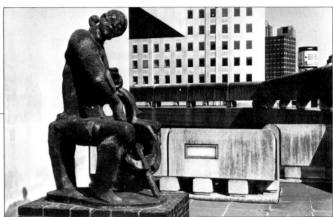

135 mm

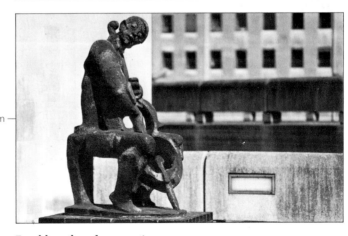

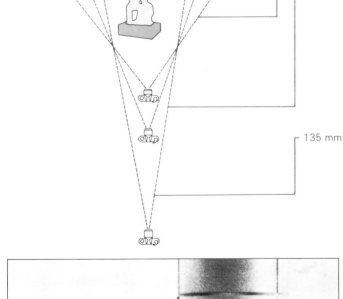

Focal length and perspective

The pictures above were taken with three different lenses — 28 mm, 50 mm, and 135 mm. In each case the camera distance has been changed, greatly altering the perspective. But the different focal lengths of the lenses have kept the statue the same size.

With the wide-angle lens, top, there is a strong feeling of depth in the picture and objects in the background appear small and distant. Some of this depth is lost with a more distant viewpoint and 50 mm lens, center, and the background objects are brought much closer. Using a 135 mm lens,

bottom, the background appears almost on the same plane as the foreground.

The picture, left, was enlarged from the marked area of the 28 mm lens picture on the opposite page. The perspective is the same as in the 135 mm picture to its left, showing that changing the focal length really only affects magnification. Perspective (the size ratio of near and far objects) is altered by camera distance.

Both pictures were taken at the same aperture but the wide-angle lens gives a much greater depth of field. This is explained on page 94.

Focal length and depth of field

Changing to a shorter focal length lens always increases the depth of field in your pictures, even at the same aperture. This is partly due to the smaller diaphragm on short focal length lenses. On a 28 mm lens, for example, the aperture at f8 is only one-eighth of 28 mm, whereas on a 135 mm lens, f8 is one-eighth of 135 mm (see p. 30). In addition, short focal length lenses have a stronger bending power on the light. This means that foreground and background elements are brought into sharp focus much closer together within the camera. As a result, at any one aperture a larger area of the image is acceptably sharp than with a lens of longer focal length.

Comparing lenses

As explained on page 33, the depth of field scale on the lens shows the amount of the subject that is sharp at any given focus and aperture setting. This varies according to the focal length of the lens.

The diagrams and pictures below show the extent of the depth of field in front of and behind the subject on different lenses with the focus and aperture constant. The 28 mm lens, below top, renders objects sharp from about 6 ft (1.8 m) to infinity at f5.6. On a standard 50 mm lens, below center, the depth of field is reduced. Less of the foreground and much less

of the background is sharp — from 8 ft (2.4 m) to 13 ft (3.9 m). The bottom diagram and picture show the narrow depth of field produced by a 135 mm lens, at f5.6 — from 9½ ft (2.9 m) to 10½ ft (3.2 m).

Because of the extended depth of field, a short focal length lens is useful when the focus settings have to be estimated or made very rapidly, such as in some action shots.

A long focus lens restricts the detail to the main area of interest. But because of the shallow depth of field it gives there is little latitude, on either side of the subject for focusing errors.

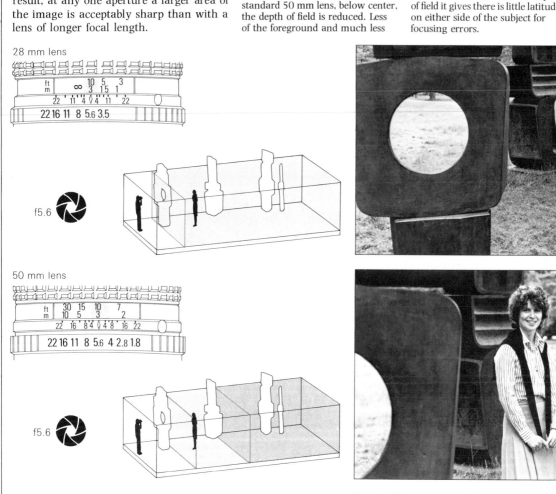

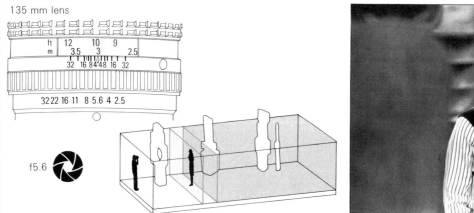

Using long focus and wide angle-lenses

Long focus lenses often give a sense of detachment from the subject in your pictures. This is because they can be used to reduce the perspective so that it does not extend beyond the picture plane toward the viewer. Long lenses are useful when you want to show objects at different distances in close conjunction, or when you want to take candid shots without disturbing the subject.

The greater sense of perspective created by working close-up using a wide-angle lens involves the viewer more. But on extreme lenses or very close-up, shapes can appear distorted. Wide-angle lenses are useful when you are working in a limited space, because they include much more of the subject than a standard or long focus lens.

With a long focus lens any unsteadiness is exaggerated by its narrow angle of view. As a rough guide, do not use slower shutter speeds than the value of the focal length of the lens. For example, 1/125 sec should be the slowest hand-supported speed you can use with a 135 mm lens.

Wide-angle lens
The picture, above right, was taken with a 24 mm lens. This wide-angle lens allowed a close viewpoint, without losing any of the subject. The close viewpoint has created a steep perspective.

Perspective is given by the way that the foreground and background figures, although only a short distance apart, are noticeably different in size. The aperture was quite large — f4 — but the depth of field still extends throughout the picture.

Note the "stretched" shape of the music score lying on the floor. This distortion, created by wide-angle lenses, is most noticeable at the corners of the picture. It has helped to give an even stronger impression of depth.

Long focus lens
A 200 mm lens was used for the picture, right. This made it possible to fill the frame with a comparatively small subject from a distance of about 100 ft (30 m) away. Perspective is flattened because both nearest and furthest objects in the picture are a great distance from the lens. The steps have been compressed almost on to one plane so that the man appears to be climbing a ladder. Even at an aperture of f11, the shallow depth of field with this lens only just renders the subject sharp.

Portraits and distortion
The picture above left was taken with a 28 mm lens at about 2 ft (0·6 m) away from the model. The nearest parts of his face are exaggerated, while the rest of his head recedes sharply. The result is a very unflattering, distorted portrait. The second picture, above right, was taken with a 135 mm lens from about 8 ft (2·4 m) away. The head still fills the picture frame but the distortion has been eliminated by the more distant viewpoint. All his features now appear correctly in proportion to one another.

Special wide-angle lenses

We have seen that short focal length lenses give a wider angle of view, help increase perspective, and can give a greater depth of field than a 50 mm lens. These effects are amplified by very short focal length lenses.

One of the most obvious characteristics of very short focal length lenses is the increased angle of view they give. An 18 mm lens, for example, has about a 94° angle of view. The wider angle of view results in image distortion — straight lines can appear curved and curved lines straight. Lenses can be built to correct this distortion, but with focal lengths shorter than about 17 mm it is increasingly difficult to make a linear corrected lens.

Using very short focal length lenses makes objects appear to diminish rapidly in size with distance. This creates an exaggerated sense of perspective — objects which are quite close appear far apart.

The depth of field on short focal length lenses is very great. Fisheye lenses often give a depth of field that extends from only a few inches away from the lens to infinity, so that focusing is not necessary.

Very short focal length lenses are not positioned at their real focal length from the film. Instead, many modern lenses are of an inverted telephoto design which enables the lens to be positioned further away from the film while maintaining the characteristics of its short focal length.

Shift lenses are a special type of wide-angle lens. They enable you to correct linear distortions produced when working close-up to tall or long subjects.

Wide-angle lenses and distortion
The picture, right, was taken with a 21 mm wide-angle lens from a close-up position. This close viewpoint, plus the image stretch created by the lens gives noticeable distortion of shape and scale. Compare, for example, the size of the girl's nearest hand to her head.

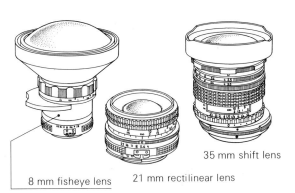

8 mm fisheye lens 21 mm rectilinear lens 35 mm shift lens

Wide-angle lenses

Three types of wide-angle lenses are shown left. The 8 mm fisheye lens, far left, is not corrected for linear distortion and produces a circular image in which most straight lines appear curved. Filtering is done by a disk in the lens barrel. The center, 21 mm lens is corrected for this linear distortion — as with a standard lens, lines parallel to the picture plane appear straight. The 35 mm shift lens, near left, can be moved on the camera around its normal position to control perspective as explained below.

Image stretch

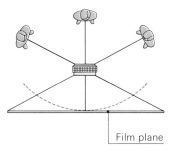

Film plane

A short focus lens positioned near to the film elongates shapes furthest from the lens center. Although modern inverted telephoto designs reduce this distortion you should try to place your main subject near to the center of your picture to minimize the effect.

Shift lens
Some wide-angle lenses have shift mounts, shown below, to control perspective. Normally, when photographing tall subjects, such as the building, right, you have to tilt the camera upward to fit them into the picture frame. As shown near right this makes vertical lines appear to converge. With a shift lens you can correct this by keeping the camera vertical. Instead you displace the lens to take in the subject, so that vertical lines appear normally, far right.

Wide-angles and linear distortion

As the focal length becomes shorter and angle of view greater on a lens, it is increasingly difficult to maintain a normal rectilinear image (straight lines recording without bending). "Corrected" lenses with an angle of view of over 100° begin to distort the image more than if they were not corrected and allowed the lines to curve. This is where fisheye lenses differ from wide-angle lenses. They do not attempt to correct the image. Fisheyes are extreme wide-angles in which image detail rapidly becomes smaller, and straight lines become increasingly curved at the edges of the picture. With fisheye lenses angles of view of 220° are possible, giving circular images within the film frame. A less extreme 180° fisheye fills the whole 24 × 36 mm frame.

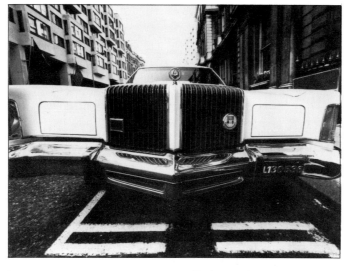

Light path

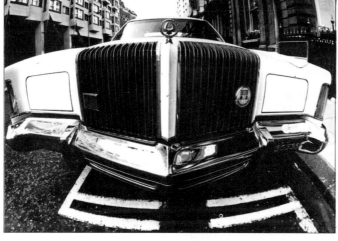

15 mm rectilinear lens

The picture, left, was taken from about 2 ft (0.6 m) in front of the automobile radiator grill using an extreme wide-angle lens. Despite the very short focal length, the lens has normal rectilinear corrections so the lines in the image appear straight and there is no obvious distortion. The width of the car is emphasized by the steep perspective created by the close viewpoint and the wide angle of view.

16 mm fisheye lens

The picture, left, was taken using a 16 mm fisheye lens from the same viewpoint as the picture above. The short focal length gives approximately the same angle of view but the image is distorted. This is because it has been magnified by different amounts across the frame. The central area, for example, has been enlarged and edge details reduced.

Fisheye construction

The diagram above shows the complex arrangement of lenses inside an 8 mm fisheye lens. Two large diverging collector elements at the front of the lens give it an 180° angle of view.

Fisheyes need many more elements than standard or long focus lenses. The glass shapes are difficult to grind and assemble accurately. This means that good fisheyes are expensive, and cheap types often give poor image quality.

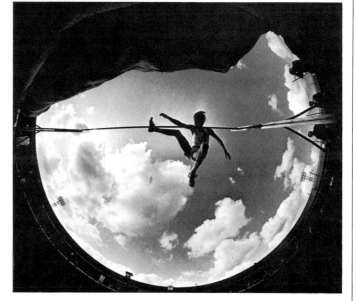

Fisheye converters

A fisheye converter is much cheaper than a complete fisheye lens but has the same effect on the image. It consists of a deeply curved lens which attaches over your standard lens, top right. The best results are achieved when the lens aperture is smallest.

A bird's eye attachment, bottom right, also gives a fisheye effect. It consists of a convex mirror at one end of a glass tube, which fits over your standard lens. The reflecting mirror always shows the camera and the photographer at the center of the image.

Fisheye converter

Bird's eye attachment

8 mm fisheye lens

An extremely short focal length, 8 mm fisheye lens gives a startling 220° angle of view, shown in the picture above. For this high jump shot the camera was positioned facing upward directly below the bar and fired by a long cable release. Even the roof of the stadium is included by the wide angle of view.

Special long focus lenses

Lenses with focal lengths beyond about 250 mm (for 35 mm cameras) offer all the characteristics of long lenses in an extreme form. Compared with standard 50 mm lenses they have a narrower angle, a smaller maximum aperture, give extremely shallow depth of field, and are more bulky.

As focal length increases so the perspective is diminished. Long focus lenses enlarge distant objects which would normally appear very small. As a result distant objects almost begin to appear bigger than larger objects in front of them — a form of optical illusion. Image magnification is proportional to focal length. For example, if you change from a 100 mm lens to a 500 mm lens the image is enlarged five times.

At one time a long focus lens was essentially a weak lens at the end of a long tube. A 300 mm type was spaced 300 mm from the film in the camera, and so on. However, by incorporating other glass elements the light path can be modified, as shown below. This means that the lens barrel can be physically shorter than its true focal length — an arrangement known as telephoto design. Today virtually all long focus lenses are telephotos. Normally, the overall length of the lens barrel is only half its focal length. Even so, lenses of 300 mm or longer are awkward to carry and use. They are also unsuitable for use on direct viewfinder cameras because the effect of parallax is increased by the narrow angle of view they give. The angle of view with a 1000 mm lens, for example, is only 2.5°.

Extreme long focus lenses should be used on a tripod. Camera shake with such bulky lenses is particularly visible because they magnify a small area of the subject. So you should always use a fast shutter speed to reduce the possibility of camera shake recording. This, combined with the fairly small maximum aperture on long focus lenses, means that you will have to use a fast film, or "uprate" the film speed during processing (see pp. 126–7).

Exposure measurement is also a problem when you are taking pictures of very distant subjects. It can be measured most accurately by a spot reading taken with a hand or through-the-lens meter (see p. 104).

The longer the lens, the flatter the image contrast tends to be. This is partly due to the amount of light scattered by the atmosphere between you and the subject. Extra development of the negative will help to compensate for this, and using a lens hood and an ultra-violet filter will assist by reducing unwanted light in the image.

A cheaper alternative to a conventional telephoto lens is a "telephoto-converter", which attaches to your standard lens, as shown below left. Other long focus lenses include the mirror lens and "zoom" lens, discussed on the opposite page.

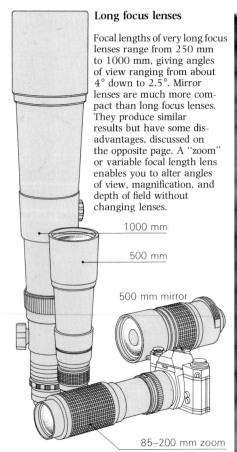

Long focus lenses

Focal lengths of very long focus lenses range from 250 mm to 1000 mm, giving angles of view ranging from about 4° down to 2.5°. Mirror lenses are much more compact than long focus lenses. They produce similar results but have some disadvantages, discussed on the opposite page. A "zoom" or variable focal length lens enables you to alter angles of view, magnification, and depth of field without changing lenses.

1000 mm

500 mm

500 mm mirror

85–200 mm zoom

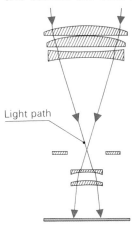

Light path

Telephoto lens construction
The telephoto construction of nearly all long focus lenses enables the lens barrel to be shorter and more compact than its true focal length. After passing through the main, frontal lens elements, the path of the light is slightly diverged by two weak elements at the back of the barrel, so as to give the effect of a lens positioned further from the film.

1000 mm lens
The picture, right, was taken with a 1000 mm lens at f16. Note how perspective is compressed, owing to the distant viewpoint.

Telephoto-converters

A telephoto converter produces similar effects to a true telephoto lens. It fits between your normal lens and the camera body, as shown right. The converter increases the focal length of your regular lens, usually by two or three times. Consequently, lens apertures become proportionally smaller. For example, a 50 mm lens set to f2 with a x3 converter produces the same results as a 150 mm lens set at f5·6. Image quality is poorer with a converter than with a true long focus lens.

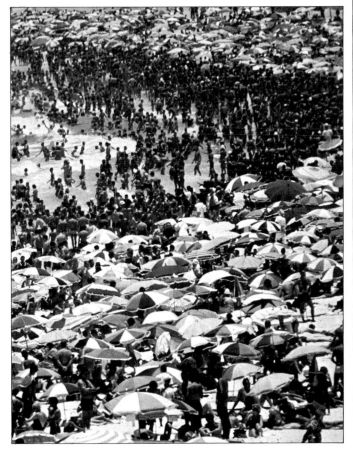

Mirror lens

A mirror lens is a telephoto with "folded up" optics. It uses internal mirrors to reflect the light twice, enabling the lens barrel to be much shorter (although broader). As shown below, light enters through a glass plate and is converged and reflected back by a concave mirror at the camera end of the lens. It then reaches a small backward facing mirrored lens attached to the center of the front element. This reflects the light back through a hole in the concave mirror to focus on the film.

Mirror lenses have two disadvantages. You cannot alter the aperture and, consequently, the limited depth of field; and out-of-focus highlights are spread into rings of light. Most mirror lenses work at an aperture of f8 or f11.

Reflectors
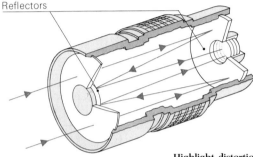

Highlight distortion
When bright highlights are rendered out-of-focus by a regular lens they spread into disk shapes. A mirror lens gives a ring shape to out-of-focus highlights owing to its front mirror. This can be clearly seen in the picture, right, which was taken using a 1000 mm mirror lens.

Zoom lens

A zoom lens has an extra control which allows you to vary its focal length. This requires very complex optics within the lens so that focus and aperture remain constant. The two pictures, right, of the same subject were taken with a zoom lens. The near right picture is equivalent to one taken with a 85 mm lens; the far right picture, is equivalent to one taken with a 200 mm lens.

Altering the focal length during exposure creates interesting blur effects. The picture below was taken with the camera on a tripod and the focal length of the zoom increased during a long exposure. Only the area in the center of the picture remains sharp.

85 mm picture

200 mm picture

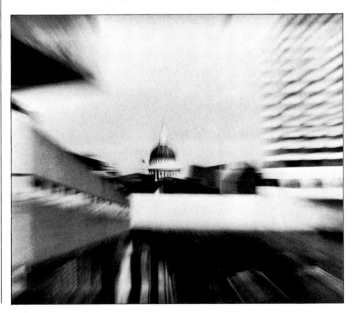

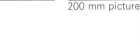

STEP 2 : FILTERS

Colored filters modify the ways colors record. Without filters, black and white panchromatic films turn colors into gray tones which roughly correspond to the tonal range we normally see. Adding colored filters selectively lightens or darkens these tones. In color photography, filters are used to correct or to distort color balance. This will be discussed on page 156.

Colored filters

A colored filter lightens the reproduction of all colors that match its own color, and darkens complementary colors (see p. 148). White, black, and neutral grays in the subject are not affected. You can always preview the effect of a particular colored filter by holding it to your eye and noting the way it affects subject colors.

Filters can be bought as glass disks, or can be cut out of thin gelatin film. Both fit into holders which screw or push on to the front of your lenses. Alternatively, you can buy filters which are ready mounted into holders. Their position on the front of the lens creates difficulties with extreme wide-angle lenses because the holder itself may

cut into the field of view. Most "fisheyes" (see pp. 96–7) house filters within the lens barrel and you just dial in as required. Most mirror lenses (see p. 99) can take filters between the lens and camera body.

Because the dye in colored filters reduces the amount of light that passes through the lens, you have to compensate with a longer exposure. With a through-the-lens meter this is not necessary — because it reads the amount of light passing through the lens. But with other types of metering you must multiply the exposure by the filter factor recommended by the manufacturer.

Ultra-violet filters

Normal black and white (and color) film responds to ultra-violet light. This light is invisible to our eyes, but in distand land-scapes or at high altitudes it makes the scene record much paler. The effect of this — aerial perspective — is shown on page 115. It can be eliminated by using an ultra-violet (UV) filter. This filter is clear and needs no extra exposure, but it removes the ultra-violet light scattered by the atmosphere. It is also used in color photography (see p. 147).

Filtering for blue skies

The picture below was taken through an orange (×3) filter which intensifies its complementary color — blue. The sky is very dark, providing great contrast with the white clouds.

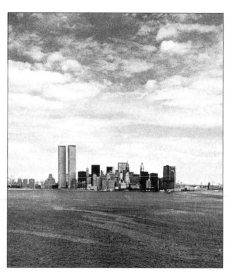

No filter

The subject below was photo graphed on normal, panchromatic film. In the picture the tones of the various fruits and vegetables are approximately the same as they appear to the eye. The tomato, cucumber, and parsley are dark; the apple, bananas, and lemon are light. The overcast sky reproduces light gray. Adding a color filter lightens objects of its own color and darkens its complementary colors.

Red filter

Through a ×6 red filter, below, most green and blue light is absorbed, and these colors are dark in the picture. Reds, such as the tomato appear white.

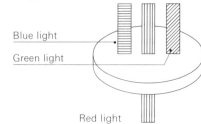

Blue light
Green light
Red light

Green filter

The ×4 green filter used for the picture below absorbs most red and blue light, darkening those colors. Greens are made lighter.

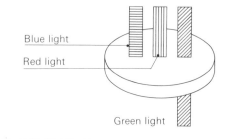

Blue light
Red light
Green light

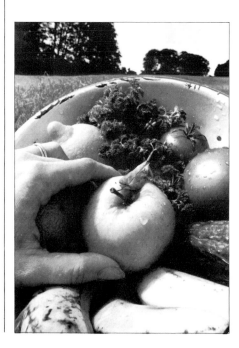

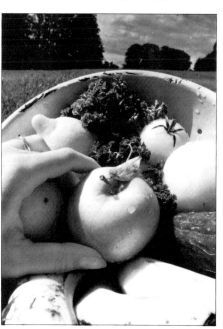

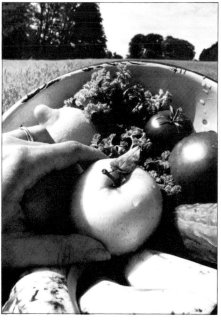

Starburst filter

The picture, right, was taken through a starburst attachment, shown below. This is a molded glass filter marked with a grid of crossed lines. It has the effect of elongating highlights, and so is most useful with subjects containing bright light sources or reflections. An SLR camera allows you to check the exact position of the star "rays". As you rotate the filter, the spread line of each highlight rotates. Its width increases as the lens aperture is reduced.

You can create other spread effects or general diffusion of detail by using a UV or similar clear filter, and smearing its surface with clear grease. This produces a hazy image. If you comb the grease into lines, it spreads the light in one or more directions. You should never do this on the lens surface.

Polarizing filter

A polarizing filter reduces unwanted reflections from surfaces such as glass or water. In the near right picture reflection interferes with the main subject. With a polarizing filter, far right, the reflection is eliminated.

How polarizing filters work

Ordinary light vibrates in all directions; polarized light — reflections from non-metal surfaces or from some parts of a clear blue sky — vibrates in one plane only. A polarizing filter works by blocking the light in one plane, as shown below. The filter can be rotated in its mount, as shown above. When this disk is at right angles to the plane of polarization the unwanted light is reduced.

Neutral density filters

Neutral density filters reduce the intensity of light but do not affect tonal range. The picture above was taken with a small aperture and fast shutter speed. With a neutral density filter added, right, the aperture could be increased so that the depth of field is reduced and only the main subject is sharp.

STEP 3 : CLOSE-UP ATTACHMENTS

Most focusing mounts do not allow the lens to move far enough forward to focus subjects closer than about 12 ins (30 cm). When you want to work close-up there are four devices you can use to solve this: an extension ring or tube, a bellows attachment, a close-up lens, or a "macro" lens.

With all close-up attachments you should use a standard 50 mm lens. Do not use long or very short focal length lenses unless they have a "macro" setting on the focusing ring. This repositions the lens elements, enabling you to work close-up. Zoom lenses are unsuitable as they will not hold sharp focus with close-up attachments.

Macro lenses
If you want to do a lot of close-up work, it is easiest to use a macro lens. Most of these are 50 mm lenses. With them you can extend the lens to twice its focal length, or more, from the film. At two focal lengths from the film the lens will focus the subject at its correct size. Further extension of the lens magnifies the subject.

Lens elements and extension attachments
A close-up lens fits over the front of a standard lens. It converges the light rays before they reach the camera lens, so that very close subjects can be brought into focus.

If your camera has a detachable lens you can use extension attachments between the lens and the camera body — rings, tubes, or bellows — to work close-up. You still use the focusing ring on the lens for focusing. All attachments that fit between the lens and the camera reduce the amount of light reaching the film. To compensate, you should multiply the exposure by the factors shown in the table on the opposite page. This is not necessary if you have through-the-lens metering.

An extension bellows, shown right, is more versatile than rings or tubes. It fits between the lens and the camera to allow continuous focusing.

Close-up accessories
Some useful equipment for working close-up is shown right. A tripod — either a standard or table-top size — is important to keep the camera absolutely steady. You will often have to use very slow shutter speeds, to compensate when the lens is stopped down to improve the depth of field. A cable release also reduces the possibility of camera shake. A tape measure enables you to calculate the increase required in the exposure if you do not have through-the-lens metering.

Equipment for working close-up

Tripod

Table top tripod

Cable release

Ball and socket tripod head
Tape measure

Bellows extension

Extension tubes

Magnification and close-up attachments

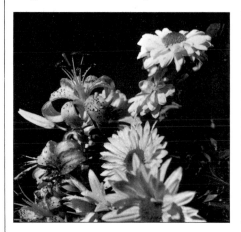

Closest normal focusing
A standard 50 mm lens will allow you to focus a subject sharply down to about 18 ins (46 cm). The flowers above were taken from this distance. Lenses on simple cameras will not even focus this close (see p. 26). In this series, the text refers to image size on the film. The prints shown are enlarged × 2.

Standard lens

Magnification by one quarter
With a close-up lens attachment you can move in to about 9 ins (23 cm) from the subject. This is close enough to magnify the image to one quarter life size on the film. The extra lens reduces the image quality slightly. Sharpness is maximized if you stop the lens down.

Close-up lens attachment

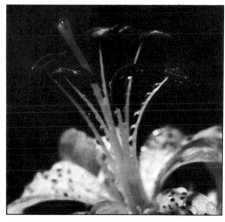

Magnification by one half
The picture above was taken using a standard lens with a reversing ring extension tube. The lens was 6 ins (15 cm) from the subject, giving an image half life size. The ring enables the lens to be reversed so that it is attached to the camera body by its filter thread.

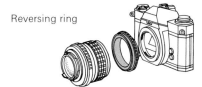

Reversing ring

Close-up attachments and image intensity

When you use a close-up attachment to increase the distance between the lens and film the image becomes dimmer. Doubling the lens-film distance quarters the light. The same amount of light comes through the lens, but because it is spread over a larger area, as shown right, less reaches the film.

A through-the-lens meter will measure the reduced light; but if you use any other sort of exposure meter you must multiply the reading by the relevant factor given in the table below. The figures given only work for a 50 mm lens.

35 mm format

Exposure correction for close-up attachments

Subject distance	6 ins (15 cm)	4 ins (10 cm)	3 ins (7·6 cm)	2½ ins (6·25 cm)
Lens extension	1 in (2·5 cm)	2 ins (5 cm)	4 ins (10 cm)	8 ins (20 cm)
Magnification	½	1	2	4
Exposure factor	2¼	4	9	25

Reminders: lenses and attachments

Wide-angle lenses increase the amount of the scene that is included	A short focus, wide-angle, lens gives a wider angle of view and a greater depth of field than a normal lens. The shorter the focal length, the more the image is distorted toward the edges of the picture frame.
Long-focus lenses magnify and reduce the amount of the scene that is included	A long focus lens fills the picture with a small area of the scene. It has a shallow depth of field.
Perspective is altered by changing camera distance and lens	Changing subject distance and lens changes the apparent perspective in a picture. If you change your viewpoint to fill the frame, a long focus lens will tend to eliminate perspective and a wide-angle lens increase it.
Colored filters alter the tonal balance in black and white photography	Colored filters lighten their own colors and darken complementary colors.
To work close-up you must increase the distance between the lens and film	To work closer than about 12 ins (30 cms) use a standard 50 mm lens with extension tubes, a close-up attachment, or bellows; or change to a "macro" lens. If you do not have through-the-lens metering, increase exposure.

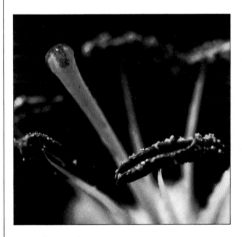

Magnification by one
One short plus one long extension tube position the lens twice its usual distance from the film. The image on the film is now the same size as the subject. Distances from subject to lens, and lens to film, are both 4 ins (10 cm). Depth of field is very shallow so focusing is critical.

Magnification by one and a half
A whole set of extension tubes allows still closer approach, to about 3¼ ins (8.3 cm) from the subject. The lens is two and a half times its focal length from the film, and the image is increased to one and a half times the size of the subject.

Magnification by two and a half
Fully extended, the bellows unit below positions the camera lens three and a half times its focal length from the film. The lens is about 2¾ ins (7 cm) from the subject, giving an image two and a half times life size. For such magnifications, photographers often use a reversing ring with the bellows or a macro lens.

Two extension tubes

Set of extension tubes

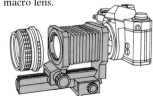

Bellows extension

STEP 4: EXPOSURE CONTROL/Metering techniques

Light meters measure the light so that the mid-tones of the subject are always acceptably reproduced in the picture. (The basic methods of taking light readings were introduced on pages 42–3.) But by using more advanced meters or methods of taking readings you can more closely control the tonal range in your pictures.

You may want to bring out detail in the highlights or shadows or limit the range of tones in your picture. With practice you can take your exposure readings and determine which parts of the subject will reproduce dark gray, mid-gray or light-gray.

For most subjects a built-in camera meter is convenient and quick to use. If you are using filters or other lens attachments that alter the light reaching the film, a through-the-lens meter automatically measures the reduced light. But a hand-held meter is more versatile for advanced exposure control. It enables you to take more specific measurements from the subject or fit attachments to control the exposure reading.

Instead of taking a reading from the reflected light, by fitting a light-diffusing dome over the meter you can measure the light that illuminates the subject — an "incident" light reading. This ensures that maximum detail in the highlights is recorded on the film. Some hand-held meters are also available or can be adapted, by using a spot reading attachment, to take distant readings from a very small part of the subject.

Advanced light reading equipment

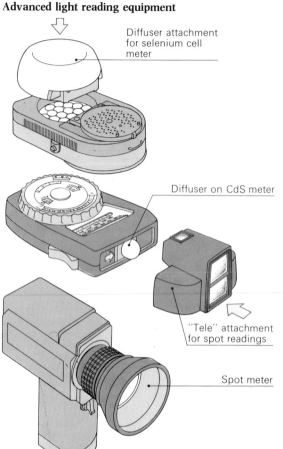

Diffuser attachment for selenium cell meter

Diffuser on CdS meter

"Tele" attachment for spot readings

Spot meter

Most hand meters have a small plastic dome or disk which fits over the light sensitive cell. This is used for incident light readings where the meter is pointed toward the light source instead of the subject. The plastic dome diffuses the light as it enters the cell and widens the meter's angle of view. On a selenium cell meter the dome clips over the cell. The much smaller cell on a CdS meter can be covered by a sliding diffusing attachment.

Some hand meters will accept a narrow angle, spot reading attachment. This has a viewfinder so that you can aim the meter accurately to cover a selected part of the subject. A spot meter enables you to read from a very small area of a distant subject and so is very useful with long focus lenses.

Spot meters with a built-in viewing screen are more sophisticated than the adaptors. You dial in the ASA film speed and shutter setting before viewing the subject through a viewfinder. The meter covers a 1° angle of view, which is shown on the viewfinder. The aperture number for the correct exposure of each area appears on a display when you pull the meter trigger.

Spot meter readings can be modified by turning a dial so that the chosen area will be white on the print instead of mid-gray.

Taking readings for highlights

The two pictures, right, show the effect of measuring for highlights in exposure. In the top picture an overall reading was taken and the highlights are overexposed. In the bottom picture the reading was taken with an incident light reading attachment on meter. This ensured that highlight detail—very important here—was not overexposed.

There are three ways of ensuring correctly exposed subject highlights. You can use a spot meter to measure highlights only, and then modify the reading. This measures from the reflected light.

The other two methods — a white card, and a meter fitted with a diffusing attachment — use incident light. When using a white card, hold it near the subject and take a reading about 6 ins (15 cm) away from the card. Then increase the meter reading by eight times to reproduce highlight detail almost white, not gray.

With an incident light attachment, hold the meter near the subject, pointing toward the light source for highlight detail. The reading gives correct exposure.

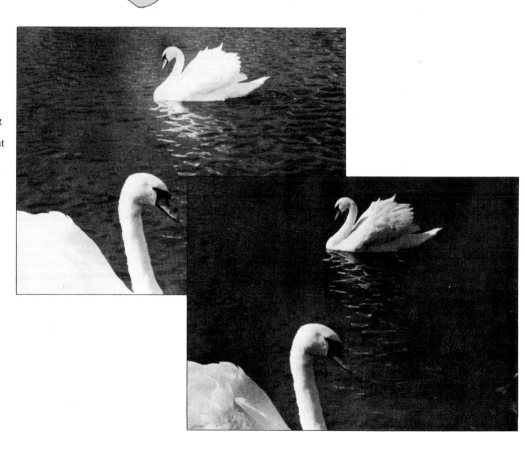

The zone system

The zone system was devised by the American photographer, Ansel Adams, as an aid to calculating the required exposure for a particular range of tones. It divides the tone scale into separate zones, numbered 0–9. A reflected light exposure reading taken from a gray card, or its equivalent within the subject, will record that area in the tone of zone 5. Increasing or decreasing exposure by one f stop will move the tone reproduction throughout the picture by one zone, up or down the scale. Remembering this you can adjust the exposure to make any subject tone you choose record as zone 5.

The zone system is based on a Weston hand meter, and requires strict control of development and enlarging conditions. However, it is a system you can apply generally to hand and camera meter readings.

Gray card reading
Taking readings from a gray card, as shown right, will maintain a constant mid-gray in all your pictures. Measure the reading off the card under subject lighting conditions. "Mid-gray" card is sold by Kodak, but any suitable mat surface card reflecting 18 per cent of incident light is suitable.

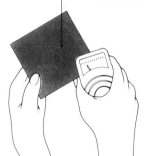

The zone scale
The subject above reflected a wide range of tones. Using one gray card reading they reproduced as values on the scale, above left.

This general reproduction of detail is suitable for most subjects. Meter readings are designed to give this sort of result. But sometimes you may want to reduce shadow detail in the image, by reducing the exposure, or reduce highlight detail, by increasing the exposure. Increasing exposure by one f stop shifts all the tones in the picture along the scale by one value. Subject areas 4 and 5 will be interpreted as zones 5 and 6 and so on, showing more detail in the shadows, less in highlights. The reverse happens when exposure is reduced.

To use the zone system you must standardize your processing and printing, following the procedure that will reproduce the full zone range from a subject with a wide range of tones.

Selecting zones
The essence of the zone system is to "place" one tone value by careful exposure measurement, then if necessary control where other tones fall by altering development. The picture below right shows the result of giving an overall reading and normal development. The girl's shadowed face has reproduced as about zone 2 on the zone scale, so all detail is lost. In the picture below left the meter reading was taken from close to the face. This showed that three f stops more exposure was needed, reproducing the face as zone 5. The lighter background is now mostly zone 8 and "burned out". Detail here can be improved by giving the negative less development (p. 127) which compresses the whole tone scale. This would restore the background to about zone 7 or 6.

Shadow reading

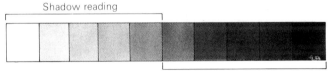

Highlight reading

Low lighting

If you intend to take many pictures indoors or after dark using available light you should use lenses that have a wide maximum aperture. A lens with a maximum aperture of f2 will allow you to take hand-held pictures in half the light possible with an f2·8 lens.

In dim lighting a light meter sensitive enough to give reliable readings is essential. Selenium cell meters are comparatively insensitive in poor light. Battery powered hand and built-in meters with CdS, silicon or similar cells (see p. 39) are much more responsive. If lighting conditions are very low, you can use a white card reading to get a response from the meter, as shown on page 104. Alternatively, set the ASA dial to twice or four times the correct rating for the film to get a meter reading. Then multiply the reading by this amount.

Long exposure times create problems of camera shake and reciprocity failure, as explained on the opposite page. To avoid these, you can use supplementary lighting, discussed on pages 108–13.

Contrasty lighting

Low light level subjects such as room interiors, bars, or street scenes at night are usually contrasty as well as dim. The lighting is much more uneven than daylight. As a result contrast is more of a problem than dimness. The more exposure you give to bring out shadow detail, the more "burned out" the lightest areas become. "Uprating" the film, by underexposing and overdeveloping (see pp. 126–7), which has advantages for dim lighting, increases the contrast still further. It is better to choose a viewpoint from which the subject is as softly and evenly lit as possible, rather than just brightly lit. To do this, make use of any supplementary lighting from signs, reflective surfaces, or open doorways. The flatter the lighting the more you can overdevelop fast film — up to 3000 ASA or beyond — and still avoid producing unacceptably hard negatives.

If you are using flash lighting you can reduce contrast by firing the flash several times during a long exposure (see p. 113).

Contrast and distance

When photographing someone indoors it is tempting to place them near the window. This does increase the light but often gives very harsh contrast, as shown near right. By moving the subject away from the window and toward the opposite wall the contrast is reduced, as shown far right. Light from the window is weaker and reflected light from surroundings such as the rear wall is increased. The exposure must be increased to compensate for the reduced light.

Low intensity, soft lighting

Subjects with low, soft lighting, such as shown left, are not difficult to expose for if you have an accurate light meter. The exposure reading suggested was 1/30 sec at f2 on fast, 1200 ASA film. But to avoid camera shake it was exposed at 1/60 sec, and the film given longer development. Because the lighting was soft the overdeveloped negative still printed well on normal grade paper.

Low intensity, harsh lighting

Low intensity, harsh light created by a dark-toned interior, and brilliant daylight outside a window presents a difficult exposure problem. It was solved in the picture, below, by losing the detail through the window. The exposure was measured by averaging only the light and dark areas within the room. The 400 ASA film was overexposed by one stop, then given reduced development to decrease the contrast.

Weak, uneven illumination

Under weak, uneven light you will often have to use a very long exposure. One way of reducing the contrast is to spread the illumination. Indoors you can do this by using light-toned reflectors positioned around the subject. Or, if you are working under normal room lighting, you can swing the light, during exposure, to spread the illumination. If the lamp is included in the picture its path will record as white trails. Outdoors at night you can use street lamps or the light cast by passing automobiles to illuminate a scene. The long exposure will record moving lights as bright lines, such as shown right, which can form interesting patterns in themselves.

Reciprocity failure

If you give extremely brief or long exposures most films behave as if they have a slower speed rating and give altered contrast. This is called reciprocity failure. It means that you must give extra exposure when working at speeds of faster than 1/1000 sec or longer than $\frac{1}{2}$ sec. The easiest way to do this is by opening the aperture, as a longer exposure will simply increase the reciprocity failure.

In practice you will hardly notice any effect on black and white film with exposure times of up to 2–3 seconds. Color films show a noticeable color change at slow speeds.

The table below shows by how much you should open the aperture to compensate for reciprocity failure with normal black and white film. The development time should also be adjusted as shown below, to reduce the contrast. Long exposures increase contrast and require a shorter development.

Indicated exposure (secs)	$\frac{1}{10}$	1	10	100
Aperture increase	0	1 stop	2 stops	3 stops
Reduction in development	0	10%	20%	30%

Candlelight

A solitary candle gives very hard, contrasty lighting. But in the picture above, the random grouping of candles has created a softer, almost floodlit effect. The high contrast was reduced by the reflective white table cloth and slight flame movement during the 4 second exposure. The light reading was measured from the faces to record them correctly. Notice how the figures were arranged so that they could hold their positions comfortably during the exposure.

The aperture suggested by the meter reading was increased and the development time of the film reduced to avoid reciprocity failure with the long exposure.

STEP 5 : ARTIFICIAL LIGHTING/Equipment

With artificial lighting, you have complete control over the direction, quality and strength of the light. You can move light sources around, and diffuse or reflect them. In addition, you can alter the intensity of light to suit the subject, or to match a chosen lens aperture or shutter speed.

Such control enables you to use the lights to create many special effects. But for most purposes you will want to produce lighting that looks natural and does not intrude upon the main subject. This requires great skill and imposes some restrictions on using artificial lighting. For example, normally we are used to seeing one set of shadows, as cast by the sun, not two or three as produced by several lights. And natural lighting is usually cast from above, not below the subject.

Everything you have learned so far about natural lighting quality and direction also applies to artificial lighting. You can decide to use a harsh light source, such as a spotlight, flashbulb or desk lamp, to give lighting quality similar to direct sunlight. Or you can use a photoflood to cast softer illumination which will give lighting comparable to hazy sunlight. With either light source you can produce an effect like overcast daylight by diffusing the light with tracing paper, or by reflecting it off a mat white surface.

Natural and artificial lighting
For most subjects you will want to use artificial lighting to reproduce the effects of natural light. You will only want to create unnatural lighting conditions for special effects. To simulate natural lighting you have to control the position of the lamps and the quality of the lighting very carefully.

The picture, top left, was taken in diffused daylight. Detail is clear on the girl's face and there are no harsh shadows. The picture, bottom left, was taken in artificial lighting, carefully set up to create a similar diffused quality to the natural lighting. Two diffused photofloods were used, one as a main lamp and one to fill-in any shadows. Again, the lighting is constant across the subject and detail is clear and distinct on the image.

Light and surface

To control lighting, you must understand how light changes in quality and direction when it meets a surface. The five main effects are shown below — light is either diffused, reflected or absorbed, or sometimes modified by a combination of these changes.

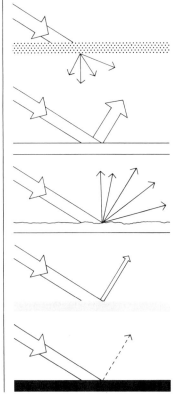

Diffusion
A diffusing material such as tracing paper, ground glass, or opal plastic, scatters light passing through it. This changes its quality from hard to soft.

Specular reflection
When you reflect direct light off a glossy light-toned surface, it remains harsh and directional. The reflection records as a glare spot.

Diffuse reflection
Reflective, irregular surfaces, such as blotting paper or other textured materials, scatter light. This alters the quality of the light, changing it from hard to soft.

Selective absorption
Smooth gray or colored surfaces absorb some light and reflect the remainder. Colored surfaces reflect selected wavelengths (see pp. 141–3); gray surfaces a percentage of all wavelengths.

Absorption
A black surface absorbs most of the incident light falling on it. The light energy is usually turned into heat, so dark-toned subjects or equipment will heat up easily.

Lighting equipment

There are two main kinds of photographic tungsten lighting: spotlights and photofloods. Spotlights are small clear lamps, which give you a concentrated beam of hard light. You can soften the light by diffuse reflection from a mat white surface, such as a white lined umbrella, or a white wall. You can also pass it through a diffuser, made of gauze or tracing paper. Barn doors and snoots attach to spotlights to restrict the beam width. A photoflood has a diffused lamp and large mat reflector, and gives you softer, even lighting.

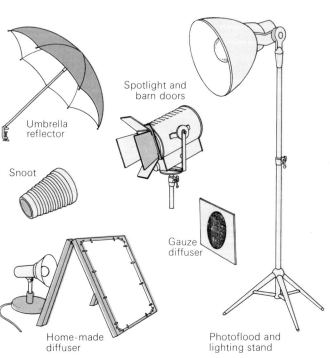

Umbrella reflector

Spotlight and barn doors

Snoot

Gauze diffuser

Home-made diffuser

Photoflood and lighting stand

Using one light source

When you are learning to control lighting, block out all other light from the room so that lighting effects are created by you alone. You can start experimenting with a single lamp — a small flood or a spotlight — on an adjustable stand. Set up an interesting still-life subject, and place your camera on a tripod. At first, position the lamp near to the lens axis so that you can see full detail while focusing and composing. Then move the lamp, varying its height and position in relation to the subject. The lighting variations produced by the five different positions of quite a hard light source illustrated in the diagram, right, are shown on this page.

Notice the enormous changes produced in the apparent shape and form of the bust, even by a relatively small movement of the light source. The effect is more dramatic than similar changes in the direction of sunlight outdoors because of the absence of softening fill-in light from the sky. As well as moving the light, explore the effects on your still-life of changing from a hard light source to a soft, diffused one.

Lighting positions

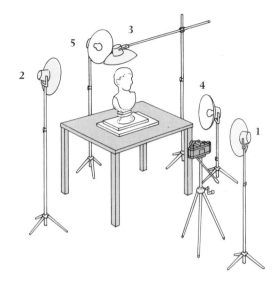

1. Front lighting
Front lighting reveals detail, but also flattens subject form and texture. The effect on the bust, shown above, is uninteresting — the picture appears all on one plane.

2. High side-lighting at 45°
Side lighting gives a much bolder, three-dimensional effect. However, deep shadow suppresses detail in the parts of the face furthest from the lamp.

3. Top lighting
With the lamp placed above the bust, all its top-facing surfaces are highlit. The eyes and neck are in deep shadow, but the forehead, nose and cheek bone are emphasized.

4. Low side-lighting at 45°
Low side lighting gives a "footlight" effect. Since the head is facing the lamp, both sides of the face are lit. But an ugly shadow is cast by the nose.

5. Back lighting
The lamp is just above the bust facing the camera. Mat white paper beside the camera scattered some illumination on to the bust to give an even, low illumination.

Hard and soft lighting

Both of the pictures, right, were side-lit by the same single source, from the same height and position. For the near right picture a spotlight was used direct. This produced harsh light with dense, sharp-edged shadows. For the far right picture a large sheet of tracing paper was placed across the light beam, close to the subject. This diffused the light, producing soft quality side-lighting that reveals form and detail in the subject.

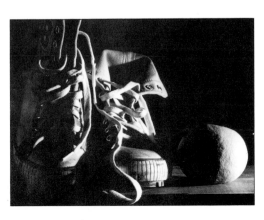

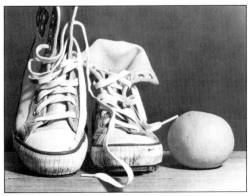

Using two light sources

There are times when one lamp is not enough, and you must add another light from a different direction. This may be to reveal detail in shadow areas, light one part of the picture separately, or simply to illuminate a larger area. The most important rule in lighting is to decide exactly what job you want each lamp to do. Never add lamps indiscriminately just to increase the light.

Always treat one lamp as your main source, and begin by selecting its best position. If it is close in, it will create strong contrast. Further back it will have a more even effect across the subject.

Filling-in shadows
Often your main lamp will reveal form and shape in the subject but create dark, empty shadows. You can fill these by placing a second lamp opposite the first. If the two lamps are the same distance from the subject they will "cancel out" and give unnatural double shadows. To avoid this, "bounce" (reflect) the second light off white card, or diffuse it. This dims and softens the light, so that only one set of strong shadows are formed by the main lamp. You can fill-in shadows, even when working with a single lamp, by reflecting some of the light back on to the subject, as shown right.

Lighting the background
You can control the tones in the subject and the background independently of each other by using a second lamp to light the background. A gray card background, placed a reasonable distance behind the subject, helps you to assess the effect of the second lamp. If the card is lit more strongly than the subject, it will appear almost white. But if the subject is lit more strongly, and the exposure adjusted accordingly, the background will then appear quite dark.

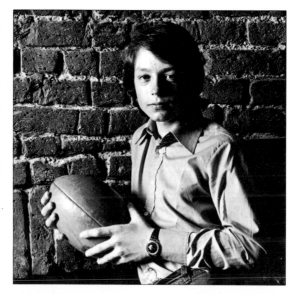

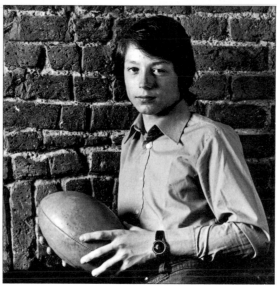

Using one lamp and a reflector
The picture, left, was lit by a small floodlight about four feet (1.2 m) from the figure. The strong side lighting shows the form of the figure and brings out the texture of the wall, but the shadow areas are unnaturally harsh and lack detail. These dark shadows could be reduced by using a second, weaker light source to fill-in. For the picture, below left, a large white reflector board was used to reflect back diffused light. The shadow areas were illuminated without creating conflicting shadows. The effect is less artificial than the first picture and more like sunlight plus light from the sky. Notice how the lighting is still rather uneven left-to-right across the picture — this could be corrected by increasing the distance of the lamp, or by printing-in (see p. 86) when printing.

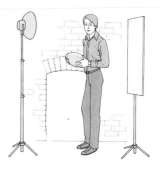

Controlling background lighting

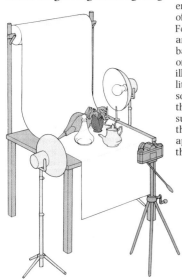

Using two lamps on a subject enables you to control the lighting of your subject very accurately. For the still-life, left, two lamps and a roll of seamless paper for the background were used. The lamp on the left provided the main illumination. The one on the right lit the background independently, so that it was possible to control the background tone relative to the subject. In this way you can arrange that the lightest parts of the subject appear against the darkest part of the background and vice versa.

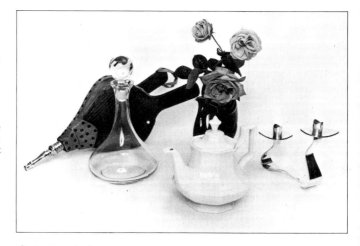

Eliminating shadows
The still-life above was lit by a diffused lamp above the camera. There are no hard shadows, but light tones tend to merge with the bright background.

Varying lighting distance
When you are photographing strong three-dimensional shapes, using a second light source at varying distances gives complete control of tonal values. In the example shown right, the top picture was lit with two equally placed floodlamps, resulting in even tone and flatness of form. For the lower picture, the distance of the right hand lamp was doubled, quartering the illumination from this side. This has darkened two faces of the cube and rounded the cone and cylinder. Placing the second lamp even further away would increase the effect.

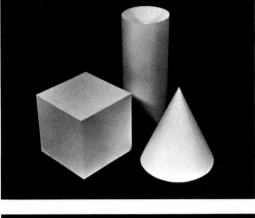

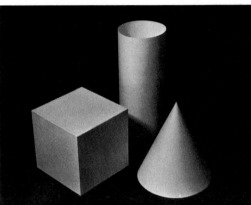

Inverse square law

Doubling the distance between a lamp and a subject quarters the surface illumination. This "inverse square law" strictly applies only to compact, bare lamps. Reflectors upset the relationship slightly. But it forms a good working guide for positioning lights. You will meet the law again when you use extension bellows (see p. 103) or calculate exposure for flash (see p. 112).

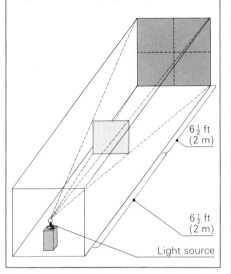

$6\frac{1}{2}$ ft (2 m)

$6\frac{1}{2}$ ft (2 m)

Light source

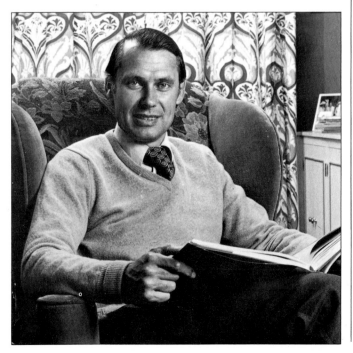

Using a spotlight and floodlamp
The picture below was lit by one spotlight, high and to the right of the camera, plus a photoflood from the rear left. The lighting is hard but naturalistic — you have the impression that the man is using a reading lamp in the room with other lighting. Notice how the photoflood lights the side of the head which would otherwise merge in shadow with the chair.

Using two lamps, bounced
For the picture above two lamps were used, both directed on to the ceiling. The result is even, soft, top lighting, similar to the quality given by a diffused domestic ceiling lamp at night. (Flash bounced off the ceiling gives very similar results, see p. 113.) This lighting can form dark, downward shadows. To reduce this effect you should illuminate the ceiling above the camera more than the area directly above your subject.

Using flash

A flash unit is basically a portable, hard light source. It briefly lights a wide area, but the illumination it gives falls off rapidly with distance. There are two quite different types — bulb and electronic. Bulbs are cheap to buy but can only be used once. They give a brilliant flash lasting around 1/50 sec. Electronic flash units cost more to buy but give thousands of flashes, each lasting less than 1/1000 sec. Both types are color balanced to match daylight (see p. 146).

The flash is usually briefer than the time your shutter is open, so it, not the shutter speed, determines the actual exposure time. The shutter must however be fully open at the moment the flash fires. This means you must synchronize the flash with the shutter, and with focal plane shutters, use speeds of 1/60 sec or longer, so that the complete frame is exposed.

You cannot measure the light given by a flash with a regular meter, the exposure is calculated indirectly. Guide numbers, or "factors", supplied with the unit give you the combinations of aperture and subject distance for the correct exposure.

You can use flash on almost any subject. You can vary its position — it need not be on the top of the camera — and use it bounced or diffused as well as directly on the subject. It also has some special advantages. You can use it to fill-in harsh shadows or simulate sunlight. With electronic flash you can "freeze" fast movement, or even give a series of flashes during a long exposure, to create unusual effects.

Types of flash

Flashbulb

Flashbulb reflector unit

Synchronizing lead

Reflector for bounced flash

Electronic flash

Bulb flash
Flashbulbs burn brilliantly for around 1/50 sec. The illumination rises to a peak and then fades. You use a battery to fire most bulbs, but some require only the weak current generated within the shutter. The flashbulb unit fits into the "hot shoe" on the top of the camera (see p. 29) or it can be plugged into the "M" socket on the camera, using the synchronizing lead, shown left. Flashbulbs are available in cubes, flip-flash bars or individual bulbs, such as shown left. Bulbs can be fitted into reflector units.

Electronic flash
Electronic units use batteries, and can be used in the "hot shoe" or plugged into the "X" socket, using the synchronizing lead. The flash is immediate, constant, and very brief. Units range from miniature types to large professional kinds. The intermediate unit, shown left, has a head which can be tilted to "bounce" the light. Some units read the illumination during the flash, and cut it off as soon as enough light has been given for the aperture in use.

Aperture and distance
Flash units carry guide numbers, or factors from which you calculate the correct exposure. Exposure is correct if your chosen f number multiplied by your flash-to-subject distance results in the guide number for your film speed. For example, if the guide number is 110, you can use f11 at 10 ft, f22 at 5 ft, and so on. This relationship between aperture and distance depends on the inverse square law (see p. 111).

Synchronization of flash and shutter
In the diagram below, the center disk shows when the shutter is open; the outer ring the flash period; and "C" when the shutter triggers the flash. A flashbulb is correctly triggered by the "M" socket, top left, allowing the bulb to burn to full power. Electronic flash fires correctly with the "X" socket, bottom left. Electronic flash fired on "M", top right, or a flashbulb on 'X', bottom right, fails to synchronize with the shutter.

Positioning the flash
The picture, right, was taken with a flash fired from on the top of the camera. It has created harsh, unnatural lighting.

The picture, below, shows the same subject, again taken with flash. The more natural lighting was achieved by pointing the flash upward to bounce it off the ceiling. Some flash heads hinge for this purpose; others have a "bounce board" included with the unit. When using the flash indirectly you must compensate by increasing the exposure by two stops.

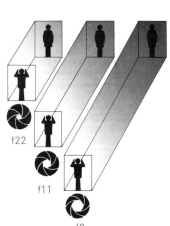

f22

f11

f8

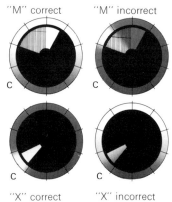

"M" correct "M" incorrect

C C

C C

"X" correct "X" incorrect

Fill-in flash

Flash is a useful fill-in light source when existing lighting conditions are very contrasty. This happens, for example, when you are taking a subject indoors against a bright window, such as shown below left. Used carefully, fill-in flash enables you to expose for the detail through the window without underexposing and losing detail in the subject and interior, below right. You can use flash in either daylight or tungsten light for black and white photo-graphy. But for color film, avoid mixing flash with tungsten light because the flash light is color balanced for daylight.

Fill-in flash is best used on the camera itself, but it is usually necessary to bounce or diffuse the illumination given by the flash to prevent double shadows from forming in the subject.

To calculate the exposure for fill-in flash, double the flash factor, divide it by the subject distance, and then set the resulting f number on your camera. Now use your exposure meter to measure the brightest existing highlight area, and use the shutter speed that is shown against your calculated lens aperture. Doubling the flash factor underexposes the light given by the flash by two stops. As a result the flash does not record as brightly as the existing lighting — filling-in the shadows without upsetting the balance of the natural lighting.

Lighting a dark interior

When you are photographing a dark, contrasty interior, such as shown below, you must use arti-ficial lighting to avoid under-exposing the scene, such as shown left. By firing the flash from several different positions during a long exposure you can light the whole subject without destroying the impression of natural lighting. In the picture, below right, the camera was on a tripod and the shutter set to "B", the flash was fired from six separate points to give natural, even lighting and to bring out detail.

Reminders: exposure and artificial lighting

By taking the exposure reading carefully you can control the tonal range in the image	Measure the exposure from the most important part of the subject. An incident light reading measures the high-lights in the subject, other wise the area you read will record mid-gray.
In low lighting avoid reciprocity failure	The long exposures required in low lighting may create reciprocity failure. Adjust the aperture and reduce the film development time to over-come this.
Artificial light can be used to simulate natural lighting or for special effects	Spotlights, photofloods, and flash, plus diffusers and reflectors are generally used to simulate natural light con-ditions. To do this consider carefully the height, direction, and quality of your light source
The inverse square law relates distance and illumination	Doubling the distance between a lamp or flash and the subject quarters the illumination.
Flash gives hard lighting which must be synchronized with the shutter	Flash gives similar lighting to a single tungsten lamp. All flash must be synchronized with the shutter. With focal plane shutters use 1/60 sec or longer. Exposure is calcu-lated from the guide numbers.

STEP 6: ADVANCED PICTURE BUILDING/Linear perspective

Making your photographs look three dimensional mainly depends on your use of linear and aerial perspective. Linear perspective in a subject is created by lines appearing to converge toward one or more "vanishing points". The more steeply you make the lines converge, the greater the sense of three dimensions. Vanishing points may fall inside the picture frame, as in the picture right, but often they will fall at imaginary positions outside the photograph.

A picture may have one or several vanishing points. The picture shown right has one vanishing point. Two or more vanishing points are created when lines or surfaces in the picture are at right angles to each other, and are oblique to the picture plane. You can see this when you stand at a street corner looking down two streets — the buildings appear to diminish and converge at two separate points. Two point perspective is shown in the picture below right.

Camera viewpoint and angle, and the focal length of the lens are important for emphasizing linear perspective. A close viewpoint used with a wide-angle lens gives a steep perspective. Receding horizontal lines converge sharply, making corners, walls or similar elements close-to loom toward the camera. A distant viewpoint with a long focus lens gives a shallow perspective. Receding horizontal lines hardly seem to converge at all.

The angle of your camera to the main lines of the subject determines which surfaces will be seen most obliquely — increasing the feeling of depth — and which will be seen square-on — reducing the sense of depth in your picture.

Single point perspective
Diminishing, repeating elements such as the arches and their shadows above create a strong feeling of depth. The single point perspective is shown in the diagram below. The effect is increased by positioning the camera to one side of the arches and by including a close-up of the near wall surface. The changing forms of the arches emphasizes the sense of depth and the close-up of the wall highlights the diminishing scale of the pillars.

Two point perspective
When viewed obliquely the two near faces of the building, right, appear to taper to two vanishing points on either side of the building. Bringing the two vanishing points closer together will increase the perspective. You can do this by moving in closer, so that the lines converge more steeply.

Moving the camera to the left or right will steepen the converging lines of one wall, and flatten them on the other. If you tilt the camera up or down, you will notice that vertical lines start to converge toward the top or the bottom of the frame, forming two more vanishing points.

It is a useful exercise to take up a camera position, and then study the changes in perspective on your focusing screen while you move the camera from side to side or up and down. Subject geometry alters dramatically, particularly if you are using a wide-angle lens. If you move back and change to a longer focal length lens to keep the subject the same size, linear perspective is less steep and the sense of depth is reduced (see p. 93).

Aerial perspective

Objects at differing distances in a landscape tend to appear progressively paler and less contrasty the further they are from the camera position. These changes in tone create aerial perspective.

You can emphasize aerial perspective by arranging your camera position so that a dark toned object is included in the foreground. But still take care that the tone values in the main subject are recorded accurately. Measure the exposure so that mid-distance grays reproduce correctly. The final print will then include the pale detail in the background. Remember that in distant landscapes background detail may record weaker than it appears to the eye, and almost be lost, unless you use an ultraviolet filter over the lens (see p. 101).

For interior shots it sometimes helps to use aerial perspective to make a room appear much bigger than it really is. You can simulate the outdoor effects of haze and ultra-violet light by choosing lighting that emphasizes darker, close-up objects and progressively softens the tone of objects the further they are from the camera.

Using aerial and linear perspective
In the picture, above, a strong feeling of three dimensions and depth has been achieved by both the viewpoint and lighting. The position of the window gives lighting quality and direction that creates a sense of aerial perspective in a relatively small space. The wheelchair in the foreground appears almost as a heavy silhouette and objects generally become paler in tone the further they are from the camera. Also, by choosing a viewpoint in the corner of the room and using a wide-angle lens, a two point linear perspective has been formed. Lines converge strongly toward two vanishing points outside the picture, left and right.

Aerial perspective in landscapes
The scene, left, is given considerable depth by the way tones change with distance. The background mountains are very pale in tone, showing the effects of haze and light scatter by air molecules. The hills in the middle distance and foreground appear progressively darker and stronger in tone. The aerial, or atmospheric, perspective effect here is greatly helped by the low lighting from the side and rear.

Creating emphasis

The camera often records too much — unlike the eye, it cannot distinguish between important and unimportant details. You can remedy this by moving close-up to exclude all the background. But frequently you want to show or at least suggest the environment, to give your subject depth and character. Several techniques can help you use the environment to emphasize and support the main subject, without detracting from it.

One of the principal ways you can direct the viewer's eye is by using perspective. If you compose your picture carefully in the viewfinder, you can make the surrounding lines and shapes create a natural frame or lead-in to your subject (see p. 61).

You can make your subject stand out from the background by selective focusing. Limiting depth of field to the main elements and leaving the rest blurred gives the subject special emphasis. Alternatively you can pan the camera with a moving subject, to render it sharp and blur unwanted surroundings, as shown below. Or you can focus on a stationary object, which will stand out if it is positioned against a moving background.

And finally, you can make use of the effects of exposure and lighting to place emphasis on one area of your picture. You can correctly expose the center of interest and under- or overexpose the surroundings; or light only the main subject, using studio lamps or flash.

Using perspective
The picture above uses linear and aerial perspective to convey depth and so emphasize the solitary foreground head and shoulders. The position of the head at the vanishing point in the composition, and at the inter-section in the scene, directs our attention.

The depth of field is shallow, reducing distracting detail in the background, but it is still sharp enough to capture the context of the portrait.

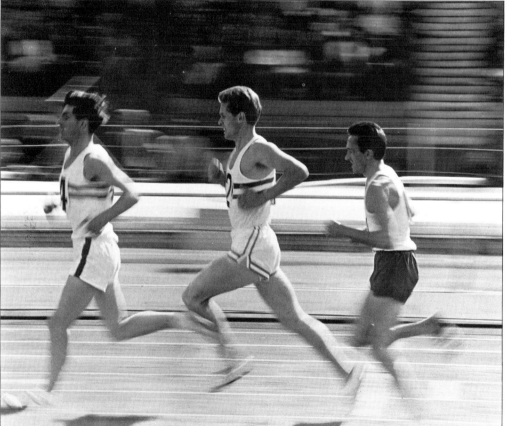

Using blur
Panning enables you to use a slower shutter speed to freeze action than when the camera is still. Prefocus on the path of the subject; move the camera in a smooth arc to follow the direction of the movement.

Shutter open

Camera follow through

Path of moving subject

Using lighting
The foundry where this picture was taken, right, was cluttered by machinery and pieces of metal. In order to simplify the picture and concentrate on the casting, the scene was lit by flash.

The flash unit was taken off the camera and connected to the camera shutter by a long lead. It was held above and to the left of the ladle, so that the narrow beam of side-lighting illuminated all the important elements, leaving the background and foreground in shadow. Exposure was calculated for the flash-to-subject distance. As a result the surrounding, unimportant detail is left dark.

Using selective focus
Not all pictures can be specially lit — this portrait of the sculptor Giacometti below was taken in available light. A long focus lens and wide aperture were used to give a depth of field of only about 12 inches (30 cm). The sculptor and one of his works were the same distance from the camera. So these two elements are picked out and emphasized, while the other sculptures reproduce as diffused silhouettes — simplified but still recognizable in style. Exposure was measured from light reflected from the face, to leave the background pale and unobtrusive.

Using the environment

Your initial reaction to an unfamiliar environment can often be the truest. Perhaps you find a subject peaceful or dramatic, mysterious or exhilarating. It adds character and life to your pictures if these impressions are well conveyed.

The camera will often record too much — it is as important to know what to omit from a picture as what to include in it. Frame your image to exclude any details that might interfere with or distract from your main subject. Select an appropriate part of the environment and try to portray it in such a way that it sums up the whole. Sometimes it is best to concentrate on close-up details. Notices, worn steps, doorways, or some other characteristic features may evoke the mood of a place more strongly than an overall view. A wide-angle lens is often useful here. You can go in close to a small area but still show the background because of the depth of field given by a wide-angle lens.

You can use viewpoint, framing, and perspective to stress the essential character of a subject. For instance, when photographing a bridge, you can use the steep perspective of vertical framing from a low viewpoint. This will emphasize the strength of the bridge's construction.

Consider the direction and quality of lighting, and the effect they have on form, depth, and texture. Wherever possible, wait for the right weather and lighting conditions to suit your interpretation of your subject. This may mean photographing during or just after rain, getting up early to use morning mist, or picking the right balance of light around dusk. Remember that you can change tonal contrast by using filters.

Using the right exposure is vital for capturing atmosphere. Generally you must take exposure readings from the most important subject area. But you will have to make corrections for glare when near water in strong light, and for taking pictures into the sun at sunset and dawn.

Exploiting focal length
The two pictures below show how changing your lens can give contrasting interpretations of environment. The low key, wide-angle landscape on the left suggests a forbidding, endless terrain. The 15 mm lens strongly brings out the weathered granite foreground, carrying through its pattern and detail by steep perspective, to the exaggeratedly distant mountains.

The 500 mm lens, used for the picture, below right, has the reverse effect on perspective, bringing beach, mountains and sky almost on to the same plane. Careful exposure has given a high key effect, reducing tonal contrast and so underlining the effects of the mist and haze. The balanced silhouettes of the bird and the fisherman combine with the horizontal lines of the beach to give a feeling of serenity and calm.

Choosing time of day
The time of day you choose for taking a picture can totally change the apparent form and relative importance of objects in their surroundings. At night, a cityscape is transformed into isolated patterns formed by building and street lights, and the head and tail lights of automobiles. The picture below of New York's Broadway with 5th and 6th Avenues was taken at dusk.

The photographer waited until the artificial lighting in the city was about equal to the light remaining in the sky. Enough visible detail is left to show the complex shapes of the buildings — a feature complemented by the dynamic lines of the illuminated streets, converging toward the water front. Minutes later, the focal point of the picture— the towers of Lower Manhattan— merged in the darkness.

Dramatizing the sky
Your strongest impression of a place may often be the sky or weather conditions. It is sometimes effective to make a landscape disappear into a thin, silhouetted band, as in the picture above.

A single exposure reading was taken from mid-gray cloud. As a result, land detail is merged by underexposure, and tone variations in the cloudy sky are fully resolved. Dark, contrasty printing has added to the somber mood.

Selecting details
Details can often be more representative and create a stronger impression of a subject than an overall view. This is particularly true when the subject is crowded and your picture could easily become confused. The picture, right, is an example of a subject that is evocative because the two figures have been separated from the busy street. Nothing is superfluous — their expressions and clothing provide information, while the blurred background suggests the context without distracting attention from them.

Working to themes

Working to a theme is a good way of developing your skill as a photographer. There are several kinds of theme on which you might choose to concentrate. The subject matter itself could provide the link for your pictures, like the photographs on these two pages, or you might decide to shoot a series of pictures based on one of the picture building elements, such as pattern or shape. Alternatively, you could tackle an abstract theme, such as love, greed or anger, or illustrate contrasting concepts, like young and old or large and small. If you are observant and imaginative, almost any theme can be treated in an interesting and unusual way.

Your project may consist of separate pictures, all relating to the same theme, or a sequence of pictures which tell a story, such as the building of a house. In either case, the way you arrange your photographs on the final mount or album page is crucial to the success of your project. In general, try to avoid juxtaposing pictures of the same size — one larger picture placed with several smaller ones creates emphasis.

Water
Each of the pictures on this page includes water either as the main subject or as a part of the composition. Water is a good theme to begin with, because it can easily be found, and in a variety of forms.

Water and reflections
Reflections are an obvious subject for the theme of water. They can extend or distort the shapes in a picture, producing slightly unreal, ghostlike images such as shown left. Or you can use reflections to include subjects outside of your picture frame such as clouds or the tops of tall buildings. These bright reflections can sometimes appear like windows on to another world.

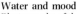

Water and pattern
The concentric circles formed by rain or other objects falling on to still water create interesting patterns. The bright reflections in the picture above, add to this effect.

Water and mood
Photographs of the sea, in particular, can evoke a strong mood and atmosphere. In the picture, right, the overcast sky was included to add to the subdued, almost somber mood

Windows

A theme like "windows" can be given a wide range of interpretations. A hole in a fence, a pair of spectacles, or the reflection from a puddle of water could all serve to illustrate it. Windows can be used in the same way as mirrors or as frames — to unify or separate different elements in your picture. They also allow comparisons to be made between what is outside them and what lies behind — for example, you could photograph the windows of a crowded train contrasted with the empty railroad platform behind. See how much you can vary your approach, remembering that each picture should be strong enough to work on its own.

Doors as windows
In the picture left the effect of a window is created by an open door-way, which creates a frame within the picture frame, dividing the photograph into two related areas. This effect is further increased by the contrasting lighting in the two areas.

Windows and distortion
The translucent glass in the window below diffuses the shapes of objects increasingly, the further away they are. It has distorted the two figures into strange, ghostly silhouettes. Only the hand on the window pane is distinguishable.

Eyes and windows
The picture above, taken with the aid of an extension tube, draws a direct parallel between eyes and windows. The photograph was taken indoors and the camera viewpoint was chosen to position the window's reflection across the pupil of the eye.

Windows as mirrors
A wide-angle lens was used in the picture, below, of an office block, reflected in the back window of a car. The lens allowed a close view-point, necessary to show the entire building, while still including most of the car window. The brush inside the car takes on a strange relationship to the reflection.

Varying your picture proportions by cropping

Your final print need not conform to manufacturers' sizes of printing paper. Sometimes the image is helped by cropping when enlarging. This need not be wasteful — large sheets, for example, can be cut lengthwise to give two narrow picture formats.

Long low prints emphasize horizontal features and actions; tall thin versions tend to exaggerate height. Narrow, horizontal pictures are often more satisfying than the vertical kind, probably because of the way our eyes see the world.

When a print is cropped to very elongated proportions you tend to look at it from a closer viewpoint than if the entire negative had been printed this size. If you used a long focus lens for the image the reduced perspective works against the dynamic horizontal shape of the print. It is better to use a wide-angle lens, composing the picture within a central strip. Make as big an enlargement as possible — some enlarger heads can be turned to project on to the floor, or even a wall.

Low low format
The picture below is cropped top and bottom from a 35 mm negative taken with a 21 mm lens.

SUMMARY Further equipment and techniques

Additional lenses

Wide-angle (short focus) lenses give you a wider angle of view, and more depth of field than normal lenses. You can, for example, include more of a subject when working close-up; this produces pictures with steeper perspective. Extreme wide-angle lenses begin to stretch and distort shapes in the subject, particularly toward the edges of the picture.

Long focus (telephoto) lenses give a narrow angle of view, a shallow depth of field, and (by including the same amount of a subject from further away) a flattened perspective. Extreme long focus lenses enable you to work from a very long distance, but they lower the contrast of the image, and exaggerate camera shake. Mirror lenses are lighter and smaller but cannot be stopped down; they also make out-of-focus highlights appear ring-shaped.

Lens attachments

Color filters lighten the black and white reproduction of their own color, and darken their complementary color. Polarizing filters reduce reflections from non-metallic surfaces. Neutral density filters allow wide aperture exposures in bright lighting. Close-up lens elements, bellows, and extension rings enable normal lenses to be used for close-up work. Alternatively you can use a specially designed macro lens for close-up work. You may need to give a longer exposure when using a close-up attachment. If your meter is a through-the-lens type it will compensate for this, otherwise you should follow the manufacturer's recommendations for adjusting the exposure.

Exposure and tonal range

Normal meter readings reproduce subject mid-tones as mid-gray on the print. Over- and underexposure shift tonal values up or down the tone scale. You have least latitude for exposure error with contrasty subject lighting. Extremely long exposures change the film characteristics — reciprocity failure — effectively reducing the ASA speed.

Artificial lighting

Think of tungsten lighting (spots and floods) and flash in terms of their "hard" or "soft" quality. Direct lighting is hard, diffused or bounced lighting is soft. In most cases you will want to control the height and direction of the main light to produce lighting similar to daylight. Use one lamp as your main source and a second lamp for local control of lighting. Diffuse fill-in illumination from a second light, for example, can be used to control contrast.

Perspective

The impression of depth in your picture is mainly created by linear and aerial perspective. Linear perspective is the convergence of lines, and is controlled by viewpoint and focal length of the lens. Aerial perspective is created by the way tones grow paler with distance. It is mostly controlled by lighting and viewpoint. Depth is also created by blur — differential focus and overlapping elements in the subject.

Emphasizing objects

To emphasize one object among many you can use lead-in lines, differential focus, blurred movement of surroundings, or separation by contrasting tones — controlled by lighting and exposure.

ADVANCED DARKROOM TECHNIQUES

STEP 1: Controlling the negative

STEP 2: Manipulating the print

STEP 3: Presenting prints

This section, like the last, covers more advanced techniques in black and white photography. It is concerned with darkroom work and other manipulations of the image after exposure, and includes ways of producing unusual results from normal negatives. You should already be doing your own black and white processing and printing — you need little more than the equipment introduced in that section of the book. It also helps if you have taken quite a number of pictures, perhaps by working through the first picture building section of the book.

Organization of the section

Much of this section deals with solving particular problems on the negative or print so that you can get thé final result you want. The first of the two main Steps explains the ways that film, exposure, and development interrelate. It shows you how, by altering one factor or another, you can produce a negative with better printing characteristics. It is helpful to read through this Step first, as the information given is fundamental to controlling the quality of your negatives.

The second Step covers a variety of different processes inside and outside the darkroom that alter the final print. Each page here can be regarded as a starting point for visual experiments. It is advisable to read through the whole Step to see its general scope, before you begin any particular technique. At this point it helps to have a wide range of existing negatives from which you can make experimental prints. Some of the diagrams and illustrations show the results of manipulating 35 mm negatives, but exactly the same principles apply to negatives in other formats. The final Step shows you some of the ways you can mount and present your final print.

For the first Step no new equipment is needed. However, you will want some new materials — different developers, normal contrast and line sheet film, and a few chemicals. A good photographic store will be able to supply these. Most of the solutions can either be bought in ready-to-use packs or are simple to make up from basic chemicals — formulae and mixing advice are shown on page 213. Don't be put off by the theoretical diagrams. You will find they are really quite straightforward, and all have a direct practical value. Most of the techniques here are only extensions of methods you have already learned.

Film control

Until now you have been working with one general-purpose film and a fine grain or universal developer. The effect of using films of slower or faster speed ratings was discussed in a general way on page 38, and it may help to re-read this and what happens during processing (see pp. 70, 73), before you start. Using different fast or slow films requires different developers. Generally these are chosen to enhance the particular qualities of the film itself — perhaps to create maximum detail and sharpness on the negative, or effectively to increase the speed of a fast film still further.

Your choice of film and developer depends upon your type of subject, practical problems such as lighting, movement, and depth of field, and finally the type of image you want to produce. Perhaps the subject is a still-life, or a landscape where you want to show finest detail. To take the picture, you might have used the camera mounted on a tripod. To give a crisp resolution, improve contrast, and minimize grain on the image you should use a slow film and process this in a high acutance developer.

The opposite combination — ultra high speed film in a -speed enhancing developer — is ideal for photography in very dim lighting. It is particularly useful when, for example, you have to use a relatively short exposure, when the camera is hand-held or you want a large depth of field (and therefore want to use a small aperture). Again, you might choose this same combination for a still-life or portrait to get a strong grainy pattern, destroying fine detail and giving an impressionistic effect.

Even with a particular film and developer combination you might still decide to set a higher or lower ASA setting on your meter, under- or overexposing the film slightly and compensating in the development. For example, if the subject is very contrasty, underdeveloping will help to give normal contrast negatives. To prepare for this you would slightly overexpose, so that the image on the negative is not too thin. (Always think of development as mostly giving contrast, exposure as mostly giving density — particularly shadow density.)

These sort of manipulations can really only be done with the complete film. You have to decide at the outset to treat all twenty or thirty-six exposures in the same way. But after processing, individual negatives (as well as complete films) can be given certain treatments to make them darker or lighter, or changed in contrast. The results are not as good as altering the exposure and development, but they do help to rectify mistakes. For example, you might discover that a negative turns out thin and gray, and will not print well. Intensification or reduction, and modifications to the enlarger light, can then enable you to obtain a more acceptable final print.

Print manipulation

In the second Step of this section eleven techniques for manipulating prints are explained. These have been chosen partly for their general usefulness, such as printing borders around your prints, and partly to suggest new areas for you to experiment in, without being too complicated or unnecessarily time-consuming.

Double printing, for example, allows you to combine two or more images together on the same print to construct realistically new and unusual images. This technique, with montage, produces results quite different from normal photographic imagery. You can combine negatives and positives in the same picture, present things in bizarre relationships, and overturn normal perspective. Here it is worth looking ahead to the work of Jerry Uelsmann on pages 200–1. Even though you may not want to use such extreme manipulations at the moment, it is worth knowing what is possible. On some future occasion, one of these techniques might provide the ideal way of making the statement you want with a particular subject.

Multiple negative printing, and montage, have a long tradition in photography. Some of the most influential photographers, who dominated exhibitions and clubs in the late nineteenth century, literally constructed images piece-by-piece. Aping the painter, they would compose and photograph figures individually, then find or construct a suitable background setting and photograph this too. Unwanted parts of each negative were painted out with opaque pigment and the separate negatives were carefully

positioned and printed in sequence on to one sheet of paper.

All this technical skill was directed toward a totally accurate re-creation of a scene, just as sketches are incorporated into a painting. Although we often regard this work as contrived and artificial, it would probably have been unacceptable at the time for photographers to make the more surrealistic or graphic images that we are accustomed to seeing today.

Photograms — the direct printing of objects placed on light-sensitive material — is another "open-ended", creative printing technique. It is an area which requires no special equipment and gives quick results. No two photograms are ever quite the same. There is hardly any limit here to the way shadows can be cast on to printing paper from three-dimensional and flat objects. You can light them from above or obliquely, or shift or remove them after part of the exposure. The photograms by Man Ray or Laszlo Moholy-Nagy illustrate some of the possibilities available.

Many other special techniques are possible in printing. Some processes are perhaps more complicated than the final results justify. Two we have chosen here, bas-relief and solarization, are not difficult to undertake. They give strange results and teach you quite a lot about the way positive and negative images relate. You will need the 5×4 ins sheet film specified, and an appropriate safelight, normally deep red (orthochromatic). Panchromatic films can be used for these processes instead, but since you have to handle them in total darkness or under an almost invisible dark green safelight the work is more difficult.

We also look at some manipulations which can be carried out in normal room lighting after the darkroom side of printing has been completed. Here you might decide to change the image color, either completely or just in certain areas. Backgrounds can be bleached away so that objects appear isolated against white paper. You can also lighten local areas of the print using a weak reducing solution — to get similar effects to shading or dodging during the printing exposure.

The final Step in the section deals with presentation of your final work. Mounting really does make a big difference to the finished appearance of your prints. The last three pages — 138–40 — apply equally to the presentation of black and white and color prints. At this stage you can make your final decision on how and where to crop the composition. Two cards cut as "L" shapes (as used in a miniature form for contact print assessment on page 79) will help. After mounting you can spot and retouch any blemishes as explained on page 88. You might finally frame the picture, with or without a mat surround.

Working through this section on darkroom techniques will improve your technical understanding and control of your final image. If you know the sort of images each process makes possible, you can plan everything right from the start, beginning with lighting, viewpoint, type of film and exposure, and leading to processing and printing.

STEP 1 : CONTROLLING THE NEGATIVE/Developers

For most films you can use a general purpose or "universal" developer. But other types of developer are available which enable you to alter the grain, or contrast on the final negative, or increase the film's sensitivity.

All developers should be matched with the appropriate film type. High acutance developers, which resolve fine detail on the negative, work best with slow films (under about 50 ASA). Fine grain developers help to minimize the graininess of medium or fast films (between 50 and 800 ASA). Speed enhancing developers which have the effect of increasing the sensitivity (speed) of the film can compensate for underexposure, and work best with films of 400 ASA or more.

Black and white film structure

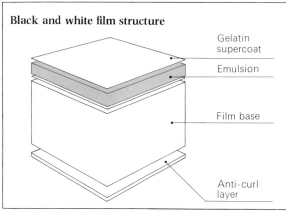

Gelatin supercoat

Emulsion

Film base

Anti-curl layer

A clear gelatin top coat helps to protect the sensitive emulsion from abrasion. Light-sensitive silver halides in the emulsion layer are either fine and thinly coated (slow film) or are relatively coarse and thickly coated (fast film). The emulsion layer is supported by a plastic, or triacetate, base. Beneath it, another gelatin layer inhibits curling and contains a gray antihalation dye that prevents any light reflecting back into the upper layers.

Matching film and developer

Slow film (32 ASA)

Universal developer
The negative, left, was processed in general, or universal, developer. Because the film is slow there is good detail on the image.
The area of the negative shown on this page is magnified 28 times.

Slow film (32 ASA)

High acutance developer
The negative, left, was taken on the same slow film but processed in a high acutance developer (Acuspecial FX-21). The developer has sharpened local contrast so that detail is brought out further. High acutance developers work best with slow films.

Fast film (400 ASA)

Universal developer
The negative, left, was taken on a fairly fast, 400 ASA film and processed in the same general developer as the slow film above. But because this film is ten times faster than the slow film, coarse grain is clearly visible on the processed negative.

Fast film (400 ASA)

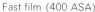

Fine grain developer
The negative, left, on the same fast speed film, was processed in a fine grain developer (D.76). This has reduced the graininess on the negative by inhibiting the clumping together of the black silver gains during development.

Ultra fast film (1250 ASA)
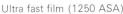

Normal developer
Universal developer, used for the two films above, would cause staining and fogging if used with the coarse grained emulsion of this ultra fast film. The recommended normal developer (DK-50) was used instead. The detail is broken up on the negative by graininess, left.

Ultra fast film (1250 ASA)

Speed enhancing developer
Processing with Acuspeed or a similar speed enhancing developer greatly compensates for underexposure as shown in the negative, exposed as if 3000 ASA, left. Speed enhancing developers increase the speed of your film by up to $2\frac{1}{2}$ times, enabling you to take pictures in extremely low lighting. If you know you are going to use such a developer you can uprate the film in the camera by the amount recommended by the developer manufacturers.

Altering the tonal range

The image recorded on your film results from the various light intensities reflected from the subject. Each light level records as a separate tone, different density of black silver, on the film when it is developed normally, as shown on the graph, right. For any given subject and type of film, the lighting, exposure, and development time all affect the tonal range in the negative.

Normal black and white film can reproduce a wider range of tones than you will find in most subjects. But near the top and bottom end of the range on the graph (extremes of exposure) you can see that tone differences flatten out. One tone becomes difficult to distinguish from the next. A properly used light meter will suggest camera settings that give the film sufficient exposure to use the lower middle section of its range.

It is best to aim for a negative of slightly low density, where tone values in shadow areas are still definable. Detail is often lost in excessively dark tonal areas of negatives due to light spread and increased graininess so most films are designed to use more of the low end of the scale.

Over- and underexposing locate the range of recorded subject light intensities very high or very low on the performance graph. You can counteract this by respectively decreasing or increasing development. This changes the steepness of the curve on a representative graph of recorded tones, thereby decreasing or increasing contrast. By deliberately underexposing and over-developing, you can get acceptable negatives on film that is not fast enough for the lighting conditions. This effect — "pushing" development to uprate film speed — is shown opposite.

Film performance graph

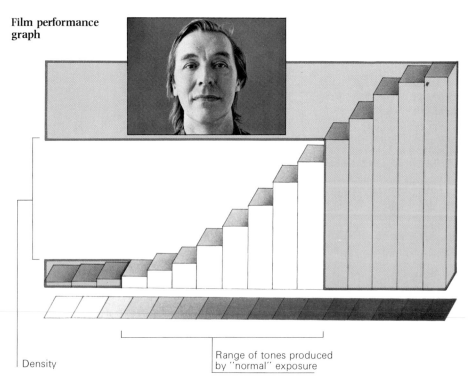

Density

Range of tones produced by "normal" exposure

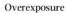

The simplified diagram above shows how normal black and white film converts parts of the image at different brightness levels into separate tones on the negative, left. It shows the evenly graded tones recorded by a theoretically ideal exposure. The range is extensive and tonal values only merge at the extreme ends of the graph.

Underexposure
The graph below right remains the same shape as the normal performance curve but shows how underexposure only uses part of the tonal range — giving you a pale negative, above right. The darkest shadow parts of the subject now fall at the lightest end of the tone curve, where it flattens to almost a horizontal line. It becomes impossible to distinguish one tone from another on the negative here — shadows are transparent and "empty". Only the brightest parts of an underexposed subject record with differentiated tones. When you print the negative, these midtone-to-highlight parts of the subject require normal or hard grade paper; the remaining tones require a very hard grade, even then will give little more than black or flat gray.

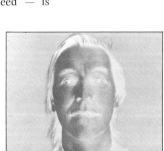

Overexposure
Overexposure causes subject tones on the negative to fall toward the top end of the film performance graph, below right. All the tones appear very dark on the negative, but now it is the highlights in the subject which merge, as shown above right. When you print the negative, normal grade paper is required for the shadow areas, which still have well separated tones. The lighter subject areas will print with a bleached or, if printed-in, a muddy gray appearance, even on hard grade paper. An overexposed negative appears very grainy and fine detail is not clearly resolved. This is because more light-sensitive grains than necessary have been affected by the long exposure.

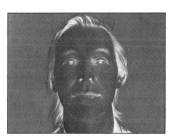

Pushing

When you know that a film has been underexposed, try "pushing" — increasing the development time. The performance curve, right, is much steeper than the normal curve. The difference between each tone is more marked and so the negative is more contrasty. This increased contrast helps to prevent tones from merging in shadow areas on the negative, as shown far right.

This correction can be used up to the point when mid-tone-to-highlight range becomes so contrasty that it begins to require soft grade paper to print well.

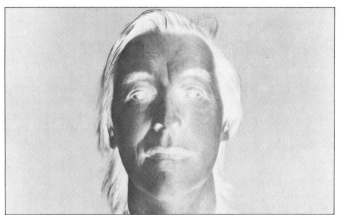

Holding back

To compensate for overexposure you can "hold back", or reduce the development time. As shown right, the film performance graph is flattened so that the processed negative appears less black and grainy, far right. Tone values in the highlight areas are still poorly separated, but there is now less difference between this range and the mid-tones-to-shadows range. The negative will give acceptable results overall if you print it on a hard grade paper. If the subject itself was of low contrast this compensation could result in an unacceptably flat negative.

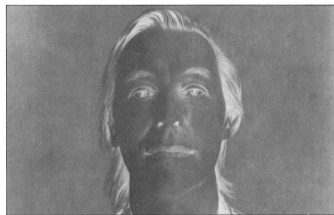

Compensating for lighting conditions

A film performance curve helps you decide how to change the exposure and development of your film to improve the tonal range on your negatives.

The subject shown near right had very flat, frontal lighting. The brightness range between the darkest shadow and lightest highlight is slight. Overdeveloping would result in a steeper performance curve, shown center, near right. This gives an expanded, more normal tone range on the negative. But the extra development would also make the negative darker overall. To avoid a very dark result, you can slightly underexpose the film and increase the development time proportionally, to produce an image such as shown bottom, near right.

Compensating for a harshly lit, high contrast subject, such as shown top far right, works the other way round. You overexpose the film, and then reduce the development to produce a flatter negative, with a more normal tone range as shown bottom, far right.

In low light levels with slow rated film, you can increase the rating by underexposing and pushing. Set the film speed dial on your camera to two or three times the real film speed. 25 or 50 per cent extra development time will produce near normally graded tones.

Flat lighting

Hard lighting

Subject lighting conditions

The quality and direction of the lighting in the subject, far left, has produced a low contrast negative. Hard lighting conditions in the subject, near left, have produced a contrasty negative.

Compensating for the lighting

You can compensate for the lighting, above far left, by slightly underexposing then overdeveloping the negative. Hard contrast, above near left, can be improved by overexposure and underdevelopment. Exposure determines the part of the graph you use, the development alters its shape.

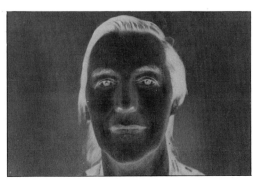

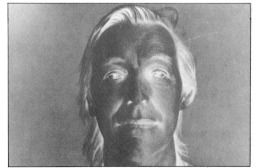

Improving poor negatives

Technical mistakes which spoil your negatives are not always without remedy. As long as the image is not underexposed — and is therefore lacking in any detail — or out-of-focus, or uneven in density, you may well be able to compensate after processing.

Underdevelopment, due to a timing error, inaccurate processing temperatures, or exhausted processing solutions, may produce a pale, low contrast negative with almost ghost shapes. If you print such a negative on even the hardest grade paper it will give poor tonal range and contrast. To improve it you can use intensifying chemicals to bring out faint detail, improve contrast, and strengthen the image.

Hazy subject conditions, or overexposure combined with underdevelopment, may create a dark negative with low contrast. You can improve such results only by treating them with a chemical that reduces the overall density of the image.

Overdevelopment or harsh subject lighting, or both, will produce very contrasty negatives. These will give hard, stark prints even on the softest grade printing paper. You can remedy this by combining the negative with a very pale positive image of itself, contact printed on film. This will mask out the harsh contrast in subsequent prints. Another remedy is to use a proportional reducing chemical on the negative which

has most effect on the darkest parts of the image, reducing the contrast.

Before you give a negative extra chemical treatment, ensure the film is fully fixed and washed. All the chemicals for treating the negative can be used in normal lighting. If an entire film needs treatment, load it on to a developing tank reel and pour the solution into the tank. To treat a single negative, attach a clip to one corner so you can hold it in the solution.

Information for making up reducers and intensifiers is shown on page 213. Some intensifying and reducing chemicals are toxic. Handle them carefully and keep the solutions out of reach of children.

Reducing a dark negative

To lighten a dark, flat negative, such as shown top right, and improve its contrast, you can use ferricyanide — "Farmer's reducer". It reduces every tone by the same amount, as shown center right. Leave the negative in the solution for about five seconds, then rinse and examine. Repeat this until the density is correct.

Where less contrast is required, use a proportional reducer. This dissolves most silver from the darkest areas of the negative, as shown right. It has a very slow action, taking about 20–30 minutes.

Intensifying a pale negative

To increase the density of a pale negative with faint detail, such as shown top right, use a chromium intensifier solution. This builds up the metallic silver image. Leave the film in the intensifier until it has bleached yellow. Wash the film and then transfer it to a tray of print developer for about 5 minutes to re-darken the image. Finally wash the film again. Intensification has a proportional result, having most effect on the darkest tones. as shown bottom right. Contrast is increased in the negative as well as density.

Negative masking

An alternative method for reducing contrast in a print, such as shown near right, is to mask the negative during printing. Make an underexposed contact print of the negative on to continuous tone film, preferably a type such as Kodak Gravure Positive. Underdevelop the contact print in diluted developer and process it — it will be a very weak, gray positive image, as shown bottom right. When printing combine this image in register with the original negative. This will add tone to the shadows, giving a less contrasty print, as shown far right.

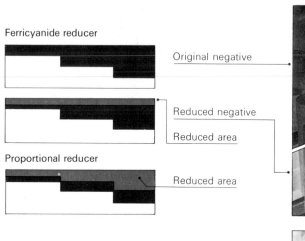

Ferricyanide reducer

Original negative

Reduced negative

Reduced area

Proportional reducer

Reduced area

Chromium intensifier

Original negative

Intensified negative

Intensified area

Original print

Original negative

Weak positive mask

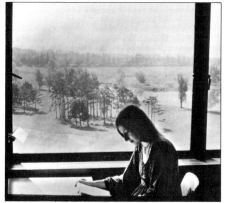

Final print

Modifying the enlarger

You can use several techniques at the enlarging stage to improve prints made from very contrasty or very flat negatives.

The design of the enlarger you are using is important—if it has a condenser system giving harsh spotlight-type illumination, the negative will print harder than if the lighting is more diffused. Placing a diffuser, as explained below, between the lamp and the condenser will effectively lower the contrast. Another, simple way you can reduce contrast is to fog the printing paper slightly, by very briefly exposing it to light.

To increase contrast on the print use a smaller size lamp in the enlarger. This intensifies the beam, as shown below right.

Condenser system

Negative

Diffuser system

Negative

Contrast and enlarger light

Light from a condenser system in the enlarger, top left, is direct. This means that contrast in the negative is brought out. Clear areas of the negative allow the direct light to pass, while denser areas absorb and scatter the light and appear dark.

A diffuser system, below left, passes light which is already fully scattered through the negative. As a result the difference between light and dark areas of the image (contrast) is less marked, since dark areas in the negative cannot further scatter the light.

Enlarger light sources

Enlargers illuminate the negative by different systems. In one arrangement a grainless diffusing disk (on an enlarger with a color head, a "scatter box") diffuses light rays in all directions. The negative is softly and evenly lit. In other enlargers a condenser concentrates direct light through the negative. This system gives a brighter, harder image. Negative scratches are made more obvious, and you may have to adjust the lamp position at maximum size enlargements so as to illuminate the negative evenly.

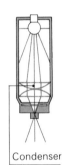

Condenser

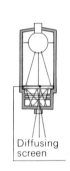

Diffusing screen

Modifying the light quality

You can make a hard negative print one grade softer in a condenser enlarger by putting tracing paper in the filter drawer. For the opposite effect put a black card with a small hole cut out just below the lamp. This reduces lamp size and dims the light, but makes lighting quality harder. With both methods, make a test strip to re-assess the exposure for the negative.

Softening the light

Making the light harder

"Flashing" the print to light

You can reduce the contrast of an excessively hard print, shown above left, by "flashing" — slightly fogging the print — before processing. First expose the image normally — to suit subject shadow and mid-tone detail. Then hold tracing paper just below the lens and give the whole print another brief exposure — try giving one tenth of the previous exposure time. After processing highlight detail is improved on the print, as shown above right. Improvement continues in proportion to the fogging exposure time, up to a point when light areas begin to look gray and veiled.

Reminders: Controlling the negative

Film and developer	Choose a developer to suit the film speed. You can modify the quality of the negative by the developer you use. But image graininess is mostly determined by your choice of film. Exposure, type of developer, and development time are secondary factors.
The performance of all film is restricted to a limited tonal range	Film can only respond accurately to a limited range of tones in any one subject. Beyond the light or dark ends of this range tones begin to merge and lose detail.
The development time can be altered to compensate for exposure errors	Underexposure is compensated for by overdevelopment, overexposure is compensated by underdevelopment. But the amount of compensation you can give is limited, usually by the increase or reduction in contrast.
Contrast and the density of the negative can be improved by chemicals and by masking	Reducers and intensifiers can remedy over- or underdevelopment and, to a lesser degree, exposure errors.
The enlarger light affects contrast in the print	To increase contrast on the print, change to a condenser enlarger or make the light source smaller. To reduce contrast, diffuse the light or slightly fog the print.

STEP 2: MANIPULATING THE PRINT/Adding print borders

The various special printing effects described on the following pages will not make bad photographs into good ones, but they can make a good image much stronger. The modifications you can achieve range from simply adding print borders, to almost completely transforming the original image.

Sheet film
For most of these printing techniques you require special 4 × 5 ins black and white sheet film. There are two main types available: one for high contrast and one for low contrast. These films have emulsions with very slow speed ratings so you can use them under the enlarger giving long printing exposures and manipulating the results in a similar way to normal printing papers. Line film (Kodaline or Ilfoline) is a very high contrast sheet film. Normally it is used for photographing line drawings and lettering because it records all tones as either black or white. Continuous tone sheet film, such as Kodak Gravure Positive, gives normal contrast over a full range of tones — like photographic printing paper but on a film base. Both films must be handled under red or orange safelighting (check the instructions given on the box label).

Treat these two types of sheet film like normal photographic printing paper. Use normal print developer (double strength for line film) and process them in trays. You can expose them under the enlarger like normal printing paper, or in your camera. If you have a 35 mm camera, the 4 × 5 ins film must be cut to size and loaded, a frame at a time for each new exposure under the appropriate safelighting.

Making black print borders
Cut out a rectangle the size of your picture from a sheet of black card. Then trim the rectangle evenly all the way round by an amount equal to the width of the border you want. Place the frame of black card on the printing paper on the baseboard and expose the image. Then add the center piece of card so that an equal gap is left all round the print. Remove the negative from the enlarger and give the same exposure time again to fog the uncovered edges of the paper.

Prints which have pale toned areas at the edges of the picture, such as shown right, are strengthened by adding black borders.

Making a white vignette
Hold an opaque card about half way between the enlarging lens and baseboard. With the negative in position, turn on the enlarger. On the card, draw around the part of the image you want to be included in the vignette. Cut out this shape cleanly with a sharp knife. Hold the card in the same position above the baseboard throughout the printing exposure, moving it slightly to further soften the edge line. After processing the print borders will appear as shown right.

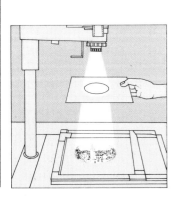

Making a black vignette
To make a black vignette use the same technique used for the white vignette, left, but this time use the piece of card you cut out. Tape this to a thin, stiff wire handle, as shown below. First, expose your image normally. Then remove the negative and give the same exposure time again, using the card to shade the area of the image you want to remain visible.

Using line film and texturing

Normal photographic films and papers give continuous tone images — they form a range of grays between black and white, as shown right. But you can convert existing pictures by using line film to create a stark line image in black and white only, as shown below right. There are two ways of doing this — by copying or by contact printing.

You can add texture to your final image by printing it on to textured bromide paper (see p. 77). But to achieve a wider range of effects you can print your normal or line negative together with a texture screen — a patterned line negative.

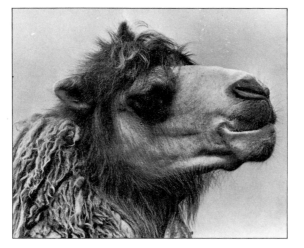

Subjects for line film
Because line film simplifies tones to either black or white, fine detail and the sense of depth conveyed by tonal changes are lost. The photograph shown left is ideal for conversion into line. It is a strong, two dimensional graphic image. In addition it contains a range of textures that translate well into line, below.

Copying on to line film
Make a normal 10 × 8 ins enlargement from your negative, and set this up in front of the camera for copying as shown on page 212. Load the camera under safelighting with a single, frame-size piece of high contrast line film. Kodaline line film is about 1 ASA. So for exposure, multiply the reading from your meter for 32 ASA film by 32. Then process the film in a tray of double strength print developer. This gives a contrasty line negative. Enlarge the negative on to hard grade paper.

Contact printing on to line film
Contact print the negative on to a piece of line film and process it in print developer, as above. The result is a contrasty positive on film. Dry this and contact print it on to another sheet of line film and process again. This produces a final line negative. Enlarge the negative on to hard grade paper.

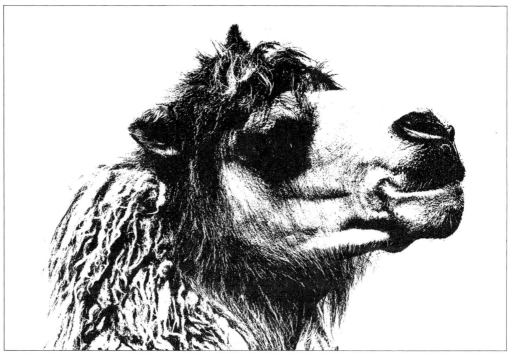

Adding texture
There are several varieties of texture screens available including "gravel", below near right, and "tapestry", below far right. But you can make your own screen by making an underexposed and slightly underdeveloped negative of a regular patterned surface.

Sandwich the negative and the texture screen emulsion to emulsion in the enlarger and expose them together at a wide aperture. Try to use a glass negative carrier to keep the two images in complete contact. The effect of the "gravel" screen is shown near right; the "tapestry" textured print is shown far right.

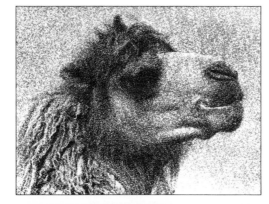

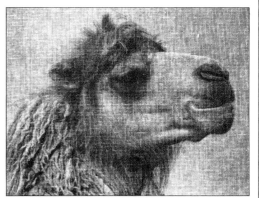

Gravel screen

Tapestry screen

Photograms and combined negatives

Photograms are made without using a camera. You simple arrange objects directly on top of light-sensitive paper (or sheet film) and make an exposure under the enlarger. Opaque objects appear as sharply defined shapes with hard, line edges. Semi-transparent materials give gray tones according to their opacity. A straight photogram gives negative tone values, but you can contact print this on to another sheet of printing paper to create a positive image.

You can construct interesting, new compositions by "sandwiching", that is simultaneously exposing two normal negatives, or one normal negative and a photogram on sheet film on to printing paper.

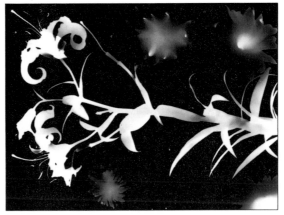

Making a direct photogram

The photogram, left, was produced by exposing a sheet of grade 2 bromide paper with dried flowers placed on top. Parts of the flowers not directly in contact with the paper are blurred and unsharp, giving the image a feeling of depth.

When making a photogram, position the enlarger at the top of its column and use the smallest aperture so that it gives a hard light. Make a test strip to find the exposure time that gives a rich black background and makes any translucent objects print gray. Overexposure will blur the edges of the objects because of light spread.

Making a photogram/negative combination

1. Under safelighting arrange the objects on the printing paper. With the safe filter over the enlarger lens, check the shadows they form before making an exposure.

2. Develop the photogram until you can just see the position of the clear areas. Then remove it, rinse and blot off any liquid, and replace the paper under the enlarger.

3. With the safe filter in position set up a negative in the enlarger so that the image combines well with the half-developed photogram. Expose, then fully develop and process the paper. The picture below was produced by this technique.

Combining two negatives

Printing two negatives at once, or "sandwiching", can sometimes create interesting results, particularly if the two images are quite simple. The two negatives, right, are of very simple subjects. When they are printed together, below, they produce an effective image that is not confused or complicated by too much detail.

To print two negatives at once you must either use a glass negative carrier, or modify other carriers by using a glass slide mount to hold the two negatives firmly so they can be focused together. The negatives should be sandwiched emulsion sides inward. If the images will only work well the other way around, you must use a small lens aperture to keep both images sharp.

First negative

Second negative

Final print

Double printing

Double printing means exposing two negatives, one after the other, on to the same sheet of printing paper. This is a much more flexible technique than sandwiching because you are printing each image separately. As a result the density, size, and position of each image can be controlled.

Select two negatives that relate well in perspective, lighting, and densities so that one paper grade will suit both. Make a test strip for each negative to determine the exposure. It helps to use two enlargers so that you can load one negative in each carrier, and then transfer the paper from one easel to the other. But with care you can manage well with one, as shown below.

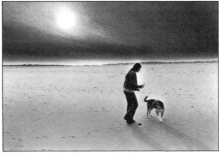
Print from the first negative

Print from the second negative

Making a double exposure print

1. Position the first negative in the enlarger. Place a piece of card the same size as your paper on the baseboard. Mark on it the area of the first negative you do not want included in the print.

2. Cut out the marked area from the card. This shape will be used for shading the first negative. The other piece of card will be used for shading when you print the second negative.

3. Expose the first negative, shading the area you want left out with the first piece of card. Remove the paper and mark the top of the image. Replace the paper.

4. With the other negative in position make a second exposure. This time, use the second piece of card to shade the area that was exposed during the first exposure.

Double printed image
The print, right, was produced by combining the prints of the two negatives shown at the top of this page. They were chosen because they were simple and had a similar range of tones. Both images needed enlarging by the same amount so that the two negatives were simply changed over in the enlarger and the easel shifted to position the leaves above the woman. When printing the leaves, the shading card was held stationary above the beach scene to create a sharp "horizon" in the scene.

Bas-relief

Bas-relief is a darkroom technique which transforms normal negatives into images that look like low relief sculptures, lit from one side. The original range of tones is restricted to a narrow range of grays and best results are achieved with simple, strong shapes and low, flat lighting.

To make a bas-relief you must first contact print the chosen negative on to continuous tone sheet film. The resulting film positive should be similar in contrast and density to your original negative although reversed in tones. You then sandwich these two images together, slightly out of register, and print them as one.

Normally printed negative
Choose an image which is full of detail and sharp throughout for bas-relief. Subjects with strong patterns or textures, like the trees and tiles in the image shown left, work well.

Making a bas-relief print

1. Contact print your chosen negative on to a sheet of 4 × 5 ins continuous tone film. Use a red, rather than amber safelight.

2. Process the film in half-strength print developer. Aim for a low contrast positive by overexposure and underdevelopment. Leave the film to dry.

3. Cut each sheet to a 35 mm strip. Select the positive which, when registered emulsion-to-emulsion with the original negative, nearly cancels out the image.

4. Shift one of the images slightly sideways so narrow light and dark lines appear. Insert the two images between the glass in the negative carrier, then enlarge.

Bas-relief print
To make the bas-relief image, shown right, the positive image on film was made to match the original negative in density and contrast. The negative and positive, when printed rogether on to hard grade paper gave the "embossed" result. The image has been simplified into a pattern of lines and flat tones and appears to be on one plane.

Solarization

Solarization (the "Sabattier" effect) partially reverses the image, by fogging to white light during processing. You can fog the image during enlarging on bromide printing paper, by briefly exposing it to normal lighting during development. You will achieve better results by printing on line film instead, fogging this, and then enlarging.

The exact effects of solarization are not predictable — you will have to experiment to achieve a controlled result. Some tones on a solarized print are rendered positive, some negative. A thin line appears around the boundaries of adjacent strong black and white tones in the solarized image.

Print from a normal negative
Most tones are eliminated in a solarized print, and a white edge line divides areas of white from black. Consequently, an image like the one shown right, with strong interesting shapes and sharp detail, is particularly suitable for solarization.

Making a solarized print

1. Make a series of contact prints on to 4 x 5 ins line film to discover the correct exposure. Contact print the negative at the exposure you found correct.

2. Half way through developing the print, place the tray on the enlarging easel. Switch on the enlarger and fog the film for the full exposure time.

3. Complete the development time and fix, wash, and dry the film. If the image is light enough, cut the film to 35 mm wide and enlarge.

4. If the image is dark contact print the film on to continuous tone film. Process in print developer to give a less dense image, suitable for enlarging.

Print from solarized film
The print, right, was enlarged on to normal grade paper from the solarized negative below. Notice how areas darker or lighter than the main subject can be either negative or positive. The white sky, for example, has become as dark as parts of the tree on the solarized print.

Solarized image on film

Bleaching and toning

After processing the print there are still some chemical treatments you can use to alter its appearance. The two most important of these are bleaching and toning, both of which can be done in normal room lighting.

There are two useful bleachers — ferricyanide and iodine. You use ferricyanide to slightly reduce the density of dark areas of the print; iodine erases parts of the image completely, leaving white paper. Toners change the black silver in the print into a compound of another color. They enable you to tint part of the image, leaving some areas black and white, or the whole image. Formula for making up bleachers and toners are shown in the table on page 213.

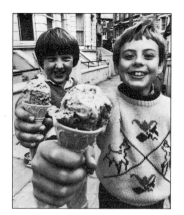

Bleaching areas from the print
You can use iodine bleacher to bleach out parts of the image from the print completely. You may want to isolate one element in a picture, like the two children shown left. The result, after bleaching, is a much stronger image, shown below. After applying the bleacher prints must be re-fixed and washed.

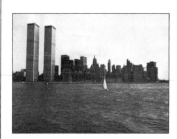

Improving print contrast
You can apply ferricyanide ("Farmer's reducer") directly to prints, to make tones lighter. In the picture, left, the sailboat needed to be picked out more strongly. The print was difficult to shade accurately while enlarging. So a straight, dark print was made and the sail was lightened, as shown below, by applying ferricyanide.

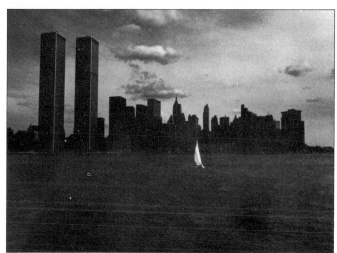

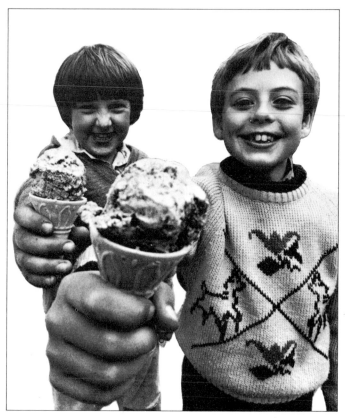

Local bleaching with ferricyanide

1. Make up the ferricyanide bleacher — check its strength on a scrap print. Dampen your print and apply the bleacher on a brush or cotton swab.

2. Almost immediately swill over the print with water. Repeat this bleaching and washing until the area is the tone you want. Then re-fix and wash your print.

Bleaching out an image

1. Soak your print in water before applying the iodine solution. Use a cotton swab for treating broad areas and a brush for working in small areas.

2. You can see the area fading under the yellow stain of the iodine. When it is clear, remove the stain by re-fixing the print for 5 minutes, then wash.

Toning

Toning first bleaches the black image on a print, then, after washing, re-darkens it in a chemical solution and adds an overall color, as shown far right. Sepia is the most popular and permanent toning color, although you can also buy toner kits for blue, green and other colors. Some of these may only color the print temporarily — in time the color fades. Prints chosen for sepia toning should have a rich range of tones with good blacks. The process lightens the image so make your print slightly dark.

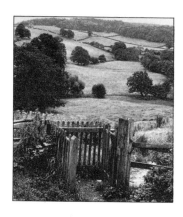

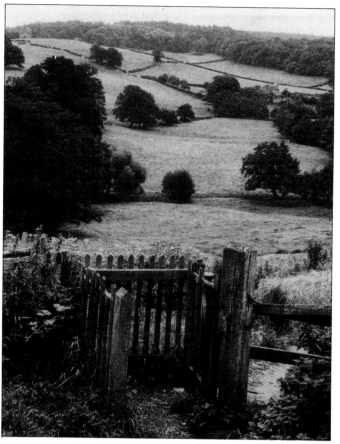

Making a sepia-toned print

1. Immerse the print in the sepia toner bleach solution for 2–3 minutes until only a pale yellow-brown image remains.

2. Rinse the print and place it in the toner solution for 5 minutes. Finally wash and dry the print thoroughly.

Localized toning

A print will only accept tone where it has been bleached first. So by bleaching only limited areas you can add tone selectively. You can apply the bleach using a swab or brush, as shown right, or you can leave the print in the bleacher for a very short time, so that the darkest shadows remain black. Always rinse the print before placing it in the toner.

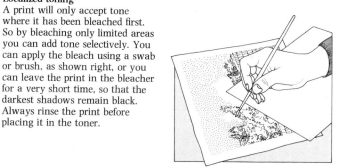

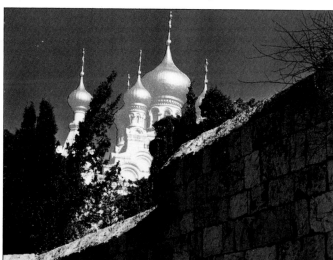

Assignment: Manipulating the print

Select several negatives which contain images that you feel may be combined to illustrate a theme, such as "nightmare" or "childhood". Make prints that illustrate the theme in the following ways:

A. Sandwich two negatives together and enlarge them as one. You may find one suitable negative, then have to take a second picture specially. This enables you to get the subject at the right size and position in the frame.

B. Make a photogram and sandwich it with a negative for a combination print.

C. Print two or more negatives on to one piece of printing paper. Consider using images of very different scales.

D. Choose one negative and, using the intermediate film method, make solarized prints using different fogging times.

E. Using one of the prints produced above make a solarized print by contact printing the image on to printing paper.

F. Enlarge a slide (either color or black and white) and a black and white negative sandwiched together or separately on to a sheet of bromide paper.

With all the prints you produce consider using bleachers or toners, either selectively or overall to improve the image.

STEP 3: PRESENTING PRINTS/Mounting and framing

You can mount your small prints in an album, using double-sided tape, self-adhesive print corners, or cement. Make sure you buy cement designed for use with photographic prints, as some contain chemicals which erode and discolor the image on non-resin-coated prints. You should mount larger prints on to thick card or blockboard, especially if you intend to hang them on display.

Rubber cement is the cheapest way of mounting larger prints because you do not require any special equipment. It gives a good finish but, unless you cover the print with glass, the corners may begin to peel after a few months in a warm room.

Dry mounting gives a more permanent, professional looking result and is quicker and not as messy as most other methods. It involves inserting a thin sheet of shellac-coated tissue between the mount and the back of the print. You place this sandwich in an electrically heated mounting press which melts the shellac, joining the two surfaces. The mounting press should be set to the recommended temperature, usually 200–210°F (93–99°C); above this some resin-coated papers may blister. With care you can use a domestic iron to dry mount small prints up to about 6 × 4 ins.

If you are careful, mounting should not affect the original surface of your print. But you can alter the surface finish by using an embossing kit (as shown at the bottom of the opposite page) or a surface spray. Aerosol surface sprays will give a semi-mat or mat finish to a glossy print. This will help to hide any surface marks or blemishes that you may have left after retouching.

Mounting montages

A montage is a composite image, created by mounting parts of one or more prints on to a prepared background. It is best to use dry mounting for the background prints, and adhesive to apply the smaller overlaying sections of the other prints.

Mounting adhesives are available in sprays, or cans. For dry mounting you require an electrically heated tacking iron (to first attach the shellace tissue and position the print), the shellac tissue itself, and a small heated press.

To trim the print or the mount, you can use a guillotine cutter or simply a sharp cutting knife and a steel straight edge. You also need a set square, to make sure the print corners are square.

Mounting equipment

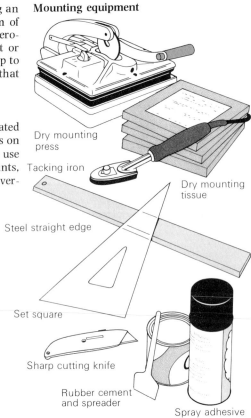

Dry mounting press

Tacking iron

Dry mounting tissue

Steel straight edge

Set square

Sharp cutting knife

Rubber cement and spreader

Spray adhesive

Mounting a print using rubber cement

1. Trim your print. Take care to make the edges straight and the corners at right angles. Lay the print on the mount and mark its position lightly in pencil at all four corners.

2. Spread cement over the back of the print and the marked area on the mount using the spreader or a rule edge. The cement should be spread as thinly and evenly as possible.

3. Wait until the two surfaces are no longer wet to touch. Carefully lower one edge of the print on to the mount, aligning it with the corner pencil marks.

4. Lower the rest of the print into contact with the mount, smoothing its surface to remove bubbles. Rub away any excess adhesive with your fingers.

Dry mounting a print

1. Use a piece of shellac tissue the same size as your picture, or larger. Place it over the back of the print and attach it by touching the center lightly with the hot tacking iron, making a cross.

2. Using the steel straight edge and a sharp knife trim the print and its attached tissue. Cut straight downward on to a hard surface.

3. Carefully position the print on the mount. Without moving the print, lift two opposite corners and tack the loose tissue beneath to the mount with the hot iron.

4. Slide the print and mount, face up, into the mounting press, set to the recommended temperature. Close the press and leave under pressure for about 5–10 secs.

Montaging and texturing

The most effective montage pictures are those in which the points where the overlaying prints meet the backing print are not obvious. It helps if you deliberately make the montage much larger than your usual print size because you can make smaller prints from this, on which the join lines and any retouching will also be diminished. The cut out parts of a montage should be on single-weight paper with a surface finish that matches the backing print.

Try to match the lighting on each part of the composite picture, and take care that the perspective is not distorted unrealistically in the different prints. When you place a subject in the foreground, make sure it has been photographed from a close viewpoint so that it has a steep perspective. Conversely, the backing print and overlays for background areas should have a shallow perspective to obtain a "realistic" result.

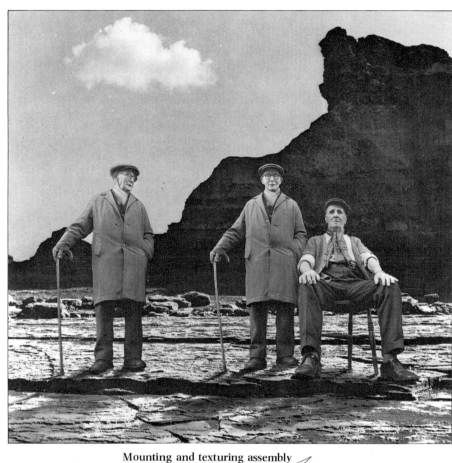

Montaged print
The montage, right, was constructed using prints from four negatives — the background rocks, two shots of the standing figure, and the seated figure. All four negatives were printed to match in tone and contrast, to give added realism to the scene. Shadows at their feet were added by hand to the background print using watercolor.

Texturing the print surface

Although you can still buy printing papers with a variety of different surface finishes (see p. 77), fewer types are made each year. It is becoming popular to add the final finish at the mounting stage. This was done with the canvas finish on the print shown below. To surface your prints you need a dry mounting press and a texturing kit for your print size. The kit includes sheets of clear, heat seal film, and embossed paper sheets.

You place the film over your print and then put the embossed paper on top. The texture is impressed into the film surface in the mounting press.

You can use a whole variety of embossing sheets — even devising your own, such as wallpaper, sandpaper, linen, or canvas. If one texture is unsuccessful, the print surface can be re-molded by returning it to the press with a different embossing sheet. Uncopied montage prints will not texture well as their surfaces are uneven.

Mounting and texturing assembly

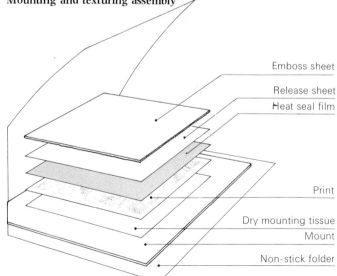

Emboss sheet
Release sheet
Heat seal film
Print
Dry mounting tissue
Mount
Non-stick folder

The multi-layer assembly above will both dry mount and texture the print surface in one operation. At the bottom place the mount and the print, tacked together by the dry mounting tissue. Above this, lay a clear heat seal film and lightly tack it to the print surface by touching it with the iron through a non-stick sheet. Remove the sheet and cover the film with a non-stick, release sheet. Different sorts of release sheet can be bought to produce a glossy or mat finish. Finally place your emboss (texturing) sheet on top. Insert the whole assembly in a folder of non-stick material, and place in a dry mounter set to 205°F (94°C). Leave in the mounter for 4–5 minutes.

After removing the folder leave it to cool for several minutes with a weight on top. Peel off the texturing and non-stick sheets, which can be used again, and remove the mounted textured print.

Adding a print surround

A cardboard mat, or surround, protects the print and makes it more durable as well as providing a frame.

You should choose the color and proportions of your surround carefully. Ideally the cardboard should be a subdued color, perhaps a gray or pale brown, so as not to "compete" with your image.

Mark out the picture dimensions on the center of the card. Carefully cut this area out using a straight edge and a sharp trimming knife. If you can, hold the blade sloping at 45° toward the print surface, to give a beveled edge to the "window". Push out the unwanted card and carefully remove any burrs remaining in the corners. You should attach the print to the underside of the mat with adhesive tape.

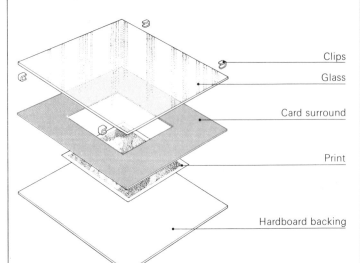

Clips

Glass

Card surround

Print

Hardboard backing

Framing
Once a print has been mounted you can frame it, with or without a mat. You do not have to use glass in the frame, but you must add a rigid backing to the print in addition to the card mount. As shown above, a frame can be simply made by using clips to clamp the print between a backing board and a sheet of glass.

Frame kits can be bought from artists' supply stores. They include metal or wood frames with mitered corners that you assemble with screws or catches.

SUMMARY — Advanced darkroom techniques

Film, exposure, and development

Select a combination of film and developer which suits your type of photography best. Slow film records fine detail but requires good lighting. If processed with a high acutance developer, detail on the negative is further brought out. A combination of fast film and a fine grain developer (which reduces grain) is useful for most general photography. Ultra-fast film plus speed enhancing developer is useful in very low lighting conditions.

The factors which most affect graininess on the negative are film speed, type and degree of development, and exposure.

Continuous tone films can record a very wide range of image tones, but those at the very top and bottom of the scale become poorly separated. These extremes on the scale are avoided except when you over- or underexpose, or photograph an extremely contrasty subject.

Increasing or reducing development to compensate for over- or underexposure alter the contrast. This limits the amount you can alter the development. You can record a high contrast subject by slight overexposure and underdevelopment, or a low contrast one by slight underexposure and overdevelopment. You can improve dense or thin negatives by using reducers or intensifiers, or compensate in printing by altering the enlarger light.

Special printing techniques

Two types of sheet film are useful for special printing techniques — continuous tone copying film and line film. (Line film is a high contrast film which converts normal continuous tone images to stark black and white.) Both of these films require long printing exposures like normal photographic paper. As a result you can control the image on the film. Special printing effects include bas-relief, solarization, and photograms. Solarization is produced by using line film and slightly fogging the image. Bas-relief is created by printing a positive and a negative of an image sandwiched together, slightly offset. Photograms are simple images produced without a camera, formed by contact printing objects direct on to printing paper.

Negative sandwiching, double printing and montage provide great scope for special effects in your pictures. They enable you to combine images taken at entirely different times and places.

Even after the darkroom stage your print can be made lighter (with ferricyanide reducer), have selected parts bleached-out completely (with iodine), or toned to change the color of the black silver image.

Mounting and presentation

For mounting use rubber or spray adhesive or, for finest and most permanent results, dry mounting. A dry mounter can also be used for texturing the print surface. Finally, you can protect and improve the appearance of your finished print by adding a mat and framing it.

COLOR PHOTOGRAPHY

STEP 1: Color film

STEP 2: Color picture building

If you want to work in color this section of the book is essential. It introduces all the special technical and visual aspects of camera technique in color. It also gives you necessary background information for the next section which deals with color processing and printing. You should read through the Steps in this section in order, because each builds on the one before, introducing and explaining terms as you go along.

Some people start their photography with color. This book introduced black and white photography first, because it is simpler and cheaper. All the basic camera and picture building techniques have been presented in black and white. You should therefore have worked through these earlier sections at least before beginning color photography.

Color photography introduces several new factors. You must consider the color of lighting as well as its direction and quality, and use film designed to match the type of light source – daylight, flash, or studio lamps. You have to decide whether to work with color slides, or color negatives and prints. And you must take rather more care over setting exposure, because errors here can upset color rendering as well as density and contrast.

Most important of all, you now need to think and see in terms of color, building a further visual vocabulary on to the black and white aspects you have already covered. The later pages of this section therefore discuss using color schemes and juxtapositioning colors to achieve particular effects. This color vocabulary is essentially a practical guide, so you should explore the topics discussed by finding appropriate subjects and situations, and taking pictures as you go along.

You can see results most directly if you use slide film, because this eliminates the changes that can occur in printing. You can immediately trace the effects of different amounts of exposure, or types of lighting. It is also cheaper per picture. If you intend eventually to do color darkroom work, you may prefer to use color negative film (and have it commercially processed and printed) so that you will have plenty of negatives to work from.

Arrangement of steps
The first Step in this section discusses different types of color film. You will see here how color film really consists of three black and white layers, coated one on top of the other. This relates directly to the "balancing" of color films to give accurate colors with particular types of light source. If you use the wrong lighting, you will have to use a correcting filter over your lens.

Step two begins by introducing the key terms used when discussing color, and the inter-relationships of various colors of the spectrum. (This Step is also essential reading before tackling color printing.) The pages on picture building in color, show you how to use color contrast, color harmony, and muted or strident colors, to produce particular effects. Don't be put off by the number of factors to consider. As in the black and white picture building section, the illustrations are chosen deliberately to emphasize the aspect being discussed and exclude others. But in practice, you will find that the color relationships in scenes overlap several definitions.

Color itself can form the main, dominant element in your picture, particularly if you manipulate it by means of filters, or choice of film and lighting. Pete Turner's pictures on pages 186-7 are examples of this approach. More often you will use color along with the other picture-building elements to strengthen your main subject. You can see this in the work of Rolph Gobits (see p. 179) and Gerry Cranham (see pp. 190-1).

What is color?
Before the seventeenth century it was believed that color existed in objects, irrespective of the light by which they were seen. Isaac Newton proved that light itself is the real source of all colors. He

split sunlight into a color spectrum by passing it at a certain angle through a glass prism. He then directed the band of colors through a second prism, which re-combined them into a beam of colorless light. Clearly, the colors formed did not exist in the actual glass, but came from the light itself.

A green leaf looks green because it reflects the green wavelengths present in white light. You can see this yourself by examining a green object under a red safelight – because the lighting contains no green, the object appears black. To take a more familiar example: when you buy a colored garment in a store, you often take it to a door or window to check how it looks in daylight. This is because you know that incandescent interior lighting, although "white", contains a slightly different mixture of wavelengths from white light outside, and so alters the apparent color of the garment.

Light is the source of all color. Colored objects are reflecting light selectively. They reflect only the wavelengths (i.e. colors) that you see, and absorb the rest. There are four different ways this can happen: selective reflection by pigment molecules; scattering; diffraction; and interference.

Pigment is the most common selective reflector of light. Molecules of pigment are present in practically every object created by nature and man – ranging from plants and animals to dyes and paints. Each pigment has a "resonance" or affinity for a particular wavelength or group of wavelengths. The pigment molecules most readily absorb these colors. A red flower, for instance, contains pigment molecules which "resonate" with, and absorb all the wavelengths in "white" light other than red. So that red is the only color it reflects.

Some colors are formed by a special kind of reflection – scattering. The most obvious example is a blue sky: it contains gases which tend to scatter the short (blue) wavelengths of sunlight. If the earth carried no atmosphere, the sun would appear in a black sky, just as it does in color pictures taken on the moon. Our sky often contains dust and moisture molecules too, which scatter a wider range of wavelengths and make the blue appear paler. Since dust and pollution are cleansed from the atmosphere by rain, skies are usually a deeper blue in color when strong sunshine follows a shower.

Scattering of light produces a wide range of sky colors. At sunrise and sunset, light from the low sun travels obliquely through the atmosphere along a path hundreds of miles longer than at midday. Consequently, nearly all the blue wavelengths

are scattered on the way; so the sunlight that reaches you is orange, or even red (see p. 154).

A few surfaces appear colored because they cause diffraction or interference. Diffraction of light occurs when light strikes a surface structured with extremely fine lines or ridges. These break up the light in such a way that some wavelengths are suppressed and others strengthened. The result is a shimmer of muted hues according to the angle from which you view. You can see diffraction colors on records, shot silk fabrics, and mother-of-pearl.

Interference colors occur on soap bubbles, or splashes of oil on water. Both soap and oil form extremely thin membranes. Light is reflected from both the front and back surfaces of the membrane, so that the waves are slightly "out of phase", reinforcing some wavelengths and suppressing others. This produces changing colors across the surface.

Color vision and color film
Things around you derive their colors from the interactions of light source and subject surface. But the way they look colored also involves the response of the actual receiver – your eyes (or photographic color film, eventually viewed by your eyes).

As you read on pages 20-1, human vision depends partly on the eye and partly on the brain's response to images. The back

Isaac Newton
The portrait of Newton, left, was painted in 1702 by Godfrey Kneller, shortly before the publication of his major work on the behavior of light, which included his color theory.

Discovering the spectrum
A contemporary copper engraving by B. Rode, left, shows Newton in a darkened room, using two prisms to separate a beam of light into the colors of the spectrum, and then reconstitute it. This crucial experiment, in 1666, demonstrated that light is the source of all colors.

OPTICE:
SIVE DE
Reflexionibus, Refractionibus,
Inflexionibus & Coloribus
LUCIS
LIBRI TRES.

Authore ISAACO NEWTON, Equite Aurato.

Latine reddidit *Samuel Clarke*, A. M.
Reverendo admodum Patri ac D. JOANNI
MOORE Episcopo NORVICENSI à
Sacris Domesticis.

Accedunt Tractatus duo ejusdem AUTHORIS
de Speciebus & Magnitudine Figurarum
Curvilinearum, Latine scripti.

LONDINI
Impensis SAM. SMITH & BENJ. WALFORD, Regiæ Societatis
Typograph. ad Insignia Principis in Cœmeterio D. Pauli.
MDCCVI.

Title page of Newton's "Optics"
Newton published his discovery of the spectrum and his color theory in his major work, "Optics". The title page of the original Latin edition, published in London in 1707, is shown left. The work also covered the laws of reflection and refraction of light, and laid the foundations of optics as a science.

surface of your eye is covered by a retina – a microscopic net of about 130 million light-sensitive cells. Some cells respond to color; these are known as cones. They are grouped mostly near the center of the retina. Other more numerous cells, known as rods, are much more sensitive to light, but cannot identify colors. They are mostly located away from the retina center. Cone cells respond to light as if they were an even mixture of three different kinds of receptor – each sensitive either only to red wavelengths, or only to green, or only to blue. So each color in the image formed within the eye gives rise to a different combination of the three basic signals. Blue will affect only one type of receptor; greenish-blue will affect two receptors; white or gray will affect all three. This tri-color concept is also used as the basis of color film: which consists of three separate emulsion layers, sensitive to red, green, and blue light.

Unlike color film however, the eye alters its sensitivity away from color and toward black and white in dim light. The color of a car is almost impossible to see by moonlight because at night you see almost entirely by the highly sensitive, but color-blind rods. Color film does not change in dim light. You can take color pictures by moonlight, although your results will then be distorted by reciprocity failure (see p. 107).

Another difference between color vision and color film arises from the central grouping of cones on the retina. Your eyes only respond fully to color in a narrow central zone of your field of view – the zone where you resolve greatest detail, and where you are focusing these words as you read. It is only because your eyeball moves almost continuously, to place whatever you are concentrating on within this retina zone, that you do not notice this. Try staring fixedly ahead, then bring a colored object at arm's length just within your field of view. You are conscious of its movement and general shape; but there are insufficient cones in this peripheral zone to make you sure of the object's color – until you turn your eye.

Provided they look squarely at objects, in strong light, most people can differentiate between the various hues (colors), and distinguish their saturation (richness), and brightness (dark or light color). About 8% of men and 0.5% of women do however suffer cone or nerve deficiencies which produce some form of color blindness. The most common type leaves you unable to differentiate clearly between greenish and reddish colors, and gray. Defective color vision is obviously a handicap in color photography, and you will find that it makes doing your own color printing impossible. So have your eyes checked by an optician if you are in any doubt.

The eye provides your brain with signals denoting the color of objects, which the brain then interprets. It has a color memory and this means that often you tend to "see" the colors you expect. You "know" from experience that grass is green and lips are red, so even when looking through tinted spectacles or viewing in colored light you are not muddled. You will, however, become confused as soon as you see an unfamiliar object – suddenly the colored light or glasses will become an obstruction to understanding what you see. You can accept the paper on this page as white, when reading outdoors in bluish daylight. If you then walk into a room lit by incandescent lamps, you will be briefly conscious of the more orange light but soon accept the page again as white. Colors inside the room will appear correct, provided you cannot compare them directly with the same objects lit by daylight. In other words, your color vision is capable of adaption to different conditions.

Color film cannot adapt. Film designed for daylight gives an orange cast to pictures if used in artificial light. Even the adaption of your eye finds this cast unacceptable, particularly when the color photograph is viewed in an environment lit by daylight. Color film is therefore more objective than the eye: it records what is present rather than what it wants to see. But you can also use it subjectively – for example by over- or underexposing to change color saturation (see p. 153).

Color relationships

When you change from black and white to color photography, the biggest difference is learning to observe and use subtle color relationships in your subjects – aspects which up to now you could ignore. Some colors are "cold" and others "warm", some are dynamic, others quiet; certain colors have a harmonious relationship, whereas others – such as orange and purple – always give a strident, shock effect. Color reactions of this type can greatly strengthen your color photographs, if handled well.

Gray looks lighter when seen against black, and darker against white. Adjacent colors create such effects too. The same gray looks redder against a green background, and greener against red. You can take advantage of "simultaneous contrast" effects like these to put boldness into a composition, when in black and white it would look weak and flat.

Color provides an expansion of your photographic range, but it also requires new skills. Until you can manage color relationships clearly, you must take care that color does not distract or confuse the eye, or unbalance your composition. Strong colors will be particularly dominating to the exclusion of other elements, perhaps even the subject itself. But once you are really used to the new materials, you will find color photography a medium with great potential.

STEP 1 : COLOR FILM/Types and structure

There are two main factors to consider when choosing color film. First, the form you want your result to take — slide, print, or perhaps both. And second, the lighting you will be using to take the pictures. Different types of film must be used under daylight and tungsten (artificial) lighting.

Modern color films produce either slides (color transparencies) or color negatives (for color prints). Black and white prints can be obtained from both types of film. The final form of your image is not fixed by the film you use. You can obtain slides from negatives, or prints from slides (see pp. 172–5). But the best all-round results are achieved when you use the film that gives you the final form you want — transparencies or prints. A third type of color film — instant picture film — is discussed on page 210.

Color slide film
Slide film, also called reversal film, is given a processing sequence which forms positive images directly on the film taken from the camera. These transparencies can either be projected on to a screen or looked at in a hand viewer. You can process most color slide films, such as Ektachrome and Agfachrome, yourself, as explained on page 164. A few types, such as Kodachrome, have a particular chemical structure which means that the processing must be done by the manufacturers or their agents.

Using color slide film has several advantages. You can do your own processing without a darkroom or any special equipment. Color slides, shown on a good projector in a blacked out room, give images that are unrivalled for fine detail, brilliance, and accuracy of color. Another consideration in favor of color slide film is that in terms of cost per picture, slides are the cheapest form of color photography.

Color negative film
All color negative films can be home processed. In processing, they follow a simpler sequence of stages than slide film to produce an image with negative tone values and complementary (or "opposite") colors. Like a black and white negative, this is an intermediate form from which positive prints can be made on photographic paper for which you require a darkroom. You will need much of the equipment used in black and white printing, shown in the larger darkroom on page 74.

Unlike color slide film, negatives allow you to lighten or darken the image during printing, and adjust the colors by filtering. Color prints are a convenient form for your pictures, and you can make many prints from the same negative.

Daylight and tungsten film
Color film consists of three layers of light-sensitive emulsion, as shown above right.

Each layer is sensitive to one of the three primary colors — blue, green, and red — from which all other colors are composed. The sensitivity of all three emulsion layers of the film is carefully "balanced" to record and reproduce colors and tones acceptably.

Most color films are balanced for subjects lit by daylight. Tungsten lighting produces slightly more red and less blue wavelengths than daylight. This is not normally noticeable because our eyes quickly adapt when changing from outdoor daylight to tungsten lit, indoor surroundings. Unlike our eyes color film is fixed in its response. Consequently, daylight balanced films give results with a strong orange cast if the subject is in tungsten light. If you use a film balanced for tungsten lighting in daylight conditions, the results will appear blue.

If you are using color negative film with the wrong light source, you can, to some extent, correct for this when printing. But this should be avoided as the heavy filtering required often obstructs other, more subtle color controls.

For the best results use daylight and tungsten films only in the lighting for which they are intended. Try to avoid subjects lit by a mixture of daylight and tungsten light unless noticeable differences in color are part of the effect you want. On page 146 you can see how to use correction filters with tungsten or daylight film to compensate for incorrect lighting.

Speed and brand
The speed ratings of color films for general photography range from 25 ASA (Kodachrome), the slowest, to 400 ASA (Kodacolor and Fujicolor), the fastest color film available. As in black and white photography, the appearance of fine detail deteriorates and grain becomes more noticeable with faster film. In extreme cases, particularly when very fast film is overdeveloped, tiny irregular globules of color can be seen in enlargements. For maximum resolution of detail, you should use the slowest film that lighting conditions will allow.

Each make and brand of color film gives slightly different reproduction of colors, as shown opposite. Some people find that they prefer the colors given by one brand to another. But the differences are unavoidable, so if you want to make a series of pictures, keep to the same film type, or at least to the same manufacturer.

When using color film, try to choose lighting that will keep the exposure times within the range 1/1000–1 second. Owing to reciprocity failure (see p. 107) films not only respond to very long or very short exposures as if they had a slower speed rating, but often alter their color balance, distorting the color reproduction.

Before and after use store all unprocessed color film in cool, dry conditions.

The structure of color film

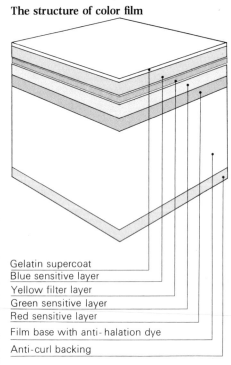

Gelatin supercoat
Blue sensitive layer
Yellow filter layer
Green sensitive layer
Red sensitive layer
Film base with anti-halation dye
Anti-curl backing

Color film consists of three permanently coated layers of black and white emulsion, carefully balanced in speed and contrast, and one filter layer. The top emulsion is sensitive only to blue light — similar to the blue-only color sensitivity of bromide paper. Below this, a yellow filter layer prevents blue light from penetrating further. The second emulsion layer is sensitive to green light. The third layer is sensitive to red. The film base and backing are the same as in black and white film (see p. 125).

All four layers collectively measure less than ·001 mm thick. Together they can encode all the colors of an image, each color or tone giving a different combination of responses in the three emulsion layers. White or neutral gray gives an equal response throughout.

In most film, dye-forming compounds are present in each emulsion layer. These combine with the processing chemicals to develop three separate image layers, each in a different color (the yellow filter becomes colorless). The changes which occur in each layer during processing to form a full color image are shown on pages 162–3.

Slide and print systems

Color slide film given color reversal processing produces positive color images on the film. Each image can be mounted separately in plastic or card frames, and projected or hand-viewed.

Color negative film is processed to form negatives. These can be enlarged and printed on to color photographic paper. The negatives appear orange, because of a dye arrangement which reduces contrast and improves the color accuracy of the print.

The procedures for making prints from color slides, slides from color negatives, and black and white prints from both types of film, are shown on pages 172–5.

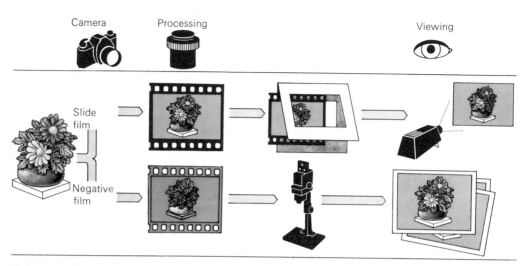

Camera Processing Viewing

Slide film Negative film

Over- and underexposure

To measure exposure for color film, you can generally use the same methods you have found successful in black and white work (see pp. 39–43 and 104–7). But there are some characteristic differences between negative and slide films.

Underexposing slide film results in a dark image, near right, particularly in the shadows. Overexposure gives a pale image, far right, particularly in the highlights. In practice, a slightly dark transparency is usually more acceptable than one which looks washed out, so underexposure is preferable to overexposure with color slide film.

Underexposing color negative film gives a thin image, near right, and overexposing produces a dense result, far right.

The orange mask on the negatives makes them appear darker than they really are, so check very carefully for the presence of shadow detail. Because the negatives are an intermediate stage, general adjustment of density is possible during printing, providing sufficient detail exists in the image. Thin color negatives seldom print well so you should overexpose rather than underexpose.

Underexposed Correctly exposed Overexposed

Color slide film

Color negative film

Differences in color reproduction

Even with accurate exposure and the correct light source, different brands of film give slightly different color reproduction, particularly on slide film. This is largely due to differences in chemical dyes.

The films shown here are, from left to right, Kodachrome, Fujichrome, and Agfachrome. Variations between them are much more noticeable in neutral tones or pale, skin colors than in strong colors. You will find that some brands may give a slightly more pleasant reproduction of reds and yellows, others of greens and blues.

Kodachrome Fujichrome Agfachrome

Balancing light source and film

What we call "white light" is really a mixture of wavelengths containing all the colors of the spectrum. This mixture varies according to the light source. For example, candlelight contains more red than blue wavelengths, giving it a slightly warm color. In shadow areas on a clear day, where the only light is scattered from blue sky, the light is bluish. These differences in the components of white light are sometimes expressed in temperatures on a scale measured in Kelvins (K), see below. The temperature of each color corresponds to the temperature of a hypothetical black body when heated to emit that color light. As the body grows hotter, it glows red, then through orange

and yellow to blue; so the reddish light cast by an ordinary household lamp is lower on the scale than the more bluish light of sunlight at midday.

Most of the light sources used for photography are shown below. The 500 watt tungsten lamps used in most photolamps and spotlights have a color temperature of 3200K. Photofloods are short-life over-run lamps, which give a slightly bluer light and have a color temperature of 3400K. In practice, sunlight is often mixed with bluer sky light so that typical "photographic daylight" is at least 5400K. Noon sunlight, blue tinted flashbulbs, and electronic flash are fairly similar in color temperature.

Color correction filters

Color slide films will render true colors only in light of a specified color temperature. The two main types of slide film are "tungsten" (3200K) and "daylight" (5500K). The pictures below show you how, by fitting the appropriate correction filter over the lens and making the recommended compensation in exposure, you can use both types of film in other lighting (the filter numbers refer to Kodak filters). In fluorescent lighting use daylight film for "cold white" (bluish) tubes, and tungsten light film with a 40R correction filter for "warm white" types. Color negatives can be color balanced in printing.

Color temperature and correcting filters

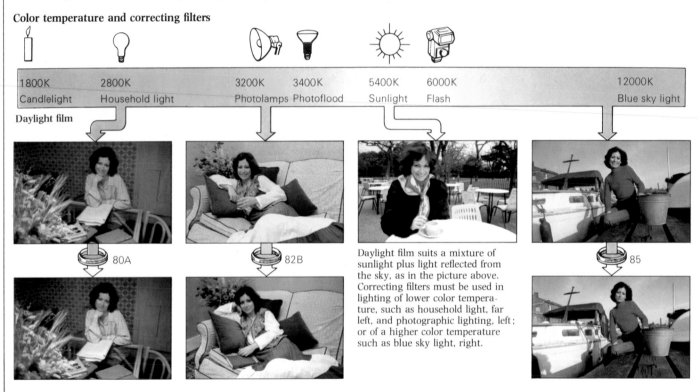

1800K	2800K	3200K	3400K	5400K	6000K	12000K
Candlelight	Household light	Photolamps	Photoflood	Sunlight	Flash	Blue sky light

Daylight film

Daylight film suits a mixture of sunlight plus light reflected from the sky, as in the picture above. Correcting filters must be used in lighting of lower color temperature, such as household light, far left, and photographic lighting, left; or of a higher color temperature such as blue sky light, right.

80A 82B 85

Tungsten light film

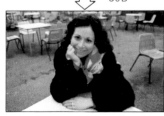

Tungsten film is balanced for scenes lit by photographic lamps, such as above. Correcting filters must be used in higher color temperature lighting, such as daylight, right, and blue sky light, far right; and in lower color temperature lighting, such as household light, left.

82C 85B 86

Mixed light sources
The scene below was lit by two different light sources — 100 watt lamps and daylight. Because it was taken on daylight film, correct color has recorded only in the area lit by natural light — the foreground. Tungsten film would reproduce the background color correctly, but would tint other areas blue.

Where mixed light is unavoidable you may be able to part-filter the image to correct for the mismatched light. In studio work you can put the appropriate filter over the light source.

Color and daylight
The color temperature of daylight varies enormously according to weather conditions and time of day. Most photographers do not try to filter the light in every scene so that it appears neutral. The dawn scene, right, was taken unfiltered on daylight film and reproduces the subject as it appeared at the time. However, with another subject, such as a portrait, the pink cast created by the light may well be unacceptable.

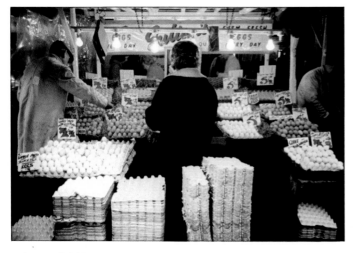

Other useful filters

The colored filters used in black and white photography cannot play the same role in color photography. Two apparently colorless filters are more useful — ultraviolet and polarizing filters.

Ultra-violet filters
An ultra-violet (UV) absorbing filter removes ultra-violet light which, although invisible to the eye, records as a blue cast on color film. This occurs most noticeably in distant landscapes at high altitudes, and in seascapes. You can therefore choose to include the blue haze, near right, or, by using this filter to absorb ultra-violet light, record the scene as it actually appeared to the eye, far right.

Polarizing filter
Some of the light from a blue sky is polarized (see p. 101), particularly in sky areas at right angles to the sun's rays. This reduces the intensity of color recorded, near right. A gray, polarizing filter can remove polarized light rays without distorting other colors, if positioned correctly. By rotating the filter on the lens you can, for example, deepen the blue of a sky, far right, or reduce glare — polarized light reflected from glass, water or polished non-metal surfaces.

Without ultra-violet filter

With ultra-violet filter

Without polarizing filter

With polarizing filter

STEP 2 : COLOR PICTURE BUILDING/Color terms

To understand color terms and relationships, we must begin by looking at the component colors of white light, divided into a spectrum by a glass prism. Deep blue appears at one end of this spectrum, red at the other. If we join the two ends of the spectrum it forms a continuous circle with each color graduating into the next. (If you were to spin a color circle fast on a record player turntable the colors would merge into white.) Each color on the color circle is pure, or "saturated", which means that it contains no white, black or gray.

Primaries and complementaries

The color circle can be divided into three broad zones – red, green, and blue. These are called the primary colors of light; by mixing them in different quantities you can form any other color. Between the primaries are three other zones – these are the complementary colors, magenta (bluish red), yellow, and cyan (greenish blue). A primary and its complementary are opposite to each other on the color circle. For example, magenta is positioned opposite to green, and is its complementary color. Each complementary is a mixture of two primary colors; and when two complementaries are mixed you get the primary color which is common to them both. For example, cyan (blue and green) and magenta (blue and red) give blue. This relationship between the complementaries and primaries is called "subtractive", and forms the basis for color processing and printing, as explained on pages 159–61.

Color and saturation

Tones of each color on the color circle can be made by adding white (increasing the light), or adding black (reducing the light). This makes the colors less saturated. Adding white to a pure color creates pastel tones; adding black or gray creates rich, dark tones. Consequently, lighting and reflectiveness of the subject surface are important influences on color saturation.

The color circle

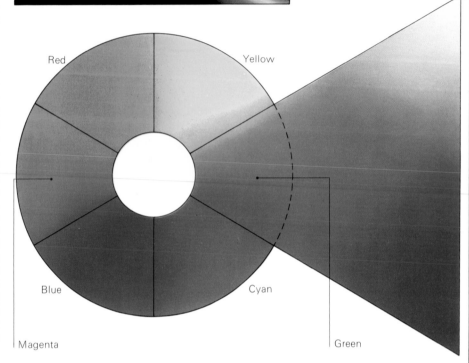

White light spectrum
If you direct a beam of white light through a steep sided prism at an angle, the light is separated into a narrow spectrum of colors, as shown left. This is because the component, colored wavelengths of white light are refracted (bent) at different angles and separated by the glass prism.

Primary and complementary colors
Color photography is concerned with colored light, which can be divided into three primaries–red, green, and blue. The three colors on the circle opposite these primaries –magenta, yellow, and cyan–are known as complementaries. A primary and its complementary placed together, such as red and cyan, left, produce the most striking color contrast in a composition.

Tones of brightness
The more a color is diluted the less saturated, or pure, it appears. The green, above, decreases in saturation from left to right, as white or gray is added, and in tones of brightness from top to bottom. Near the top, green is mostly replaced by white, giving a washed-out appearance to the color. Toward the bottom an increase in neutral gray subdues color brilliance.

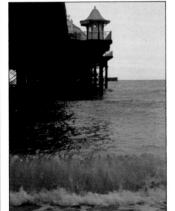

"Cold" colors
The blue, cyan, and green half of the color circle contains colors mostly regarded as "cold", due to association with ice, and winter conditions. By limiting the color in the picture, left, to blue, a bleak atmosphere has been created.

"Warm" colors
The "warm" half of the color circle –red, magenta, and yellow–contains colors associated with fire, and summer. The subject colors in the picture, left, contribute to its warm appearance and their similarity provides harmony.

Color contrast

Differing colors placed together in a composition create contrast, particularly if they are strongly saturated, far apart on the color circle, or offset by black or white. Saturated warm and cold colors together give bold contrast, the strongest effect being produced when a saturated complementary color is adjacent to its primary in a composition.

The importance of color contrast can be seen if you consider how the pictures on this page would look if they were in black and white only. Subject colors would all become similar tones of gray, greatly reducing the points of emphasis created by the color contrasts and combinations.

Too many bright colors detract from each other and can confuse the image, and should be used only when you want to create a discordant effect (see p. 155). The greatest impact with bright colors can often be created by keeping the composition simple.

Try to keep unwanted objects out of your pictures — they can be more assertive in color than in black and white.

Contrast using black and white
The strong red color of the mountains in the picture above is emphasized and made more luminous by its contrast with the black, underexposed foreground and the light toned sky. The simple, dark silhouettes of the cacti and bushes form powerful shapes against the background color.

Contrast using color
The pictures above and right use a limited range of tones, and create contrast through their use of color. The same scenes in black and white would appear flat and uninteresting by comparison.

In the picture above, soft, even lighting brings out the graduated, desaturated colors of the leaves against the muted color of the wall.

A more intense contrast is created in the picture of the lawn and flower-bed, right. Here the composition has been kept very simple, almost two-dimensional, to make the most effective use of the saturated reds and greens.

Color harmony

Closely related colors produce a sense of harmony, especially when linked by muted tone. You can create color harmony by limiting the color range of a composition either to several colors near to each other on the color circle (particularly if no more than one is fully saturated), or to one color only in a wide variety of tones. This does not mean that you must always use predominantly warm or cold colors. You can use both halves of the color circle harmoniously in a picture, if they are blended into a predominant tonal or color effect. But when warm and cold colors are used in equal ratio in a composition they tend to work against, and neutralize each other.

The dominant color range you choose for a harmonious picture depends on the subject and its associations, and the mood and atmosphere you wish to evoke. Here the effects of using warm and cold colors are important. Lighting, weather conditions, exposure, and filters can be used to strengthen the color harmony in your pictures.

Color and tone

You can most simply achieve harmony in a composition by using tone variations of one color only. As in black and white photography, variations in tone are mostly achieved by the direction and quality of the light, and have the effect of conveying form and depth in a subject.

Warm harmony
Color harmonies abound in nature. Even in a simple subject such as the leaves, left, all sorts of subtleties of color and tone can be found. The irregular shapes of the leaves in this picture are blended and unified by the harmonious, warm colors. The photograph was taken on daylight color film in diffuse light which brought out the subtle colors without forming any harsh shadows.

Cold harmony
The seascape, left, was taken in evening light on tungsten light film to create a bleak, cold atmosphere. The tungsten film suppressed any warm colors and gave the whole scene a cold, blue cast.

Using a filter to increase harmony
The picture below was taken using a 30 magenta filter on daylight color film. By careful selection of the intensity of the filter, the pink light cast by the early morning sun was enhanced without losing the realism of the colors.

Harmony using one color
Harmony in the landscape, below, is created by the use of one main color — green. The wide range of subtly differing tones is made more apparent by the hard sidelighting, giving the picture a feeling of depth and separating the shapes and forms. The exposure was averaged from the highlights and shadows. This preserved detail throughout the subject and avoided creating areas of dense shadow.

Harmony through underexposure
The picture, right, was restricted to a wide range of harmonious tones of one color by underexposure. Foreground objects have been reduced to dark shadows. These offset the delicate pattern created by the low sunlight reflecting off the sea. The exposure was read off the highlights on the sea, in order to underexpose the scene.

Harmony through diffusion
Ultra-violet light, present at high altitudes, reduces the intensity of the colors in a subject. This is most visible in distant landscapes. In the picture below ultra-violet and blue light scattered by the midday haze have changed the normal colors in the scene to one dominant color. The haze scatters the light so that objects in the distance appear paler in tone than foreground objects —creating a strong aerial perspective. This effect has been emphasized by using a long focus lens to make the distant part of the scene appear closer to the foreground.

Assignment: exploring color

Decide on a color film — tungsten or daylight — and using the appropriate filters for the lighting conditions take the following pictures:

A. With slide film, three pictures each of the same subject. Bracket the exposures so that the first is twice, and the second is half the exposure judged correct. Repeat the series with negative film and compare the colors in each series.

B. Four portraits of someone you know, without using correcting filters in: correct lighting for the film, candlelight, fluorescent light, and mixed lighting.

C. Of two subjects, one with warm, the other with cold colors dominant. If necessary use color filters to amplify the effect, but be careful to preserve the realism of the original colors.

D. A close-up of a subject with strongly contrasting colors that are more or less equal in tone. Then, after moving away or changing your viewpoint to include an area of neutral color, such as a cloudy sky, take a second picture. Compare the color contrast in the two pictures.

E. In diffuse lighting and in direct sunlight, of a subject that has one main color in a wide range of tones. Compare color harmony in the two pictures.

Muted color

In color photography, you will often find that "less is more". In other words, that restricted color is usually more effective than a picture filled with a confusion of varied colors and tones. On pages 150–1 you saw how reducing color to one harmonious scheme strengthened the image. Another means of creating harmony and strength is to limit yourself to the subtle effect of muted, or desaturated, colors. Pictures using muted colors can convey many different moods. They may use a full range of desaturated tones, or be restricted only to pale tones (high key) or dark tones (low key).

Even in subjects which might at first appear almost colorless, muted colors can be found — modern color films can record, and even slightly exaggerate, very pale colors. A composition with a predominance of white, gray or other neutral tones makes the presence of muted color very significant. This is because neutral tones help to pick out every slight variation in tint.

Hazy lighting, rain or mist, can subdue the colors in your subject. When working indoors use diffused or bounced illumination to soften colors. The simplest method of desaturating color is to use a clear plastic diffuser on the lens. Diffusers can be bought in a variety of strengths but all have the effect of spreading the light.

Slight overexposure of color slide film tends to desaturate colors and generally give a high key effect. Overexposure dilutes color in the brightest parts of the picture most, and so only the dark areas record color strongly. Underexposure gives a more low key effect, with color recording most strongly in the highlights.

Diffused light and muted color
The fishing scene, above, appeared almost monochromatic at the time of shooting. But through the slight mist light from the dawn sky gives a pink flush to the water, adding greatly to the atmosphere.

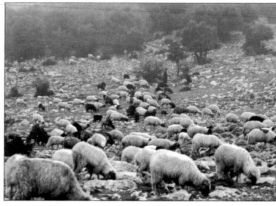

Muted colors and black and white
Taking a largely black and white subject such as the sheep, above, with color film might seem pointless. Yet the shades of black and white work effectively to bring out the muted colors, that blend and change with distance.

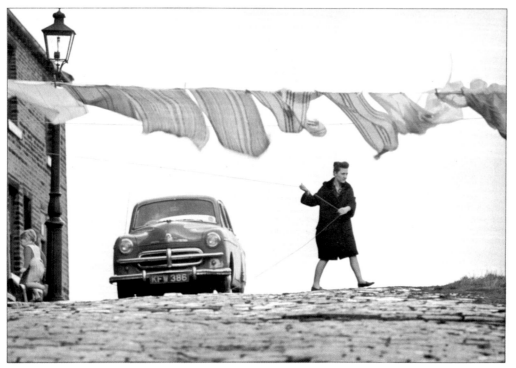

Muting colors by exposure
Overexposure gives a bleached effect to color reproduction, such as shown left. Normal exposure would have given a grayer sky, which together with the strong colored washing would have detracted from the central figure. The muted, almost colorless effect is further enhanced by the low camera viewpoint which makes the most of the white overcast sky.

Exposure effects are difficult to predict accurately. You may have to bracket several exposures to obtain exactly the result you want.

High and low key

Overexposure gives pale tones and colors (high key); underexposure has a low key effect.

The portrait below, was taken against the light. Overexposure has reduced the saturation of the colors, giving it an added delicacy. Underexposure of the man's face, right, has caught rich color in his features and created dense black elsewhere.

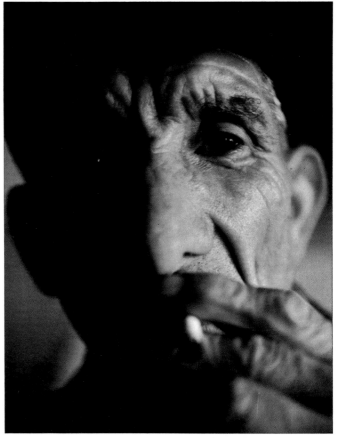

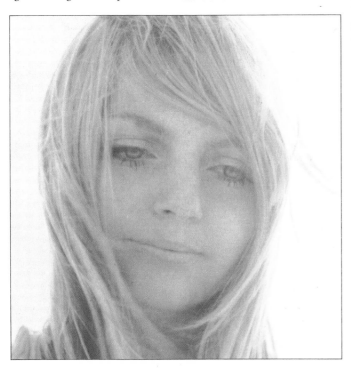

High key and overexposure
The muted colors in the picture of Tower Bridge, London, left, were created by overexposure and the misty conditions. There are no tones darker than mid-gray in the picture, yet the muted tints in the sky and reflections on the water have not been lost. The meter reading was taken for the foreground and the shutter set to give three times the indicated exposure.

Low key and underexposure
The picture of the boatman, below, owes much of its strength and atmosphere to underexposure. Here the meter reading was taken only from the evening sunlight as it reflected off the water and then half the correct exposure time was given. The rich color range extends from fully saturated to deep tone, and the main shape is simplified to a black silhouette.

Time of day

We saw on page 52 how the position and height of the sun changes subject appearance. In color photography, these changes are even more important.

Daylight alters in color throughout the day and year. The color temperature of the light which reaches us gradually increases with the height of the sun. When the sun is near the horizon most blue waves are filtered out by scattering and absorption. Thus at dawn and sunset the light is predominantly orange or red. You can see in this series of pictures how the color of the light only matches the color balance of daylight film strictly at about noon, when the blue light is least filtered by the atmosphere. Dawn and dusk are the periods of most rapid change in the lighting color.

The direction of the lighting also changes throughout the day and the year. Around midsummer the sun describes a much wider arc in the sky than during winter, and rises and sets at further separated points on the horizon. Early morning or late evening on a summer day may be the only time the sun directly illuminates a north-facing building.

Lighting quality is most affected by the weather. In temperate climates water vapor in the atmosphere sometimes softens the light. This is most noticeable at dawn or dusk, when the oblique light waves have to travel a greater distance through the diffusing haze.

7 am
The early lighting is indirect as the sun has not yet risen. Tones in the subject are merged, and the light is predominantly blue—giving a cold appearance to the scene.

9.30 am
The sun has risen and the direct sunlight separates forms and reveals detail in the scene. The low, hard side-lighting is quite yellow and brings out a full range of colors in the subject.

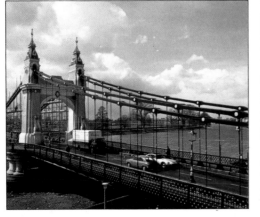

12 noon
The sun is now high, facing the camera, far left, and its light is nearest to being "colorless". The changed lighting direction has reduced color saturation of the sky. Detail in the near surfaces of the tower is suppressed.

5 pm
Clouds still obscure the sun, which is now much lower in the sky, left. Light is reflected off the water and pale sky to give a high contrast, almost monochromatic effect.

6 pm
As the sun begins to set, right, stronger colors appear, and rapidly change in the sky. The shadows are more intense and the form of the bridge is less distinct.

6.30 pm
Half an hour later, far right, the sky has changed color significantly as the sun has dropped below the horizon. It is now bluer, but the colors are still mainly warm. Shadows are dark, but shapes silhouetted against the sky are strengthened.

Strong colors

Strong, saturated colors demand attention. One or two bold colors can create a dramatic effect, particularly when they fill a picture, but several strong colors of similar area and tone can easily overpower a subject. If you limit the number of colors, and set them against neutral black or white tones, the overall effect is intensified and the content of the picture is not overwhelmed.

When taking a subject that has strong colors be careful to measure the exposure accurately. For example, take a reflected light reading (see p.104) from the strong colors alone, if they are quite small in area. On slide film always avoid overexposure, and on negative film avoid underexposure. Indeed, on slide film it may even help to underexpose and then overdevelop the image to increase contrast and brilliance.

Strong color can be intensified by using the right equipment and by lighting. A polarizing filter is sometimes useful to deepen the tone of blue skies and reduce surface reflections, which desaturate color. In landscapes and distant shots try to choose a day with a clear atmosphere, such as when hard sunlight follows rain, so that distant colors are not diffused by haze.

Offsetting strong color
The bright pink car, above, is given added impact by the close-up viewpoint, which fills the frame with color, but retains a small neutral colored area of ground. This contrast offsets and strengthens the main color. The photograph was taken in flat light after rain which gave the color greater intensity.

Contrasting colors
Two contrasting, equally saturated colors can often detract from each other. But they are effective in the picture, above, because of their great difference in area. The tone variations within the green give just sufficient form to identify this as part of a car. But the intense colors, hard edge lines, and framing deliberately create a more abstract composition.

Simplifying several strong colors
The subject above included a confusing variety of strong colors, all in similar sized areas. However, in the picture, three main devices have been used to simplify the image. First, the plain white background separates the bright colors; it also clarifies the shapes of the figures. Second, photographing at an angle, from a close viewpoint, has varied the scale of the figures (and colors) considerably across the frame. Third, the wide lens aperture (i.e. shallow depth of field) has limited detail in the picture to the center of interest.

Symmetry and strong color
The photograph on the right was taken on an exceptionally clear day, in hard, direct sunlight which produced brilliant contrasting colors in the flowers, grass, and sky. A polarizing filter helped to darken the tone of the sky and intensify its blue color. The areas of color in the picture are emphasized and balanced by the symmetrical composition. The edges of the flower beds are positioned at the same height on both sides of the frame, and the horizon is placed so that it divides the picture almost exactly in half. Using a wide angle lens created the steep convergence of lines that gives a feeling of depth in the picture.

Manipulating subject colors

You can create new and striking images by manipulating subject colors during exposure, either using filters, or by over- or underexposure (see p.145), or by using inappropriate film for the lighting. You may do this to "warm-up" or "cool down" a color scheme, or to create a particular interpretation.

Extremely pale filters give a slight overall tint, most noticeable in delicate colors and highlight areas. Subjects of normal contrast are often spoiled by using a strong filter. However, backlit or similar high contrast images can give you interesting results with strong filters, particularly if you also under- or overexpose them. The result is often the filter color plus either black or white, as shown below.

Color negative film allows selective filtering during printing, so color changes can be made in the darkroom, see page 170. If you use slide film, color manipulation will mostly have to be done in the camera, usually by adding lens filters. If you have your color negatives commercially processed, your manipulations may be "corrected" as errors. So you should include instructions when the film is sent off to maintain filtering and exposure as for normal negatives.

Using film in the wrong lighting
Another way of deliberately distorting image colors is to use the wrong light source. The effects on color balance of mismatching lighting and film were shown on page 146. It is worthwhile experimenting with the color casts created under different lighting to get the effects you want.

Graduated filters
Sometimes the colors in a scene can be given added interest and variety by using graduated filters, such as the one shown right. These filters have one color that diffuses into clear glass. The seascape above was taken first without a filter, left, and is almost monochromatic. The same scene, above right, using two graduated filters — blue and brown — has added color, especially in the highlights.

A similar effect can be achieved by simply holding pieces of gelatin part-way across the lens.

Red filters
The high contrast scene, above, was photographed on daylight film through a strong red filter, and underexposed to restrict the main colors to red and black. The sun itself is just brilliant enough to overexpose and so bleach through the red cast created by the filter.

Blue filters
The picture right, was taken against the light on daylight film through a dark blue filter. Most of the brightly lit center of the picture was overexposed, resulting in little or no color. The darkest blues appear in what were originally dark mid-tones and shadows.

Mis-matching film and light source
Occasionally the color cast created by using color film in the wrong lighting can be used to enhance your interpretation of a subject.

The picture below was taken on daylight film in fluorescent lighting. Fluorescent light varies so much that it is often difficult to filter accurately for it. The pale green cast that resulted was not exactly predicted but it contributes to the impression of the congestion and discomfort experienced by the crowded rush-hour travelers.

The red cast and dark, generally low key tones in the picture, right, convey the warmth and intimacy of candlelight. The warm cast was created by using tungsten film without a filter. A long exposure was given to the scene to compensate for the poor lighting.

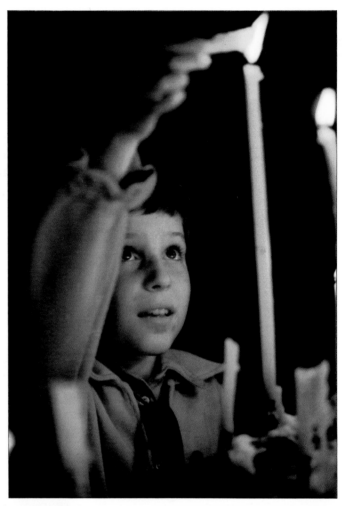

Infra-red film

Infra-red Ektachrome film was originally designed for air surveillance photography, but can be used ordinarily to give bizarre color distortions. It has three emulsions, sensitive to green, red, and infra-red respectively. This means that surfaces which radiate invisible, infra-red light such as sunlit vegetation, reproduce as red. Red objects photograph yellow. Faces appear wax-like, but blue reproduces normally although more contrasty than on regular film.

Infra-red Ektachrome is designed to be exposed through a deep yellow filter for a maximum range of colors. But other filters can be used. For example, a strong green filter gives intense red foliage, near right. If you give the film color negative processing instead of normal Ektachrome slide film processing (see page 164) your results appear as shown far right. Magenta leaves revert to their complementary (green) but blacks and whites are negative in tone.

SUMMARY Color photography

Light source and color film
The two main types of color film
are balanced for tungsten light
(3,200K) or daylight (5,500K).
Orange (tungsten film) or blue
(daylight film) correction filters
should be used if you want to use
films with other light sources. For
the best results always try to
work on film of the nearest bal-
ance to the lighting.
 Unless you want to create a
special effect, such as shown below,
avoid working in mixed lighting of
different color temperatures.

Color contrast
Color contrast is formed by dif-
ferences in hue as well as tone.
You can use contrasting hues of
the same tone, contrasting tones of
the same hue, or combinations of
both. A primary color and its
complementary, such as blue and
yellow, adjacent to each other
create the greatest contrast.
 Colors are greatly affected by
their surroundings. When sur-
rounded by black they tend to
appear brighter; white surround-
ings make colors appear richer.

Color harmony
Harmonious colors are located
close to each other on the color
circle. They do not necessarily fall
into the groupings of "warm" and
"cold" colors. A single dominant
color, used in a range of tones to
give depth and form, will give a
particularly strong, harmonious
picture. Atmospheric conditions,
such as haze, help to enhance
color harmony. Mis-matching film
and lighting, using pale filters, or
under- or overexposing can also
increase color harmony.

 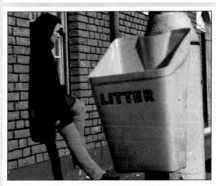

Muted color
Muted, or desaturated, color can
either include a full range of tones,
as above, or be restricted to pale
tones (high key) or dark tones (low
key). Under most conditions, over-
exposure gives a high key effect.
Underexposure gives a darker, low
key image with black shadows and
rich color in the highlights. High
key pictures are enhanced by
using pastel colored subjects, and
diffused front lighting. Low key
pictures often use rich colored
subjects and high contrast lighting.

Strong colors
Fully saturated colors — with al-
most no black, gray or white —
are the strongest, most intense
colors. They have to be used care-
fully as they easily detract from the
main subject, and can confuse
shapes and forms. Color saturation
can be intensified by a polarizing
filter, which suppresses some surface
reflections and darkens blue skies.
Direct lighting, clear atmospheric
conditions and subjects with shiny
(or wet) surfaces help to give an
image maximum color brilliance.

Distorted color
Manipulating color, either locally
or overall, can create interesting
results; but if over-done the result
can appear too contrived. Gradu-
ated or strong filters, combined
with under- or overexposure of a
high contrast subject, alter subject
colors. Infra-red sensitive color
film gives a distorted rendering of
subject colors, such as shown
above. The exact results are dif-
ficult to predict, but you can often
make dramatic pictures from quite
simple subjects.

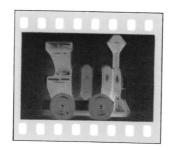

COLOR PROCESSING AND PRINTING

Color processing and printing uses many of the procedures introduced in black and white work, but it does require extra care and attention to details. You need to control very accurately the temperatures of solutions and the times they are allowed to act to get consistently good results. Very little more equipment is required than you have already used for black and white processing and printing. But the materials – films, chemicals, and paper – are more expensive than for black and white work.

Although this may sound frightening, you will in fact find color printing one of the most stimulating and creative areas of darkroom work. Since in many ways it is easier to do than simply read about, work through each stage as you read, perhaps using a trial pack of paper and minimum quantities of chemicals. Before you can start you should already be doing your own black and white processing and printing, as well as having read and worked through the section on color photography. In fact, we assume that you will have read through most of the earlier part of the book, and already have a fair amount of darkroom experience in processing and printing.

The Steps in Color Processing and Printing are sequential and concentrated. So work through them in order, taking your time, and mastering each stage before moving on. Get into the habit of making notes, on details such as times and filter settings, particularly when color printing. Later, when judging tests for example, you will want to refer back to these for details of filter settings and exposure times.

The first part of this section deals with film processing. As in black and white processing, you do not require a darkroom, but you will need more solutions and greater control of their temperatures. You can begin by processing your own films, leaving color darkroom work until later. If you are using color slide film this will give you finished results. But if you want to tackle color printing you will almost certainly be using color

negatives and it is possible to leave the routine processing of these to a commercial laboratory.

A few slide films, such as Kodachrome, cannot be home processed. They are known as "non-substantive" types and require long and complicated processing which is only practical on automatic machinery. You have to send them to the manufacturer or their agents for processing. Usually the cost is already included in the price of the film. But the great majority of slide films and color negative films can be user processed. Each type, and often each brand, follows its own particular processing sequence and requires its own kit of processing chemicals. But gradually greater uniformity in method and solutions is being introduced. Eventually there may be only two kits – one for color slide films and one for color negative films and papers. This is still in the future, so you must always check that your film and the process you are using are compatible.

The basic principles shown here are well established and still apply, but check the manufacturer's instructions with your processing kit for current temperatures and times. Generally you will find that all color processes tend to use higher solution temperatures than their black and white equivalents.

Compatibility between materials is not so essential in color printing, when selecting brand of color negative and the paper to print it on. Provided the color paper is designed for printing from negatives you can, for example, print Kodak negatives on Agfa paper. However, to begin with stick to one brand of film and paper. The contrast and the color rendering of each paper is designed to match the manufacturer's negatives, so you will not be faced with such complicated juggling of the color balance in the print. Do not try printing one make of film on to a different make of paper until you are more experienced. Then, you may find that the slightly different rendering of some colors (like the differences in slide films shown on page 145) suits some subjects.

For color processing and printing you can use your black and white film developing tank (see p.69), and probably your enlarger. Most enlargers either have a filter drawer or a color dial-in head for color printing. A filter drawer is cheaper, but a dial-in head is easiest to use. The most expensive new item of equipment you will require is a daylight developing drum for prints. You can use several trays instead, but a drum makes the job of processing prints so much more convenient that it should almost be considered essential.

The organization of the section
The first Step in this section explains how color films work – the changes that have to be made within the three emulsion layers (see p.144), sensitive to blue, green, and red, to reproduce the colors in the original image.

From the three primaries you can make up any other color in the color circle. But instead of these primary colors, all modern films and papers use complementary colored dyes to reproduce the subject. These are the three colors that are opposite to the primaries on the color circle, as shown on page 148. A complementary color absorbs light of the primary color opposite it, and passes the remaining light, that is, light of the other two primaries. Yellow dye, for example, absorbs light of its opposite, primary color – blue, but allows the two other primaries – red and green – to pass. Similarly, magenta absorbs green and passes blue and red, and cyan absorbs red and passes blue and green.

Since yellow, magenta, and cyan absorb about one third of the spectrum each, they can be used superimposed together to create colored images. Primary colors absorb two thirds of the color spectrum and only pass their own color. Consequently they could not be used in film or paper to produce an image, because the top layer would block colors present in the two lower layers.

Color processing therefore produces a complementary colored

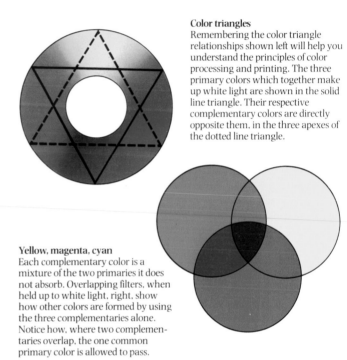

Color triangles
Remembering the color triangle relationships shown left will help you understand the principles of color processing and printing. The three primary colors which together make up white light are shown in the solid line triangle. Their respective complementary colors are directly opposite them, in the three apexes of the dotted line triangle.

Yellow, magenta, cyan
Each complementary color is a mixture of the two primaries it does not absorb. Overlapping filters, when held up to white light, right, show how other colors are formed by using the three complementaries alone. Notice how, where two complementaries overlap, the one common primary color is allowed to pass.

How dyes affect light
As shown below, left, deep blue, green, and red dyes each absorb two-thirds of the spectrum from white light. The layers in film and paper are sensitive to these colors but after processing form three negative toned images of the subject in the complementary colors – yellow, magenta, and cyan. As you can see, below right, each of these subtract from white light only one primary color. Each color passes two thirds of the spectrum so that the three colors sandwiched together in film or paper give a full color result.

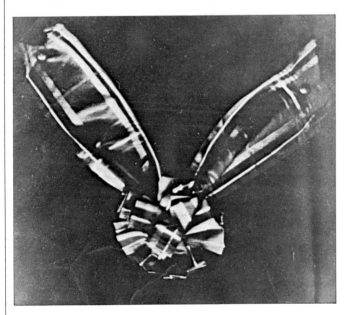

First color photograph
In 1861 James Clerk-Maxwell produced the first natural color photograph, above, to demonstrate the additive three-color principle. He used three separate plates, exposed through a red, green, and blue filter respectively. Then he projected each with light of the same color as the filter, and superimposed the images. (Clerk-Maxwell's red plate was not in fact red sensitive – it was later discovered that it recorded ultra-violet light reflected from red areas.)

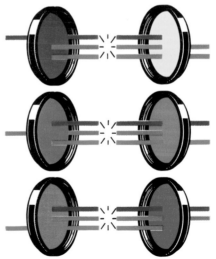

image in each layer. In a color slide, for example, the top layer is made yellow wherever blue was not present in the subject. The yellow dye image stops unwanted blue light, but without interfering with the green and red sensitive layers (magenta and cyan) below. The diagram on page 162 shows how an image is built up in this way.

Color negatives also use yellow, magenta, and cyan dye images. Since it is a negative image the colors are reversed – yellow appears where blue was actually present, magenta where green was present, and so on. The image is complementary in tone and color to the original subject. Color paper has three similar layers of emulsion so that when the negative is enlarged on to it, and processed, it gives a positive, correct color print.

Color film processing
Different chemicals and more processing stages are required for color slide films than for color negatives because you produce a final color positive on the film itself. It takes about 30 minutes excluding washing; color negative film takes about 17 minutes. Most color slide films can be "pushed" or "held back" by altering the time given for the first processing stage. This compensates for up or down-rating the ASA speed, respectively, during exposure. However, doubling or halving the speed is about the maximum you can expect without creating some unwanted side-effects. These include loss of subtle tones of color, producing grays on the image instead of blacks, or an overall color cast. Don't try adjusting the development time of color negative film – the resulting negative may look fine but often proves impossible to print, with shadows giving one tint and highlights another.

You will find that the main challenge in film processing – in fact all color processing – is to maintain temperatures and times with the greatest possible accuracy. Manufacturers warn that most developer stages have to be held within $\frac{1}{4}$°F (0.1°C) of the specified temperature. If the temperature is a few degrees in either direction your results will usually be acceptable, but when you compare your films you will notice the color variation.

Color printing
In the next Step – color printing from color negatives – there are two alternative ways of working. The cheapest, but crudest method is to give the paper three separate exposures to the image through three filters – deep blue, green, and red. This is like exposing each emulsion layer of the paper separately. By varying the three exposure times you control the respective color in your print. This "additive" system sounds simple but it is very time-consuming and you will find that controlling the density and color on the print by shading and printing-in is impossible. So we have followed the more popular, "subtractive" exposing method for color printing.

Subtractive printing uses yellow, magenta, and cyan filters in varying strengths to tint the enlarger light source. In this way you control the amounts of blue, green, and red light which reach the color paper and affect each of its layers. Only one exposure is needed, and it is easier to control the image than with the "additive" method.

Practice at color printing is very important. You must get used to judging both the density and color in the print, and deciding by how much filters should be changed to give the exact result you need. The best way to give yourself experience is to make a "ring-around" set of prints like the one on page 167, using one of your own, correctly exposed color negatives.

Once you can successfully make "straightforward" prints you can begin introducing the local controls. These include shading or printing-in through filters to correct or alter the color in different parts of the image. Pages 170-1 show you some of the more interpretative effects possible, such as printing black and white negatives through filters on to color paper. Even color photograms are possible. There is no reason why your color printing should always aim for a faithful accuracy to subject colors. Try experimenting fully – this will improve your technical expertise and understanding of color printing, and may open up new areas for creative ideas.

If you prefer working with slides, or have a large collection of slides, you can make color prints from them by reversal, or positive-from-positive printing. This involves enlarging the color slide on to a reversal printing material, which is then given a special reversal processing. In theory this system is very convenient, although some reversal papers do require six processing stages. In practice the quality, especially from contrasty slides, is not as good as from an original color negative. Improvements are still being made in reversal printing and this might eventually become the most popular way of working. It has the advantage of allowing you to project your color pictures as well as having them as prints. Some manufacturers offer trial kits of reversal paper and chemicals, and since you only require your color enlarger and developing drum to do reversal printing you can easily try out this system for yourself.

You can also make black and white prints and color slides from color negatives. In fact whether you start from a color slide or color negative you can adapt the final result into another form. The diagram on page 172 summarizes the various methods of converting your final image.

Color print retouching and mounting follows a routine similar to black and white retouching and mounting (see pp.88, 138-40). You can, for example, texture the print surface, following a similar method as for black and white prints (see p.139). Page 176 explains some of the corrections you can make to color prints and the more minor modifications you can make to slides.

Do not display your color prints in strong sunlight. Most print dyes are not very resistant to fading. Reversal print materials such as Cibachrome are much more permanent, but no color image, print or slide, will survive long exposure to brilliant light without some change in the colors occurring. Slides always look best when projected – information on different projectors is shown on page 212.

STEP 1: HOW COLOR FILMS WORK

All types of color film (and most printing papers) use the same basic principle. They have three layers of light-sensitive silver halides and linked dyes which record and reproduce the subject as three separate color images. Each layer responds to one of the three primary colored wavebands (blue, green, and red) that compose white light. As both film and paper use the subtractive principle the subject colors are finally reproduced in the three complementary colors — yellow, magenta, and cyan.

Exposure and processing

In the film the top layer responds to blue light. The middle layer responds to green.

And the bottom layer responds to red. All layers respond to white and none of the layers respond to black.

When the film is exposed each layer forms a latent image wherever its primary color was present in the subject. But it is the remaining, unexposed area on each layer, carrying no image, that is important. In slide film the dyes in each layer form complementary colored images in these areas. Consequently on the first layer those areas of the image that were not blue carry a yellow dye; areas that were not green on the second layer carry a magenta dye; and areas of the image that were not red on the bottom layer carry a cyan dye.

When the slide is viewed in normal white light the three layers recreate the original subject colors by subtracting color from white light. Each dye subtracts one color where that color was not present in the image, and passes the other two.

You can see how the image is formed by following the slide sequence shown below. Slide film is given reversal processing which forms a positive image in the film.

Color negative film is processed to a half-way state in which the tones in the image are negative and the colors complementary. When the negative is enlarged on to color paper it creates the same final dye positives as slide film, as shown below.

The subject
White light is selectively reflected by the subject and gives rise to different colors. These are analyzed and separated into combinations of the three primary colors by triple emulsion color film.

Red sensitive layer

Green sensitive layer

Blue sensitive layer

Latent response
On exposure, three latent images are formed in the layers corresponding to the color sensitivity of each layer. White produces a response throughout since it contains all three primary colors. Notice how yellow affects both the red and green sensitive layers.

Cyan image

Magenta image

Yellow image

Dye positives
In the final print or slide each emulsion layer carries a complementary colored image: yellow in the blue sensitive layer, magenta in the green sensitive layer, and cyan in the layer sensitive to red. Together these can give any color or tone variation. (For clarity solid color is shown here, in practice each image has gradations of dye.)

Overall result
The three layers are permanently superimposed and viewed as one. If the result is a color slide you hold it up to white light, or project it. On a color print the dye images are seen against white paper. Either way each dye layer removes unwanted light of one primary color. (Where the three dyes overlap, all three primaries are subtracted and the image appears black.)

White light

Cyan layer Magenta layer Yellow layer Final image

The processing sequence

Processing turns the latent image in the layers of the exposed film into images in complementary colored dyes, as shown below. The yellow filter layer, shown on page 144, becomes colorless during processing and so is not shown here.

Slide films should be given reversal processing, forming a positive image directly on the film. Color negative processing is shorter and gives a negative image which should be printed on to color photographic paper. The paper follows a similar, but still shorter processing sequence. Slide film can be processed as negative film for special effects; but negative film given reversal processing produces no image.

The subject
The three primary colors on the toy train, left, are separately recorded in the film in the three layers. Yellow (red and green) produces a response in the red and green layers of the film. White produces an equal response in all three layers (not shown here).

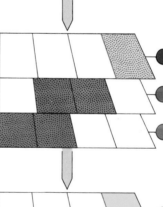

Reversal slide development

First development
The first solution in slide processing is a black and white developer, which forms black and white negatives in each layer, corresponding to the latent images. The timing of this stage can be altered to allow for up- or downrated film.

Fogging and color development
After the first development and wash, the film is put in a reversal solution. This fogs the unexposed areas, rather like fogging by light. The next solution — color developer — changes the fogged areas into complementary colored dyes and black silver, producing a positive image.

Bleach
The bleach removes the black silver from all parts of the emulsions, without affecting any of the dyes. Fixing and washing remove the by-products, leaving positive complementary colored images in the dyes alone.

Color negative development

Masking in color negatives
Both the magenta and cyan layers in color film and paper absorb some wavelengths they are intended to transmit. This is most serious in negative film because each dye is formed twice — in the film and then in the print. It is overcome by making the magenta layer yellowish and the cyan layer pink wherever their dyes are not formed. As a result color negatives have an orange cast, but this does not appear on the final print.

Color development
In the first stage, a color developer forms black silver and complementary dye images corresponding to the latent negative images in each emulsion layer — a different dye for each layer. The development time should not be adjusted for up- or downrated film as this affects the color too.

Bleach
A metallic bleach removes the black silver parts of the image, and fixing and washing leaves a negative dye image in complementary colors and opposite tones to the original subject. The negative is suitable for printing on to color paper.

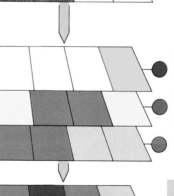

Color slide

Color negative

STEP 2 : COLOR FILM PROCESSING

Color film processing involves little additional expense, once you are equipped for black and white work (see p. 68). You can use the same developing tank, timer, and thermometer (providing it is accurate at temperatures of around 100°F/38°C). You will require more graduates or plastic containers, one for every chemical stage of the process, each large enough to hold a tankful of solution. Label each solution and number it in order of use to avoid contamination. You will also require a flat bottomed bowl or tray, large and deep enough to allow all the containers to stand in warm water up to the same level as their contents. During processing the loaded tank should also stand in this water bath to maintain its temperature.

Processing chemicals
Color processing chemicals are available in kits which contain all the materials for a particular process. As this varies between different films, make sure you buy the right kit for your particular film. The chemicals are generally supplied in liquid form and simply require mixing or diluting for use.

You can use the solutions several times, but developers will need their processing time gradually increased with use. The maximum number of films you should process is about four 36 exposure 35 mm films per pint (about seven films per liter) of developing solution. Other solutions have twice this processing capacity, so most kits contain double quantities of developer. After use, pour back each solution into its own labelled bottle.

The processing sequence
The temperatures of the solutions are critical to color processing, sometimes with a tolerance as low as one third of one degree. The two tables at the bottom of the page show C41 color negative processing and E6 color slide processing. The solutions, times, and temperatures given apply only to these two processes. For other processes, check the kit instructions.

Before you start, make sure that the temperatures of the solutions are within the recommended range. Put each container in the warm water bath. The temperature of

the water should be the same as the recommended developer temperature, and this should be checked throughout processing. Load the tank in complete darkness, following the method shown on page 69. If necessary, prewarm the outside of the tank with water at 100°F (38°C).

Use a standard routine to agitate the solutions, in accordance with the kit instructions. Usually you should tap the tank several times as soon as it is filled with solution, to dislodge any air bubbles. Then, with developer, bleach, and fixer solutions, you should invert the tank several times every half minute during the allotted time. Always allow the last ten seconds of each stage to drain the tank, so as to minimize contamination of the next solution.

Soak both negatives and slides in the stabilizer solution after the last wash. The stabilizer hardens the film, acts as a wetting agent for drying, and reduces image dye fading. Most color films have an opalescent, almost unfixed appearance when wet. This disappears after drying but means that you should not try to judge your results before then.

Color film processing

Preparation Put on rubber gloves and pour out all the solutions into numbered containers. Stand these in a tray full of hot water at about 118°F (48°C) and wait for the solutions to warm up. Check the temperature of first developer. When this reaches 95°–105°F (35°-40°C) run hot or cold water into the bath until it is stable within the temperature tolerance. Have the loaded tank ready in the bath, and the timer, storage bottles, and funnel close at hand. Make sure that you have plenty of water at the correct temperature for washing the film.

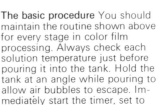

The basic procedure You should maintain the routine shown above for every stage in color film processing. Always check each solution temperature just before pouring it into the tank. Hold the tank at an angle while pouring to allow air bubbles to escape. Immediately start the timer, set to

the correct time for this stage. Tap and agitate the tank as directed during the set time, remembering to replace it in the water bath between agitation. At each stage about ten seconds before the time is complete, begin pouring the solution back into its storage container.

Slide film sequence
The E6 slide processing times, temperatures, and solutions are shown in the table, right. Slide films take longer and are more complicated to process than color negatives because the image has to be "reversed" to form a positive. The total time needed, excluding drying, is 30 minutes.

The temperature of the first developer is most critical, but the temperature of the color developer must also be correct to within ¼°F (0.2°C). Once the film has been in the reversal bath you can remove the tank lid.

Keep a record of the number of films each chemical has processed. Make sure you wash and dry all processing equipment after use.

Solution (at 100°F/38°C)	Time (mins)
Black and white developer	7
Wash	2
Reversal bath	2
Color developer	6
Conditioner	2
Bleach	7
Fixer	4
Wash	6
Stabilizer	1

Negative film sequence
The C41 color negative processing sequence is shown right. Color negative processing typically involves six stages, and takes about 17 minutes excluding drying.

The temperature of the first stage — color development — is most important because this really determines the color density of the final image. If you wish, you can remove the tank lid after the bleaching stage.

At the end, mark all the storage bottles with the number of films they have processed and thoroughly wash out your equipment.

Solution (at 100°F/38°C)	Time (mins)
Color developer	3 mins 15 secs
Bleach	4 mins 20 secs
Wash	1 min 5 secs
Fixer	4 mins 20 secs
Wash	3 mins 15 secs
Stabilizer	1 min 5 secs

STEP 3: COLOR PRINTING/Equipment

You can use the same enlarger for color and black and white printing. There are two main types of enlarger, which differ in the way they filter the exposure. One has a built-in color filter head on which you can "dial in" the filtration. This type, shown right, is the easiest to use. The less expensive kind, shown at the bottom of this page, has a filter drawer beneath the lamphouse and uses a set of acetate or gelatin filters. You may find a voltage stabilizer and an electronic color analyzer helpful to regulate and assess the exposure.

Choose a color paper from the same manufacturer as the negatives you are printing, and use the kit of processing chemicals for this brand of paper.

The basic equipment for processing the print is shown below right. The cheapest method is to use trays, but this makes it difficult to maintain temperatures, and requires large quantities of chemicals. Trays are awkward, so you may contaminate the solutions. A developing drum, preferably the type shown, which rotates in its own water bath, is easier to use and more efficient.

Printing equipment and materials

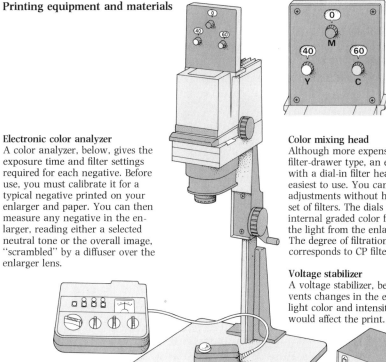

Electronic color analyzer
A color analyzer, below, gives the exposure time and filter settings required for each negative. Before use, you must calibrate it for a typical negative printed on your enlarger and paper. You can then measure any negative in the enlarger, reading either a selected neutral tone or the overall image, "scrambled" by a diffuser over the enlarger lens.

Color mixing head
Although more expensive than the filter-drawer type, an enlarger with a dial-in filter head is the easiest to use. You can make color adjustments without handling a set of filters. The dials move three internal graded color filters into the light from the enlarging lamp. The degree of filtration shown corresponds to CP filter numbers.

Voltage stabilizer
A voltage stabilizer, below, prevents changes in the enlarging light color and intensity, which would affect the print.

Color paper
Most color printing papers are made in only one contrast grade and, usually, three different surface finishes. All color papers are resin-coated (RC) which means that the print must always be air-dried.

A label on each packet gives the batch numbers and filter recommendations. These are explained on page 169. Color paper can be handled under a deep amber safelight, but most people work in total darkness.

Print processing equipment

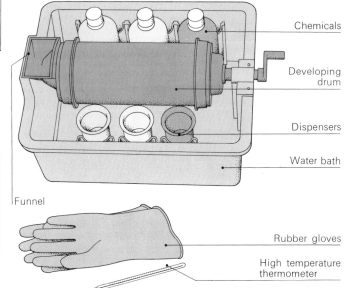

Chemicals

Developing drum

Dispensers

Water bath

Funnel

Rubber gloves

High temperature thermometer

Filter drawer and filter set

Filter set

If your enlarger has a filter drawer, left, you require a set of twenty-one color printing (CP) filters to control the image color. There are usually seven of each in yellow, magenta, and cyan. An ultra-violet filter must be used with the pack, and an infrared heat filter fitted between the lamphouse and drawer before use.

A developing drum is quick to use, gives even temperature control and agitation, and minimizes the risk of mixing chemicals. The most useful type, above, rotates in its own water bath, which also controls the temperature of the three chemicals. A few drums are designed to float in a bowl of warm water during processing. Agitation can be hand-operated or motor driven. All types of drum allow you to work in normal lighting once they are loaded with prints.

Rubber gloves should be worn to protect your hands from the chemicals. You must have a good thermometer, accurate between 50°–122°F (10°–50°C). A resin-coated paper wash tray, such as a sprinkler tray (see p. 77) is useful for the final stages.

Assessing exposure and filtration

The most important skill in color printing is controlling the tone and color of your result through exposure and color filtration. This is necessary for every image; you are unlikely to find a negative which does not require some filtration. Differences in enlarger lamps, types of film, subject lighting, paper batches, and your subjective assessment of the image, mean that some color filtration is always necessary.

Additive and subtractive printing
You can control the color balance of your print either by subtractive ("white light") printing or by additive ("tri-color") printing.

In subtractive printing, pale yellow, magenta, and cyan filters are used to subtract some of the blue, green, and red from the light source. Additive printing uses three separate exposures through strong blue, green, and red filters to control the color balance. Increasing the exposure through a particular filter decreases this color in the print. Because three exposures are made for each print, additive printing is slow and shading and printing-in (see p. 86) are difficult to do. Subtractive printing is much more convenient and therefore we shall be concentrating on this method.

Exposure and filtration tests
For each color negative you need to make two tests, the first for exposure and the second for filtration, as shown below. For the exposure test, you keep the filtration constant and then make several exposures of different times across a representative section of the image, rather like the black and white test strip (see p. 80). To assess the required filtration accurately, you should print the complete image each time using a different filtration, on a second test. You can do this by using a piece of black card, with one quarter cut out, laid over a whole sheet of color paper. For each filtration, turn the card to expose a different quarter of the paper. The exposure time must be adjusted for each new filtration, as explained on page 169.

Each filtration uses one or two of the filter colors only. Never filter all three colors at once. This creates "neutral density", lengthening the exposure time unnecessarily, as explained on the opposite page. As a rough guide for the first filtration, if you have a Kodacolor II negative, use a 50Y 50M filtration. To remove a predominant color cast in the print you must increase this color in the filtration. The "ring-around" guide on the opposite page shows the effects of adding different filters.

Always try to view your test strips and prints under a consistent light source to make your results as accurate as possible. A special "color matching" fluorescent tube or "daylight" lamp is ideal.

Making the exposure and filtration tests

1. Dial-in an estimated color filtration and compose and focus the image on the baseboard. In total darkness insert a strip of printing paper under the easel.

2. With a piece of card make a series of exposure bands across the paper, giving increasing time to each band, e.g. 5, 10, and 20 seconds. Process the results as shown on page 168.

3. From the exposure test strip estimate a likely filtration. In darkness place a whole sheet of paper under the easel and place the black card with one quarter cut away on top.

4. Give four exposures, using the card to uncover a new quarter of the paper. Each time alter the filtration (and adjust the exposure time given by your first test accordingly). Process the print as shown on page 168.

Analyzing the two tests

Exposure test
Judge the first test strip as you would a black and white print — considering its darkness or lightness and ignoring the color. In the best exposure band, in this case 20 seconds, there should be a good range of tones. Highlights should not appear bleached-out and the shadows should not be too dark. The first test strip also gives you a guide to the required filtration.

Filtration test
Reading clockwise from the top left these prints were filtered at 50Y 50M, 50Y 55M, 55Y 55M, and 60Y 60M. The exposure times were 12 seconds, 12 seconds, 14 seconds, and 17 seconds respectively. To remove a color cast you must add this color to the filtration. Use the ring-around on the opposite page to help you decide on the changes in filtration.

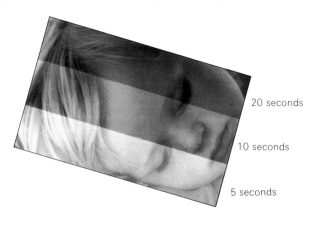

20 seconds

10 seconds

5 seconds

50Y 50M 50Y 55M

60Y 60M 55Y 55M

Ring-around guide

A ring-around is a useful guide
when color printing. The center
print shows the best possible result
from a typical negative. This is
surrounded by prints which have
been given different filtrations or
exposures in regular amounts.
Four of the six colors that can be
produced by using the three com-
plementary colored filters are shown
— magenta, cyan, yellow, and
green. To remove a cast from the
print, you add filters which match
that color. This means that to re-
duce a primary color cast, you
add the appropriate two com-
plementaries (e.g. subtracting 10G
from a print is achieved by adding
10Y and 10C filters).

Each filter affects one emulsion
layer in the paper. For example, a
yellow filter reduces the light affect-
ing the blue sensitive layer, so that
less yellow dye is formed in the print.

Neutral density

Sometimes after adding or sub-
tracting filters you find yourself
using all three filter colors together.
This lengthens the exposure time
because of the gray (neutral) den-
sity created by equal amounts of
all three colors. The neutral den-
sity can be removed by subtracting
the lowest filter value from all
three filtration values. For ex-
ample, if you calculate a filtration
of 60Y, 80M and 10C, you can
simplify it to 50Y, 70M by sub-
tracting 10 throughout. This gives
the same color result but with a
shorter exposure time.

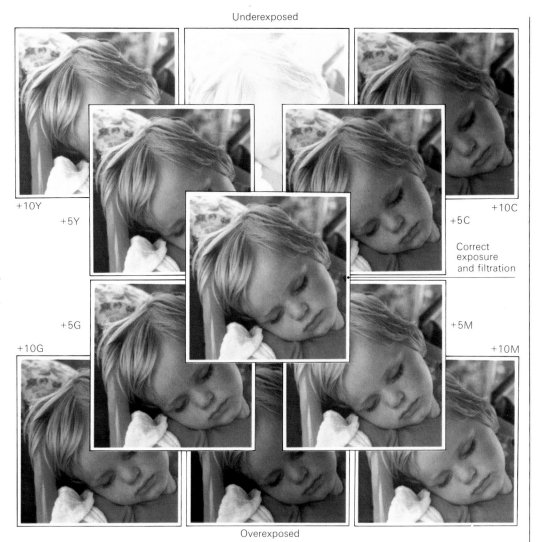

Underexposed

+10Y
+5Y
+10C
+5C

Correct
exposure
and filtration

+5G
+10G
+5M
+10M

Overexposed

Additive printing

Additive printing is cheaper
than subtractive printing —
you only need deep blue, green,
and red gelatin filters. But
because you have to use the
three filters separately it takes
three times as long as sub-
tractive printing and shading
and printing-in are impractical.

Before starting you should
notch each filter so that you
can identify its color in the
dark. The most useful test to
make in additive printing is a
"patch chart", shown right, from
which you can judge the correct
exposure. This is made by using
each of the filters in turn. First,
with the blue filter under the lens,
expose the whole image. Then
change to the green filter and
give a series of exposure times,
left to right, across the print.
Finally, using the red filter, give
the same exposure series from
top to bottom. Your processed
test print will show nine variations.

Blue filter

Green filter

Red filter

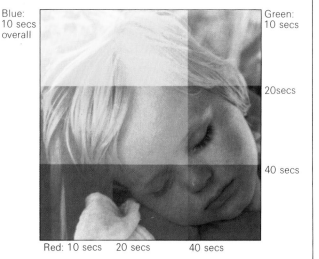

Blue:
10 secs
overall

Green:
10 secs

20secs

40 secs

Red: 10 secs 20 secs 40 secs

Assessing the results

From this patch chart it can be
seen that all three exposure times
should be reduced by about one
third to give a lighter result. The
correct color here seems to lie in
between the last two squares on
the center row. The filtration chosen
for the final print was 6 seconds
through the blue filter, 20 seconds
through the green filter and 29
seconds through the red filter.

Processing color prints

Color processing chemicals are designed to be used at high temperatures, with little margin for error. Throughout processing you must control the times, temperatures, and agitation of the chemicals to get consistent results. You should also take great care to avoid contaminating the chemicals. You will find it easiest to work with a developing drum, rather than with trays. If possible use a drum that rotates in its own water bath, like the one shown below.

Preparing the chemicals
Processing color paper, from drum loading to dry print, takes about 12 minutes. Before you start, make sure you have the right chemical kit for the paper you are using. Then mix the chemicals according to the kit instructions, and keep them in separate,

labelled bottles. Take the three smaller bottles that clip inside the warm water bath, and pour enough of the appropriate solution into each one for the number of prints you want to process. Put sufficient solution for one print only into each of the three cup dispensers. Fill the bath up to the level of the solutions in the dispensers with warm water at about 92°F (33°C).

Drum loading and processing
Once you have everything ready, you can load the exposed paper into the drum, working in the dark. You can then do the processing in normal room lighting. Most drums take only one print at a time, but some will accept several small prints.

During processing, you pour small quantities of each solution in and out of the drum

in turn. Always leave the last 15 seconds of each stage for draining the drum, to minimize contamination. All the developers, and some makes of the other chemicals, should be discarded after use.

The temperature of the first solution—the color developer—is the most critical. Some tanks require a prewash of warmer water before adding this solution, to warm up the tank and the paper. Once you have poured them into the drum, the solutions must be agitated continuously. You may have to roll or rotate the tank by hand, or it may have a motor.

The sequence described below is typical for a three-bath process of developer, bleach—fixer, and stabilizer. But since the stages and times are constantly being reduced, you should refer to your kit instructions.

Color print processing

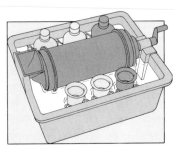

1. Put on the rubber gloves and pour the solutions out of their storage bottles into the three dispensers. Check the temperature of the water bath and add warm or cold water until the solutions in the dispensers are stable within the recommended temperature range.

2. Remove the drum from the water bath, take off the end cap and make sure that the inside is dry. Take off your gloves and switch off the lights. Expose the print and then, curving it emulsion inward, insert it into the drum. Replace the lid and switch on normal room lights.

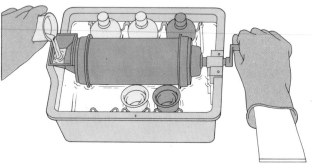

3. The same procedure is followed for the three solutions—developer, bleach-fixer, and stabilizer. Set the timer. Return the drum to its water bath fitting. Put on the rubber gloves and check the thermometer reading of the appropriate solution in the dispenser. If necessary, add hot or cold water to the water bath until the temperature of the solution is exactly right. Now revolve the drum steadily and pour the solution from its dispenser into the feed end funnel of the drum. Start the timer and continue revolving the drum to agitate the solution.

4. About 15 seconds before the end of each stage unclip the drum and begin to pour out the solution from its drain end. Let the drum drain for the full 15 seconds before returning it to the water bath ready for the next solution. Bleach/fixer and stabilizer can be used 2 or 3 times, so they can be poured back into their dispensers after use.

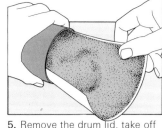

5. Remove the drum lid, take off the rubber gloves and pull out the print. The final washing stages are best carried out in a tray, while you wash and dry the developing drum ready for the next print.

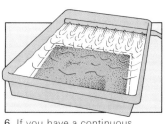

6. If you have a continuous supply of warm water, wash the print in a resin-coated print washer (see p. 77). Otherwise put the print in a tray of warm water and change the water every half minute during the recommended washing time. Finally, drain the tray, pour stabilizer over the print and leave it to soak for the recommended time.

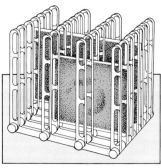

7. Wipe or blot off any surface moisture on the print with photographic blotting paper and dry the print in an air-drying rack, such as shown above. If you want to dry the print very quickly, hold it in front of a fan heater or pass it through a drying machine for resin-coated paper.

Filtration changes and tracing printing faults

Judging the color printing exposure is really no more difficult than in black and white printing (see pp. 80–1). But recognizing color deficiencies and knowing how to use the color filters to make the right corrections require more practice and skill.

For consistent and accurate results standardize the lighting conditions you use for viewing your prints. Try to assess your tests in the same lighting by which the final print will be seen. This may involve installing a special "color-matching" fluorescent tube or a "daylight" lamp in your darkroom.

You can begin to judge the correct filtration for the image by viewing the most accurate-looking section on the second test strip through different printing filters, until you find one which makes the midtones in one band look correct. Then remove a filter

half that strength but of the same color from the filter pack to make the next print. (Alternatively, add a half-strength filter in the complementary color.)

The ring-around on page 167 illustrates the amount of color shift you can expect each filter change to produce. Filters of 10 or less give slight changes; 15 or 20 have a moderate effect. Filters over 20 give a major change — you will need to make a further test strip to adjust the print color if you have to use a filter of this strength.

Check the new filter pack for neutral density and if necessary alter the filtration so that only two of the three basic filter colors are in use. Lastly, look at your filter calculator or the table below to see if the altered filtration requires a change in the exposure time for the print.

Paper batch changes

You must alter the filtration and exposure slightly if you change paper batches.

To calculate the new filtration, begin by subtracting from the values of your filter pack the recommended filtration values for the paper batch you have finished using. For example, if your present filtration is 50Y 30M, and the recommended filtration for the paper was +15Y 00M, subtracting them would give you 35Y 30M. To find the new filtration, add this result to the values printed on the new batch label. In this example, if the new batch values are +20Y +20M, the new filtration would be 55Y 50M. Finally, to obtain the new exposure time, divide the exposure factor on the new label by the one on the old label, and multiply this by the old exposure time.

Exposure adjustments for filter changes

Each time you change the exposure filtration you must recalculate the exposure time.

To find your new exposure, first divide your original time by the factor for each filter you have removed. Then multiply it by the factor for each one you have added. For example, removing a Kodak 50M and using a 20M filter instead means altering a 9 second exposure to 6 seconds (to the nearest whole second).

Filter	Factor	Filter	Factor	Filter	Factor
025Y	1.1	025M	1.2	025C	1.1
05Y	1.1	05M	1.2	05C	1.1
10Y	1.1	10M	1.3	10C	1.2
20Y	1.1	20M	1.5	20C	1.3
30Y	1.1	30M	1.7	30C	1.4
40Y	1.1	40M	1.9	40C	1.5
50Y	1.1	50M	2.1	50C	1.6

Printing faults

Appearance	Cause
Yellow or brown streaks	White light fog from a badly blacked out darkroom.
Cyan or blue fog	Orange safelight left on during printing.
Stains	Chemical contamination. Developer in the bleach gives a cyan stain, or cyan and magenta streaks. Stabilizer contaminated with bleach or fixer stains the print yellow.
Poor yellows	Weak bleach-fixer, or insufficient time in this solution.
Shadows and highlights tinted different colors	Reciprocity failure from long exposures, typically of 40 seconds or more.
Bleached color	Bleached filters — check for this by comparing old and new filters against white paper.
Uneven color	This is caused by lack of agitation, using too little of the chemical solutions, or loading the paper into drum emulsion side outward.
Inconsistent color	If your enlarger lamp is new it needs "burning in" — running for an hour or so — to reach a steady color temperature.

Reminders: Color processing and printing

The way negative and slide films work	Color negative film processing turns the latent images in the three emulsion layers into complementary colored negative images. Slide film processing forms black and white negatives, and then turns the remaining emulsion into complementary colored positive images.
Always follow the temperatures, times, and agitation recommended with the processing kit	In color processing, consistency and care are essential if you want to get good results. You must maintain the high temperatures; agitate the solutions evenly; follow the recommended times; and avoid contaminating the chemicals.
The advantages of additive and subtractive printing	You can control the color on a print by additive or subtractive use of filters. Additive printing is cheaper, needing only three filters, but subtractive printing is quicker and more practical.
Color printing requires two tests	In color printing always test first for exposure, then for color. The main skill in color printing is judging the filtration needed for accurate color results. To remove a cast add filters which match that color. Record the exposure and filtration on the back of every print. Avoid creating neutral density in your filtration.

Special effects

With color negative film you can control and manipulate the image during printing. This is easiest with subtractive printing. You can shade or print-in chosen areas to make the image lighter or darker — in the same way as in black and white printing, see page 86. But in color printing these techniques alter not only the density but also the colors on the final print. For example, a portrait may have greenish shadows on one side of the face, cast by nearby foliage. If you shade this shadow area with a 50G filter for part of the exposure it will print lighter and more neutral in color. Or you can make a pale, gray looking stretch of sea print darker and more bluish-green, by printing-in for an extra period through a red (or magenta plus yellow) filter.

Special effects through printing

More experimental, interpretive effects are possible by printing black and white negatives on to color printing paper. You can then introduce any color or colors you choose by general or local color filtering. Both the pictures on this page were created by this method.

Unusual effects can also be achieved by printing color slides on to color printing paper. They give high contrast negative images in complementary colors, which can be further modified by filtration. In fact all the techniques described on pages 130–5, such as making photograms, bas-relief, and solarization can be adapted to color printing.

100Y 80M 100Y 50M

105Y 30M 110Y 65M

Printing black and white negatives on color paper

The picture above was produced by enlarging a black and white negative on color printing paper. Exposure and filtration tests were made to produce a neutral gray. Then the two strips above were made to assess the effects of adding and subtracting filters from the neutral gray filtration. The lower part of the landscape was exposed at the neutral filtration, and the rest shaded. The filters were changed to 66Y 30M, and the remainder of the image exposed. Since black and white negatives have no orange mask you must expect to use strong yellow and magenta filtering on all exposures to avoid an overall cast.

Local coloring

The picture, left, is a color print made from a black and white negative, using the method described above. But in this case only the tops of the trees were shaded during neutral filtration. They were then printed back with 65Y 35M subtracted from the pack, to produce this sepia looking effect.

Double printing

You can print two negatives on one sheet of color paper in the same way as in black and white printing (see p. 133). These might be two color negatives, or one black and white and one color negative. The picture right was made from two black and white negatives. The small image of the boat was exposed first, filtered to give neutral color, and vignetted (see p. 130) to avoid hard picture edges showing. Then the second negative, of the landscape, was exposed with the filters set to give an orange-brown result.

When making a double exposure of two negatives, make sure that you trace out the images on a layout sheet so that you can position the negatives accurately on the paper.

Printing color slides

The bizarre beach scene below was created by printing a color slide on to normal color paper. The image produced is negative in color and tone. All the colors in the original subject, such as the yellow sandstone cliffs and the green grass, appear in their complementary colors. Blacks and whites are reversed. The sky and sea were originally bluish-cyan, becoming paler and lighter toward the furthest horizon. In the print they graduate from fiery orange to dark brown. Notice how the aerial perspective is reversed, giving a stormy quality to the distant sky and adding to the strangeness of the scene.

Image contrast is always extremely high in prints made direct from slides, because slides are designed to look bold and brilliant when projected, not to act as intermediates for printing.

STEP 4: CONVERTING PRINTS AND SLIDES

The type of film you use does not determine the form of your final image completely. You can make color slides and black and white or color prints from both color negative and color slide film, although sometimes with a loss in quality.

You can make color slides from color negatives by printing them on a print film. This film is like color paper but has a clear base. You can contact print or enlarge on to it like regular color paper — using similar filtering techniques. The resulting transparency should be processed in a similar way to a normal color print.

To make black and white prints from color negatives, you simply enlarge the negatives on to regular black and white printing paper. However this may distort the tonal reproduction of some colors. For the best results, you should use panchromatic printing paper.

Slides can be made into color prints by making an intermediate color negative. This is formed by re-photographing the slide on to regular color negative film with copying equipment, shown below right. Some commercial processors will make negatives from slide film on special low contrast color internegative film (this material is too complex for home use). You can also print color slides directly by using a special reversal printing material, explained on pages 173–5.

Finally, black and white negatives can be made from slides by either copying direct or contact printing on normal, panchromatic black and white film. (If you slightly overexpose and underdevelop the film, this may compensate for the relatively high contrast of the slides.) Then the negatives can be printed on to regular bromide paper.

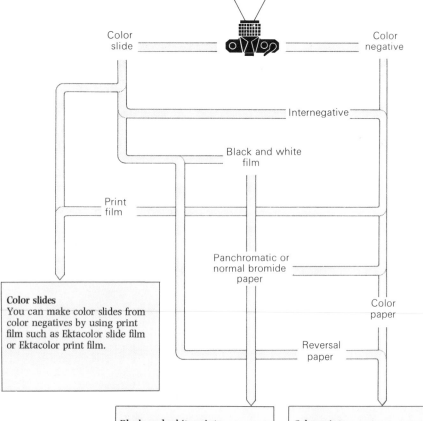

Color slides
You can make color slides from color negatives by using print film such as Ektacolor slide film or Ektacolor print film.

Black and white prints
Black and white prints can be made from color negatives by using regular or panchromatic bromide paper. From color slides you should make an intermediate black and white negative on a slow or medium speed film by copying, and print from this.

Color prints
Color prints can be made from color slides by enlarging them on to reversal printing materials (see pp. 173–5). Alternatively you can make an intermediate negative by copying the slide on color negative film, and then printing on to normal color paper.

Making black and white prints from color negatives

Regular bromide paper
If you enlarge a color negative on to regular bromide paper as in the picture, left, you should give three times the normal exposure for a black and white negative. There is some distortion in translating the colors into gray tones, because bromide paper is blue sensitive. In this print, red parts of the subject are much darker and blues are lost or are much lighter than they would normally be in black and white.

Panchromatic bromide paper
In the picture, left, the same color negative as above was printed on panchromatic paper. This paper reproduces the colors in the same tone values they would normally have on black and white film. The blue stripes in the background, for example, are now clearly visible. Panchromatic paper must be handled and processed in absolute darkness or dark green safelighting. As a result it should be processed in a developing drum.

Slide copying

The equipment below will copy slides same-size on black and white or color film. The copying tube, below left, has a close-up lens element which you attach over the camera lens. The color slide is held at the other end. The bellows copier, below right, includes two adjustable bellows. One fits between the camera body and the lens, and the other between the lens and slide holder. This allows you to copy small areas, as well as complete slides.

Both units should be pointed toward an even light source. If color film is being exposed, the light source must be the correct color temperature for the type of film you are using.

Copying tube Bellows extension copier

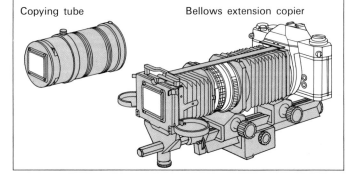

Reversal printing

Because slides are positive images, to obtain a printed positive direct without using an intermediate negative, you must print on to a special "reversal" material. This can be a reversal paper or a dye destruction material. Reversal paper is a triple-layer color paper which is given black and white development followed by color development (very similar to slide film processing). Ekta-chrome paper is of this kind. Dye destruction materials consist of three sensitive layers containing ready-formed dyes. They require a simpler processing sequence which partly bleaches away unwanted color to leave the image. Cibachrome material uses this dye-bleach, or dye destruction principle. The processing sequences for both reversal systems are shown on pages 174–5.

Slide film gives an image with contrasty, well saturated colors—ideal for projection—but lacks the compensating orange mask built into color negatives to counteract dye inaccuracies when printing. As a result subtleties of tone and color in the image may be lost when slides are reversal printed, particularly if the original lighting conditions were contrasty. To get the best results choose slides which are of medium or low contrast, correctly exposed, and with bright whites and neutral shadows. Avoid printing overexposed, "burnt out" slides.

To print color slides you do not need any additional equipment to that already used for color printing (see p. 165). As before, you can use either the subtractive or additive methods for filtering the print. For subtractive printing you may need a slightly wider range of filters.

As with normal color printing, you must make two test strips—one for exposure and one for filtration. Each packet of reversal material carries filtration suggestions to suit various popular brands of slide film. But it is useful to make a ring-around with a standard, well-exposed slide for reference.

Exposing the slide
Clean the slide carefully before printing. Any specks of dust will appear as black marks on the print and are difficult to retouch. Slides can be printed while they are still in their cardboard mounts, but should always be removed from glass holders. The enlarger masking easel forms black frame edges on reversal prints, so if you want white borders on your print the edges must be fogged, as shown below.

Because you are making a positive from a positive all the normal color printing techniques have the opposite effect in reversal printing. For example, more exposure gives a lighter print; shading darkens the print;

and to reduce a color cast you remove filters of the same color. The table below summarizes the main differences between reversal and ordinary color printing.

All reversal printing materials are very low in contrast to compensate for the high contrast of slide film. This means that to produce the same effects on the image as in negative/positive printing you have to make greater changes in exposure and filtration.

Do not judge your tests or prints until they are dry. When wet both materials appear to have a slight magenta color cast which disappears when dry. Prints from both reversal systems should be air-dried (see p. 168) and have a glossy or semi-mat finish.

Differences between reversal and negative/positive color printing

	Reversal	Neg/Positive
More exposure	final print lighter	final print darker
Less exposure	final print darker	final print lighter
Printing-in	area is made lighter	area is made darker
Shading or dodging	area is made darker	area is made lighter
Covered edges	gives black borders	gives white borders

Correcting color casts

	Reversal	Neg/Positive
Print too yellow	reduce yellow filters	add yellow filters
Print too magenta	reduce magenta filters	add magenta filters
Print too cyan	reduce cyan filters	add cyan filters
Print too blue	reduce magenta and cyan	reduce yellow filters
Print too green	reduce yellow and cyan	reduce magenta filters
Print too red	reduce yellow and magenta	reduce cyan filters

Making white borders on reversal prints

1. Place the slide in the negative carrier. In total darkness expose the image with the masking easel holding the paper flat.

2. Raise the easel masks and place a sheet of glass over the print. The center of the glass should be opaque, over an area slightly smaller than your enlarged image.

3. Remove the negative carrier with the slide. With the easel masks still raised, give twice the original exposure time to fog the paper borders.

4. Process the print following the appropriate procedure shown on pages 174–5. The final result should have white edges.

Reversal printing – dye destruction process

Dye destruction print materials, such as Cibachrome, have color dyes already built into the three emulsion layers, instead of forming the dyes chemically during processing. The top layer, sensitive to blue, incorporates yellow dye; the green sensitive layer has magenta dye; and the bottom, red layer contains cyan dye.

Only three solutions are required to process dye destruction materials. The prints have brilliant well-saturated colors, more resistant to fading than conventional color images. This is because the three complementary colored dyes are not created during processing and have been manufactured for their purity and permanence.

The bleach solution is very acidic, so it is essential to wear gloves when mixing or handling the chemical. Kits contain neutralizing chemicals that should be added to the used bleach before throwing it away. The whole process takes 12 minutes and should be carried out at 75°F (24°C), with a tolerance of plus or minus 3°F (1·75°C).

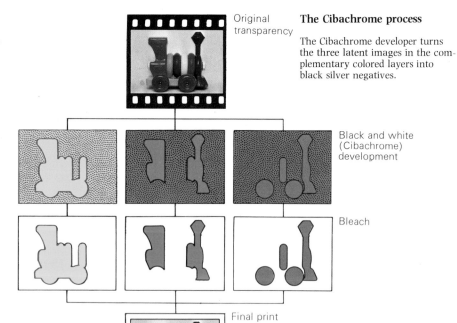

Original transparency

Black and white (Cibachrome) development

Bleach

Final print

The Cibachrome process

The Cibachrome developer turns the three latent images in the complementary colored layers into black silver negatives.

The bleach destroys the black silver and dye images in the negatives, leaving three complementary colored positives. Together these make up the final image.

Cibachrome processing

In complete darkness load the exposed print, emulsion side inward, into the developing drum. Replace the drum lid and turn on normal lighting.

1. Put on the rubber gloves and check that the temperature of the developer is about 75°F (24°C). Pour in the developer, then follow the kit recommendation for agitation. Typical development time is two minutes.
 Begin draining the drum into a pail about 15 seconds before the end of development time.

2. Return the drum to the water bath. Check the temperature of the bleach. If it is within the recommended range, add it to the drum and start the timer. Bleaching takes four minutes. Once again start draining the chemical 15 seconds before the end of the time. Pour the bleach into the pail and add the neutralizing chemicals.

3. Make sure that the temperature of the fixer is correct, then pour it into the drum. Start the timer — fixing takes three minutes — and agitate the solution for the full time. Pour away the fixer.
 Take off the rubber gloves and carefully remove the print from the drum. Wash the print for three minutes in a resin-coated print washer. Follow any of the methods used for resin-coated papers to dry the print.

Assessing exposure and filtration

As with ordinary color prints, the exposure and filtration should be assessed from two separate tests.

For the first test strip, to assess exposure, set the filters as suggested by the print material manufacturers to suit your brand of slide film. Then make a series of doubling exposures across the paper. Process and check the results.

From the most accurately exposed band on the first test strip you can judge the filtration. Remove or add filters accordingly, referring to the table on page 173. Using likely filter settings, make a filtration test following the method shown on page 166.

In general filter changes produce much smaller alterations to colors than in negative/positive printing. Correcting color casts on slides therefore calls for quite large changes in the filter values.

Reversal printing - reversal papers

In reversal paper the final dyes are formed chemically during processing, in a similar manner to ordinary color paper. However, reversal paper is designed for full reversal processing, like that used for slide film. It also produces images with much lower contrast than ordinary color paper.

Processing first forms black and white negatives. The remaining unexposed emulsion is then fogged and color developed, and bleaching removes all the silver. Processing takes eighteen minutes and is carried out at a temperature of 86 °F (30 °C). The tolerance of the developer is only $\pm1\cdot8$ °F; all other solutions have a tolerance of ±3 °F.

Reversal paper is supplied in packs, which give the filter ratings and exposure rating for that particular batch. These enable you to calculate the new exposure and filter settings when changing from one paper batch to another, see page 169. It is best to start working with this paper by using a good quality slide, with the filters all set to zero. You can then make a first exposure test strip, which will serve as a guide for more difficult slides. Most reversal papers are much slower than ordinary papers so longer exposure times are necessary.

Always wait until your test strip print is dry before assessing it. The best way to judge results is to look for detail in highlights and shadows. From this you can decide by how much to shorten or lengthen the exposure. The color balance on the second, filtration test strip can be assessed by checking the midtones of the transparency against the print.

Original transparency

Black and white development

Reversal: color development

Bleach

Final print

Ektachrome reversal paper

The first, black and white development forms black silver negatives in the three emulsion layers. No dyes are present.

The color developer fogs the film, forms positive silver and dye images, and stabilizes the dyes. The unwanted silver is removed by the bleach to leave three positive images in colored dyes.

Processing Ektachrome color prints

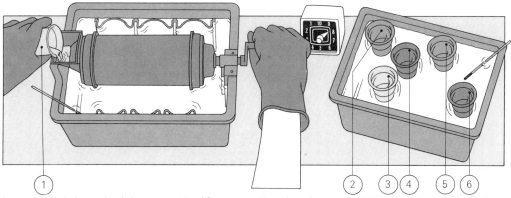

In complete darkness load the exposed print, emulsion side inward, into the developing drum. Replace the drum lid and turn on normal lighting. Put on the rubber gloves and replace the drum in the water bath.
The temperature of all the solutions and the washes should be 86 °F (30 °C). The temperature range of the developer is only 1·8 °F; the range for the other solutions is shown in the table, far right. You need a separate bowl as a warm water bath for the solutions.

1. After pre-wetting the print, bring the first developer up to 86 °F (30 °C) before pouring it into the drum. Agitate, then drain as suggested.

2. Pour in the first wash. Agitate for the recommended time, then repeat twice to prevent any contamination of the next chemical.

3. Add the color developer, agitate, then drain the tank at the end of the recommended time.

4. Wash the print to remove all traces of developer.

5. Add the bleach/fix to the drum, agitate, then pour it away.

6. Wash the print for the recommended time.

Finally, air-dry the print in a drying rack like that shown above, right.
Note that all times, right, include a ten-second drain at the end of each step.

Solution	Time (mins)	Temp. range (86°F/30°C)
1. Pre-wet	½	±3° (2°)
First developer	3	±1.8° (1°)
2. First wash	½	±3° (2°)
Second wash	½	±3° (2°)
Third wash	2	±3° (2°)
3. Color developer	3½	±1.8° (1°)
4. Fourth wash	2	±3° (2°)
5. Bleach/fix	3	±1.8° (1°)
6. Fifth wash	3	±3° (2°)

STEP 5: FINISHING PRINTS AND SLIDES

Before presentation, your slides must be inserted in holders ready for projection; prints can be retouched if necessary, and mounted. Use any of the mounting techniques suggested for resin-coated papers on page 138.

Spots or blemishes on color prints are retouched by methods similar to those used for black and white prints (see p. 88). Do not attempt to knife out black specks — this just reveals the three color layers.

If the mark originates with the negative, spot it on the negative itself with black opaque dye. You can then color in the resulting white mark on the print.

To retouch large marks on the print use retouching colors or colored pencils. The yellow, magenta, and cyan retouching colors should be the same make as your paper. Before use they must be diluted with a solution of half water and half print stabilizer. Apply them in the same way as for black and white spotting — with an almost dry brush. You can use colored pencils directly on mat surface prints. Other print surfaces should be "keyed" first by spraying them with retouching lacquer. For most small spots use gray dye, watercolor, or black retouching pencil.

Slide finishing and mounting

You can make only very limited corrections to a color slide. Some selective bleaching solutions are available which reduce either the yellow, magenta, or cyan layers (or all three). They are expensive to buy and, because transparencies are small, can really only be used to make overall corrections.

The cheapest way to prepare your slides for projection is to cut each frame from the film and mount it in a self-adhesive card mount, such as shown above right. Glass-faced plastic holders give much better protection to the film, but are more expensive.

Self-adhesive card slide mount

Glass-faced slide holder

Preparing a slide sequence

 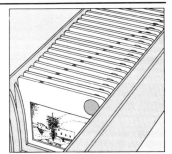

1. Hold the slide exactly as you want it to appear on the screen, and put a spot in the bottom left hand corner of the mount. Be careful not to touch the surface of the film or glass in the holder.

2. Load the slides into the projector with all the spots positioned at the top right, facing toward the back of the projector. Draw a line diagonally from one end of the sequence to the other across the edges of the slides. Lining up the marks on the individual slides will show you if they are out of order.

SUMMARY	Color processing and printing
Color processing	Compared with black and white processing, color film processing has more stages, and uses higher temperatures. It also requires a stricter control of time, temperature, and agitation. You will not need much more equipment than you used for black and white processing, but color chemicals are more expensive and must suit your particular brand of film.
Color printing: filtering methods	Color printing uses either the additive or subtractive filtering methods. Subtractive printing requires more filters; but additive printing takes more time and calculation, and local adjustments are more difficult.

For both methods you require ultra-violet and infra-red filters. |
| Color printing: procedure | Always make two test strips — the first for exposure, the second for filtration.

Try to avoid exposures exceeding 10–15 seconds, and make sure you eliminate neutral density from your filter pack.

Alter the filtration when changing your paper batch, replacing the enlarger lamp, changing to a negative of a different brand, or using an image taken under different color temperature lighting. |
| Printing slides 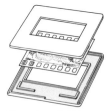 | To print direct from slides you require reversal color printing material. This may use dye destruction or chemically formed dyes. All the normal filtering and exposure techniques work in reverse.

Reversal print materials have more exposure latitude, but require larger filter value changes than normal color printing papers. Dye-destruction print material has some special advantages—fewer processing stages, lower processing temperatures, and wide tolerances. It also produces richer, more fade-resistant colors. |
| Color printing faults | Most faults are traceable to the chemical side of processing and printing — contamination, exhaustion of solutions, and uneven action.

When tracing faults look at the negative first, comparing it against a negative which is known to print well. If the fault is not in the negative then it must have resulted in printing or print processing.

You can spot and locally dye color prints, but do not knife out blemishes. Some limited overall correction of color casts is possible with slides by using selective bleaching solutions. |

EVOLVING YOUR
OWN APPROACH

This section presents a selection of work by fourteen photographers, whose styles vary widely. It is designed to place in perspective the techniques, equipment and visual skills you have learned, and to show you how these tools can give quite different results in different hands. More important, it displays the range and flexibility of photography as a medium and a study of the work in this section will lead you toward developing your own individual approach.

By now, you should have worked through most of this book. You will have gained confidence with your camera, learned to see and control picture building elements, and handled a wide range of equipment. You have begun, in effect, to master the craft of photography. You may feel that this is all you want — that you do not need to develop a personal style for your particular photographic interest. Perhaps you want to use the camera only as a recording device, to produce accurate pictures of family, friends, events, and vacations. Perhaps you only want to use it as a technical aid for some other interest. But it is more likely that by now you have already become interested in the creative aspect of photography.

The photographic medium
At the beginning of the book, on pages 20–1, some of the differences between seeing and photography were discussed. There you read that human vision is selective and interpretive, while the camera merely records. But as your photography has developed, you will have realized more and more clearly that the way the camera is used can be just as subjective as the eye. Even more so, if you wish it to be. The camera can even record things the eye never sees. It all depends on how you use it.

In its early days, photography was largely regarded as

a recording medium. In fact, the artistic world expressed some alarm that photography might replace painting in areas such as portraiture and landscape. Photographers tried to apply the subjects and themes of the "higher" arts to their work, while the recording power of photography was one of the factors that caused artists to turn to more abstract, interpretive styles.

Even by the middle of this century, most people still used photography largely as a recording medium. Interpretive effects were felt to be too technical for anyone but experts. Even among professionals, more creative work was rare. But modern camera technology has simplified and automated many of the technical controls, such as measuring exposure. At the same time, photography has become accepted as a creative medium. It is recognized now that photography and painting are two quite different arts, each with their own discipline and potential. International art galleries regularly purchase and show photographs. The subject is taught in schools, art colleges, and universities, and hundreds of books of photographs are now published and sold. More and more visually talented people are turning to photography to express their ideas. This leads to even greater diversity of approach and style.

Until fairly recently, most serious photographers worked in black and white. But advances in color technology, and new generations of photographers, have now established color, too, as a dynamic, growing field for creative work.

Studying different approaches
As you look at these portfolios, consider each of the photographs critically. They cover a very wide range of styles, not all of which you will necessarily like. It will help if you argue and discuss with other people the characteristics of

particular photographers and their pictures. Later, return to these pictures again, and reassess your judgment in the light of greater experience. You may find that images which had the greatest immediate impact have little more to offer on second viewing, you may discover that the more subtle pictures increase their appeal the more you return to them.

Notice how greatly the photographers included differ in both their subject matter and their interpretation. Some have a particular interest in one type of subject — portraiture, reportage, landscape, sports photography. But compare the portraits of Karsh, Herrmann, and Gobits, or the "reportage" of Cartier-Bresson and Arnold, and you will see how personal interpretation produces quite different results in similar subject areas.

Many of the photographers work only in black and white, particularly the older generation. Working in black and white has led photographers such as Cartier-Bresson and Brandt to develop photographic styles that would not translate into color. Brandt, for example, uses tone, contrast, and the effects of light on form as a personal language, explored through many subjects. On the other hand, color itself forms a main subject in the sensuous work of Haas and Turner — their evocative color imagery would not translate into black and white.

For some, the subject of a photograph is of dominant interest; for others the visual qualities of the image is itself the subject. In their different ways, Kertesz, Cartier-Bresson, and Friedlander are all concerned with the content of their pictures first and foremost (although this is not to say that form is unimportant in their compositions). The subject they choose to record depends very much on their own philosophy. To an extent, their pictures are statements of ideas. Haas, Callahan or Turner's "subjects" are more abstract. Their photographs are more aesthetic, and are intended to appeal in their own right — Callahan's photographs, for example, are essays in structure and design — the actual subject is less important.

Working methods and equipment and materials used differ too. This in itself is a reflection of the photographer's style and approach. A photographer may use every type of photographic equipment to interpret his subject in new and dynamic ways, or only the barest essentials. Gerry Cranham, for example, uses a great range of equipment to capture movement the eye can never see, or situations where the photographer himself cannot go. He wants to recreate the experience, the excitement, of a sport. Karsh on the other hand uses a static, tripod-mounted camera, often one of the slow, sheet-film types, for his portraits. Cartier-Bresson uses only a simple, direct vision viewfinder camera, and rarely enters a darkroom, relying on laboratory processing. Many other photographers do not do their own processing or printing. But Jerry Uelsman sees the darkroom as his main creative area, treating the original photographs merely as raw materials for his montages and multiple exposures.

Some photographers (Kertesz, Friedlander, Cartier-Bresson) take subjects strictly as they find them, even to the extent of refusing to crop the picture at the enlarging stage. Others manipulate and control their subjects — posing, selecting background and foreground, arranging lighting, adding accessories. Karsh and Gobits, for example, both take extreme care in the composition and arrangement of their portraits. Yet Gobits, even in his fashion work, still aims for a naturalistic result, while Karsh's work is more formal and deliberate.

Manipulation can extend into the darkroom, and even beyond it — Brandt sometimes alters earlier published work, as his ideas change. This raises another point. The pictures shown here represent only a small area of the work of these photographers. They are always developing and exploring their ideas, ranging into new areas, reconsidering their approach. If you look at the work of a photographer over time, you will see this process of development. It is an essential part of creative photography.

Studying the work of a photographer over time will reveal to you how he or she sees and reacts to the world. It will also begin to show you how personal styles evolve. Look around for books which collect together pictures by the photographers you have found most interesting here. Find work by other photographers tackling similar subjects, or visual ideas. Look in monthly photo-journals for features on new photographers, and visit exhibitions.

Developing your own style

You cannot develop a personal style by consciously trying to be "different", nor by borrowing other photographers ideas. Concentrate first on developing self-confidence, with your camera and equipment and learning to be sure of acceptable results every time. Then use this ability to express your own views on people, places, situations, life itself. Allow yourself, as an individual human being, to come through in your photographs. Don't follow popular trends, or suppress idiosyncracies in your own work. Don't be intimidated by other photographer's criticisms. Decide for yourself whether you like your own pictures, and in which ways you could improve them.

If you want to specialize in a particular subject area, choose one where you already have specialized knowledge, experience, or strong interest. A good wildlife photographer, for example, must also be a naturalist. To be a travel photographer you must learn a lot about each country; to photograph buildings you must know architecture. If you are already interested by abstract images, or graphic design, you could apply these approaches to your subjects and photography.

If you can, join a club or class on photography, where you discuss ideas with other people. Even if you don't agree, you can at least compare your work with the work of others and re-assess it. Finally, keep a portfolio of your work, well mounted and presented, and regularly look back over it to see in what ways your personal style is changing.

ROLPH GOBITS: Using the setting

Rolph Gobits is a young Dutch photographer who is establishing himself in fashion and reportage work.

On fashion assignments, Gobits uses relevant, existing interiors instead of a studio reconstruction to enhance a model. He relates color schemes and lighting, architecture and furnishings, to the style of the garments concerned. In his reportage work he again integrates people with their normal environment.

Gobit's pictures are carefully composed, without appearing in any way unnatural or contrived. If the subject is positioned off-center, it is always perfectly balanced by line, objects, and colors in the composition. This harmony is increased by his use of simple linear divisions of the picture frame, and his range of rich pastel colors. One of the most important features of Gobits' work is the care he takes to include only those elements that will add to the composition of a picture. There is never a clutter of unwanted detail to detract from the strength of his simple compositions.

Gobits mostly uses a $2\frac{1}{4}$ ins square camera, and prefers soft directional lighting — either diffused daylight or a studio type electronic flash, bounced from a large reflector. This lighting gives a very wide tonal range from highlight to deep shadow, and Gobits uses the resulting lighting contrast to emphasize specific areas of a photograph. Shadow often provides an important foil to detailed highlight areas.

Three fishermen
The symmetrical positioning of the three fishermen, below, is emphasized by the natural lighting. Shadows and highlights divide the faces. The lighting (from the left of the camera) picks out the straight lines of the walls and the table top, partially framing the men.

Woman on stairway
In the picture, right, the diagonal line of the stairway divides the balanced shadow and highlight areas. The model is brightly illuminated by a large electronic flash unit at the top of the stairway. A smaller lamp provides fill-in lighting from the left of the camera position.

Seated man
The picture, below, is illuminated by two windows. One, to the right of the camera, sidelights the face. The other window, top left, gives soft, fill-in lighting. The subject's off-center position is balanced by the position of this window.

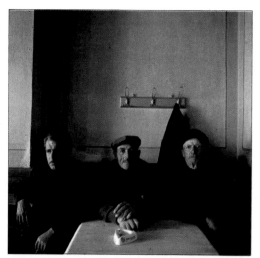

Sleeping model
Bounced electronic flash illuminates the Art-Deco scene above. The model's face and arms are set strongly against the deep shadow of the lower left part of the picture.

Her reclining body echoes the curve of the bronze figure. Again Gobits structures his composition using line. The horizontal lines of the furniture and mirror balance the vertical lines of the room.

YOUSUF KARSH: Classical portraiture

The Armenian-born photographer Yousuf Karsh is the most celebrated living representative of the classical tradition of studio portraiture. A portrait by Karsh is seldom naturalistic — his approach is formal and controlled. He works mainly in the studio and poses his subject, using artificial lighting, with few or no props, to obtain the effect he wants. For almost half a century he has photographed some of the world's most famous men and women — statesmen, popes, scientists, writers, musicians, and artists have all sat for his camera. Posing for Karsh was long considered to be one of the hallmarks of distinction or success.

The Karsh style has been immensely influential on other portrait photographers, particularly in the 1940s and 50s. His critics would argue that his idealistic interpretation of character works against him — that he imposes his own philosophy too strongly on his sitter. None can deny however that his portraits are executed with superb craftsmanship.

His work is characterized by his classical Hollywood style of lighting, producing brilliant highlights, rich textures and extreme overall sharpness and detail. Every hair, every pore and wrinkle of the skin stand revealed in the final print. Usually Karsh concentrates on his sitter's head, or head and hands, lighting them in such a way that they stand out strongly against a plain dark background. This gives his portraits the qualities of monumental strength, dignity, and grandeur for which he is renowned.

Karsh has stated that he would like his portraits to be seen as historical documents. He is more concerned with capturing the mind and soul of his sitters than their appearance. Therefore he portrays his subjects both as they appear to him and as they have impressed themselves on their generation. His expressed philosophy is that there is a "moment of truth" when the photographer can record the "inward power" that reveals his subject's greatness.

His favorite format is an 8 × 10 ins stand camera. But his equipment also includes 5 × 4 ins and $2\frac{1}{4}$ ins square cameras. For lighting he generally uses powerful floods and spotlights, made specially for him, but when travelling he carries studio flash. Without such intense lighting he could not use the small lens apertures needed to gain sufficient depth of field with his large format cameras. His final prints are usually 16 × 20 or 30 × 20 ins.

Martha Graham, 1948
Karsh photographed the dancer sitting on a stool, as the room had a low ceiling. But even sitting down, she seems to be dancing. Hard frontal lighting accentuates the face and hands.

Pablo Casals, 1954
An unusual Karsh portrait in its
use of a rear camera viewpoint and
back lighting. Karsh photographed
the cellist in an old deserted abbey
in France. The portrait suggests
immense physical and spiritual
strength despite the small size of
the old man. Karsh once asked a
visitor to one of his exhibitions
why he was staring at this picture
for so long. "I am listening to the
music", he replied.

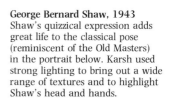

George Bernard Shaw, 1943
Shaw's quizzical expression adds
great life to the classical pose
(reminiscent of the Old Masters)
in the portrait below. Karsh used
strong lighting to bring out a wide
range of textures and to highlight
Shaw's head and hands.

Jan Sibelius, 1949
Taken in Finland, the composer's
home country, this portrait has
all the strength and dignity of a
monumental sculpture. Double side
lighting with reflector fill-in creates
a strongly framed head and rich
tonal contrasts.

ERNST HAAS: Using color creatively

Austrian-born Ernst Haas is famous for his highly imaginative and evocative use of color, in particular for the way he uses color as an important visual element in itself — even, in some pictures, as the main subject interest. His supreme talent lies in conveying the essence of a scene by an impressionistic rendering of its light and color. Haas once defined photography as "a transformation, not a reproduction". Where other photographers may strive to reproduce the details and tones of a subject as realistically as possible, Haas produces more interpretive images in which he captures the atmosphere and mood of a scene.

His early color work was shot on Kodachrome 1, an extremely slow (12 ASA) 35 mm film. The color characteristics of this film, combined with the slow shutter speeds it necessitated, greatly influenced his approach. He learned to control and exploit the effects of blurred color and line that were produced with moving subjects.

Haas achieves his blurred impressionistic effects in several ways. Sometimes the swirling movement results from using a long exposure on a moving subject with the camera held still. In other shots he deliberately pans or jiggles the camera, mixing the colors of his subject with those of the background. His images are blurred so skilfully that the subject remains recognizable and the colors are spread without turning muddy. Haas works with a direct vision camera, as unlike a single lens reflex its viewfinder enables him to continue to follow the action during exposure.

Haas is a highly versatile photographer. In his pictures of the outdoors — wild open country and pastoral scenes as well as cities

as diverse as Venice and New York — he switches from one style to another according to his subject. He can communicate the excitement of a bullfight in swirls of vibrant color or the serenity of an autumn landscape in dreamlike images and muted colors. But in all his work, color itself is his main creative concern. He often uses the effects of mist, rain, or other weather conditions to diffuse his colors, sometimes waiting days or weeks to obtain the right quality and direction of light for the effect he wants. Some of his more recent pictures, notably his close-ups of peeling paint or discarded junk, approach the abstract in their use of pure color and bold design.

Untitled, 1964
The picture, below, uses a single overall color scheme to express serenity and warmth. Haas took the picture when the trees were caught by soft, diffused lighting from the late afternoon sun. The warm light emphasizes the golden colors, linking the complex pattern of foliage into a single, harmonious color scheme.

Winter fantasy, 1966
The picture, left, again uses a single color scheme to convey a dominant mood — the cold atmosphere of winter. Haas carefully chose the exposure to create contrast between the dark, linear patterns of the branches in the foreground and the delicate, misty background.

Calf roper, 1958
Haas panned the camera in the direction of the movement during a long exposure in the picture, right. Blurring the subject and colors conveys a feeling of motion and excitement more effectively than a "frozen" picture would have done.

Sailboats, 1958
The picture below, like the one above, uses an impressionistic effect to convey movement. Haas took the photograph from a boat using a hand-held camera and a long exposure. The motion of the camera and the subject produced the multiple images in the picture. Notice how the exposure chosen for the contrasty back lighting has created brilliant highlights in the foreground, which counterbalance the darker, angular shapes of the boats.

HENRI CARTIER-BRESSON: Capturing the "decisive moment"

Henri Cartier-Bresson is one of the world's best-known reportage photographers. He is famous for his philosophy of the "decisive moment" — that point in time when all the transitory elements of form and content in a scene fuse into a harmonious and telling composition. Indeed, "The Decisive Moment", was the title of his first book of photographs (1952), and has become synonymous with his particular approach to photography. In this book he defined photography as "the simultaneous recognition, in a fraction of a second, of the significance of an event as well as of a precise formal organization which brings that event to life . . .".

Cartier-Bresson sees himself as an observer, using his photography passively to record the often unnoticed, but nevertheless significant aspects of daily life. His approach to his subjects is always unobtrusive and respectful and he would never think of contriving a photograph by posing his subjects or by altering their setting. In his photographs people seem dovetailed into their environment and yet they do not lack a feeling of life and movement.

Although Cartier-Bresson describes himself as a photojournalist, very few of his pictures actually treat journalistic events in the orthodox sense. For he is concerned with the natural and typical rather than the sensational, with recognizing the timeless significance of ordinary moments, rather than recording a historical event.

The amount of equipment used by Cartier-Bresson is minimal — consistent with his belief in realism and his desire to work unnoticed. His photographs do not rely on special equipment or techniques. He works exclusively with a 35 mm direct view-finder camera, mostly restricting himself to a normal 50 mm lens with an aperture of f2. If the situation demands it, he will use a 35 mm or 90 mm lens but in general his approach to his subject calls for the most natural and realistic viewpoint. He never uses intrusive, additional lighting such as flash, preferring instead to use a high speed film if light is dim. His pictures are never re-touched and rarely cropped as he believes that cropping can seldom save a picture that is compositionally weak. He edits his pictures from contact sheets and has prints made for him according to his instructions, feeling that his time is better spent with the camera than in the darkroom.

Jerusalem, 1967
A fine example of Cartier-Bresson's use of the "decisive moment". Each of these four Hasidic Jews is beautifully placed within the line and tone structure of the image. To help him achieve this balance of form and content, Cartier-Bresson uses a reversing prism fixed to the top of his Leica. The image appears upside down, so that he concentrates on the composition without being distracted by the subject. When all elements of the picture are at their maximum expressiveness, he presses the shutter.

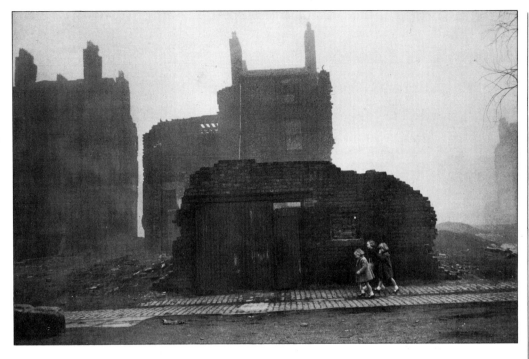

Liverpool, 1963
The heavy tone and strong shape of the ruined wall forms a frame-within-a-frame for the running figures. Cartier-Bresson once wrote: "inside movement, there is one moment at which all the elements in motion are in balance".

Kashmir, 1948
A group of Moslem women on the slopes of a hill in Srinagar pray toward the sun rising behind the Himalayas. For a brief moment, the gray figures set against the spectacular landscape seem to symbolize prayer and supplication.

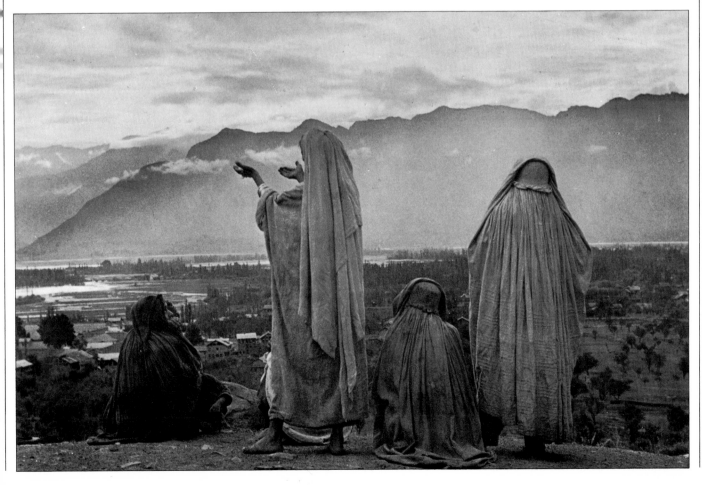

PETE TURNER: Combining design and color

Pete Turner's photographs are immediately recognizable by their strong design qualities and their extremely saturated colors. Like Ernst Haas he is particularly interested in exploring color in his photographs, but Turner works with a more limited range of color, is less naturalistic, and his photographs often rely on bold, simple shapes to create a strong, graphic composition. He often uses flat areas of vivid color, devoid of the normal photographic qualities of tone and detail, creating an effect like a silkscreen print or poster.

Turner has extended his range of color photography in imaginative and technically novel ways by means of strong color filters and slide copying. He works almost exclusively with 35 mm Kodachrome film and carries about 100 filters with him on assignments. Sometimes he exposes his subject through a deep filter, using incorrect color balance film for the light source. More often he generates his strikingly brilliant colors by introducing filters when using a slide copying attachment (see p. 172).

The disadvantage of copying color slides on to color slide film is that it increases image contrast. Turner capitalizes on this however, first by choosing the right subject, and second by carefully controlling exposure while copying. The tonal range is simplified so that shape and pattern are brought out.

Turner therefore uses his original subject only as raw material for the final print. At each stage of processing his image is fashioned into something increasingly remote from an objective recording. The result is often starker, more abstract and more synthetic in color.

Sand Dune, Egypt, 1964
By using an imaginative viewpoint, Turner emphasized the shape and texture of the burnt sienna sand dune, above. Copying through an orange filter increased the tone contrast, intensifying the unreality and saturation of the color.

Magenta Horse, 1969
The image, left, was created in three stages. First, the horse was slightly underexposed through a deep blue filter, producing a black horse on a blue field. Second, the slide was copied on to Ektachrome slide film which was given color negative processing. This reversed the colors, giving a white horse against a yellow background. Finally, this color negative was copied on to Kodachrome slide film through a magenta filter, making the horse appear magenta and the background red.

Indian face
This was originally part of a slightly blurred color slide. Turner enlarged the face — exaggerating contrast and grain — using a slide copier with a deep blue filter to create the overall color cast.

Mannequin, 1971
The silhouette below was photographed through a square "window" of black material. To obtain the repetition Turner took several exposures through different filters on to one frame of film, using a shift lens (see p. 96) to slightly offset each image.

BILL BRANDT: Working with form and light

Bill Brandt has worked as a documentary, landscape, and portrait photographer, but is probably best known for his highly original, distorted images of the human form. His pictures are stark, and often somber, with strong graphic impact.

Brandt learned his basic photographic skills in Paris as assistant to the Surrealist painter and photographer Man Ray. He returned to England in the 1930s and, influenced by the work of French photographers such as Cartier-Bresson, turned to reportage photography.

After documenting the years of the Depression, and London during the Blitz, Brandt turned away from social realism and started concentrating on landscapes, nudes, and portraits. Early in the 1940s, Brandt discovered an old wooden sheet film camera

which he used with an early ultra wide-angle lens. The optical distortions produced by close-up use of this lens, combined with its extreme depth of field, led to his strange studies of the nude female form. He started by photographing nudes in room interiors; later, using modern cameras and lenses, he moved his location to the seashore, often making use of the rough texture of sand and rocks to highlight the smooth shape of the human form. The exaggerated shape and scale, and stark tonal contrasts of Brandt's nudes transform them into sexless, almost monolithic structures.

Brandt's attitude to photography is in several respects the antithesis of his contemporary, Cartier-Bresson. Brandt is no purist — he will pose his subject, use additional lighting such as flash, or optically

distort the image, if he thinks he can improve a picture by these means. Similarly, he is not averse to darkroom manipulation or retouching, even to changing the tonal contrast of a picture that the public has already seen in its original form.

Brandt's interest has shifted over the years, not only in terms of his subject matter, but also in his approach. In earlier years he stressed the atmospheric and naturalistic effects of light and shadow in subtle gradations of tone. Today, in reprinting the same works, he tends to eliminate the soft mid-tones, giving his pictures a hard-edged graphic quality. Increasingly often he uses high-contrast paper, reducing the shadows to deep blacks and intensifying the highlights, sacrificing realism and detail for an increased emphasis on pattern and design.

October, 1959
The fingers appear to be hewn out of stone in this strongly sculptural image, right. Brandt's use of an extreme wide-angle lens has destroyed normal spacial relationships whilst framing the subject against a low horizon, combined with contrasty printing and lighting adds to the imposing feeling of the image.

February, 1953
Brandt's use of lighting and tone to create a mood of mystery and detachment is well illustrated by the picture, right. He has used the mirror to distort and extend the model, and her face, peering out of the mirror, adds to the surrealistic effect. Notice how the strong lines in the picture lead-in to the double-headed image.

May, 1957
The picture above is an extreme example of Brandt's series of nudes. He has used abrupt contrast of size, shape, texture, and tone to produce a photograph that is neither nude nor landscape but an uneasy mixture of the two. The exaggerated mass of the model's arm dominates the pebble beach. And the jagged shape and texture of the rock clash sharply with the smooth white contours of the body.

Top Withens, Yorkshire 1945
To convey the bleakness of the atmosphere, Brandt took the picture, above, on a stormy February day. Using a high-speed film to compensate for the dim light and brief exposure, Brandt was able to close down the aperture to f 11 which gave him sufficient depth of field. He printed the negative on hard grade paper in order to achieve sharp tonal contrasts.

GERRY CRANHAM : Interpreting motion

Gerry Cranham is a well-known and widely published British sports photographer. He is celebrated for his skill at interpreting motion in color. Most sports photographers concentrate on capturing detail and produce "frozen" images of event winners crossing the finishing line. Cranham produces blurred images of an event, sacrificing detail to communicate movement and effort. In his pictures he aims to convey the particular characteristics, energy, and excitement of each sport in a way that even the non-enthusiasts can appreciate.

Like many other specialist photographers Cranham combines an interest and knowledge of his subject with his photographic expertise. He was once an athlete himself and this helps him to understand and recognize the crucial moment when action is at its peak. In sports photography split-second timing is all-important. The critical moment must not only be recognized but anticipated. Cranham travels widely to different sporting venues, in each case putting in a great deal of preliminary research before the event occurs. He plots locations and angles of view and selects what equipment he will need. In addition, he studies the nature of different types of movement — whether it is the serve of a tennis player or the running style of an athlete — so that he can convey the individual qualities of each sport.

Cranham makes use of every technical tool at his disposal to produce his images. His photographs are created entirely within the camera, rather than in the darkroom, by means of a variety of filters and lenses.

For most purposes he favors the Nikon range of 35 mm SLR cameras, sometimes with a motor drive attachment, but he also uses radio control when he wants to place his camera in a position where he is unable to stand, such as on the track at a race meeting or inside the foliage of a steeplechase jump. He uses a wide range of lenses including extreme long focus mirror lenses, prisms, fish-eyes, zooms, and wide-angles.

His range of equipment is matched by his technical versatility — he will use a combination of zooming and panning to explore the effects of movement on color and line, or pan slowly at a slow shutter speed to follow the flow of a particular movement. Cranham will often take advantage of the atmospheric effects of heat on the track or wet or hazy weather conditions to create delicate pastel colors.

T.T. Race, Isle of Man, 1967
An impressionistic image created by a combination of selective focus and panning the camera at a slow shutter speed.

Kempton Park, 1975
Cranham used a very fast shutter speed and wide aperture on his 500 mm mirror lens to take this picture at the racetrack. The long focus lens foreshortened the perspective and magnified the horses and riders, emphasizing the sense of effort and concentration.

Silverstone, 1978
Cranham took advantage of the
blue haze and diffused light created
by a rainy day to convey the at-
mosphere at this race. The picture
was taken with a 500 mm mirror
lens using a fast shutter speed.

Sprinters
Panning with a zoom lens at a
slow shutter speed, Cranham
turned the group of runners, below,
into a blurred kaleidoscopic pattern
of brilliant colors.

ANDRE KERTESZ: Capturing the unexpected

André Kertész is one of the acknowledged masters of the art of photography. For over sixty years he has concentrated on recording the ephemeral moment, on extracting meaning and beauty from the everyday lives of ordinary people. His work is characterized by great spontaneity, an innate talent for formal design and an extraordinary eye for the unexpected, telling detail.

His photographs are deceptively simple — at first sight they appear to possess the casualness of snapshots. Closer study, however reveals Kertész' unusual sensibility to pictorial form, his fine control of picture-building. No matter how complex his photographs are in terms of structure or detail, nothing is superfluous. Yet considerations of design or structure never overwhelm the human element in his works — even those images that approach the abstract (such as Martinique, 1972) always remain firmly secured in the real world.

In many ways, Kertész pioneered the approach to photography formulated by Cartier-Bresson in his philosophy of the "decisive moment". The main difference between the two photographers lies in Cartier-Bresson's stricter adherence to a detached, naturalistic viewpoint and his concentration on the moment when action is at its most expressive. Kertész uses a wider variety of viewpoints of greater or less realism, sometimes even portraying his subjects partly amputated by the frame. Rather than concentrating on the moment when action is at its peak, he suggests the passing of time. And Kertész' work is perhaps more personal and light-hearted and less journalistic than Cartier-Bresson's.

Few photographers have stood the test of time as well as Kertész has done. His work has continued to develop from candid scenes of Paris in the 1920s and 30s, through a series of distorted mirror images of nudes, to his more formal angular compositions of recent years. The common thread that links his work is a talent for capturing life just as he finds it, with gentleness and humor.

Satiric dancer, Paris 1926
This early picture already shows Kertész' use of a high viewpoint, a characteristic of much of his later work. The composition draws a light-hearted parallel between the exaggerated pose of the dancer and the plaster torso and framed picture in the corners. The tones and shapes of all other objects are subdued so that the environment is suggested without distracting from the main images, which are lighter in tone.

Martinique, 1972
The photograph, right, has a
strong structural resemblance to
the works of painters like Mon-
drian or Hockney. The relationship
of one line to another and to the
edges of the picture frame is
crucial in such an austere compo-
sition. As in all Kertész' work the
picture is relieved from total ab-
straction by the suggestion of a
human form, silhouetted behind
the frosted glass.

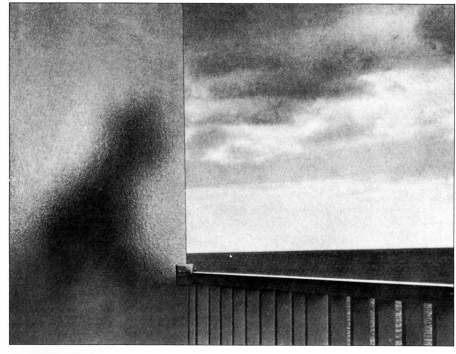

Homing Ship, 1944
An element of surrealism is pro-
vided in the picture below by the
ship which is apparently floating
in air and the areas of tree and
sky reflected in the puddle. The
tonal contrasts, balance of shapes,
and strong use of perspective to
direct attention, all make this a
satisfying and complete image.

Washington Square, 1954
In this intricately patterned pic-
ture, nothing is superfluous. If you
cover the central figure, for in-
stance, you will see how much the
image is weakened despite the
strength and beauty of its line.
Kertész used a high viewpoint to
add depth and perspective to a
finely balanced composition. Strong
contrast reveals the rhythmic curves
of line and shape.

EVE ARNOLD: Candid portraiture

Born in the United States, of Russian extraction, Eve Arnold is a documentary photographer who made her name with essays on themes as diverse as small-town America, Hollywood film stars, and childbirth. Her pictures are compassionate, thought-provoking and direct.

Over the years, Eve Arnold has been able to explore and extend her interests both as a photographer and as a person. She tends to choose subjects for which she feels a strong personal commitment and is critical of photographers who bow to commercial interests. Several themes recur in her work — poverty, children, and above all women. The photographs featured here come from her book "The Unretouched Woman", in which she aimed to present an unglamorized view of women as they live and work.

In her studies of Hollywood stars, such as Marilyn Monroe and Joan Crawford, Arnold avoids the conventional, idealized portrait in which the subject is posed in the most flattering position and blemishes are erased by the retoucher. Instead she chooses to show the stars in their unguarded moments, without embellishment or pretence. In this her approach is the precise opposite of Karsh's carefully posed, studio-lit portraits of the famous.

Although the power of her subjects rightly dominates her work, her pictures (both in black and white and color) also demonstrate a strong sense of form and tone structure. The way she frames her portraits in particular is exceptional, including just enough background detail to "place" her subjects without overwhelming them.

Nursery school in the Kuban
The picture above is one of several that Eve Arnold took while working in the USSR. The severe portrait of Lenin contrasts sharply with the huddled group of children absorbed in play. Powerful use of highlights and deep shadows gives a strong sense of form to this rather somber study.

Marlene Dietrich
Eve Arnold photographed Marlene Dietrich, left, as she recorded the songs she sang for soldiers during World War II. An unglamorized though by no means unflattering portrait of the woman at work, using the oblique lines of the music and instrument as a natural lead-in to the singer.

Fencing mistress
Arnold used an oblique viewpoint to emphasize the difference in size and strength between the two figures in the picture, right. Strong use of differential focus and abrupt tonal contrasts between the woman and the girl distances the two figures in this powerful character study.

Salvation Army Colonel
A compassionate and expressive study of evening prayers in a home for the aged in Manchester, England. Diagonal lines (provided by the arms of the two figures and the edges of the table) lead the viewer's eye into the picture.

Contralto at audition
The nervousness and isolation of the singer, below, are emphasized by using a wide-angle lens to frame the performer at the opposite side of the picture from the close group of men at the piano. An entirely different and less telling image would have resulted from a camera position beside either the woman or the men.

LEE FRIEDLANDER : Portraying modern city life

At first sight, most of Lee Friedlander's photographs look like the sort of snapshots a beginner might mistakenly take. His photographs capture seemingly random, inconsequential moments, confronting the viewer with glimpses of city life he might otherwise fail to notice or choose to ignore. He might almost be described as a photographer of the "non-event" — none of his pictures are of subjects that conventional photographers would consider taking. His series of self-portraits, for example, contains only distorted or truncated reflections of himself in mirrors or shop windows.

There is no clear-cut conclusion or message to be drawn from his photographs. But his work is typical of a new breed of American "social landscape" photographers, influenced by Robert Frank, who are committed to direct, unglamorized recording of urban life in their pictures.

Friedlander's subject matter is the city and its people. He uses a viewfinder camera and carries with him a minimum of equipment, restricting himself to three lenses — 28 mm, 35 mm, and 50 mm — as he prefers to work close to his subject.

Like Cartier-Bresson he works as an observer, using his camera to record a moment in time. But whereas Cartier-Bresson is concerned with the "decisive moment" when both subject and composition are at their most expressive, Friedlander is more interested in the random events of everyday life. His pictures are often visual paradoxes in which the viewer is constantly challenged and tricked, not without a gentle humor.

Although Friedlander claims that his work is not premeditated and at first his pictures seem haphazard, they are carefully considered. Most of his photographs seem to turn the traditional, accepted rules of composition upside-down. His pictures often have no main subject or center of interest, the whole frame being filled with distracting elements. Background and foreground are equally distinct and detailed and the viewer's eye is often led around or out of, rather than into, the picture by his device of cutting off large shapes at the edges of the frame. People are generally depersonalized — shown from the rear, obscured by streetlights or other objects, or amputated by the picture frame.

Friedlander's pictures are as much questions as statements about urban America and a great deal is left for the viewer to decide. His photographs make us wonder if the well-composed, subject-oriented picture is not a little contrived and unreal; whether randomness and fragmentation are not a truer reflection of modern urban life.

Chicago, 1966
A characteristically random picture of a cluttered city street. As in most of Friedlander's work, the people are depersonalized and dominated by the street "furniture" and the viewer is left to wonder what the man will look like when he appears.

Connecticut, 1973
This seemingly aimless street scene demonstrates one of Friedlander's favorite compositional devices — the use of linear objects, such as streetlights, to divide up the frame into panels. This device demands that the viewer draws connections between the people or objects in the different compartments — in this photograph, the statue of the soldier seems to be stalking the women in the next panels.

Los Angeles, 1967
The headless figure at the top of the frame and the bodyless head at the bottom give a strange sense of transition and continuity in this unusually symmetrical picture. Friedlander has used the traditional compositional elements, line, tone, and balance to distract and confuse the viewer rather than to lead to any main point of interest.

Hotel room, Portland, Maine, 1962
This picture exemplifies all the bleakness of a hired hotel room in a strange town. The only "humanity" is provided by the image on the television screen. The harsh lighting helps to accentuate the emptiness and sense of isolation.

AARON SISKIND AND HARRY CALLAHAN: Abstract design

The photographs of Harry Callahan and Aaron Siskind are often discussed together. This is partly because of the emphasis on abstract design in their pictures, but mostly because for many years they both taught at the photographic department of Illinois Institute of Design in Chicago, often called the "New Bauhaus".

Aaron Siskind

Aaron Siskind was originally acclaimed as a documentary photographer of subjects such as Harlem slums and life in the Bowery. In the early 1940s he turned from a subject-dominated approach to one in which subject matter was subordinated to abstract design. He started taking close-ups of the rocks and boulders along the Massachusetts coast, studying their interesting textures and forms. Soon he had moved on to subjects which were often no longer recognizable for what they were. Defaced walls, weathered wood, blistered paint and other inconsequential objects normally ignored were transformed in his photographs into aesthetic images.

Siskind was inspired by the Abstract Expressionists' tenet that art need not be representational to be expressive. He believes that meaning and beauty should be conveyed by the photograph itself, rather than by any meaning in the scene it shows. The response he evokes therefore relies largely on his organization of abstract shapes, tones, and textures. Like Callahan he is not interested in the ability of the camera to represent the world we normally see or to record events, but to explore the abstract qualities of ordinary, often unnoticed subjects. His pictures are characterized by strong tonal contrasts, extreme crispness of detail, and lack of depth — everything seems to be on the same plane. He often increases the dark tones of his pictures in order to emphasize a certain texture or shape. But he never arranges a subject before photographing it nor retouches it afterwards, believing in the straightforward application of photography.

Rome, 1973
Like the work of Abstract Expressionist painters, the close-up picture, left, relies entirely on surface design. The subject itself is both unrecognizable and unimportant — the impact of the picture results from Siskind's organization of shape and texture.

Peeling paint, Jerome 1949
Siskind used crisp detail and sharp tonal contrasts to transform a simple subject into a picture with both mood and character.

Harry Callahan

Callahan's work is characterized by strong use of line and pattern and extreme formal simplicity. Although most of his subjects are drawn from nature, his primary concern is not to represent but to explore the abstract qualities of his subjects. His photographs are studies of line, texture, and other elements of picture building. To this end he uses his camera and photographic work to isolate and exploit those elements he finds interesting in a subject. For example, he will often emphasize line and form in a subject by using the extremes of the tonal scale, creating a simplified, linear design in pure black and white.

Many of his plant forms and landscapes display a lack of space and depth, appearing to be on the surface of the print rather than being seen through photography's "window on the world". He will photograph these in flattened perspective, with no foreground. By eliminating the sense of three-dimensions he enhances the purely abstract, non-representational qualities of his subject.

One of Callahan's favorite subjects is the facades of buildings — chosen for their pattern and proportions rather than for any architectural significance. He also photographs nudes, often showing them in silhouette or in the same austere linear form as his studies of plants and trees.

Occasionally Callahan experiments with multiple images, using multiple exposures or superimposition to achieve a sense of movement and juxtaposition of pattern. Unlike Jerry Uelsmann (see pp. 200–1) he composes and blends his images in the camera rather than constructing them in the darkroom from separate negatives.

In comparison to Siskind, Callahan's subject matter is both more varied and more recognizable. But both use photography to pick out and transform familiar subjects into abstract works of art. Some critics would argue that their pictures are obscure and austere; others admire them for their formal economy and strong sense of graphic design.

Tree in winter, 1956
In the photograph, below, shape is transposed into pattern and dynamic movement. Callahan used a multiple exposure, rotating his camera slightly between exposures to produce a repeating pattern of varying tones.

A weed, 1951
The picture above is an example of the extreme simplicity of Callahan's approach. To achieve the delicate linear quality of this photograph, Callahan used a combination of underexposure and overdevelopment and printed the negative on high-contrast paper. The resulting image could easily be mistaken for a line drawing.

JERRY UELSMANN: Creating surreal images in the darkroom

Encountering Jerry Uelsmann's photography is like entering a dream world. His strange images of floating trees and hands cradled in stones conjure up the world of the subconscious. By skilful use of darkroom techniques, Uelsmann creates a disquieting fantasy world, where the normal rules of perspective and scale are disregarded, and the natural laws of time and space suspended. His technical mastery only serves to heighten the strangeness of his images. The quality and fine detail of each print give them a disturbing realism.

Unlike the other photographers in this section, Uelsmann uses the darkroom and the facilities it provides not just to modify but to create his final images. Uelsmann's range of equipment is highly unusual — he uses only one camera (a $2\frac{1}{4}$ ins square single lens reflex) but up to six enlargers. He finds it easiest to make composite prints by setting up his chosen negatives in different enlargers and moving the printing paper from one enlarger to another between exposures. Uelsmann believes in what he calls "in-process discovery". Whereas most photographers print images that they have previsualized at the shooting stage, Uelsmann

is concerned with "discovering" a satisfying composite image in the darkroom. In this way, he believes in allowing the limitations and characteristics of the photographic materials themselves to contribute toward the formation of the final print.

Uelsmann takes hundreds of photographs of subjects such as trees, hands, rock forms, weathered wood, nudes, and landscapes. Each negative is meticulously contact printed and filed so that, at a later date, he can easily find an appropriate image for the picture he is building.

At the shooting stage, most of Uelsmann's images are committed only in terms of their possible foreground or background use in later constructing a composite image. When framing the subject he leaves space at the top or bottom of the negative. Beyond this nothing is finally decided until he enters the darkroom. Here he sets up his enlargers with negatives or contact printed film positives and begins the process of building up a picture — by masking parts of one image and printing-in another image in its place, or by sandwiching negatives. Sometimes he sandwiches a negative and positive together, producing a surrealistic combination of

negative and positive tone values. Uelsmann avoids overlapping images, keeping them separated by masking parts of the printing paper, so that each image can make its own distinct contribution to the composite. His prints are made on variable contrast paper which, combined with filters, compensates for the problems of printing negatives which are of very different contrast on to a single sheet of printing paper.

Apocalypse 11, 1967
Uelsmann communicates a strong feeling of revelation and awe in the composite image below. The top half of the picture was constructed by laying two negatives of a tree side by side on the enlarger. The resulting film positive was then printed on to the top part of the paper, giving a symmetrical pattern of white branches and horizon shapes. Uelsmann printed direct from a negative of the figures, silhouetted against the sea, to provide the bottom part of the image.

Equivalent, 1964
The picture, left is one of Uelsmann's least ambiguous images. It was printed from two separate negatives, using the black background of both to mask the join. The similar lighting direction of both hand and nude links the two images, stressing the similarity of their shapes. Contrast and variety are provided by the textures in the hand and the body.

Untitled, 1969
The picture below appears to have been constructed from three basic negatives — a double-printed landscape (with one half laterally reversed), a strange peapod shape, and the repeated image of a tree, with another tree grafted on upside-down to appear like tree roots. By repeating the tree image in a smaller scale and printing it in a lighter tone, Uelsmann breaks the symmetry and creates a sense of perspective.

Untitled, 1973
Uelsmann draws a light-hearted parallel between the idealized decorative foliage of the painting or tapestry and the bleak bare shapes of the real trees in the picture above. By photographing the painting from an oblique viewpoint, Uelsmann creates a strong foreground lead-in to the picture. Uelsmann overlapped the two images, shading them carefully where they join, so that they blend gradually into one another in the background.

Untitled, 1972
The powerful shape of the seaweed in the foreground dominates the disquieting seascape, right. Uelsmann made the top part of the picture by sandwiching a negative with a carefully masked film positive of the same image, producing an uneasy combination of negative and positive tone values.

FRANK HERRMANN: Photojournalism and portraiture

Frank Herrmann is a British photojournalist, perhaps best-known for his portrait studies.

As a newspaper photographer, Herrmann is bound by the brief he is given and by the restrictions of the printed page. For instance, the single newspaper column requires a vertical format for his portraits. But where space permits a larger, 2 or 3 column horizontal picture, more detail and context can be incorporated. Herrmann's pictures tend to be bold and simple in structure with a minimum of detail. In photojournalism, content is of primary importance — the picture with the most information and impact will always tend to take precedence over a more subtle, well-composed shot.

The nature of a photojournalist's job also restricts the equipment he uses. Elaborate studio lighting, large format cameras and tripods are out of the question for most journalistic assignments where timing and speed are essential. For most portraits Herrmann uses a normal or long focus lens and existing lighting, sometimes with flash. Long lenses are particularly useful as they allow him to take close-ups without any distortion, from a fairly distant view point, and their shallow depth of field separates the subject from any distracting elements in the background.

Bishop of Woolwich (1966)
In the picture below Herrmann has produced a strong, tightly cropped image for a newspaper page which would still work well if reproduced small. The head was lit from two different light sources giving a fine tonal range and shadow detail. Information such as the ring and white collar is included, without appearing contrived.

Orson Welles
Herrmann's timing and choice of viewpoint were crucial in the portrait below. Backlighting and unsharp focus simplified the image and, combined with the over-exposed background, produced a strong silhouette.

Duncan Grant
The artist Duncan Grant's cluttered home, and his self-portrait as a young man, contribute both character and contextual detail in the picture below right. Pose and lighting have been carefully considered to match Grant's painting.

APPENDIX

Rollfilm cameras

The most popular film used to be rollfilm, which gave a large, $2\frac{1}{4}$ ins square image. Today, improvements in lenses and emulsions have made 35 mm and smaller films more popular and rollfilm has become a specialist medium size material, mostly used by professionals.

The film itself is rolled on a spool combined with a length of opaque backing paper. It is attached to the paper by tape at its leading edge. The backing paper is about 8 ins (20 cm) longer than the film at each end so you can load in daylight by threading the leading edge on to a take-up spool in the camera. By winding a knob at the top of the take-up spool you draw the film into position. At the end of the film you continue winding, so that the backing paper end

protects the film from light when you open the camera. You can then use the empty spool to act as the next take-up spool.

The most generally used rollfilm size (120/620) gives a picture $2\frac{1}{4}$ ins wide. Most rollfilm cameras take square pictures, 12 to a film. As you can see from the full size drawings, right, a $2\frac{1}{4}$ ins square picture is over four times the area of a 35 mm picture and so needs less enlargement, minimizing graininess on the print.

Two main types of rollfilm camera are widely used. The twin lens reflex, described opposite, is made in both fixed and interchangeable lens models. The rollfilm single lens reflex, shown below, has a system of interchangeable lenses, film magazines, and other accessories.

$2\frac{1}{4}$ ins film

35 mm film

Reflex viewing problems

Both single and twin lens reflex rollfilm cameras use a mirror at 45° to reflect light from the lens up on to a horizontal focusing screen. You see the image the right way up but reversed left to right, as shown right. This makes it hard to pan (follow) moving subjects. You can correct this by fitting a pentaprism over the focusing screen, as in a 35 mm camera, but pentaprisms for rollfilm cameras are relatively expensive.

Subject

Focusing screen image

Single lens reflex rollfilm camera

The viewing system in the rollfilm single lens reflex camera uses the same principle as the 35 mm SLR (see p. 29). A hinged mirror reflects the image formed by the taking lens up on to a focusing screen. At the moment of exposure the mirror lifts, and a focal plane shutter fires at the back of the camera. Generally you view the focusing screen through a removable folding hood with a flip-up magnifier. But you can add different viewfinders or focusing screens for different purposes.

Most rollfilm SLR cameras use detachable film magazines. You pre-load these with rollfilm and clip them on to the camera back. The film is protected in the magazine by a thin metal dark slide, which you remove before taking any pictures. You can change from black and white to color material, instant picture film or sheet film — at any time, even in mid-film — simply by switching magazines.

There is a wide range of interchangeable lenses that fit the rollfilm SLR.

Film back

Film crank

Film advance lever

Dark slide

Film magazine

Hood

Fine focus magnifier

Lens

Shutter release

Twin lens reflex rollfilm camera

The twin lens reflex uses two lenses of identical focal length. One forms the image on the focusing screen, the same size as the picture frame. The other lens is fitted with a bladed shutter, and forms the image that records on the film. When the image is in focus on the screen it is also in focus on the film because the distances between top lens and focusing screen, and bottom lens and film are identical. Both lenses move forward and backward on the same front panel to focus. If you buy a model with interchangeable lenses you have to buy the lenses in pairs.

The internal viewing system is similar to a single reflex in design, but has a fixed mirror. However the twin lens viewing system does suffer from parallax error, as shown right.

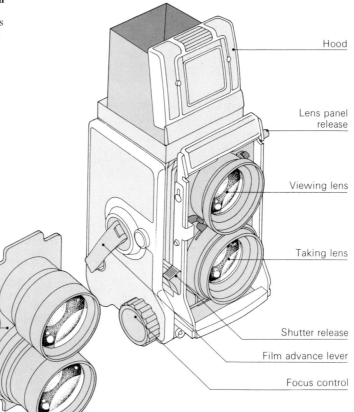

Hood

Lens panel release

Viewing lens

Taking lens

Shutter release

Film advance lever

Focus control

Interchangeable telephoto lens panel

Correcting for parallax

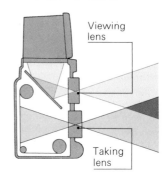

Viewing lens

Taking lens

The 1½ in (3.8 cm) gap between the two lenses may lead to serious errors in close-up work. For subjects nearer than about 8 ft (2.4 m), a pointer shows the true top of the picture. Ideally, you should use a tripod to raise the camera by the exact inter-lens distance to eliminate parallax, as shown below.

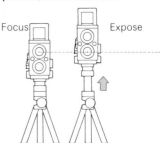

Focus　　　Expose

Variety of viewpoint

Despite its clumsy appearance, the twin lens reflex allows the widest range of viewpoints of any camera design. A waist-level position, or chest height if you use the folding focusing magnifier, is normal. But you can easily focus the camera at ground level. For viewpoints over people's heads or other high obstacles, you can hold the camera upside-down, above your head. The front of the hood folds down for action photography and forms a simple frame finder, viewed at eye level through an aperture at the rear. This finder is essential for panning moving subjects, but it does increase parallax error.

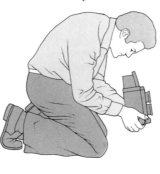

Other rollfilm camera formats

Square pictures are sometimes awkward to compose, and square negatives tend to waste printing paper, which is rectangular. However, there are some single lens reflex cameras which take rectangular pictures on rollfilm.

The 6 × 7 cm model, bottom, has a revolving back. This enables you to turn the film compartment for a horizontal or vertical format. The 6 × 4.5 cm camera can be fitted with a hand grip that includes a shutter release and film wind lever. By folding down the front of the hood it can be operated like a single lens reflex camera. Other models are fitted with pentaprisms and have similar, scaled-up controls to a normal 35 mm single lens reflex camera. A 6 × 7 cm camera gives you eight pictures, and a 6 × 4.5 cm model 16 pictures, on a 120 rollfilm.

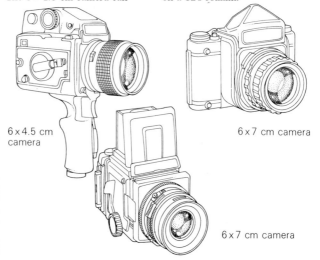

6 × 4.5 cm camera

6 × 7 cm camera

6 × 7 cm camera

Special purpose cameras

Cameras designed for special purposes range from surveillance types, fitted with electronic image intensifiers for use in the dark, to aerial cameras and instant picture cameras (see p. 210). You can, for instance, buy cameras with endoscope lenses — the lens is set at the end of a narrow tube which may be up to a $3\frac{1}{2}$ ft (1 m) long. This enables the camera to take pictures in otherwise inaccessible places. Panoramic cameras take pictures covering a view of up to 360°. Others, such as the two models shown right, allow you to do general or macro photography underwater. (Some cameras will take panoramic pictures underwater.)

Sometimes special purpose cameras are modified production designs, given a new housing, or a different lens or viewfinding system. Some are scaled up or down versions of other cameras, for example single or twin lens reflexes made for 4 × 5 ins sheet film. The normal wide-angle lens for a 8 × 10 ins camera can be fitted to a special body — the Linhof Technorama — which restricts the image to an 8 ins (20 cm) long narrow format on rollfilm.

A specialized camera may be used as an auxiliary for another hobby altogether, like golf. The Check Polaphy with its array of eight shuttered lenses, will record the action of your swing as a rapid series of images on instant picture film.

Underwater cameras and housings

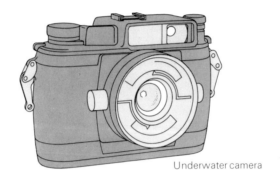
Underwater camera

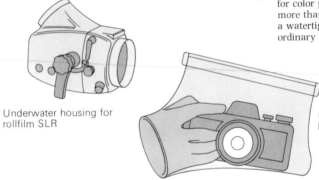
Underwater housing for rollfilm SLR

Underwater camera bag

Cameras for underwater photography may be specially designed with watertight parts for direct submersion, as shown left. But you can adapt ordinary cameras by fitting them into special underwater housings. Underwater, your camera must be simple to operate. Film wind, aperture, and shutter controls have to couple up to large knobs and levers on the outside casing.

It is important not to exceed the maximum water pressure for your equipment. The simple quick-seal plastic bag, shown below left, is safe at shallow snorkel depths; the camera, top left, can be used down to 165 ft (50 m) and the rollfilm SLR housing, bottom left, will function down to 500 ft (150 m). Because of the filtering effect of water, flash is practically essential for color photography at depths of more than a few feet. You can buy a watertight acrylic housing for an ordinary electronic flashgun.

Panoramic cameras

A panoramic camera gives an extremely wide angle of view in one dimension, usually horizontal. This is achieved by a panning movement of the lens during exposure. The lens may rotate through 120°, 180° or even 360°. The camera, below right, gives a 140° horizontal scan using a 26 mm lens on normal, 35 mm film. Instead of the usual 36 exposures there is room on the film for only 21 pictures, 24 × 59 mm in size. You need a $2\frac{1}{4}$ ins square enlarger for making prints.

Panoramic cameras give spectacular "wide screen" images, well suited to horizontal subjects, such as the building, right.

Swivelling lens panoramic cameras
Most panoramic cameras have a swivelling lens. This can cover a very wide area, typically 180°, while the image remains stationary throughout exposure. The film, held in a curve, is swept by a narrow aperture as the lens swivels.

Lens movement

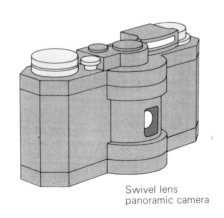
Swivel lens panoramic camera

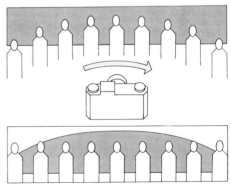

Panoramic perspective
Subjects arranged in a curve record in a straight line. Horizontal lines curve toward two vanishing points outside each end of the frame.

Large format sheet film cameras

A large format camera, usually 4 × 5 ins, is quite simple in design. This kind of camera is used mostly for architectural and studio still-life work. It consists of a lens and bladed shutter mounted on a panel at one end of the bellows. At the other end there is a ground glass focusing screen.

Large format cameras have some particular advantages. Pictures are exposed on separate sheets of film, which can be processed individually to suit subject and lighting conditions. You can use a wide range of films, from line and other black and white films to instant picture and color films. The large negatives produced by these cameras can be easily retouched; they need less enlargement, and give finer image detail. You can also move the lens and film on large format cameras to control perspective and depth of field, as explained overleaf. Because of the long bellows you can work very close-up to the subject without using extension tubes.

Large format cameras are slow to set up and use — a tripod is essential. The image seen on the focusing screen is upside-down. Outdoors you must have a hood or a camera cloth over your head to be able to see the subject. Finally, there is delay between focusing the image and inserting and exposing the film, so that action pictures are almost impossible unless pre-planned.

Basic types of large format camera

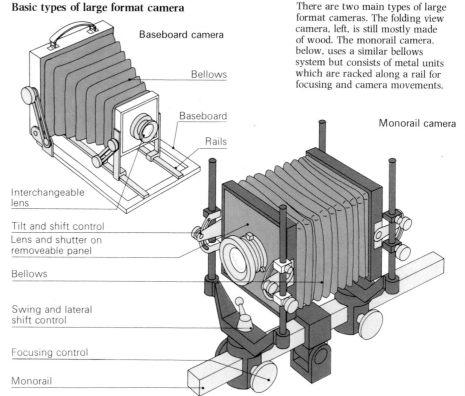

Baseboard camera
Bellows
Baseboard
Rails
Interchangeable lens
Tilt and shift control
Lens and shutter on removeable panel
Bellows
Swing and lateral shift control
Focusing control
Monorail

Monorail camera

There are two main types of large format cameras. The folding view camera, left, is still mostly made of wood. The monorail camera, below, uses a similar bellows system but consists of metal units which are racked along a rail for focusing and camera movements.

Film holders
All large format cameras use sheet film, loaded in holders. Most take pictures 5 × 4 ins, although there are some 10 × 8 ins models. Other large format cameras are made, or can be adapted, for 2½ × 3½ ins and 12 × 9 cm size film. The usual film holder takes only two sheets, which must be loaded in the dark. You insert the holder into the back of the camera and, after one exposure, turn it the other way around. You can use a film pack back. This contains 16 sheets of ready loaded film which are moved into position one at a time by pulling a tab. You can also obtain backs for Polaroid instant picture films and rollfilms.

Sheet film holder

Film pack back

Polaroid back

Interchangeable bellows
You can detach, add to, or rearrange the units of a monorail camera very easily. The normal bellows, for example, unclips at each end and can be replaced by bag bellows. This does not have the usual concertina folds. Consequently it allows you to position a wide-angle lens close to the film, but still enables you to shift the lens and make other camera movements. To work close-up you add extension bellows. These fit between the regular bellows and the lens panel and so increase the length of the normal bellows.

Extension bellows

Bag bellows

Inverting focusing hood
This hood overcomes the nuisance of an upside-down image, and at the same time shields the focusing screen from stray light. The hood clips on to the back of the camera and you look down through an eyepiece on to a large mirror which reflects the focusing screen image the right way up.

Sheet film camera movements

Large format sheet film cameras offer a range of movements — swings, tilts, and shifts of the lens relative to the film. These modify perspective, shape and depth of field in the image. The monorail camera is the most versatile. It uses movable units with locking screws, such as shown right, at the front and back of the camera. These control horizontal and vertical pivots, and sliding movements up, down, and sideways.With this arrangement camera movements are unlimited. The monorail camera should be used with a lens that has an extremely good covering power, as the camera movements often position it off-center to the film.

Sheet film camera unit

Principal camera movements

The movements of the front and back sections of a monorail camera can be divided into shifts — up and down, or sideways; swings around a vertical axis; and tilts on a horizontal axis. Shifts give the same effect as a shift lens on a 35 mm camera (see p. 96). By raising the front and/or lowering the back you can include more of the top and less of the bottom, without tilting the camera upward. As a result you can view upward, sideways, or downward, without making parallel lines in the subject appear to converge.

Swinging or tilting the back of the camera alters the appearance of shape in the image, as shown below. This allows you control over perspective. One or even two planes in pictures of cube shapes (like buildings) can be altered without disturbing the third. Back movements also help improve depth of field when the subject is principally on one oblique plane, as shown on the opposite page.

The main purpose of swinging or tilting the front of the camera is to improve depth of field by bringing the lens more closely into parallel with an oblique subject. Shift movement is also useful to avoid "vignetting" the subject unintentionally with, for example, the lens barrel itself.

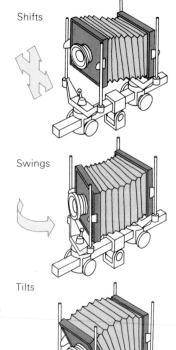

Shifts

Swings

Tilts

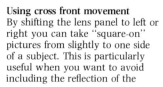

Using cross front movement
By shifting the lens panel to left or right you can take "square-on" pictures from slightly to one side of a subject. This is particularly useful when you want to avoid including the reflection of the

camera in a mirror. The reflection-free version of the picture, above right, was taken with the camera moved right but the lens shifted left, so that it still framed and focused on the original subject, shown above left.

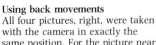

Using back movements
All four pictures, right, were taken with the camera in exactly the same position. For the picture near right, top, the lens was square on to the camera back. In the picture, near right, bottom, the camera back was swung so as to shift the part of the focusing screen showing the right side of the box further from the lens. Linear perspective on the front of the box now con-verges toward the left instead of the right. For the pictures, far right, the camera back was swung and tilted, moving first the part of the screen showing the bottom left corner of the box away from the lens, top. Then the bottom right corner was pulled away from the lens, bottom. Double movements alter both the vertical and hori-zontal perspective of the box.

These pictures are extreme examples; in most cases back movements are used for subtle control of image shape in still-life and architectural photography.

Maximizing depth of field

One of the most useful properties of front and back camera movements is the way you can use them to improve depth of field. The small picture, near right, was taken without camera movements. Depth of field is shallow even at a small aperture — f11. You can correct this by tilting the camera lens forward and the back panel backward until imaginary lines through the subject plane, lens panel plane and focusing screen plane all converge to a single point, as shown below right. As in the picture, far right, the depth of field now extends throughout the whole subject plane, at the original aperture. You can use the same principle when photographing along an oblique vertical surface, using swing movements instead of tilts.

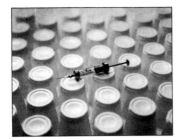

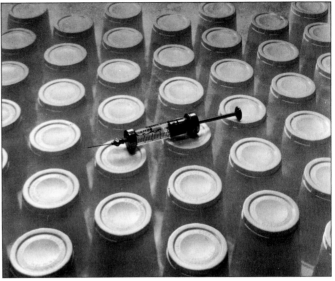

Types of film

Sheet films are available in many different specifications. Be careful to check what safelighting (if any) can be used in the darkroom. Notches in the edge of each sheet identify the film type. When you hold the film with the notch at the right-hand end of the top edge, the light-sensitive surface faces you.

Type	Speed (ASA)	Use
Pan Royal	400	General black and white photography
Plus X	125	„ „
Ektachrome 64	64	Color transparency
Vericolor S	100	Color negative
Gravure positive	8	Copying prints

Identifying sheet film
From front to back these films are, Kodak: Plus X; Ektachrome daylight, and tungsten; Vericolor S.

Loading sheet film

1. Pull one of the plastic dark slides half out of the film holder. The dark slide can remain in this position during loading and unloading.

2. Open the hinged end of the holder and switch off the white light. Unwrap the sheet film, remember to handle the film by its edges only.

3. Hold one sheet with the notch at top right. The emulsion side is now facing you — when loaded, this side must face outward.

4. Load the sheet under the film holder guides. Push back the dark slide and close the holder. Turn the holder over and repeat with a second sheet of film.

Processing sheet film

1. Switch off white light and carefully remove the film from the film holder. Hold the film by its edges only.

2. Attach the film to a processing hanger by the four corner clips.

3. Place the hanger in a sheet film processing tank of developer. Agitate. Replace the lid and switch on the light.

4. Transfer the film to stop bath then fixer. Finally rinse in wetting agent and hang the washed film up to dry.

Instant picture cameras

As the name implies, instant picture cameras use special film which self-develops a few seconds or minutes after exposure. There are two types of material in common use — material you have to peel-apart, and integral processing material.

With a camera designed for peel-apart material, such as shown right, you expose the picture on a piece of light-sensitive paper or film. You then pull a tab which brings the film into contact with a receiving paper and pulls the two sheets from the camera through a pair of spring-loaded rollers. These rollers spread chemicals between the two surfaces. After an appropriate number of seconds — the time varies according to the temperature — you peel the sheets apart. A positive, right-way-round image is printed on the receiving paper. You then either discard the negative or, if you have used a black and white film designed for printing, wash the negative and retain it. Polaroid peel-apart film packs, for black and white and color, also fit specially designed direct viewfinder cameras, and attachments for 120 rollfilm single lens reflex or 5 × 4 ins sheet film cameras.

Integral-processing instant picture materials are made by both Polaroid and Kodak. The two systems are similar, but incompatible. In both systems one multi-layer sheet is used both for the exposure and the final print. This is ejected from the camera immediately after exposure as a creamy looking blank print, on which a color image gradually appears.

Peel-apart instant picture film

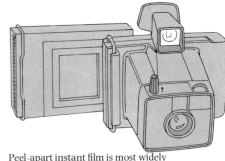

Peel-apart instant film is most widely used on simple viewfinder cameras, such as shown above, right. Peel-apart film backs, above left, are also made to fit rollfilm single lens reflex cameras.

Cameras for integral processing

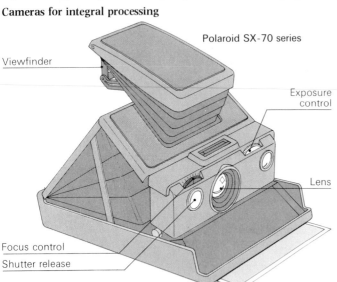

Polaroid SX-70 series

Viewfinder

Exposure control

Lens

Focus control

Shutter release

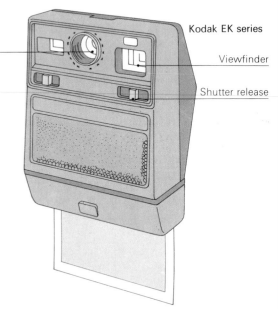

Kodak EK series

Lens

Viewfinder

Shutter release

Polaroid SX-70 system
Polaroid's integral-processing instant picture material forms a finished color photograph on the same surface that received the image. The image is reflected by a mirror inside the camera so that it is not reversed left-to-right on the final print

The SX-70 is a special type of single lens reflex. During focusing a face-down hinged mirror covers the film pack. Light is reflected from a mirror fixed to the rear of the camera so that the image is seen and focused on the back of the face-down mirror, as shown right. When you take a picture the mirror rises, seals off the eye-piece, and reflects the image on to the light-sensitive material.

Motorized rollers then eject the card, spreading re-agent chemical and light-proof white pigment between the processing lower layers and the top receiving layers. Gradually yellow, magenta, and cyan dyes released from below rise and permeate the white surface to form a visible color picture.

Lens

Mirror

Ejection rollers

Film pack

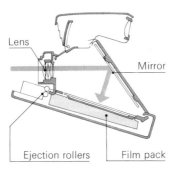

Film

Action of reagent

Kodak EK system
In the Kodak instant picture system, right, one side of the multi-layer coated plastic sheet is exposed to the image, while the finished picture forms on the opposite side. So to form the final image the correct way around, either the exposing surface must face the lens directly, or the image must be reflected twice before reaching it.

Light from the lens is reflected twice in the camera by fixed mirrors on to the sensitive material. You compose the picture and aim the camera by means of a separate, direct vision viewfinder.

After exposure the eighteen-layered material is ejected through rollers which spread reagent within the film. Yellow, magenta, and cyan dyes pass through a central opaque layer, except where they are anchored by developer molecules. A positive color image slowly appears against a white background on the far side of the material from the exposed surface.

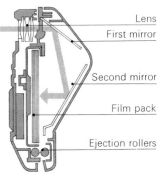

Lens

First mirror

Second mirror

Film pack

Ejection rollers

Film

Action of reagent

Useful accessories

The difficulty in choosing accessories is knowing what you can afford to do without. In various parts of this book we have looked at tripods (see p. 34); close-up attachments and filters (see pp. 100–3, 156) and flash (see p. 112). The accessories shown right and below are often overlooked but are all useful in various ways.

An "ever-ready" camera case is almost a necessity. It protects the camera, yet keeps it ready for use at a moment's notice. Protection is also necessary for any additional lenses. They can be kept in their original padded cases or perspex lens boxes and stored loose in a gadget bag. Or you can fit caps and keep them in an outfit case like the one shown right.

So much photographic equipment today is run from batteries — meters, flash, auto-winders, and so on — that it is helpful to carry a spare battery of each type. The life and use of some battery types are shown at the bottom of the page. You must also carry materials for cleaning dust or hairs from lenses, see below.

When choosing a case for a complete outfit, think carefully before you buy anything expensive-looking which may attract thieves. An airline-type soft bag with a shoulder strap, or a fitted case which cannot be distinguished from an ordinary business attache case, is often a wiser practical choice.

Accessories

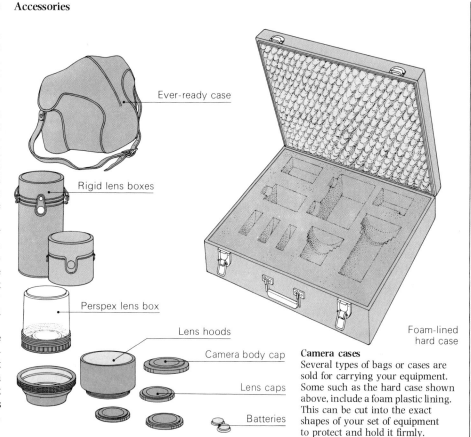

Ever-ready case

Rigid lens boxes

Perspex lens box

Lens hoods

Camera body cap

Lens caps

Batteries

Foam-lined hard case

Camera cases
Several types of bags or cases are sold for carrying your equipment. Some such as the hard case shown above, include a foam plastic lining. This can be cut into the exact shapes of your set of equipment to protect and hold it firmly.

Camera and lens care

The most common causes of damage and poor performance of equipment are dirt, water, and condensation. Check that the film compartments of your camera are clean and that the shutter works each time you load a new film. From time to time tighten any external screws on the camera — they tend to become loose as a result of vibration.

Always keep lens caps on both ends of lenses when they are not in use. Protect the lens on the camera with an ultra-violet filter

or a dust cap when you are not using the camera. Most small hairs and dust particles on the glass surface can be removed by puffing air from a blower brush. Blow and brush any debris toward the rim of the lens and remove it with a cotton bud or lens cleaning tissue.

A lens marked with dried-out rain splashes should be gently wiped with a cleaning cloth moistened with lens cleaning fluid. Condensation on a lens should be allowed to evaporate as the camera warms up.

Motor drives and autowinders

Motor drives and autowinders auto-matically wind-on film after each exposure. A motor drive will fire the shutter and wind-on for a pre-set number of exposures or work continuously. The cheaper auto-winder simply winds on rapidly after each manually fired exposure. This is usually just as useful, more controllable, and less wasteful of film than a motor drive.

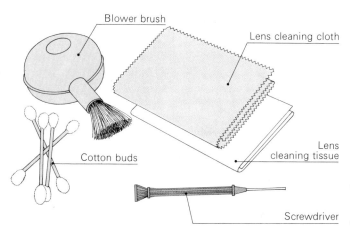

Blower brush

Lens cleaning cloth

Cotton buds

Lens cleaning tissue

Screwdriver

Battery types

Type	Rechargeable	Use
Nickel-cadmium	Yes	Electronic flash
Silver-zinc	Yes	Internal meters
Silver-cadmium	Yes	Internal meters
Zinc-carbon (leak proof)	No	Bulb and electronic flash
Zinc-carbon (layer type)	No	Some electronic flash
Mercury	No	Internal CdS meter cells

Copying and slide projection

It is useful to be able to photograph and copy images, either pictures, drawings or text. By copying you can achieve special effects such as converting an image to line (see p. 131) or montage. The most important factors for success are even lighting, and a camera position absolutely square-on to your original. For copying continuous tones use general purpose fine grain black and white film; for color copying use film appropriate to the light source. The best way to measure exposure is to place a mid-gray card over the original and take the reading from this. Remember to allow for extension tubes or bellows if your meter does not measure through the lens.

Copying equipment

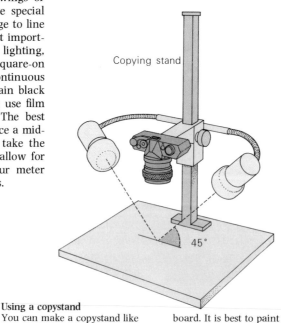

Copying stand

45°

Checking evenness
Your lighting should be as even as possible. One way to check this is by placing a pencil or ruler at the center of the original and comparing the darkness of the two shadows formed. If these are obviously different, alter the relative distances of your lamps. Avoid having lights too close — this will give a patchy effect.

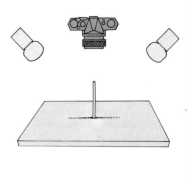

Avoiding camera reflections
If you are copying an original which is behind glass or has a glossy surface, bright parts of the camera may reflect off the surface and record in your copy. Use a large sheet of black card, as shown above, to mask the camera, cutting a hole for the lens.

Using a copystand
You can make a copystand like the one shown above, or adapt one from an old enlarger. The stand will hold the camera steady and ensure that it is always square-on to the image. Arrange two lamps equidistant from the camera support, directed at about 45° to the

board. It is best to paint the copy board and reflective parts of the lamp supports black to reduce flare. For black and white photography 100 watt lamps are adequate, but for color work the reflectors must be large enough to accept 3200°K type lamps.

Slide projection
The best way to view color slides is to use a projector, but the quality of your projector and conditions of viewing can greatly affect your results. Strong illumination makes the most of image colors and increases apparent sharpness, but projectors with efficient cooling systems for strong lamps and good wide aperture lenses are expensive. If you only have a small projector keep to a small image which will then be well illuminated.

All projectors heat-up color slides, to a greater or lesser extent. If the film is held in a simple cardboard mount it will bow slightly during projection so that the center or edges appear out-of-focus. Glass faced plastic mounts (see p. 176) avoid this problem.

Types of projector

Hand-operated projector
A simple projector, like the one above, uses a sliding hand-operated carrier. This takes two slides; while one is projected the other can be changed.

Magazine projector
The more elaborate machine, above, holds a magazine of up to 50 slides. The slide is changed automatically by remote control.

Rotary magazine projector
Projectors with rotary magazines allow longer slide programs to be shown without a break. In the model above, up to 80 slides are stored in a dust-proof magazine. Each slide is automatically lowered, projected, and replaced in turn.

Setting up projection
When you project slides it is essential to black-out the room properly. Even a small amount of extraneous light will dilute your image blacks to dark gray, degrade contrast, and de-saturate color. If you do not have a projection-screen use a flat mat white wall, or large card. You can buy screens with highly reflective beaded surfaces which give a more brilliant image than a mat white. They are very directional and your audience should sit near the projector beam.

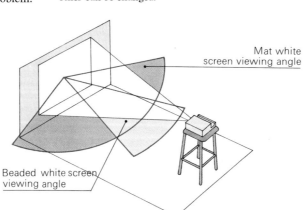

Mat white screen viewing angle

Beaded white screen viewing angle

Chemical mixing formulae

Up until about thirty years ago photographers prepared all their processing solutions by weighing out and mixing the basic chemicals. Today this is done in factories, and most processing solutions are bought as liquids ready for dilution. If you have time you can still save considerable expense by weighing and mixing up your own solutions, provided you can obtain the raw chemicals. Some photographic solutions — certain bleaches for instance — are not available ready-made, and so have to be prepared. The only equipment you need is a pair of scales, a set of weights capable of measuring as little as half a gram, and, if possible, a small laboratory chemical mixer. Never touch chemicals directly with your hands, always wear rubber gloves. Most black and white photographic chemicals are fairly harmless but you should take special care with strong acids or alkalis such as sodium hydroxide.

When mixing an acid, you should always add it to a solution, never the reverse. Measure and mix chemicals in a well ventilated room, and avoid inhaling fumes — particularly from acids, fixers, and toners. Keep all chemicals well out of the reach of children and do not store solutions in bottles which look like drink containers.

Mixing from formulae

Weigh out correct amounts of all the chemicals listed in the formula, as explained below. You can use either letter scales or the chemical balance as shown. (Balances are more accurate for small quantities but you have to weigh larger amounts of chemicals in several lots.) The chemicals in each formula shown right are listed in order of mixing. Dissolve the chemicals one after the other into slightly less than the final volume of water, and then add water to make up the final volume.

Most of the chemicals shown are anhydrous or monohydrate — fine powders which dissolve fairly readily in water of about 70°F (20°C). Some may be crystals, which dissolve more easily in warmer water at around 100°F (38°C). Crystals lower the temperature of the solution as they dissolve. Make sure one chemical has completely dissolved before adding the next. Give time for your solution to settle and regain normal temperature before use. Keep it stored in a sealed bottle — most solutions deteriorate when left exposed to the air.

Sepia toner	
Bleach:	20 gm Pot. ferricyanide (c)
	20 gm Pot. bromide
	Water made up to 1 liter
Toner:	20 gms Sodium sulfide
	Water made up to 1 liter

Iodine bleacher	
15 gm	Pot. iodide (c)
4 gm	Iodine
	Water made up to 1 liter

Stop bath	
Paper	15 ml Acetic acid (glacial), or citric acid made up to 1 liter
Films	30 ml Acetic acid' (glacial), or citric acid made up to 1 liter

Ferricyanide (Farmers) Reducer		
Solution A	8 gm Pot. ferricyanide (c) Water made up to 1 liter	
Solution B	200 gm Sodium thiosulfate (c) Water made up to 1 liter	Mix equal quantities of each just before use

Chromium intensifier		
9 gm	Pot. dichromate (c)	After bleaching re-blacken in normal print developer
6 ml	Hydrochloric acid	
	Water made up to 1 liter	

Tray and tank cleaner		
25 gm	Pot. permanganate (c)	Leave in the dish for several minutes, then rinse, clean with fixer, and wash out
5 ml	Sulfuric acid (concentrated)	
	Water made up to 1 liter	

Developer ingredients (gm)	D76	D.8 (Line)	DK50	D.163 (Prints)
Metol	2		2·5	2·2
Hydroquinone	5	45	2·5	17
Sodium sulfite (anh)	100	90	30	75
Pot. Sodium hydroxide		37·5		
Sodium carbonate (anh)				65
Borax	2	30		
Sodium Metaborate			10	
Pot. Bromide			0·5	2·8
Water made up to	1 liter	1 liter	1 liter	1 liter

Fixer ingredients (gm)	Acid fixer	Acid hardening fixer	Rapid fixer
Sodium thiosulfate (c)	300	250	
Ammonium thiosulfate			200
Sodium sulfite (anh)	10	15	15
Acetic acid (glacial)	15 ml	17 ml	21ml
Boric acid (c)		7·5	7·5
Pot. Alum (c)		15	25
Water made up to	1 liter	1 liter	1 liter

Pot. — potassium anh — anhydrous C — crystal

Weighing and mixing chemicals

1. Place two equal size pieces of paper, one in each pan, to hold the chemicals. Never pour the chemicals directly on to the balance pan.

2. Put the required weights on one pan. Gently tip the chemical on to the paper in the other pan until the two pans balance. Remove the chemical on its paper; replace with new paper.

3. Use a jug large enough to hold the final quantity of solution. Pour in two thirds of the water, then slowly pour in and mix each chemical in sequence, stirring continuously.

4. Add the remaining water to the mixture and pour the solution into a storage bottle. Seal and label.

Glossary

Terms in *italics* denote useful cross-references to other glossary entries.

A

Aberration The inability of a lens to produce a perfect image in shape and sharpness even when it is focused correctly on a subject. Aberrations are greatly reduced by the compound construction of lenses but the degree of correction varies according to lens quality.

Accelerator An ingredient of developer – normally an alkali – which speeds up development by quickening the action of the reducing agent in the solution.

Actinic The ability of light to change the nature of materials exposed to it.

Acutance Objective, physical measurement of the sharpness of a processed photographic image.

Additive color synthesis Way of producing complete color images (with white) by mixing light of the three primary colors, red, blue and green in appropriate proportions.

Additive systems Systems of color reproduction based on reproducing naturally occuring colors by mixing three primary colored lights.

Aerial perspective The increase of apparent depth in a landscape due to changes of *tone* with distance. This is caused by the presence of haze or smoke which creates extraneous *ultra-violet* light.

Agitation Method of keeping fresh processing solution in contact with the emulsion surface during photographic processing.

Airbrush A retouching instrument which uses compressed air to spray liquid color.

Anamorphic lens Lens which compresses or "squeezes" the image in one plane. Rectangular pictures can be recorded as square images.

Anastigmat Lens containing a number of elements in a compound structure that reduces optical *aberrations*, particularly *astigmatism*.

Angle of incidence The angle formed between an incident ray of light striking a surface and an imaginary line running perpendicular to the surface, known as the normal. The angle of incidence equals the *angle of reflection*.

Angle of reflection The angle formed between a reflected ray of light and an imaginary line running perpendicular to the surface at the point of reflection – known as the normal. The angle of reflection equals the *angle of incidence*.

Angle of view The widest angle of acceptance of light rays by a lens which still gives a full format image on the *film plane* of usable quality.

Anti-halation layer Light-absorbing dye within, or on the back of the film *base*, or between the base and the emulsion, that absorbs light which has passed through the emulsion. See also *halation*.

Aperture Opening within or close to a lens. Allows control of the amount of light passing through the lens, and is therefore usually variable in diameter. This diameter is calibrated in *f numbers*.

ASA Denotes American Standards Association and indicates the speed rating or sensitivity to light, of film. The higher the ASA number, the faster the speed of the film. The ASA scale is based on an arithmetical progression where 400 ASA film, for example, is twice as fast as 200 ASA film.

Astigmatism Lens *aberration* where parallel rays of light passing through the lens obliquely come to focus as a line rather than a point.

Automatic exposure control System of exposure setting in a camera in which the electric current produced or inhibited by the action of light on a *photo-electric cell* operates a mechanism that adjusts the *aperture* or *shutter* speed automatically.

B

Back focus The distance between the vertex of the back surface of the lens and the *focal plane*. This is not always equal to the *focal length* as is the case with *telephoto* and retro-focus lenses.

Back lighting Artificial or natural lighting coming toward the camera from behind the subject.

Back projection Projection of a picture on to the back of a translucent screen. Subjects can be placed in front of the screen and will appear superimposed against the projected background picture. Lighting and color intensity have to be balanced if the foreground subject is to match the projected image.

Bag bellows A short, flexible sleeve which replaces the normal *bellows* when using a short focal length *(wide-angle)* lens on a large format camera.

Barn doors Masking accessory for studio lamps which controls the direction and width of light by the movement of hinged flaps.

Barrel distortion Lens *aberration* which causes lines parallel to the picture edges to appear to bend inward as they approach the corners.

Baryta Coating of barium sulfate between the base and emulsion of non-resin coated photographic paper to provide a smooth white, and chemically inert barrier.

Base The backing of a film which supports the photographic emulsion. It is usually made from paper, plastic or glass.

Bas-relief A technique where a contact positive (on sheet film) and its negative are sandwiched slightly off register in the negative carrier of the enlarger. Resulting prints look like side-lit embossed images.

Batch numbers Serial numbers stamped on packs of sensitized materials to indicate particular batches of emulsion.

Bellows Light-tight, folding sleeve which can be fitted between the lens and the film plane for close-up work.

Between the lens shutter *Diaphragm shutter* placed within the components of a compound lens near to the aperture diaphragm.

Bi-concave lens Single lens element where both its faces curve inward toward the optical center, causing light rays to diverge.

Bi-convex lens Single lens element where both its faces curve outward away from the optical center, causing light rays to converge.

Binocular vision Visually, the ability to determine three dimensions from the parallax effect created by two eyes.

Bleach Chemical bath which converts the black and white silver image created by exposure back to a halide. Bleaching is a preliminary step in most toning, reducing and color processing.

Bleed off To print a photograph so that one or more of its sides is flush to the edge of the paper.

Blocking out Painting out unwanted backgrounds on a negative with an opaque liquid before printing.

Blooming Putting a transparent coating on to the surface of a lens so that surface reflection is eliminated through destructive interference of the waves of light.

Bounce flash Directing *flash* to illuminate a subject indirectly by reflection (usually off a ceiling or a wall). It gives diffused lighting quality.

Bracketing In exposure, taking a series of pictures of the same subject that vary only in the exposure given. For example, correct, half, and double estimated correct exposure.

Bright line viewfinder Viewfinder in which the subject area is outlined by a white line frame. It may similarly show parallax correction marks.

Brightness range The difference in *luminance* between the lightest and darkest areas in a subject, or an image.

Bromide paper Most common type of black and white photographic paper used for printing and enlarging. Its light-sensitive emulsion consists mostly of silver bromide.

B setting A shutter setting indicating that the shutter will remain open as long as the shutter release button remains depressed.

Burning in Another term for *Printing-in*.

C

Cable release Also known as an antinous release, this is a flexible cable which can be screwed into the shutter release button. It helps to reduce camera shake when firing the shutter.

Callier effect A *contrast* effect which results from the scattering of directional light from an enlarger condenser system during printing. High density negative highlights scatter much more light than low density negative shadows, giving a higher contrast in an enlargement than would show on a contact print. On diffuser enlargers the effect is far less marked as light is pre-scattered.

Camera movements Mechanical systems which enable lens and film plane to be adjusted in relation to each other so as to alter *depth of field* and correct or distort image shape

Cartridge Pre-packed and sealed film container designed for quick loading. Commonly used in 110 and 126 format cameras.

Cassette Metal or plastic film spool container with a light-trap which allows handling and camera loading in daylight. Commonly used in 35mm format cameras.

Cast Overall bias toward one color in a color photograph.

CC filters Color correction (or conversion) filters are used in various hues and degrees of saturation primarily for balancing color in subtractive color printing processes. CC filters can also be used on the camera in adjusting *color temperature*.

CdS cell A photoresistant cell, see *photo-electric cell*.

Celsius scale (centigrade scale) International temperature scale where 0° and 100° C represent the freezing point and boiling point of water respectively.

Changing bag Opaque, light-tight fabric bag. Light-excluding sleeves allow the safe handling of light-sensitive materials inside.

Characteristic curve Graphical representation of the performance of a light-sensitive material. Shows the relationship between *exposure* and *density* under known developing conditions and provides emulsion speed, fog level and contrast indexes.

Chemical fog Uniform, overall veil of metallic silver deposited over a negative as a result of the development of unexposed *silver halide*.

Chloro-bromide paper Photographic printing paper coated with a mixture of silver bromide and silver chloride. Produces warm tones with normal development.

Close-up attachment Accessory which enables the camera to focus subjects nearer than the lens normally allows. The attachment may be an *extension tube, bellows,* or a supplementary lens.

Cibachrome Process for making color prints from color slides based on the *dye destruction* principle.

Circle of confusion Patches or disks of light formed by a lens when it reproduces points of light in the subject. The smaller these disks are, the sharper the image.

Coated lens Lens whose refracting surfaces have been coated with a transparent substance which decreases lens flare.

Cold cathode illumination Low temperature fluorescent light source. Inclined to reduce *contrast* and edge definition.

Color balance Adjustment in color photography so that a neutral scale of gray tones is reproduced.

Color circle Chart of *spectrum* colors, presented as a circle. It is often divided into sectors with the three primary colors, red, blue and green, opposite their complementaries.

Color contrast Difference in intensity of the sensations caused by two juxtaposed colors.

Color saturation The strength of a color, due to the absence of white, black or gray.

Color sensitivity The response of a sensitive material to colors of different wavelengths.

Color temperature Way of expressing the color quality of a light source. The color temperature scale is based on the Absolute temperature (in *Kelvins*) needed to generate an equivalent mixture of wavelengths from a theoretical black body.

Combination or double printing Printing two negatives as one, or separately, on to a single sheet of printing paper.

Complementary color Two colors are complementary to one another if, when combined in the correct proportions, they form white light.

Compound lens A lens comprising a number of lens elements working as one. Reduces many *aberrations* inherent in a simple lens. All modern camera and enlarger lenses are of compound construction.

Condenser Optical system which concentrates light from a source into a narrow beam. Used in spotlights and enlargers.

Contact printing Making photographic prints with the printing paper in direct contact with the negatives.

Continuous tone image Image created by deposits of silver, dye, or pigment, which reproduces the range of tones in the subject by varying the density of the distribution of the deposits.

Contrast Subjective judgment on the differences in brightness and *density* in the subject, negative or print. Contrast control is affected by the inherent subject contrast, lighting, lens flare, type of film, development, enlarger type, contrast grade and surface quality of the printing paper used.

Contre jour Description of a photograph taken from a viewpoint facing toward the light source also called backlighting.

Converging lens Lens which causes light rays to converge to a point of focus.

Convertible lens Compound lens consisting of two detachable sections that can be re-arranged together or used separately to provide two or three *focal lengths*.

Converter lens Compound lens system attachment which converts an existing normal camera lens to a longer or shorter focal length.

Correction filter Filter used in front of the camera lens to correct differences between the *color temperature* of the subject lighting and the *color balance* of the film.

Coupled exposure meter *Exposure meter* built-in to the camera and linked with the *aperture* or *shutter* speed controls, or both.

Coupled rangefinder *Rangefinder* system directly linked to the focusing control on the camera lens.

Covering power The maximum area of the image of good quality formed by a lens at the focal plane for a given focused distance.

Cross front Lens panel of a *view camera* which can be moved laterally to shift the lens to the right or the left of its normal position.

Cut film Alternative name for *Sheet film*.

Cyan Blue-green subtractive color complementary to red. Transmits the blue and green but not red components of white light.

D

Darkcloth Opaque cloth placed over the operator's head and the camera back for viewing and focusing images on a ground glass screen on large format cameras.

Darkroom Light-tight room for handling, processing and printing light-sensitive materials in darkness or under *safe lighting* to which the material is not appreciably sensitive.

Darkslide Removable light-tight sliding front to a film magazine or large format sheet film holder.

Definition Subjective term for the clarity of a photographic image. Not just the result of sharpness or the resolving power of the lens, but also of *graininess, contrast,* and *tone* reproduction.

Density General descriptive term for the amount of photographic (usually silver) deposit produced by exposure and development. Strictly, measurement is based on light stopping ability *(opacity)* and is usually expressed as the logarithm of this opacity.

Depth of field The distance between the nearest and furthest point from the camera within which subject details record with acceptable sharpness at any one focus setting.

Depth of field scale Scale on a lens showing the near and far limits of *depth of field* possible with a lens at any particular *aperture.*

Depth of focus Focusing latitude that results from the possible distance that the film plane can be moved away from the exact point of focus while still maintaining an acceptably sharp image.

Developer Chemical bath which converts the silver halides of the invisible latent image on exposed light-sensitive material, to the visible black metallic silver image by reducing agents. Other chemicals known as accelerators, preservatives and restrainers are added to the bath to maintain or modify its action.

Development The chemical or physical treatment that converts a photographic, invisible latent image into a visible form.

Diaphragm The adjustable device that forms the *aperture* of a lens. Its opening controls the amount of light that can pass to the film. The diaphragm may be in front, within or behind the lens.

Diaphragm shutter Shutter mechanism that is also the *diaphragm* of the lens. Its design allows a set of interposing leaves to open for the required time to the pre-set aperture when the shutter release is fired.

Diapositive Alternative term for *Color slide.*

Dichroic fog Bloom seen in negatives which appears blue-green in reflected, and purple pink in transmitted light. Caused by solutions which contain a silver halide solvent and a developing agent, which will produce silver salts in solution. Occurs in a fixing bath which has become contaminated by developer or which is becoming exhausted.

Differential focusing Setting the camera controls for minimum *depth of field* to limit picture sharpness to a particular subject, isolating it against an unsharp background and/or foreground.

DIN Denotes Deutsche Industrie Norm (German standards organization) and indicates the speed rating, and therefore sensitivity, of film. A change of +3° in the DIN rating indicates a doubling of film speed, e.g. 21° DIN is twice as fast as 18° DIN.

Diopter Unit used in optics to express the light bending power of a simple lens, being the reciprocal of the *focal length* in meters. + indicates a converging lens, and – a diverging lens. A +2 diopter lens is converging and has a focal length of 0.5 meters.

Diverging lens Lens which causes parallel light rays to diverge away from the optical axis.

Dodging Alternative term for *Shading.*

Double extension The extension (by *bellows, extension rings* or by special design) of a lens to twice its *focal length* from the film plane.

Drying marks Marks on the negatives caused by uneven drying, making overall *density* uneven. These marks may show up on the final print. Unlike scum marks left on the film *base,* drying marks occur on the emulsion side and cannot satisfactorily be removed.

Dry mounting Method of mounting prints by heating *shellac* tissue between the print and the mount.

Dye destruction process Sysytem of color reproduction which depends on the selective removal of dyes, existing in sensitized material rather than the chemical formation of dyes during processing.

Dye sensitizing The process by which the silver halides used in black and white emulsions are sensitized to the full spectrum of colors. Without dye sensitizing silver halides are only sensitive to ultraviolet and blue light.

Dye transfer process Way of producing color prints by printing from three color separation negatives. Positive matrixes are prepared which are each dyed in subtractive colors and pressed in register on to suitable receiving paper.

E

Electronic flash Light source produced when an electric current, stored in a capacitor, is discharged across two electrodes inside a gas-filled glass or quartz tube.

Electronic shutter Shutter where the mechanical mechanism used to control the period between opening and closing, is replaced by an electronic timing circuit.

Emulsion In photography, the light-sensitive material, consisting of *silver halides* suspended in *gelatin* which is coated on to various *bases* to make plates, films, and printing paper.

Emulsion speed The sensitivity of an *emulsion* to light. Films are given *ASA* and *DIN* numbers denoting emulsion speed.

Enlargement A print which is larger than the *negative* used to produce it.

Enlarger Device for projecting and focusing a negative image on to sensitized printing paper. Prints of different sizes can be exposed by increasing or decreasing the distance between the *negative* and the printing paper.

Ever-ready case Camera case which need not be completely removed to operate the camera.

Expiry date Date stamp on the packaging of sensitized material indicating the date beyond which the manufacturer's guarantee of specification expires.

Exposure In most practical photography exposure is the product of the intensity of light that reaches the film (controlled by the lens *aperture*) and the length of time this intensity of light is allowed to act (controlled by *shutter* speed).

Exposure latitude The amount by which you can over- or underexpose a light-sensitive material, and still produce an acceptable result.

Exposure meter Instrument for measuring the amount of light falling on or being reflected by a subject. It usually has means of converting the measurement into a range of shutter speed and aperture settings for the correct exposure.

Extension tube or ring Metal tube that fits between the lens and the camera body on small format cameras to extend the range of focusing for close-up photography.

F

Fahrenheit scale Temperature scale on which 32°F is the freezing point of water and 212°F the boiling point.

Fill-in light Direct or reflected light used to illuminate shadows cast on the subject by the main light source.

Film Photographic material consisting of a thin, transparent plastic *base* coated with light-sensitive *emulsion*. It comes as a strip or in sheets.

Filter Transparent material, such as glass, acetate or gelatin, which modifies *light* passing through it. For example color filters selectively absorb certain *wavelengths* of light and allow others to pass through. Filters affect the exposure of light-sensitive materials and are used at both camera and printing stages.

Filter factor Number by which an unfiltered exposure reading must be multiplied to give the same effective *exposure* through a filter. This compensates for the absorption of light by the filter.

Fine grain developer Film developer used to keep *grain* size in the *image* to a minimum by reducing the tendency of the image-forming silver to form clumps.

Fish-eye lens Extreme *wide-angle* lens uncorrected for *barrel distortion.*

Fixed focus Camera which has no *focusing* movement. The lens is usually set for the *hyperfocal distance* and is fitted with a small *aperture.* Subjects are sharp from about 6½ft (2m) to *infinity.*

Fixing Stage in film and print *processing* during which the photographic image is stabilized so that it is no longer affected by light. *Silver halides* which have not been converted to black metallic silver during development are made soluble.

Fixing agent Chemical, normally sodium thiosulfate (hypo) used for *fixing* process.

Flare Non image forming *light* scattered by reflections within the *lens, lens hood* or the camera interior. It reduces image contrast and shadow detail.

Flash See *Electronic flash.*

Flashbulb Expendable glass bulb containing zirconium wire in oxygen. It burns out in a brilliant flash when ignited by low voltage current. Usually grouped in a flashcube or bar which allows four or more flashes before changing.

Flash synchronization Method of synchronizing the maximum light output of a flash source with the fully open period of the *shutter.* There are usually two settings on a camera: X and M. X is the settting for *electronic flash* and M is for flash bulbs.

Flat Subjective term used where *contrast* values are low. It is used to describe original lighting conditions, or a *negative* or *positive* image.

Floodlamp Light source producing a broad spread of diffused, even illumination over the subject.

f numbers Number sequence on the *lens barrel* which is equivalent to the *focal length* divided by effective diameter of the aperture.

Focal length The distance between the rear *nodal point* of the lens and the *focal plane,* when the focus is set at infinity.

Focal plane The plane – normally flat and at right angles to the lens axis – on which a sharp image is formed by the lens.

Focal plane shutter *Shutter* system using two blinds which lie just forward of the *focal* plane. Exposure is made when a gap between the blinds passes in front of the film. The gap width can be adjusted to control *exposure.*

Focal point Point at which all the rays of light transmitted by a lens from a given subject intersect to give an *image* in sharp *focus.*

Focus The point at which light rays passing through a *lens* converge to give a clear and sharply defined *image* of a given subject.

Focusing Method of moving the lens in relation to the camera back in order to form a sharp *image* on the *film.*

Focusing scale Distance scale marked on the *focusing* mechanism of a camera.

Focusing screen Ground glass or similar screen mounted in a camera to allow the *image* formed by the *lens* to be viewed and focused.

Fog Veil of *density* on a negative or print which does not form part of the *image.* It can be caused by chemicals or exposure to light.

Format Size and shape of the picture area of a photograph.

Frame (1) One of the images on a strip or roll of film; (2) area within a *viewfinder* which indicates the view received by the *lens.*

Fresnel lens *Condenser* lens consisting of a series of concentric, stepped rings. They are used on *spotlights,* to direct light rays into a concentrated beam, and behind *focusing screens* to give an evenly illuminated image.

G

Gelatin Natural protein used to hold light-sensitive *silver halide* crystals in suspension and to bind them to the film or printing paper.

Glare Intense light reflected off highly reflective surfaces such as water, glass and very light toned subjects. It can be minimized by using a *polarizing filter.*

Glaze Glossy surface produced on some photographic printing papers by placing the wet print on

to a heated drum or clean polished surface. Glazed prints have denser blacks than mat prints.

Glossy paper Printing paper with a smooth, shiny surface giving richer blacks than mat prints.

Gradation *Contrast* range in the *tones* of an image, from white through gray to black. It is described in terms of soft, where the tonal contrast is low; normal; and contrasty where the contrast is great.

Grade Numerical description of the *contrast* characteristics of a range of printing paper. Similar grade numbers from different manufacturers do not necessarily have equivalent contrast characteristics.

Grain Minute particles of black metallic silver, often clumped together, which are formed when *silver halides* have been exposed and developed.

Graininess Term used to describe the grainy appearance of a photograph caused when *silver halide* crystals clump together during development and become a visible irregular pattern of black silver upon enlargement. Graininess is most noticeable in even, gray areas of the image and depends on emulsion sensitivity and type of developer.

Ground glass screen *Focusing screen* etched on one side to give a translucent screen for viewing and focusing the image.

Guide number Figure used to determine the *aperture* necessary with any particular subject to light source distance when a *flash* light source is in use. It takes into account the *inverse square law.*

H

Halation Halos formed on the *image* around intensive *highlights* on the subject. It is sometimes caused when light passed through the emulsion, strikes the back of the film and is reflected to the light-sensitive layer again.

Half-frame *Format* of 18mm x 24mm, half the size of the standard 35mm frame.

High key Photograph which contains predominantly pale *tones.*

Highlights Brightest, lightest parts of the subject. They appear as dense areas on the *negative* and reproduce as light areas on the *positive.*

Holography System of photography which does not require a camera or lens. Laser beams are used to create a three-dimensional image direct on to fine grain *plates.*

Hot shoe Fitting on top of a camera body to hold a flashgun. It contains electrical connections which automatically make contact between

flash gun and shutter synchronization circuit when the shutter release is fired, operating the flash.

Hue Title of a color. The property that distinguishes it from any other color; i.e. red as distinct from purple.

Hyperfocal distance The distance nearest to the camera at which a subject is sharp when the lens is focused on *infinity.*

Hypo Historical but still common name for the *fixing* agent, sodium thiosulfate.

Hypo eliminator (Clearing agent) Chemical bath used to destroy *fixing* agent from an *emulsion,* and so hasten washing.

I

Image Two-dimensional representation of a real object produced by focusing rays of light.

Image plane Plane at which a sharp *image* of the subject is formed. The nearer the subject, the further from the lens the image will be.

Incident light Light falling on to a surface, not reflected from it.

Incident light attachment Accessory for a hand *exposure meter* which allows it to give *incident light readings.*

Incident light reading Measurement of the *incident light* reaching a subject. The exposure meter is held close to the subject, pointing toward the light source.

Infinity In photography, the *focusing* position (marked ∞) at which distant objects are in sharp focus.

Infra-red Band of wavelengths beyond the red end of the *spectrum.* They can be recorded on suitably sensitized films.

Instamatic camera Simple, fixed focus camera which accepts *cartridges* of 126 film, and so has an "instant" loading facility.

Instant picture photography System which produces a processed photograph seconds after exposure.

Intensification Chemical method of increasing the *density* or *contrast* of the image. Normally used for improving *negatives.*

Interchangeable lens system Facility on a camera that enables a lens to be removed and substituted by another of different *focal length.*

Inverse square law When a surface is illuminated by a light source (e.g. *flash)* the light intensity at the surface is quartered each time the light distance is doubled. It forms the basis of flash *guide numbers.*

Irradiation In photography, the scattering of light as it travels through the emulsion. This effect results in a loss of *definition.*

J

Joule Unit of measurement describing the output of *electronic flash* and used to compare flash units in terms of light output.

K

Kelvin (K) The unit of measurement used to indicate the *color temperature* of *light sources.* It is numerically equal to units on the Absolute scale (equals degrees centigrade plus 273).

L

Lamphouse Ventilated *light-tight* housing which contains the light source on an enlarger or *projector.*

Large format camera General term for cameras taking pictures 4 x 5ins and larger.

Latent image Invisible image formed on the *emulsion* by *exposure* to light but made visible by *development.*

Leaf shutter An alternative term for *Diaphragm shutter.*

Lens Optical device made of glass or plastic, capable of bending light. In photography, lenses are used to gather together light rays reflected by an object to form an *image* on the *focal plane.* There are two types of simple lens: *converging* (positive), which cause rays to converge to a point, and *diverging* (negative), which cause rays to diverge. Both are used in *compound lens* constructions in which several elements are combined.

Lens barrel Housing for all the elements of the *lens.*

Lens hood Opaque tube, usually metal or rubber, used to shade the *lens* from unwanted light.

Light Form of energy that makes up the visible part of the electromagnetic *spectrum.* It has a range of *wavelengths* from 400–700 nm representing a change in color from violet to dark red.

Line film High *contrast* film which gives negatives of two tones only, black and white.

Line image High *contrast* image consisting of black areas and clear film, produced on special high contrast film from either line or *continuous tone* subjects.

Lith film An extreme form of *line film.* Requires processing in lith developer.

Long focus lens *Lens* with a *focal length* considerably greater than the diagonal of the film *format* with which it is used.

Low key Photograph in which *tones* are predominantly dark.

Luminance Measurable amount of light which is emitted by or reflected from a source.

M

Macro attachment Lens attachment *(extension tube or ring, bellows* or supplementary lens) used for *macrophotography.*

Macro lens Camera lens especially designed to give finest image quality in *macrophotography.*

Macrophotography Extreme close-up photography, producing a direct image larger than the original subject without the use of a microscope. Typically allows *magnification* of up to x 10.

Magenta Purple-red color composed of blue and red light. Magenta is the *complementary color* to green.

Magnification Ratio of the height of the image to the height of the subject; or the ratio of the lens-image distance to the subject-lens distance. When a subject and its image are the same size magnification is x1.

Mask (1) Opaque material used to cover the edges of printing paper and so produce white borders; (2) Weak positive image on film which, when registered with a negative, adds density to the shadow areas and so reduces *contrast;* (3) Dyes incorporated in the non-image areas of color negatives to improve color accuracy when printed.

Mat (1) Term used to describe the surface finish of printing paper that is non-reflective. (2) Cardboard surround used to frame a print.

Microphotograph Greatly reduced photograph made through a microscope and viewed through a microfilm reader. Often used for recording documents and books.

Mired Abbreviation of micro reciprocal degrees, a scale of measurement of *color temperature.* To calculate the mired value of a light source, divide one million by color temperature in *Kelvins.* Filters are often given mired shift values.

Mirror lens *Compound lens* using curved mirrors instead of some of the transparent elements. This allows an extremely long *focal length* lens to fit within a short, squat barrel.

Monochromatic Strictly, light rays of one *wavelength,* i.e. a single, pure color. Also used loosely when talking of a range of *tones* of one color, or a black and white photograph.

Monorail camera *Large format camera* unit constructed on a single rail. Offers maximum *camera movements.*

Montage Composite picture made from a number of prints or parts of prints, cut and superimposed.

Mosaic *Montage* made by piecing together a series of overlapping photographs of one subject to produce a large, continuous view.

MQ/PQ developers Developing solutions containing the developing agents metol and hydroquinine (or phenidone and hydroquinine). Extensively used for print development and many general purpose negative developers.

N

Nanometer (nm) Unit of measurement of light wavelengths. One nanometer is one millionth of a millimeter.

Negative Developed photographic *image* with reversed *tones,* so that subject *highlights* appear dark and shadows appear light. It is usually made on a transparent *base* so that it can be used to make a *positive* image by exposing another sensitive material to light passed through it.

Neutral density filter Gray *filter* which reduces the amount of light entering the camera without affecting the colors in the final image.

Newton's rings Concentric rings of colored light produced when two flat, transparent surfaces are in partial contact. Often seen in glass transparency mounts and glass *negative carriers.*

Nodal point There are two nodal points in a *compound lens.* The front nodal point is where rays of light entering the lens appear to aim. The rear nodal point is where they appear to have come from after passing through the lens. Used for optical calculations such as the precise measurement of *focal length.*

Normal lens Alternative term for *Standard lens.*

O

Opacity The light stopping power of a material. The greater the opacity of a substance, the more light it stops. In photography opacity is expressed as a ratio of the amount of light falling on the surface of the material to the amount of light transmitted by it.

Optical axis Imaginary line passing horizontally through the center of a *compound lens* system. A light ray passing along this axis would travel in a straight line.

Orthochromatic *Emulsion* which is sensitive to blue and green light, and insensitive to red.

Overdevelopment The result of exceeding the recommended amount of *development.* It is caused by prolonged development time, increased development temperature or agitation. It results in increased *density* and *contrast* leading to *fog* and stains.

Overexposure The result of giving a light-sensitive material excessive *exposure.* It increases *density* and reduces *contrast.*

P

Panchromatic An emulsion which is sensitive to all colors of the visible *spectrum,* although it does not react in a uniform way.

Panning In still photography, the technique of swinging the camera to follow a moving subject so that, in the final print, the main subject is sharp and the background is blurred.

Panoramic camera Camera with a special type of scanning *lens* which rotates about its rear *nodal point.* exposing a long, curved strip of film. It covers a very large field of view.

Parallax The difference in viewpoint between the image seen through a camera's *viewfinder* and that recorded by its *lens.* Except in cameras with through-the-lens viewing systems, there is a slight variance between the two views, known as parallax error.

Pentaprism Five-sided glass prism, usually fitted to 35 mm cameras, which makes it easier to view the focusing screen image close-up. It presents the image upright and the right way round.

Perspective System of representing three-dimensional objects on a two-dimensional surface to give a realistic impression of depth. Achieved mostly by means of linear perspective, scale, overlapping elements in the subject, and *aerial perspective.*

Photo-electric cell Light-sensitive device used in *exposure meters.* There are two main types: a photo-generative cell which produces electricity when light falls on it; and photo-resistant types which offer resistance to a battery powered circuit according to light received.

Photoflood Bright, over-run tungsten lamp giving light of 3,400K.

Photogram Pattern or design produced by placing opaque or transparent objects between a light-sensitive *emulsion,* and the light source. Then *processing* the photographic material.

Photomicrography Photography of magnified objects by means of a camera attached to a microscope.

Pincushion distortion Lens *aberration* which causes parallel straight lines at the edge of the image field to curve toward the optical axis.

Pinhole camera A simple camera which uses a very small hole instead of a lens.

Plate camera Camera designed to take glass *plates,* today usually adapted to take *sheet film.*

Plates Large format light-sensitive materials where the *emulsion* is coated on glass. Now almost entirely replaced by *sheet film.*

Polarized light Rays of light that have been restricted to vibrate in one plane only.

Polarizing filter Colorless filter able to absorb *polarized light.*

Polaroid camera Camera designed for *instant picture photography.*

Polaroid film *Sheet film* designed to give instant pictures.

Positive Photographic image (on paper or film) in which light and dark correspond to the *highlights* and shadows of the original subject.

Posterization Technique of using a number of tone-separated negatives printed on to a high *contrast* material to produce a photograph containing selected areas of flat *tone* instead of *continuous tones.*

Primary colors In light, the three primary colors of the *spectrum* are blue, green, and red. Each comprises about one third of the visible spectrum and they can be blended to produce white light or any other *hue.* (NB In painter's pigments, the primaries are considered to be yellow, blue, and red.)

Principal planes Imaginary lines which pass through the *nodal points* of a *lens* system.

Print In photography, usually a *positive* image, which has been produced on paper coated with a light-sensitive *emulsion* by the action of light, usually passed through a *negative.*

Printing-in Technique for giving additional *exposure* to selected areas when making a *print.* Other areas are shaded from the light by an opaque *mask.*

Prism Transparent material, normally glass, with plane, polished surfaces inclined to one another.

Processing General term used to describe the sequence of steps whereby a *latent image* is converted into a visible, permanent image.

Projection printing Another term for *Enlarging.*

Projector Equipment used to display enlarged still or moving images on to a screen.

R

Rangefinder A camera focusing system that determines the distance between camera and subject. The subject is viewed simultaneously from two positions a short distance apart. Two images are seen which

can be superimposed by adjusting a mirror or similar device. This adjustment is usually linked to the focusing movement of the camera lens.

Rapid fixer Fixing solution which uses ammonium thiocyanate or thiosulfate instead of hypo (sodium thiosulfate). Allows greatly reduced fixing time.

Reciprocity failure The loss of sensitivity of photographic *emulsion* when exposures are very brief (less than 1/10,000 sec) or very long (over one second).

Reciprocity law States that exposure equals light intensity x the time it is allowed to act.

Red eye effect Effect where the pupils of a subject's eyes appear red in color photographs taken with *flash* light illumination. Caused when the red layer underlying the retina reflects light into the camera lens because the flash path is too close to the camera lens axis.

Reducer Solution which reduces some of the silver from negatives or prints, lightening the image.

Reflected light reading Exposure reading taken with the *exposure meter* pointing toward the subject so that it measures the light reflected from subject surfaces.

Reflector Any surface from which light is reflected. Usually a purpose built area of reflective material positioned to reflect from a main light source into the shadow areas of a subject.

Reflex camera Camera with a viewing and focusing system that uses a mirror to reflect the image rays, after they have passed through a lens, on to a focusing screen.

Refraction The change in direction of light rays as they pass obliquely from one transparent medium to another of different density, e.g. from air to glass.

Resin-coated paper Printing paper with a water repellent base. RC papers process faster, need less washing and dry more quickly than regular fiber types.

Resolving power The ability of the eye, a lens, or a photographic emulsion to resolve fine detail.

Reticulation The minute wrinkling of the emulsion surface of film due to extreme changes of temperature, or acidity/alkalinity excess during processing.

Retouching After-treatment of negatives or prints by hand to remove blemishes and/or change tonal values.

Reversal materials Photographic materials specifically designed to be processed direct to give a result matching the image it has received.

Ring flash Electronic flash tube in the form of a ring surrounding the camera lens. Used when shadowless lighting is required.

Rising front Camera fitting that allows the lens to be shifted upward or downward, remaining parallel to the film plane.

Rollfilm 120/620, 6 x 7ins or 127 format camera film which has an opaque paper backing and is wound on to a metal spool. The backing paper is numbered to indicate frames, and is longer than the film to provide a light-tight wrapping for daylight loading and unloading. Sometimes applied to any camera film loaded in roll form.

S

Sabattier effect See *Solarization*.

Safe lighting Darkroom lighting of an appropriate color and intensity that will not noticeably affect the light-sensitized photographic material being used.

Selective focusing See *Differential focusing*.

Selenium cell *Photo-electric cell* that generates electricity in direct proportion to the amount of light falling upon its surface. Used in many older types of *exposure meter*.

Sensitometry The scientific study of the response of photographic materials to light, including the effects of *development*.

Shading The local control of print *density* by holding back light from selected areas of the print during enlarging.

Sheet film Large format *film* sold in sheets of specific size rather than in roll form. Also called cut film.

Shellac Natural resin with a low melting point, harmless to photographic prints and used extensively on dry mounting tissue.

Shutter Mechanical system for controlling the time that light is allowed to act on film in a camera. The two most common types are the between-the-lens *diaphragm shutter*, and the *focal plane shutter*.

Silver halides Compounds formed between silver and alkali salts of halogen chemicals such as bromine, chlorine and iodine. Silver bromide, silver chloride and silver iodide are the light-sensitive silver halides used in photographic emulsions.

Single lens reflex (SLR) Camera which allows the user to see the exact image formed by the picture-taking lens, by means of a hinged mirror between the lens and film.

Skylight filter Pale pink color correction filter. Used to eliminate a blue color *cast* when photographing

in dull weather or where light is solely from blue sky-light.

Slave unit Relay mechanism which fires other flash sources simultaneously when a *photo-electric cell* is activated by the light from a flash source on the camera.

Slide General term for a *positive* image on film, usually mounted in a card or plastic frame ready for projection.

Snoot Cone-shaped shield used on spotlights to direct a cone of light over a small area.

Soft focus Purposely diffused image definition. This is achieved during the camera exposure or at the enlarging stage with attachments or a soft focus lens.

Solarization (1) Term commonly applied to partial reversal effects caused by fogging photographic material to light during development (Strictly the Sabattier or pseudo-solarization effect.) (2) Reversal or partial reversal of the tones of a photographic image caused by extreme overexposure.

Spectrum Commonly, part of the electro-magnetic spectrum, between wavelengths 400 and 700 nm, to which the human eye is sensitive. It appears as the colored bands which are produced by refracting white light with a *prism*, arranged according to *wavelength*.

Split image focusing Focusing system where an area of the subject appears bisected to the *viewfinder*. The two halves of the bisected area come into alignment when the correct focus is set.

Spotlight Artificial light source that uses a simple focusing system to produce a strong beam of light of controllable width.

Spot meter *Exposure meter* which receives and measures light from a very small part of a subject.

Spotting The retouching of small white or black specks on prints, and sometimes negatives, using watercolor, dye or pencil.

Stabilization Alternative method of fixing where unused *silver halides* are converted to near stable compounds. These are not sensitive to light and washing is not required.

Stand Alternative name for a *Tripod*.

Standard lens Camera lens whose *focal length* is roughly equal to the diagonal of the picture format it is used with. The standard, or normal lens, of a camera will give an angle of view and a scale that approximates to human vision.

Stop *Aperture* of a camera or an enlarging lens.

Stop bath Chemical bath which stops *development* by neutralizing the developer. This prevents active developer from contaminating further processing.

Stopping down Reducing the size of the lens *aperture* from a large stop to a smaller one.

Stress marks Black lines or spots on the developed image caused by friction or pressure on the *emulsion* before *development*.

Strobe light (1) General term for *electronic flash*. (2) Stroboscopic light produced by a special lamp or tube flashing repeatedly at a chosen time frequency.

Subtractive color synthesis Way of producing color images by subtracting appropriate amounts of unwanted primary colors from white light by means of yellow, magenta, and cyan filters.

Swing back/front The pivoting lens and back panels found on most *large format cameras*.

T

Technical camera Large format sheet film camera, normally with a folding baseboard. Also applied to monorail cameras.

Telephoto lens Compact lens construction used to give a *long focus lens* a relatively short *back focus*.

Test strip Strip of printing paper or film which is given a range of exposures (by shading) to test for correct image density.

Texture The character of surfaces. This usually means their roughness or smoothness.

Time exposure An exposure where the shutter is opened and closed manually for a time judged by the photographer.

Tone Any area of a print or a negative which has a uniform *density* and can be distinguished from darker or lighter parts.

Toners Chemicals used to change the color of a black and white photographic image. A system of bleaching and dying converts the black metallic silver image to a dye image.

Transparency *Positive* image in black and white or color produced on transparent film.

Tripack Light-sensitive material used for color photography consisting of three superimposed emulsion layers. In its modern form, the layers are integrated and coated on one *base*. Each layer is sensitive to one of the three *primary colors*.

Tripod Adjustable, three-legged camera support, which usually has a

screw fitting for attaching small format cameras.

TTL exposure meter Through-the-lens *exposure meter*. It measures the image light, within the camera, that has passed through the camera lens.

Tungsten filament lamp Lamp in which light is generated by passing electricity through a fine tungsten filament which is enclosed in a glass envelope. It is the basic artificial light source in photography.

Tungsten halogen lamp Compact tungsten filament lamp. It contains halogen traces to reduce lamp discoloration with age.

Twin lens reflex (TLR) Camera with two lenses of identical *focal length*. One forms the image on a focusing screen; the other focuses the image on the film plane.

Type-A color film Color film balanced for tungsten lighting of 3,400K *color temperature*.

Type-B color film Color film balanced for tungsten lighting of 3,200K *color temperature*.

U

Ultra-violet Wavelengths of the electromagnetic spectrum between about 5 and 400nm. Ultra-violet light is invisible but is one of the causes of *aerial perspective*. An ultra-violet filter can be used in front of the camera lens.

Underdevelopment This is the result of too little development time or a decrease in the development temperature. Underdevelopment reduces *density* and *contrast* in the image.

Underexposure This is the result of too little *exposure* in the camera or at the enlarger stage. Underexposure reduces *density* and *contrast* in the image.

Universal developer The general name for developer suitable (at different dilutions) for both negative and print processing.

Uprating Term used when a film is intentionally underexposed, usually followed by *overdevelopment*.

V

Variable contrast papers Printing papers in which *grade* (contrast) can be varied during enlarging by changing the color of the printing light using filters.

Variable focus lens Another term for *zoom lens*.

View camera *Large format camera* with all *camera movements*, (such as a *monorail camera*).

Viewfinder System for viewing the subject, showing the field of view of the camera lens.

Vignetting Printing technique where the edges of the picture are gradually faded out to black or white.

W

Washing Usually the final part of *processing*. It removes residual chemicals and any soluble silver compounds from the emulsion.

Wavelength Method of identifying a particular electro-magnetic radiation, considered as rays progressing in wave-like form. Wavelength is the distance between one wave crest and the next. Different electro-magnetic radiations have different wavelengths. In the case of light wavelength is measured in *nanometers* (nm).

Wetting agents Chemicals which reduce the surface tension of water. A wetting agent is usually added to the final wash to improve draining and promote even drying.

Wide-angle lens Lens with wide *covering power* and short *focal length* relative to the camera *format* on which it is used.

X

X-ray Electro-magnetic radiations (like light waves) which form a shadow image of certain internal structures when allowed to pass through opaque objects and act upon a light-sensitive emulsion.

X-ray film Photographic sheet film coated with coarse grain emulsion front and back (to counteract tendency of these rays to pass through the emulsion without affecting it.)

Z

Zoom lens Lens which is constructed to allow continuously variable *focal length* without disturbing focus or *f number*.

Index

Acknowledgments

The Author would like to thank Tom Picton for helpful suggestions; his wife Pamela, as always, for help with the typescript, and staff at the Royal College of Art.

Dorling Kindersley would like to give special thanks to David Ashby and Les Smith who set the standard for the illustrations and produced most of them. Special thanks must also go to Mary-Lynne Stadler, Javed Badar, Roger Pring, Ros Franey, Charles Elliott, Frederick Ford, Caroline Oakes, Jackie Lee, Leslie Gilbert and for typesetting, Dennis Walker and the staff at Vantage (Southampton).

Illustrations and studio services by:
David Ashby
John Bishop
Denise Brown
Frederick Ford
Gilchrist Studios
Kenneth Hone
Richard Jacobs
Nigel Osborne
Les Smith
John Thompson

The photographs were taken by Andrew de Lory with the exception of the following:
Eve Arnold (Magnum) 194-5
Bill Brandt 188-9
John Bulmer 59b; 98b; 15lb; 152, t, b; 153bl, br; 157tl
Ed Buziak 21bc; 41cr; 48c, cr, bl; 49tl, tr; 51br; 52bl; 57b; 58t; 59tl; 60b; 63tl, ct, cb; 95bl, bc, br; 99bl, bc, br; 109; 111t, c; 114t; 115t; 150t; 156bl
Harry Callahan (Light Gallery) 199
Bryn Campbell 60t
Henri Cartier-Bresson (Magnum) 47; 184-5
Gerry Cranham 63br; 190-1, 99t
Stephen Dalton 8tl
Dr. Harold Edgerton (M.I.T., Camb, Mass.) 13t
EMI Medical 13bl
Monty Fresco 63t
Lee Friedlander 196-7
Joe Gaffney 107b
Rolph Gobits 179
Ernst Haas (Magnum) 182-3
Rob Henderson 60c
Frank Herrmann 10; 49b; 53; 56bl; 62; 63bl, 64tr, br; 95t; 97b; 116; 117b; 202
ICI Plant Protection Ltd. 81tl; 9
Yousuf Karsh 180-1
André Kertész 192-3
Kodak 8bl; 136l
Michael Langford 38; 42t; 43tl, tc, tr, b; 48t; 50; 51t; 52t, c; 56t, br; 87; 100t; 117t; 119tl, tr; 121tl, tr; 122; 125; 126-7; 128-9; 132c, br; 136tl, cl; 147tl; 148bl; 151tl; 157tl, br; 158bl, br; 208-9
Robin Laurance 106c; 121tr, br
Alexander Low 149t; 153tr
NASA 8bl; 11tr
Patrick Nugent 41br; 54bl, br; 121br; 147tr; 151tr; 155tl; 158tc
Popperphoto 14
Denis Postle 120t, br
Colin Reiners 119b
Chris Schwarz 106t
Shell 11br
Ronald Sheridan 61b; 64c; 206
Aaron Siskind (Light Gallery) 198
John Smallwood 158cb
Graham Smith 139
Tim Stephens 166-7; 170-1
Pete Turner 186-7
Jerry Uelsmann 200-1

Key: t: top, c: center, b: bottom, l: left, r: right

Photographic services by:
Ron Bagley
Negs
N. J. Paulo
Pelling and Cross
W. Photoprint

Typesetting:
Vantage (Southampton)
In-line Graphics
Syntonics